Andrea Bandhauer and Michelle Royer are senior lecturers at the University of Sydney.

STARS in WORLD CINEMA

SCREEN ICONS AND STAR SYSTEMS ACROSS CULTURES

EDITED BY ANDREA BANDHAUER AND MICHELLE ROYER

I.B. TAURIS

LONDON · NEW YORK

Published in 2015 by I.B.Tauris & Co. Ltd
London • New York
www.ibtauris.com

Every attempt has been made to gain permission for the use of the images in this book.
Any omissions will be rectified in future editions.

References to websites were correct at the time of writing.

Tauris World Cinema Series

ISBN: 978 1 78076 977 6
eISBN: 978 1 85773 835 6

A full CIP record for this book is available from the British Library
A full CIP record is available from the Library of Congress

Library of Congress Catalog Card Number: available

Typeset by Aptara
Printed and bound by CPI Group (UK) Ltd, Croydon, CR0 4YY

Contents

List of Illustrations

List of Contributors

Andrea Bandhauer is a senior lecturer and Chair of Department in Germanic Studies. She also teaches in the International and Comparative Literary Studies programme at the University of Sydney. Her teaching and research interests include transcultural and post-colonial literary and textual theory, contemporary Austrian and German film and literature, and Migration Studies. She is the editor of the volumes *New Directions in German Studies* (2005) and *Intercultural Migrations: Germany and Australia* (2009). Recent publications include articles and chapters on Elfriede Jelinek, Yoko Tawada and Michael Haneke, as well as on German–Australian migration.

Lizelle Bisschoff is a researcher in African film and the founder of the Africa in Motion (AiM) film festival, an annual African film festival taking place in Scotland, founded in 2006. Lizelle holds a PhD in African cinema from the University of Stirling in Scotland, in which she researched the role of women in African film. She has published several articles on sub-Saharan African cinema and regularly attends African film festivals as speaker and jury member. After completing a two-year Leverhulme research fellowship on the emerging East African film industries at the University of Edinburgh's Centre of African Studies, she is currently a Lord Kelvin Adam Smith Research Fellow in Film and Television Studies at the University of Glasgow.

Greg Dolgopolov teaches and researches at UNSW in video production, film and television theory. Greg's research interests include post-Soviet cinema and the crime genre. Greg has written extensively on historical television detective serials, reality game shows, contemporary cinema, Australian vampire films, documentary films, international horror and mafia representations. His research has been published in *Social Semiotics*, *Senses of Cinema*, *Metro Magazine*, *Lumina*, *Real Time* and

Kinokultura, where he is now a member of the editorial board. Greg co-edited *Studies in Australasia Cinema* in 2011. Greg has taught Screen Studies at AFTRS and Media and Cultural Studies at Murdoch, Melbourne and Curtin universities. He has provided specialist media and cultural commentary to a range of national media including *The Australian*, *The Age*, the *West Australian*, the ABC and *Sydney Morning Herald*. He is the curator and associate director of the Russian Resurrection Film Festival.

Rachel Dwyer is Professor of Indian Cultures and Cinema at SOAS, University of London. She is currently completing her book *Bollywood's India: Hindi Cinema as a Guide to Modern India* and then plans to research the cultural history of the Indian elephant.

Ifdal Elsaket is a PhD candidate in the Departments of History and Arabic and Islamic Studies at the University of Sydney.

Vrasidas Karalis is Chair of Modern Greek Studies at the University of Sydney. His research is focused on the development of visual cultures from the Middle Ages to the modern world, with particular emphasis on contemporary cinematic practices. He has published essays on the works of Sergei Eisenstein, Alfred Hitchcock. Andrei Tarkovsky and Theo Angelopoulos. Recently he published the first history of Greek cinema in English. His current research focuses on early Greek cinema (1900–45) and on the systematic exploration of the transition from the two-dimensional visual space of the Byzantine iconographic tradition to the three-dimensional spatiality of modernity. He also studies the rise of the 'new global realism' and the various forms of realism that Greek directors from Michael Cacoyannis to Constantine Giannaris have employed in order to address issues of identity, social conflict and transcultural reality.

Mats Karlsson lectures in Japanese Studies at the University of Sydney. He researches and teaches comparative literature and modern Japanese literature, as well as Japanese cinema. He is currently working on a monograph manuscript dealing with material aspects and practical outcomes of the proletarian cultural movement in Japan, peaking around 1930, with a focus on the fields of literature and cinema.

Michelle Langford is a senior lecturer in Film Studies at the University of New South Wales in Sydney, where she is also Deputy Head of School. She has published extensively on German and Iranian cinemas. She is the author of the monograph *Allegorical Images: Tableau, Time and Gesture in the Cinema of Werner Schroeter* and the editor of the *Directory of World Cinema: Germany*. Her work on Iranian cinema has appeared in various books and in top-ranking journals such as

Camera Obscura and *Screen*. She is currently working on a monograph on allegory in Iranian cinema.

Bliss Cua Lim is Associate Professor of Film and Media Studies and Director of the PhD Visual Studies programme at the University of California, Irvine. She is the author of *Translating Time: Cinema, the Fantastic and Temporal Critique*. Her research and teaching centre on temporality, Philippine cinema, post-colonial feminist film theory, transnational horror and the fantastic and taste cultures.

Her work has appeared in the journals *Discourse, positions, Camera Obscura, Velvet Light Trap, Asian Cinema, Spectator, Art Journal*, and in the book anthologies *Film and Literature: A Reader; Geopolitics of the Visible: Essays on Philippine Film Cultures* and *Hong Kong Film, Hollywood and the New Global Cinema*. She is currently working on a new book on the crises of archival preservation in Philippine cinema.

Karen O'Brien is Senior Lecturer in History and Indigenous Studies at the Koori Centre at the University of Sydney. She is interested in research that explores fresh approaches to researching and writing indigenous histories and experiences. Karen's research explores colonising and decolonising histories, researching and writing indigenous histories and experiences. Her research explores historical sources that are rich in personal narrative and life stories such as biography, testimonial studies and oral histories, and it draws on a range of theoretical and methodological approaches that aim to secure an authentic historical voice.

Antonella Palmieri has recently completed a PhD in Film Studies at the University of East Anglia. She is currently working as a part time lecturer in Film and TV Studies at the University of Lincoln and the UEA. Her research is concerned with the politics of gender, sexual and ethnic representations in Hollywood cinema and American and British television. She is also interested in Italian cinema and Star Studies. She is currently contributing to two forthcoming edited collections: one on world cinemas, for which she is writing on Italian and Brazilian cinemas and the other on the Hollywood director Billy Wilder.

Leonid Petrov graduated from St Petersburg State University (1994) in Russia, where he majored in Korean history and language. He obtained a PhD in History at the Australian National University on the 'Socio-economic school, and the formation of North Korean official historiography'. In 2003–2005, Dr Petrov taught Korean History at the Intercultural Institute of California (San Francisco) and Keimyung University (Daegu). In 2006–07, he was Chair of Korean Studies at the Institut d'Etudes Politiques de Paris (Sciences Po). In 2007–09 he worked on 'Historical Conflict and Reconciliation in East Asia' (ARC-ANU) and 'North–South Interfaces on the Korean Peninsula' (CNRS-EHESS) projects. Currently, Dr Petrov teaches Korean history and language at the University of Sydney.

Dr Leonid Petrov is also a research associate at ANU School of International, Political and Strategic Studies.

Michelle Royer is a senior lecturer and Chair of the Department of French Studies at the University of Sydney, where she lectures in contemporary French cinema. She also teaches Star Studies in the International and Comparative Literary Studies programme and in European Studies. Her major research interests are in the field of contemporary cinema and the work of French writer and filmmaker Marguerite Duras. Her most recent publications include chapters on Claire Denis's film *35 Rhums*, Simone de Beauvoir and cinema and Marguerite Duras's cinema. She has also co-edited special issues of the *Australian Journal of French Studies* and of *EFLAC*, and is a member of the reading committee for the Marguerite Duras series (Peter Lang). She is currently involved in a large research project entitled 'Senescence in World Cinema'.

Lisa Shaw is Reader in Portuguese and Brazilian Studies at the University of Liverpool and has just completed a book on Carmen Miranda. She is the author of *The Social History of the Brazilian Samba* and co-author of *Popular Cinema in Brazil, 1930–2001* and *Brazilian National Cinema*. She is currently working on a major research project entitled 'Tropical Travels: Brazilian Popular Culture Abroad, 1870–1945', supported by a senior research fellowship from the Leverhulme Trust and has recently published articles on related topics in the journals *Atlantic Studies*, *English Language Notes* and *Celebrity Studies*.

Ludmila Stern is the Head of the School of International Studies (UNSW). Her research covers political and cultural relations between Soviet organisations (such as Comintern, VOKS, the Soviet Writers' Union) and Western intellectuals and includes a monograph, *Western Intellectuals and the Soviet Union, 1920–40: From Red Square to the Left Bank* and a series of articles. Her contemporary research area includes interpreted communication in complex legal settings of national and international courts and examines war crimes trials, such as the Australian war crimes prosecutions, the International Criminal Tribunal for the Former Yugoslavia and the International Criminal Court. Her current projects include 'Interpreters in Court: Witness Credibility with Interpreted Testimony' and 'From the Nuremberg Trials to the International Criminal Court: Interpreting in War Crimes Prosecutions'.

Anne L. Walsh is author of *Arturo Pérez-Reverte: Narrative Tricks and Narrative Strategies*, *Chaos and Coincidence in Contemporary Spanish Fiction* and co-author of *Guerra y memoria en la España contemporánea/War and Memory in Contemporary Spain* as well as book chapters and articles on the subject of Spanish narrative (written and filmic) of the twentieth and twenty-first centuries.

Sabrina Qiong Yu is Lecturer in Chinese and Film Studies at Newcastle University, UK. Her research and publications focus on stardom, contemporary Chinese cinema, gender and sexuality and audience and reception studies. Her most recent publications on stars and stardom include *Jet Li: Chinese Masculinity and Transnational Film Stardom* and 'Vulnerable Chinese Stars: From *xizi* to Film Worker', in Yingjin Zhang (ed.), *A Companion to Chinese Cinema*. She helped to launch a translation series on Star Studies with Peking University Press in 2010 and translated Leon Hunt's book *Kung Fu Cult Masters*.

Acknowledgements

The editors would like to thank the contributors for giving their time and expertise to this book and for their unreserved cooperation.

We are grateful to Professor Lucia Nagib for supporting our project and Philippa Brewster, Anna Coatman and Lisa Goodrum of I.B.Tauris for their assistance with our manuscript.

We thank the School of Languages and Cultures at the University of Sydney for their generous support of this project.

We would also like to express our sincere gratitude to Dr Maria Veber for reading the contributions and for her great suggestions, Pat FitzGerald, our copy-editor, for her meticulous editing, and Margaret Hennessy for her careful editing and valuable suggestions.

Our thanks to Dr Angela Impey of SOAS for her helpful recommendation for the chapter on the Nollywood star system.

Our warmest thanks to Simon Guthrie, Raga Ragavan, Alex Reznic, Alexandra Royer-Guthrie and Ava Schacherl-Lam, for their generous encouragement, suggestions and support, and for the time spent discussing our project from its very beginnings to the design of the book cover and all aspects in between!

Introduction: Star Studies and World Cinema

Andrea Bandhauer and Michelle Royer

Since the very beginnings of cinema, actors and stars have been central to its history and been one of the medium's defining elements. They have also been central to the marketing of cinema, and have played a very significant part in the reception of films. Considering the impact of stars on cinema, it is surprising that more attention has not been given to their study in the academic world. This may be partly due to the fact that film stars are linked to a culture of celebrity that is considered to be shallow and vacuous.

The study of stars is a relatively recent development in film and cultural studies, although as early as 1957 French sociologist and philosopher Edgar Morin highlighted the importance of stars by showing that their influence touches on every aspect of our life and dictates taste in fashion, lifestyle and desire: 'The star participates in all the world's joys, pities all its misfortunes, [and] intervenes constantly in its destiny' (Morin 2005: 4). In 1979, Richard Dyer began what is now referred to as Star Studies with the publication of his groundbreaking book *Stars*, considered to be a cornerstone of any study of stardom. But Morin, Dyer and subsequent scholars[1] have tended to focus on Hollywood or make the contemporary Hollywood star system the point of reference, even though stars are not a new phenomenon and are not confined to Europe and North America, as this book will demonstrate.

The inspiration for this volume came from a desire to shift the primary focus of Star studies from Hollywood to the multiple centres of stardom across five of the world's continents.

This book presents a collection of 16 essays on African, Asian, Australasian, European and Latin American stars and star systems, and is divided into four sections

1

covering 'Film Icons and Star Systems', 'Stardom Mobility and the Exotic', 'The Politics of Stardom' and 'Stars, Bodies and Performance'. Each section comprises chapters on stars from a range of cultures, often consisting of case studies that intersect with each other. Thus the structure of the book encourages exploration of the interconnectedness of stars produced worldwide. Chapters are linked by their commonality and their transnational approach to the subject, and the coherence of this volume comes from its pluricentric approach, with no privileged position being given to any one star or community.

Grounded in their respective local film industries, the local history and culture but also constructed by their interconnectedness with other star systems, film industries and international contexts, film stars reach audiences within and beyond their national borders because they 'touch on things that are deep and constant features of human existence' (Dyer 2003: 17). Russell Meeuf and Raphael Raphael's book *Transnational Stardom, International Celebrity in Film and Popular Culture* (2013) gives a fascinating insight into the transnationality of stardom, with examples taken from the Hollywood and European film industries, and from East Asian, Latin American and Indian popular cinema. The study shows that the concept of the 'transnational' is very useful in providing an understanding of stars' mobility and the cross-cultural dynamics of celebrity cultures, but that Hollywood is still considered to be at the centre of the transnational mobility of stars.

While there is no denying that Hollywood has played an essential role in manufacturing stardom across the world, this fact should not obscure other complex and specific local and transnational interactions. In this book we wanted to deflect attention from Hollywood and examine stardom from a wide range of local perspectives, which in many cases does not involve reference to Hollywood. We have gathered chapters that explore stardom in Australia, Austria, China, Egypt, France, Germany, Greece, India, Iran, Japan, North and South Korea, Nigeria, the Philippines, the former Soviet Union and the US. This book dissects stardom and the circulation of stars across borders, and analyses how local star systems or non-systems construct stardom in their interconnectedness. Several chapters also raise the question of using stars for local and global political and ideological purposes. Recognising the danger of reading star texts through an overly Anglo-Saxon viewpoint while discussing local situations, we have invited scholars and specialists from a wide range of cultures to contribute to this book so that a diversity of theories and approaches would frame the volume.

Our approach is informed by the fast-developing research field of World Cinema; several major books have recently been published on the subject, including *Remapping World Cinema: Identity, Culture and Politics* by Stephanie Dennison and Song Hwee Lim; Nataša Durovičová's and Kathleen Newman's *World Cinemas, Transnational Perspectives* and *World Cinema and the Ethics of Realism*, by Lúcia Nagib. Nagib, Chris Perriam and Rajinder Durah's recent volume, *Theorizing World Cinema* (2012) with contributions from top scholars in the field, has stimulated

further thinking on world cinema, and indeed served as a starting point and formed our approach to this edited volume. The most important idea advanced by this book is that of polycentrism as advocated by Lúcia Nagib and based on the groundbreaking book *Unthinking Eurocentrism* by Shohat. Polycentrism represents an attempt to move away from binary divisions between the US and the other, centre and periphery, the West and the rest. Within the polycentric vision, 'the world has many dynamic cultural locations, many vantage points' (Shohat 1994: 1,545) and '[n]o single community or part of the world, whatever its economic power or political power, should be epistemologically privileged' (Shohat 1994: 1,545). Hence, we have chosen a multipolar and inclusive method, emphasising the interconnectedness of cinemas between cultures, rather than a dichotomised approach that would oppose the West to the non-West, Hollywood to national cinemas or dominant to Third Cinema.

However, we did not want this book to be a survey of stars around the world, for a survey 'suggests a distant gaze, panoptically monitoring the foreign for our convenience and use' (Andrew, in Dennison and Lim 2006: 19). On the contrary, we wanted it to offer a series of close encounters with stars, their cultures, their local history, and their global and international relevance. We have gathered and juxtaposed chapters not in relation to the cultural origins of the stars analysed here, but in relation to the possible connections readers would weave between them, thus establishing dynamic cultural locations cutting across chronology, geographies and film history. The result is a book structure that brings together scholarship that is grounded in local knowledge of history, language and cultural systems, but also accounts for hybridity, boundary-crossing and the circulation of practices. Stars are firmly situated in the local and, as shown in this book, are constructed by local politics and ideologies, film industries, linguistic contexts, and by specific films and directors. As Dyer has already demonstrated (1998: 60) the uniqueness of a given 'star image' founds itself in the nexus between promotion, publicity and films themselves, thus creating a multifaceted force uniting extra-diegetic persona and diegetic character. But the local is also composed of specific transnational connections with neighbouring countries, distant cultures and film industries inseparable from the local dynamic. This book is based on a desire to advance polycentrism in Star Studies, starting from insiders' viewpoints. Hence our contributors are all scholars whose research is based on an in-depth knowledge of the culture and language of the stars and star systems they study, and of the global articulations between stars and cultural practices.

The chapters below demonstrate that the methodologies for the study of stardom are strongly defined by local contexts, in which Western theoretical frameworks are often found to be of limited use. Authors in this book have, for instance, focused on the role of visual representations, music, singing, dancing and martial art as central skills in the making of stardom.

Star Studies has pushed aside the study of acting, and actors and actresses have been 'discussed in terms of their associations with celebrity, consumption and fashion' (Hollinger 2006: 21), rather than in the context of their acting skills. Up to this point little has been written also on the impact of stars on spectators, on stars' embodiment across cultures and how stars move their audiences. Stardom has mostly been conceived as textual construction, and if stars' performances have so far been given insufficient scholarly attention, a growing number of books and articles exploring theories of embodiment and sensory representation can bring new perspectives to Star Studies.[2] These theories increasingly inform trans- and intercultural studies on film, as shown by Chris Perriam's fascinating chapter 'Eduardo Noriega's Transnational Projections' (Nagib and Perriam 2012), which explores 'the ways in which actors' performances move their audiences' (77) when images of stars transit between mediums and cultures.

The role of stardom in the reception of films, the use of the intertextuality of stars in films and the investigation of theories of embodied spectatorship and the emotions which viewers invest in stars are given space here in order to further our understanding of stars in light of recent research into reception theory. In this book the notion of embodiment cuts across all the chapters and is not considered as a given of the acting process, but as requiring investigation across cinemas from a range of cultural locations. Not only is an entire section of this volume devoted to embodiment, in chapters about Austrian, French, German, Greek and Philippine cinemas, but this notion is also central to the essays on Bollywood and Nollywood stardom. These case studies of star reception and screen acting in the context of our multipolar approach will enrich star theory.

This book contains many anecdotes about stars that will entertain, revolt and move readers, while at the same time revealing to them the incredible richness of cinema across the world and the complexity of global interactions. It will inform and raise fundamental questions about individual societies, political powers, gender issues and linguistic contexts, as well as the bodily processes of intimacy that take place between stars and viewers.

The first part of this volume, 'Film Icons and Star Systems', gathers contributions spanning a vast geographical area, with chapters on Egyptian, Indian, Japanese and Nigerian stars. The authors of these chapters look at both a star's role in the construction of national identities and their international relevance. While each of these stars is discussed in the context of their local film industry, history and culture, these are never insulated from transnational interactions. This section addresses the notion of stardom not simply as international, supranational and transnational. Film icons are shown to be strongly grounded in their local socio-political contexts and star systems.

Rachel Dwyer's chapter focuses on Bollywood star Amitabh Bachchan, to show how a consideration of the emotions, notably anger, leads to a better understanding of the star's enduring popularity and the formation of a Hindi film star. In

Bachchan's role as the 'angry young man', his on-screen character, called Vijay, expressed the public anger of the time, mostly caused by the breakdown of political consensus and social upheaval. Over the years, features of Vijay have been ascribed to Bachchan himself, creating a merging between the character and his real-life persona. This created a star persona in which extra-diegetic characteristics such as his anti-communal stance, his closeness to minority communities and his roles as a devoted son, husband, lover, poet and devotee of poetry are invested in his on-screen character, Vijay.

Lizelle Bisschoff gives an overview of Nollywood, the Nigerian video-film industry that is the first economically self-sustaining cinema in Africa. Bisschoff argues that the themes and narratives of Nollywood films are able to tap into the fears, dreams and aspirations not only of local audiences, but also of all Africans, including the African diaspora. Like Bollywood's, Nollywood's huge popularity is built on its star system rather than on the films themselves, and audiences around the world watch Nollywood movies because they feature stars like Jim Iyke and Genevieve Nnaji. The relationship between audiences and Nollywood stars, explains Bisschoff, is based on a complex emotional bonding created by adulation, identification and desire. Nollywood stars bring together African communities across the world, and thus consolidate the notion of a 'post-colonial pan-African consciousness' created by Nollywood.

Through the study of Egyptian star Umm Kulthum, Ifdal Elsaket explores the intricacies of star-creation in Egypt in the 1930s and 1940s, and shows that the interplay between stardom and the Egyptian film industry was based on a process of reciprocity and exchange between various cultural mediums, including singing and dancing. As is the case with Amitabh Bachchan and Nollywood stars, Umm Kulthum's star persona represents an Egyptian construction of nationhood and of gender, and epitomises the intersections of culture and politics in stardom. As a singer and film star, through her on- and off-screen presence and her place within the Egyptian film industry, Umm Kulthum was able to articulate an idealised vision of nationhood and Egyptian-ness prevalent at the time.

Mats Karlsson's chapter on Japanese star Hara Setsuko (b. 1920) examines how her star persona was moulded and re-moulded to accommodate a changing idea of femininity. Setsuko rose to fame thanks to the film industry of Nazi Germany, and Karlsson's essay weaves together political and personal elements with an analysis of Hara Setsuko's film roles to describe the trajectory of the image of this reclusive star. The chapter provides a commentary on the rigid Japanese studio system and the formation and circulation of the star's persona within it. As is the case with Umm Kulthum, and – to a certain extent – Amitabh Bachchan in their respective socio-political contexts, her transformations are representative of social upheavals that Japan underwent around the middle of last century.

In the second part of the book, 'Stardom Mobility and the Exotic', contributors focus on Chinese, European and Latin American stars who, in one way or

another, transcended the borders of their home countries to take on roles in other film industries, such as those of Hollywood and Spain. Transnationality, when it comes to stars, involves complex processes that are often contradictory, such as racialisation and cultural and historical stereotyping, as well as whitening, inclusion and appropriation. Stars cope with their otherness and their accented-ness in various ways. As Chris Perriam puts it, 'They detach from but bear, at times, the traces of an original cultural space, which is, on occasion, relocalized or even restored' (in Nagib and Perriam 2012: 80). In this section, it becomes clear that such crossovers, even if they do not lead to transnational stardom, always leave traces of intercultural encounters, in Hollywood as well as in the star's original film industry.

The fact that the crossover of stars to Hollywood always tends to limit them to the role of the exotic 'Other' is shown in Lisa Shaw's and Antonella Palmieri's chapters. They follow the careers of the Brazilian Carmen Miranda and the Italian Alida Valli, respectively, and contend that these stars developed mechanisms to cope with and also undermine the expectations Hollywood placed on both their on- and off-screen personae.

According to Shaw, Carmen Miranda, who was a huge star in Brazil before joining the Hollywood film industry, performed her exoticism by means of exaggeration and self-parodying elements; she used an overly accented English and presented a spectacle of the exotic body through her costumes and movements, displaying 'Latin vitality'. At the height of her career in Hollywood, however, Miranda, in her increasingly caricatured 'baiana' costumes, lost most of her agency, and was moulded into a trope of 'carnival Latinness' and 'tropical Otherness'. Shaw demonstrates how Miranda's image has been used as a marketing tool for various products, and as a caricature of the 'exotic' that is reproduced again and again to this very day.

Through a critical, feminist-inflected analysis of Italian star Alida Valli, Antonella Palmieri explores the notion that stars are cultural phenomena that arise from and are inserted into specific historical and social contexts in which they acquire significance and meaning. Palmieri places Valli's career within the discourses of post–World War II American value systems around whiteness and integration. Her chapter critically investigates the filmic and extra-filmic narratives surrounding Valli's successful Americanisation, both on- and off-screen, and the strategies that were employed to create her Hollywood star persona. In contrast to Miranda, Valli undermined existing notions of female Italianness by displaying 'white' composure and restraint to a point where she became a role model for successful integration into the American way of life.

As was true to some extent of Carmen Miranda, the Spanish/American star Antonio Banderas has also used irony to play with media interest in his persona. In her chapter, Anne Walsh discusses Banderas's career in Spain and Hollywood. One of her interesting observations is about Banderas's willingness, when in Hollywood,

to conform to stereotypical expectations by accepting to play 'a generic Hispanic' in films such as *Mambo Kings* (1992), *The House of Spirits* (1993) and *Miami Rhapsody* (1995). When dealing with the publicity machine in both Spain and America, Banderas displays a self-deprecating irony that counteracts all attempts to create a movie-star myth around him. This attitude, Walsh states, made it easy for him to accept casting as the accented voice of animation characters, for example in *Puss in Boots* (2011), which proved to be a successful career move. Accent also plays an important role in the career of Danish/American actor Viggo Mortensen, who was cast as Captain Alatriste, the embodiment of all that is considered heroic about the Spanish psyche. Perceived as an American import, Mortensen's Spanish accent and its authenticity caused an ongoing debate in Spain, even though Mortensen spent his formative years in Argentina and speaks perfect Spanish, albeit with an Argentinian accent. Walsh's essay brings to light the importance of accents in stardom, and shows that accent and authenticity are becoming points of debate within a transnational and increasingly globalised film industry.

Sabrina Qiong Yu's chapter, using a Bourdieusian approach, examines the various types of 'capital' that Chinese stars hold in the Hollywood film industry by discussing the transnational careers of three kung fu stars and their setbacks in the Hollywood industry. She suggests that part of the iconic status of Bruce Lee, Jackie Chan and Jet Li is due to the fact that they are regarded in Hollywood as representing something more than the exotic 'Other'. Yu argues that it is because of their martial-art skills, which constitute their cultural capital as Chinese stars, that they were able to leave a unique mark on their original culture and on the Hollywood industry. She concludes that a non-Hollywood actor can become a transnational star with only a modest Hollywood presence, and that Hollywood is not always a one-way street in the world of stardom.

Section 3, 'The Politics of Stardom', brings together four chapters that all occupy themselves with the issue of how stars are used for ideological or political purposes, either by those in power or, as in the case of Australian indigenous stars, by the stars themselves. How is star fame used by authoritarian regimes? How have stars rebelled against dominant ideologies, and at times presented alternatives to conservative behaviours? Can stars change the way their community is perceived on the world stage? These are the questions raised by the studies grouped in this section.

These chapters examine the mechanisms by which the polysemy of an actor's image can be used to 'create' stars who are made to exhibit the dominant ideology of their nation, and mould themselves into a 'brand' and a commodity by using on-screen and off-screen performances for both a national and an international audience. Just as importantly, the chapters in this section analyse the subversive potential of stars and stardom and their power to question dominant ideologies and stereotypes of gender, culture and ethnicity.

Michelle Langford's chapter, 'I'm Ready for my Close-up Mr Ayatollah! The Ideology of Female Stardom in Iranian Cinema', shows that the dominance of Islam

7

has affected the emergence of a star system, and argues that, at each stage of Iranian film history, women in films have been subjected to intense scrutiny and control. But if stars function at times as role models reflecting state ideology, through the work of some contemporary filmmakers they also provide alternative ideas about Iranian womanhood. Langford explores the impact of the internationalisation of Iranian cinema on female stars such as Farahani and Hatami, who have adapted to the glamorous world of the red carpet but have paid a heavy price for their 'transgressive' behaviour.

'Filmmaking on the Edge: Director Shin Sang-ok and Actress Choi Eun-hee', by Leonid Petrov, also explores the nature of the relationship between film stars and ideology by focusing on the link that existed between the film director and producer Shian Sang-ok and actress Choi Eun-hee, and the political regimes in Korea at the end of the colonial occupation, liberation, civil war and democratisation. Petrov tells the extraordinary story of the stars' lives in North Korea (1978–86), their kidnapping, their central place in Korean cinema, and their relations with Kim Il-sung and Kim Jong-il, the late leaders of the Democratic People's Republic of Korea (DPRK). It also examines Shin Sang-ok and Choi Eun-hee's roles in promoting unification and peace in Korea.

In 'BEWARE FILM STAR! Towards a Performance and Cultural Analysis of Innokenty Smoktunovsky as Soviet Film Star', Greg Dolgopolov and Ludmila Stern analyse the Soviet star system and the rise to local and international stardom of Innokenty Smoktunovsky (1925–94), a postwar actor who was neither glamorous nor the ideal Soviet citizen. Through his numerous roles in plays and films, including his famous performance as Hamlet, as well as his off-screen presence, he was able to capture the mood and values of the Thaw – the period from the mid 1950 to mid 1960s that followed Stalin's death and that saw a liberalisation in politics and arts – which made him the most celebrated actor of his time in the Soviet Union.

While the first three chapters of this section deal with oppressive regimes and the question of the complex and ambivalent relationship between stardom and national and international politics, the last essay provides a counter-example. Karen O'Brien's chapter, 'Indigenous Icons and Teaching Balanda: From *Walkabout* to *Ten Canoes*; Art, Activism and David Gulpilil', explains the role that Australian indigenous actors can play in promoting the understanding of their culture within and outside Australia. The chapter explores the interconnection between painted and photographic images of Australian indigenous culture and film, and presents a history of indigenous identity and culture through the cinematic roles portrayed by indigenous artist David Gulpilil and his son, Jamie Gulpilil. The chapter considers the history of their rise to world fame through film, and explores the impact that the filmic portrayal of indigenous culture has had on world cinema and its spectators. Indigenous stars have a highly ritualised way of being in the world and representing their history and culture, which is often impenetrable to a Western audience. The

chapter reveals a whole new facet to the investigation of stars, and raises important questions about the understanding of indigenous stars and cultures in the world of cinema.

The final section is devoted to 'Stars, Bodies and Performance', with chapters examining the questions of racial, gender, age and linguistic embodiments in the acting process and on audience reception in French, German, Greek and Philippine cinemas. This section concentrates on the star body as a site of multiple meanings, and shows how it can conform to as well as subvert stereotypes of linguistic identity, masculinity, femininity and ageing. Star embodiment is shown to be culturally located, but common ground can be discerned between the chapters through juxtapositions of their analyses, which suggest overlaps between these embodiments across cultures.

The first two chapters aim to demonstrate that national history has an impact on stars' embodiments, which cannot be divorced from linguistic and racial issues in the Philippines or from representations of masculinity in Greek cinema and society.

Bliss Cua Lim revisits the star persona of two Philippine film actresses, Nora Aunor and Sharon Cuneta, in the context of racialised star embodiment in popular Philippine cinema, examining the national language debates in the 1960s and 1970s, and the subsequent rise of Taglish as the new *lingua franca* of popular culture after the 1980s. Lim suggests that the disruptive form of star embodiment that Nora Aunor actualised and Sharon Cuneta appropriated led to an unexpected convergence of class-stratified audiences in Philippine cinema.

Vrasidas Karalis discusses stardom in Greece in the context of gender relations, with an emphasis on the history of the construction of masculinity in cinema. Karalis argues that the failure of men in power to construct hegemonic discourses about their authority allowed filmmakers a considerable degree of freedom in the way they constructed their images. Male stars retained psychological power over their audiences only as embodiments of absence and defeat, of a constantly deferred and therefore frustrated integration. Karalis examines how the unstable structures of Greek society and slow economic growth hindered the process of star-making itself.

The last two chapters in this section, '"I Cannot Live Without Performing"': Romy Schneider's On- and Off-screen Embodiments of the Tragic', by Andrea Bandhauer, and 'Star Embodiment and the Lived Experience of Ageing in Cinema: The Case of *Amour* (Michael Haneke 2012)', by Michelle Royer, make use of Dyer's concept of stardom, which he defines as an amalgam of several elements: the body and face of the real person, the off-screen presence of the star, the persona created by the media, and the characters played in films (Dyer 1998: 60). While Royer's chapter focuses on two French stars' performances in a film directed by the Austrian director Michael Haneke, Bandhauer concentrates on a German/Austrian star (Romy Schneider) in French cinema. Both highlight ways in which filmmakers used the stars' off-screen tragedies, and hence their emotions and intense suffering,

to achieve the characters' embodiment and extraordinary performances. Bandhauer and Royer also shift their attention from stars to audiences, to reflect on the effect of embodied acting on viewers' corporeal sensations.

Michelle Royer argues that the memory of French actress Emmanuelle Riva in *Hiroshima mon amour* (Resnais 1959) is woven into Michael Haneke's film *Amour* (2012). Ageing stars, she contends, trigger in viewers the profound sensation of the passing of time, and provide them with a 'lived experience' of ageing. She also shows how actor Jean-Louis Trintignant's personal tragedy – his daughter, Marie Trintignant, was murdered by her lover Bertrand Cantat – resonates in Haneke's film, and raises ethical questions about the director's manipulation of the emotions of stars and their audiences.

Similarly, in her essay on Romy Schneider (1938–82), a German child star who became a star of French cinema, Andrea Bandhauer argues that it is the blending of her private and the screen personas that created the star's authenticity, charisma and aura. The fact that, in some of her best-known films, the audience watches Schneider's on-screen characters perform tragic destinies that were often considered to be projections of her private life triggers in viewers a physical sense of identification, and a corporeal response to her star persona.

The aim of this volume, with its varied theoretical approaches to stardom and its detailed analyses, is to contribute to a more complex understanding of stardom in our multi-ethnic and multipolar world. By taking readers on journeys into territories that are both familiar and unfamiliar, this book draws out multiple insights, providing new angles on the study of stars and stardom.

Notes

1. Such as Stacey in *Star Gazing: Hollywood Cinema and Female Spectatorship* (1994); McDonald in *The Star System: Hollywood's Production of Popular Identities* (2000); Austin and Barker in *Contemporary Hollywood Stardom* (2003); Willis (ed.), in *Film Stars: Hollywood and Beyond* (2004); Fischer and Landy (eds) in *Stars: The Film Reader* (2004) Hollinger in *The Actress: Hollywood Acting and the Female Star* (2006); and Basinger in *The Star Machine* (2007).

2. Mention should be made of Laura U. Marks's *The Skin of the Film: Intercultural Cinema, Embodiment and the Senses* (2000), an influential volume on 'haptic visuality' (2000: XI), although it does not directly concern itself with the study of stars and mainstream cinema, but rather with experimental film and video.

Section 1

Film Icons and Star Systems

Film Music and Star Systems

1

'I Love You When You're Angry': Amitabh Bachchan, Emotion and the Star in the Hindi Film

Rachel Dwyer

There are many books about Amitabh, and thousands of websites document his life. He was born in Allahabad, at that time in the United Provinces of British India, first son of Hindi author Harivanshrai Bachchan and Teji Bachchan. After a few false starts in the film industry, Amitabh's career followed several strands, including his superstar role as the 'Angry Young Man' and also as a comedian and romantic hero in the mainstream Hindi film industry, as well as his considerable success in the more realist 'middle-class cinema' of Hrishikesh Mukherjee. With over 160 films listed on IMDb, he ruled the box office in the 1970s and much of the early 1980s. The 1980s were a turbulent period in Bachchan's life, marked by a sojourn in politics, a near-fatal accident on the set of *Coolie* (Manmohan Desai) in 1981, and years clearing his name in court of any association with the Bofors scandal.[1] He retired from films in the 1990s, and launched an ill-fated entertainment company, ABCL. After 2000 he found film roles more suited to an older hero, and won a new fan base for his version of *Who Wants to Be a Millionaire?*, *Kaun banega crorepati?* Voted Star of the Millennium by the BBC, he was the first Indian film star to have his waxwork likeness installed in Madame Tussauds.

Amitabh married his co-star Jaya Bhaduri in 1973, and their son, Abhishek, is a film star in his own right. In 2007 Abhishek married one of the top female stars, the former Miss World Aishwarya Rai, who was seamlessly incorporated into the Bachchan family brand.

Star Theory – Amitabh and Indian Cinema

Star theory, which was developed mostly in the context of Hollywood by Dyer (1979, 1986, 1998) and Ellis (1992), and later by Gledhill (1991), Stacey (1993) and others, is based on the idea of the star text. Dyer (1979: 34–7) argues that the star is the focus of dominant cultural and historical concerns, thus creating interest in the life of the star and their whole off-screen existence, to produce a star text, which is an amalgam of the real person, the characters played in films, and the persona created by the media, which has an economic and institutional base. Gledhill (1991: 214) sums this up by saying stars 'signify as condensers of moral, social and ideological values'.

Amitabh's career exemplifies the idea of the star text. His dominance is explained as his role as the 'Angry Young Man', where his private anger expresses the public anger of the time, mostly caused by the breakdown of political consensus (Prasad 1998: 117–18) and social upheaval. Much of what is known about Amitabh is conflated with his on-screen star roles. He has acted in many great roles, whose intertextuality is reinforced by the nature of the Hindi film itself.

Amitabh's roles were unusual in that throughout the 1970s and early 1980s he often performed as two characters, Vijay and Amit. The latter is a more traditional romantic hero, but this chapter focuses on Amitabh's role as Vijay, usually called 'the Angry Young Man', created by the writers Salim (Khan) and Javed (Akhtar). The character of Vijay appeared in films scripted by Salim-Javed for various directors, including Ramesh Sippy, Prakash Mehra and Yash Chopra (Kabir 1999: 68). Amitabh also plays a character called Vijay, who has many similarities, in *Roti, kapada aur makaan*, written and directed by Manoj Kumar (1974).

Vijay's story may alter, but he is someone who confronted injustice in childhood, such as in having his parents killed (*Zanjeer*, Prakash Mehra, 1973), being illegitimate (*Trishul*, Yash Chopra, 1978), being abandoned (*Deewaar*, Yash Chopra, 1975), seemingly having no family (Jai in *Sholay*, Ramesh Sippy, 1975), or in seeing himself as wronged by his own father (*Shakti*, Prakash Mehra, 1982). His adult life shows Vijay fighting a personal war against the wrong done to him, where evil is usually embodied by a single figure or villain. Vijay breaks the law, but we can believe he is right, at least most of the time. We admire his self-respect, the respect afforded to him by others, and his moral rectitude in dealing with women, elders and youngsters. His religion is a more complex area. When Vijay feels God has abandoned him, he gives up on Him (*Deewaar*), but he usually manifests equal regard for all faiths, with demonstrable respect for the major faiths in India – Hinduism, Islam and Christianity. However, Vijay often has to perform some form of sacrifice or atonement, such as in *Kala Patthar* (Yash Chopra, 1979), where a single mistake leads to years of penance and to his risking his life working in a coal mine. Vijay is often fixated on his mother and let down by his father, leading to a seemingly Oedipal conflict where he avenges

his mother by taking revenge on his father. This goes to the extreme in *Trishul*, where Vijay's revenge destroys his father's life and business, and it is only the father's death that can bring about reconciliation for his treatment of Vijay and his mother.

Amitabh's character development was restricted by his star persona.[2] Vijay was always Vijay, whoever was directing, and Amitabh brought other performances of Vijay to all the films in which he acted. Vijay seemed to incorporate other star personas – romantic, comic – elements that didn't belong to his character, perhaps drawn from his other main character, Amit, the romantic hero, while Vijay's anger infects Amit's roles. The naming of the hero was important, as it suggested some intertextual references between the films and the sense of a particular character as an alter ego of the star – Amit, for example, being a shorter version of Amitabh's own name, while Vijay's name itself ('Victor') exemplifies the kind of hero he was going to be in the film. Vijay had many character traits that linked him across films, notably his rebelliousness, which often goes against the state. Other features of Vijay have been clearly ascribed to Amitabh himself over the years, such as his anti-communal stance, often showing a closeness to minority communities and his roles as a devoted son, husband, lover, poet or lover of poetry, manifesting seriousness and gravitas.

Although Vijay's name shows him to be a Hindu, and he is usually north Indian, though from different communities, Amitabh's standing as an all-Indian hero has been reinforced by his playing characters from different regions and communities. These include roles as a Bihari Muslim (*Saat Hindustani*, K.A. Abbas, 1969), Christian (*Amar, Akbar, Anthony*, Manmohan Desai, 1977), Rajput (*Laawaaris*, Prakash Mehra, 1981), Bengali Brahmin (*Anand*, Hrishikesh Mukherjee, 1971), Khatri (*Zanjeer*, Prakash Mehra, 1973) and Kayasth (*Khuddar*, Ravi Tandon, 1982). Amitabh has not played characters from low-caste communities – OBCs (Other Backward Castes) or SCs (Scheduled Castes, Dalits) – but this it is not surprising given that they rarely feature in mainstream Hindi cinema.[3] In all these films, Amitabh uses his great command of language and dialects to portray these roles, using sociolects and other quirks to give them symbolic charge. Yet, although he argues with Maharashtrian nationalists that Mumbai is now his *karmabhoomi* (place of work), and he is probably its highest individual taxpayer, he is closely identified with his *janmabhoomi* (place of birth), Allahabad in UP. His roles suggest that Amitabh can be seen as the all-India star who can easily identify with and slip into other roles.

One feature of the star text is knowledge of the star's off-screen biography, however manufactured this may be for publicity or for effecting intimacy. We know little about Amitabh's day-to-day life and what he is really like.[4] Nor does he offer any revelations to the media, which has long been obsessed with his relationship with his co-star Rekha. Amitabh is, however, active on social media, where he blogs and has Facebook and Twitter accounts.

Star theory was developed in the context of Hollywood, which has striking differences from Hindi cinema, not least in the latter's loose and non-corporate structures, which impact on the media creation of the star. Indian stars are not promoted by PR companies and studios and rarely have agents, only managers who deal mostly with finance and booking.

Mishra (2002: 127) argues that, while Indian cinematic stars are created in ways similar to those of the Hollywood star model, Hindi film deploys song and dialogue in specific ways to create stars. He rightly notes Amitabh's key dialogues, which are some of the most quoted dialogues in Hindi film history, still known by millions of Indians. Amitabh sang some of his own songs from the late 1970s, though his voice in his dominant period was that of the playback singer, Kishore Kumar. Yet Amitabh does not sing (or mime to a playback singer) in the film that launched his career as a star, *Zanjeer*, or in *Deewaar*, while in *Sholay* his only song is at the beginning of the film ('Yeh dosti/This friendship').

Star theory explains much about Amitabh and his role as Vijay in the 1970s and 1980s, and accounts too for his global popularity. However, the moniker 'Angry Young Man' asks us to look more closely at anger in film, especially Indian cinema, in the context of the emotions and the emotional foregrounding of melodrama, and why Vijay/Amitabh was so successful in conveying such anger.

Emotion

The melodramatic mode of Hindi cinema foregrounds emotions, and the audience responds to them in the cinema with strong reactions that, apart from laughter, would be mostly hidden or subdued in a Western cinema hall. Emotions underlie the complex relationship of the audience to the star and the role of the character in keeping the audience's interest in the film – in particular, why Indian film audiences have been so interested in Vijay's anger and its manifestations.

Emotions shape our social and cultural lives. Popular discussion of emotions draws on Aristotle's concept of catharsis and Freud's understanding of the human mind. Scholarship on the topic is interdisciplinary, as discussed in Oatley and Jenkins (1996), while there are key texts by philosophers, who often pay special attention to the arts and work centred on the arts (Altieri 2003; Feagin 1983; Grodal 1997; Keen 2007; Levinson 1982; Robinson 2005; Solomon 2004; Wollheim 1999). Much published research in this field has concentrated on the West, even though it has been noted that, while some emotions are universal, others are culturally specific (Averill 1980; Ekman 1994; Lutz 1998). Little has been written about the study of the emotions in India other than in Lynch (1990). Even the famous ancient theory of *rasa* (emotion) has been discussed in the context of Sanskrit aesthetics rather than that of wider studies of the emotions.

Film studies have barely engaged with emotions except in the discussion of melodrama (Elsaesser 1972; Gledhill 1987; Mulvey 1977/8; Neale 1986), which

has been researched in Indian film (Dwyer 2000; Dwyer and Patel 2002; Prasad 1998; Thomas 1995; Vasudevan 1989, 1998), and the changing role of the sacred (Brooks 1995; Dwyer 2006a).

Melodrama seeks to elicit an excess of emotional response from the audience. The West, or at least northwestern Europe, following Kant, has long disparaged the emotions and their expression in favour of reason, although this situation is changing with the recent rise of a new public emotionalism – a demand to feel rather than to think (Anderson and Mullen 1998). The academic study of the emotions has shown that the division between reason and emotion is far from the binary it is taken to be on a popular level, with emotional responses being an important part of the reasoning process. The division of reason and emotion was established in India only at some levels as part of a wider colonising of the mind, by European Enlightenment thought, and an emotional response to texts, including films, is seen as normal in India (Chakrabarty 2000).

It is not entirely clear how a film elicits emotions from the audience, though it can do so by portraying characters, showing emotions and creating a mood through visuals, music, narrative and so on. The Hindi melodrama stirs up several emotions rather than a single one, yet the way in which a film isolates particular emotions has not been examined in the Indian context.

The role of the emotions has implications in film-viewing practices, which in India are generally acknowledged to be different from those of Western cinema audiences (Srinivas 1996). Identification, the popular view of audience involvement with fictional characters, is seen by Neil (1996) as one way of responding to fictional characters. Murray Smith's (1995) stimulating theory suggests that the spectator's relationship to film is one of an emotional relationship to the characters, in contrast to the commonly held view that it is based on identification; while Grodal (1997) explores how emotion structures attention to narratives and generic structures in films.

Caroll (1997), arguing strongly against identification, suggests that the complicated relationship we the audience have with characters on-screen perhaps reflects a neo-Platonic view, a relationship between onlooker and observer. Characters behave; audiences entertain thoughts and emotions. We do not identify with characters; we do not become them. This means we are happy that Amitabh or his character is in love but we are not in love with the object of his love. We can be angry with him when no one else in the film is, or we can love him when no one else does. For example, when Vijay is sad, we may not feel sad but we may admire him for his self-sacrifices and his fortitude while he is not admiring himself. We can also see the world empathising with him so we too can feel angry when he does, even though we may not entirely agree with him; in *Trishul* we may understand his anger without approving of it. We can also see Vijay through the eyes of other characters in the film – he usually has a mother and a best friend of a brother – and like them, we can admire him and support him, even when we know he is doing wrong.

These theories of emotion need to be re-examined in an Indian context, linking them to audience research and fan culture, which again have been developed in a largely Hollywood or British context (Dyer 1986; Kuhn 2002; Mayne 1993; Stacey 1993; Staiger 2000).

A simplistic argument about the popularity of Amitabh's anger has often been suggested – namely, that the 1970s was a particularly violent and troubled decade in India's history, whose nadir was the State of Emergency (1975–77), and that Amitabh expressed the *zeitgeist*. This was much refined by Prasad (1998), who argues that the political upheavals and the breakdown of consensus between dominant power groups were particularly radical during this period. However, other decades were as, if not more, troubled. It is also striking that other world cinemas also became more violent in the late 1960s and early 1970s, with the global popularity of Clint Eastwood's westerns and Bruce Lee's kung fu films.[5]

But Amitabh's films are not necessarily violent and bloody. There is less emphasis on the spectacle of violence (*Deewaar* has one famous fight sequence in the warehouse) than on anger and vengeance. Many film heroes before Amitabh were also angry, but their anger was somewhat different, and Amitabh's anger had a particular resonance with audiences.

In Hindi films, anger is often destructive, and usually self-destructive. The archetypal hero, Devdas (Dwyer 2004), as his anger with his family, society and the women in his life leads him into ineffectual and impotent rage where he abandons his family, refuses the proposal of his childhood sweetheart whom he loves, and later scars her face in anger, rejects another woman who loves him, ditches his friends, and ultimately destroys himself through low living. This angry hero is an ancestor of Vijay, who also broods and is maudlin and usually has unsatisfactory relationships with women other than his mother, but Vijay's anger is also located in the wider world, connecting him to other heroes, such as Birju (*Mother India*, Mehboob Khan, 1957) and Ganga (*Gunga Jumna*, Nitin Bose, 1961), whose anger was in a good cause and often effectual, but which eventually had to give way to the law, which often demanded the hero's life. The hero who is beautiful and has to die young, tormented by an unjust world, is a popular figure in many narratives.[6] Amitabh's anger is that of the romantics and of the fighter for his family values, but is mixed with the style of the streetwise, portrayed by Dev Anand, one of the greatest heroes of Indian cinema in the 1950s and 1960s, as well as being reminiscent of that of other Hollywood heroes.

Anger as an Emotion

Anger has cultural, moral and political meanings. It is often viewed as dangerous and uncontrollable, but not always as a negative emotion.[7] Plato argued that reasoned anger is necessary for us to pursue justice, while the desire to see it done is a virtue. In the West, anger is often identified as a particularly male emotion,

admirable for them but not suitable for women, while India has many righteous avenging gods, goddesses, heroes and heroines.[8]

Whatever the pleasures offered, the Hindi film ends with the restoration of moral order (Thomas 1985, 1995; Dwyer 2006a), and Vijay/Amitabh's moral authority is often derived from his anger, which causes him to seek to right the wrong done to him. Vijay is not an angry loner, but he is enraged because of something that someone did to him or his family directly. He is not a rebel, but has anger focused on one person and will spend – and usually lose – his life in pursuit of revenge; he focuses on nothing else. Vijay's anger is brooding rather than impetuous. It is a purifying anger, which seeks only its goal. This is not political anger, that of the 1970s or the Emergency. Vijay's anger is never intended to bring about social change or global justice but is about an individual showing a generalised wrong and the focus on setting it right. It is a moral issue, not a political one.

The morality of his anger is not in dispute, but Vijay's actions or personal morality may be questionable. There is often a second hero, such as Ravi in *Deewaar*, who follows the public morality of the law, but the audience is very much on the side of Vijay. Ravi, a policeman, is morally humiliated when he pursues a hungry boy for stealing bread, while Vijay wins the audiences' respect with his declaration that he will not pick up money that is thrown at him. Ravi deals with society, Vijay with the individual. Vijay seeks vengeance, the *lex talionis*, which the film makes the audience also desire, but Vijay is punished for its pursuit, often by alienation from his family and ultimately by his death. Vijay challenges old and new moralities with a morality that has deep roots in society. As seen in *The Godfather* films of Francis Ford Coppola, the characters' values are based on older societies and moralities where family, loyalty, religion and self-respect are all-important, but this morality cannot be sustained in a world where it will conflict with the law. It brings with it murder and violence, yet the audience's sympathy lies with it. In *Trishul*, the narrative shows the son has the right, because of his love for his mother, to destroy and humiliate his father, who made her suffer.

The audience's sympathy with Vijay is secured by the way he maintains his self-respect in the face of the humiliation he faces daily, and they may feel angry on his behalf. Many in the audience may feel they share these daily humiliations, loss of dignity and public shaming because of caste, class, wealth, gender, region and so on.[9] Vijay's anger and rebellious style are emulated as a response by the audience that imitates him, quotes his dialogues and dresses as he does. His accumulation of wealth and life of crime are also presented as part of his style rather than as moral issues in the films. Parallels can be drawn with the 'blaxploitation' genre, notably *Shaft* (Gordon Parks, 1971), where style is used for self-respect.

Vijay's vengeance or desire to punish wrongdoers shows how the emotion of anger can be a moral issue – about looking for justice after suffering humiliation. This anger takes many forms – indignation, hurt, contempt, vengeance and fortitude. In all forms, Vijay also displays something of the cult of the martyr, as he

is dispossessed, his father lets him and his family down, and his mother is the one who binds the family together while girlfriends are often merely decorative. Vijay's moral authority, his reason and his passion for justice still echo in Amitabh's current films, where he can be emotionally unjust, especially to the young and to lovers, as he places justice even before himself and his own happiness, though he eventually comes round to reconnect to the more emotional and less rational young.

Anger: The Actor and the Star

Of the many angry heroes of Hindi cinema, why has Vijay/Amitabh's portrayal remained so powerful? Many elements of the films, which are some of the most loved and important in the history of this cinema, contribute to this impact, but Amitabh's performance needs to be scrutinised to see how he enacts anger in a way that transcends the script, cinematography and editing. An untrained though talented actor, he communicates his anger, more than other stars, through language, expression and gesture, in order that we recognise his emotional state and feel for him, even if we do not feel what he is feeling.

Known for his professionalism, Amitabh has evident strengths in his performance, most notably his resonant voice and ability to deliver long and difficult speeches in a convincing manner. His earlier roles did not frame him as an action hero as such, as he displayed his power through menace, use of dialogue, use of silence and the exchange of looks. His long legs soon became fighting machines (Hines 2007), and he was known to perform his own stunts, with almost fatal consequences in *Coolie*. This again made the star and the person seem increasingly inseparable.

The way we feel we probably know the real person is mostly a function of his body and physicality. Amitabh's striking physical features are used to great effect to create his screen dominance, notably his tall physique and his remarkable deep voice. They enable him to communicate his emotions, particularly those around anger, portraying his emotions in a way that makes us focus on him and on his films. One of his strengths is his ability to display anger, but controlled or expressed in dialogue. As Javed Akhtar says:

> People drop all their guard in a moment of anger, their real self is revealed . . . As an actor, Amitabh's anger was never ugly. Other actors mix anger with arrogance. But Amitabh's anger was mixed with hurt and tears. So you accept it, you get fascinated by it and you find justification for it. (Kabir 1999: 88).

Amitabh's enactment of his emotions focuses the audience and mobilises our feelings and emotions to respond with admiration.

Although anger is the primary emotion that connects Amitabh with the audience, there is a further complication in the audience's emotional response to

the character on-screen, namely the existing relationship that the audience has to the star. Whenever Amitabh appears, so does Vijay – or his ghost – and he is endowed with a certain moral authority. It is partly the star system that creates this recognition, but it affects our responses and evaluation of characters, as these are framed and informed by the star personae of the stars who perform them. While in real life Amitabh is a charismatic and sophisticated, wealthy figure, we still want to see him as Vijay – a fact that he acknowledges with regret.

It is almost impossible to define charisma or star quality. Star theory suggests that the star acts as a condenser of particular issues of the time (Gledhill 1991: 215). This takes us forward, but we still struggle to accept the definition of a star being someone who has star quality – something that cannot be defined.

The word 'charisma' has its origins in the idea of divine favour, or some superhuman quality that makes someone the focus of attention. In Hindu thought, there is little that separates the human from the divine, and gods regularly appear in the world, intervening in human affairs, often by means of images or words (Dwyer 2006a). Film stars may even be regarded as gods,[10] while their behaviour, mostly accepted by their fans, is not seen as something to emulate for the 'ordinary people' (see Dwyer 2000: 115–42). The process of deification discussed by Badri Narayan (2001: 64–6) clearly applies to Amitabh, though here we are not looking at caste, which is officially silenced by the Hindi film, but the ways in which he has come to be regarded as the leader of an oppressed group.[11]

It seems that charisma may be closely associated with the ability to communicate emotion better than others. Amitabh does it through his films with song, dance and dialogue, but in such a powerful way that in real life this charisma reaches out and touches people. The religious nature of charisma is also a function of the admiration we feel for figures of high moral status, whereas Vijay does not inspire worship himself, though the actor who performs the role does. The moral high ground, the righteous anger and self-respect, are all key attributes of this godlike star.

Concluding Remarks

It is striking how the emotions play a key role in understanding Indian cinema. This goes further than the study of melodrama in the Hindi film (Thomas 1985; Vasudevan 1989, 1998) and the emphasis on emotion in popular discourse about cinema in India, where emotional realism is highly valued, and indeed emotionalism is discussed as a key feature of Indianness itself. Rather, it is about the ways in which emotion plays a role in film viewing, keeping the audience's focus on all aspects of the film, partly through character but also through the star. The star's ability to express and depict or portray emotion is key, but charisma needs to be reconsidered, as do questions of music and language, and in particular the way they come together in the film song. A study is needed of the emotions – how they

are classified, how they are shown and interpreted, and what their significance in the text is in viewing Hindi film and in Indian culture.

A striking feature of Hindi film melodramas is that they end with the world restored in the correct manner, rather than necessarily having 'happy endings' (Dwyer 2013). The film thus offers viewers the three main types of happiness: emotional, moral and judgemental. These ensure that the audience feels happy, is satisfied that the law has been observed and the good rewarded, and is pleased that religion and traditions are upheld. This may mean that the hero has to die, as his morality is in irreconcilable conflict with the law. Vijay usually dies rather than having to face the punishment he is due.

Although Amitabh's anger continues to enthral audiences, the hero of modern Bollywood may still suffer. But his ultimate happiness lies in the middle-class values of family, consumerism and 'self-fulfilment'. The emotions that connect him to the audience are the tender ones, and his ability to convey these, notably happiness and sorrow. The other megastar, Shah Rukh Khan, specialises in the depiction of the tender sentiments. Compassion is beautiful but, as Kant says, it has no moral worth in itself, although if it motivates us to care then it has. However, Shah Rukh seems to be getting angrier; his hit film, *Chak de India!* (Shimit Amin 2007), has no romantic line, only righteous anger, a focus on his goal and a desire to correct past wrongs done to him.

Vijay/Amitabh shows that anger is a key emotion in Hindi film, and the only one that can challenge love and romance. While morality is changing with current upheavals in Indian society, there may be uncertainty as to how the hero can negotiate new values to re-establish a contemporary moral order. In the currently shifting world, he may merely be biding his time. Amitabh remains the great communicator of the moral sentiments, and Hindi film may have to wait to find a younger star who can portray those of the new India.

Notes

1. A corruption scandal in the 1980s and 1990s concerning the Swedish arms company, Bofors, in which many high-profile figures were implicated.
2. Satyajit Ray wanted to work with Amitabh, but his stardom was too much of an obstacle, so he used him only as a narrator in *Chessplayers/Shatranj ke khiladi* (1977).
3. For a detailed list, see kufr.blogspot.com/2008/02/angry-young-man-wasnt-outcaste.html (last accessed 18 September 2008).
4. Hines (2007) gives us perhaps the closest view.
5. See Srinivas (2003, 2005) for an analysis of their popularity in India. The excess of violence in Hollywood is usually interpreted as a response to the Vietnam War, with its questioning of America's role as a world leader, and a broader critique of masculine values in the face of rising feminism, while the relaxation of censorship allowed more violent films to be made.

6. On the popular genre of avenging women, see by Gopalan (2002).

7. Ngai (2005) lists 'irritation' but not anger.

8. On anger in Western texts – from the *Iliad* onwards – see Fisher (2002).

9. Francesca Orsini (personal discussion) suggests that this anger and humiliation are similar to that described in Dalit writing. While Vijay keeps his self-respect through consumption, the Dalit writers do so through production. See also Narayan (2001: 59) and Beth (2007). As mentioned above, Amitabh has never played a Dalit. The Bachchans do not use their caste name, Srivastav, and have had intercaste marriages.

10. There is said to be a temple to Amitabh Bachchan in Calcutta: movies.indiainfo .com/features/amit-temple.html (last accessed 20 March 2006: link no longer working). Amitabh has defended his family's religious activities on his blog.

11. On the absence of caste in most Hindi films, see Dwyer (2014: ch. 3), where various possibilities are explored for this silence in the imagined world of cinema, including ideas that it is anti-modern or anti-national.

2

'They Have Made Africa Proud': The Nollywood Star System in Nigeria and Beyond

Lizelle Bisschoff

An Introduction to Nollywood

The video-film industry of Nigeria, popularly called Nollywood, has been described as one of the greatest explosions of popular culture that the African continent has seen (Haynes and Okome 1998), and is the first economically self-sustainable film industry in Africa. Through the use of video technology initially, and now using affordable digital technology, Nigeria produces over 2,000 films per year, and the industry is currently ranked by UNESCO as the second-largest in the world in terms of output, after Bollywood, the popular Indian film industry. Nollywood's popularity has spread across the African continent, to the African diaspora in Europe, North America and Australia, and as far as the Caribbean and Pacific Islands, and so has the popularity of its stars, who are known internationally among these audiences. Nollywood's huge popularity is to a large extent built on the star system, and it is the Nollywood star system that will be explored in this chapter.

The first seeds for the emergence of the industry were planted in the late 1980s in Nigeria, and almost simultaneously in Ghana (which has a much smaller output than Nigeria),[1] due to the economic difficulties that these countries, along with many other African countries, experienced at the time as a result of civil or political unrest and economic measures imposed by the IMF and World Bank. This economic climate made filmmaking on celluloid prohibitively expensive,[2] and created fertile ground for the development of other, more affordable means of filmmaking. Nollywood film scholar Onookome Okome (2007: 4) describes the

prevailing myth of the origin of Nollywood as that of an Igbo trader in Lagos who found a use for a large cache of imported VHS cassettes by recording traditional Yoruba theatre performances on the tapes and selling them. The businessman, Kenneth Nnebue, started producing films with Yoruba travelling theatre artists, and wrote and produced the first major Nollywood film, *Living in Bondage*, in 1992 (Okome 2007: 16).[3] *Living in Bondage*, with its extravagant tale of a man who joins a secret cult and murders his wife in a ritual sacrifice to gain wealth, set the thematic and stylistic characteristics of superstition and witchcraft, religion, the quest for upward economic mobility, melodrama, the urban landscape of Lagos, corruption, love triangles and domestic disputes that have been replicated in many Nollywood narratives since. Since then, the VHS industry of the 1990s Nollywood has embraced the digital technology of the twenty-first century; the industry harnesses the entrepreneurial spirit of Nigeria through the use of affordable and accessible digital technology, such as small-scale digital cameras, desktop editing software and distribution primarily on DVD and VCD (video compact disc).

Despite its enormous output financing remains sparse, with the average budget for a Nollywood film being around $20,000, with a top end of around $75,000. Hollywood films, Westerns, martial arts films and other foreign films have long been distributed through a piracy system in Nigeria, and piracy is also a big issue for Nollywood films, making large investments in productions risky (Haynes 2007: 3). The very rapid turn-around time from pre- to post-production (often as little as two weeks), the lack of script development, bad lighting and sound quality, low-budget special effects and amateur editing all result in an industry characterised by, and often criticised for, its low production values. Directors are mostly self-taught, and are often less important and lower down the Nollywood food chain than stars, producers and distributors, with distributors often acting as producers. Despite the criticism of its low production values and often hackneyed and unoriginal scripts, the enormous popularity of Nollywood in Africa and the diaspora means that it demands to be taken seriously by scholars of film and social sciences, curators, and film festival and cinema programmers. A growing body of Nollywood scholarship has emerged over the last 15 years. It would also be fair to say that a number of Nollywood directors have started to make higher-quality Nollywood films (sometimes called 'New Nollywood'), notably Obi Emelonye, Kunle Afolayan and Tunde Kelani, that are seen by and accessible to non-African audiences. While Nollywood films are increasingly included in African film festivals internationally, and thus screened in cinema spaces – in particular films from the directors mentioned above – Nollywood films are usually distributed on DVD and VCD. They sell for around $2 per copy in Nigeria, and are watched at home, on street corners, in cineclubs or in video parlours. While the term Nollywood is generally employed to refer to the entire Nigerian video-film indust... important to note that it is not a unified industry, and there is muc and many different variations within it. Different genres exist, includi

melodrama, comedy and action films, as well as language divisions, including films in English, Yoruba, Igbo and Hausa.

The most obvious explanation for the popularity of Nollywood is its familiarity to local audiences. The films display familiar and recognisable cultural beliefs, lifestyles, traditions, societal and socio-cultural structures, histories, settings and locations, and their themes and narratives tap into the fears, dreams and aspirations of local audiences. For African audiences who have for decades been fed on a diet of imported foreign films – audiences who have never seen themselves and their stories represented on screen – the development of a local, home-grown film industry is hugely significant and important. Nollywood's popularity has spread across the continent, and Nollywood films are watched all over Africa, from Kenya and Tanzania to Cameroon, Guinea and Togo, sometimes dubbed into local languages or translated through live interpretation at public screenings. The South African broadcasting giant M-Net, which broadcasts across the continent, has channels dedicated to showing Nollywood films day and night. Intrepid distributors overseas, mostly from the African diaspora, have created video-on-demand online platforms for Nollywood, which increases the accessibility of the films for African diaspora audiences beyond DVD distribution. John McCall argues that the huge popularity of Nollywood could be ascribed to the development of a 'post-colonial pan-African consciousness' (2007: 94), with a nascent African cultural citizenship becoming visible through popular media, indicative of the transformative potential of popular culture and media. Not only are these films watched all over Africa, but the Nollywood model has also been exported and adapted across the continent, with local video-film industries emerging in many African countries, including Riverwood in Kenya, Ugawood in Uganda and Bongowood in Tanzania. There are also traces of this type of low-budget filmmaking in the Democratic Republic of the Congo, Cameroon, Ethiopia, Eritrea, Zambia, South Africa and Zimbabwe. Nollywood's international popularity among African audiences means that its stars are also widely known, and the importance of the star system in Nollywood is quite rare in relation to other filmmaking industries in Africa. No other film industry in Africa has developed a star system that comes close to the scale of Nollywood's, even if local stars have emerged in countries where the Nollywood industrial model has been replicated. Although African actors might have become known locally through television series and soap operas, Nollywood has produced the first-star system that has catapulted Nigerian actors into international stardom. In the next section, I explore the Nollywood star system in more detail, followed by case studies of two of the biggest male and female stars in Nollywood.

Nollywood Stars: Celebrities, Cultural Ambassadors and Monsters

The Nollywood star system forms a crucial element of the industry, and is constructed through a number of very popular and recognisable actors who appear

frequently in films. These stars also enjoy a huge international fan base wherever Nollywood films are consumed. As in star systems worldwide, films are often produced as star vehicles due to the significant contribution they make to the potential profitability of films, and they play a central role in the production and marketing of the films. Some of the most famous names of the Nollywood star system – some of those that are most often encountered in the films and in the huge amount of media and publicity around the industry – are Genevieve Nnaji, Omotola Jalade-Ekeinde, Jim Iyke, Mercy Johnson, Rita Dominic, Kate Henshaw, Desmond Elliot, Nkem Owoh and Stephanie Okereka.[4] Nollywood stars are perceived by their audiences as celebrities, role models, pacesetters and cultural ambassadors. The public often use the actors in a film as a basis for judging its quality, as some stars have become much-loved by audiences due to their particular acting styles and the aspirational qualities they exhibit, such as beauty, fame and success. A Nollywood star's popularity and celebrity status often grow due to their ubiquity – being in the industry for a long time and starring in a large number of films. They have also become stars through displaying versatility in their acting, their physical appearance (handsome men and beautiful women), being cast in famous roles in which they delivered memorable performances, their likeability on- and off-screen, having a rags-to-riches backstory and through their initial appearance in popular television productions before their transition to film. Their popularity could thus be ascribed both to quality and quantity, as an actor needs to be deemed good at their craft by the audience, and needs to feature in a lot of films and display consistency of and commitment to their craft. Their local familiarity plays a very important role in their stardom, as the famous faces of Hollywood, westerns and kung fu films, which African audiences recognised and celebrated before the advent of indigenous film industries, have been replaced by star worship of African actors with whom local audiences can much more easily identify. The fact that Africans are telling their own stories, with African actors interpreting the roles, instils cultural pride in audiences.

Having a famous star in a Nollywood film assures the film's success, as audiences will flock to see or buy films with famous faces in them without knowing much else about the film.[5] Thus they feature prominently in a film's promotion, on magazine covers and on news sites, and in celebrity gossip and lifestyle publications in print, broadcast and online. The internet has certainly increased film stars' visibility and fame worldwide, as a large number of websites and blogs are solely dedicated to discussing the latest Nollywood films and celebrity gossip, speculating about their wealth, relationships and scandals, and discussing their non-filmic public appearances and endeavours such as charity and philanthropic work, or entry into the music and fashion industries. As happens worldwide, Nollywood stars are employed as brand ambassadors, and often feature in advertisements and promotions endorsing local and global brands. They are invited to public events, and the biggest stars will charge huge amounts for a public appearance such as

the opening of a new nightclub or public building. They are even recognised by African governments, who want to employ their support base to enhance politicians' profiles and gain support in election or re-election campaigns.

Unlike in many other star systems, most Nollywood stars do not pay a huge amount of attention to image management or the creation and maintenance of their public personas. As Nollywood is such a low-budget, DIY and grassroots industry, few Nollywood stars have proper management or public relations consultants. This means that they do not craft their public personas as carefully and cautiously as many Hollywood stars do. Nollywood promoters have argued that stars do not see the value of promotion, as they regard themselves as famous already. Given that most Nollywood stars are not nearly as fabulously wealthy as their audiences might like to believe – their public image of wealth not necessarily translating into the reality of their private lives – many would ask for cash ahead of PR, and Nollywood directors have even claimed that stars have demanded payment to attend the premieres of films that they have acted in. However, with the growth of the industry and the prevalence of social media, some Nollywood stars are starting to take their public image seriously. A positive public image is perhaps all the more important in an industry where stars are regarded as cultural ambassadors and expected to change negative perceptions of Nigeria and the African continent as a whole.

Shingler (2012: 8) argues that stars are often used to represent national characteristics within the global economy of the mass media. This argument is crucial for the Nollywood star system, as stars have come to represent the desirable elements of Nigerian culture, a country that has been much maligned internationally. Nigeria has long suffered a negative public image, with the stereotypes of corruption, patriarchal oppression, poverty, conflict and superstition regularly reinforced in mainstream media and political discourse worldwide. Discussing the fame and fortunes of Nollywood actresses, James Uchenna writes on the website Nigeri-afilms.com (2010):

Nollywood sisters are talented, elegant, smart, and beautiful. They have indeed made Africa proud. They have come a long way and have shown that there is still something magical and good about Africa. Most of them came from humble backgrounds and have today become role models to millions of youths and fans around the globe.

The Nollywood star system, with stars being regarded as cultural ambassadors and role models, displays the same important relationship with and necessity for identification between stars and audiences that is present in other star systems worldwide. Richard Dyer, in his seminal work on star studies, *Stars*, published in 1979, describes the way that stars represent models of human subjectivity and social

types, through combining ordinary and extraordinary qualities. Thus Nollywood stars represent an image of success and productivity that ordinary Nigerians could be proud of and aspire to, even if they might never achieve it themselves. Perhaps this function of Nollywood stars is more important in Nigeria, and Africa as a whole, than it is in the star systems of First World economies, as representations of upward economic mobility and material, social and cultural wealth and success fulfil a crucial aspirational function in a society where the majority of the population lives in poverty.

As stated previously, Nollywood audiences can be found in Nigeria, all over Africa and almost everywhere internationally where there are sizeable African diaspora communities, including African Americans. The films' popularity has also spread to the Caribbean and the Pacific Islands. Due to the unregulated nature of the industry, it is difficult to obtain exact demographic data on Nollywood audiences, but it would be fair to say that the films are watched by the 'masses' as well as the middle classes, by men and women, and by people of all ages, though with a strong youth following. The majority of Africans on the continent watch Nollywood films in informal video parlours or at home, as Nollywood films usually bypass cinematic distribution and exhibition – a characteristic of the industry that has developed to some extent as an effect of the lack of cinema infrastructures in most African countries. Nollywood films are, however, increasingly screened in cinemas outside of Africa. The stars could count their fans among all these different geographical audiences, and Nollywood stars often travel overseas to the premieres of their films, and always draw huge crowds where there are substantial African communities. Nollywood premieres have become common in London, for example, with film premieres that have stars in attendance almost always being oversubscribed. Jedlowski (in Krings and Okome 2013: 36) states that the introduction of scheduled Nollywood premieres at Odeon cinemas in London was intended to progressively create a demand for the theatrical release of Nollywood films. The Odeon premieres have become a sophisticated ritual mostly centred on the star system and designed as social events, with journalists and media gathering around a red-carpet area before the screening begins, and fans lining up near the entrance of the cinema in anticipation of the stars' arrival. Nollywood awards ceremonies in cities with large African diaspora communities are also not uncommon, and these ceremonies are usually glamorous red-carpet events that give fans the opportunity to see the stars in the flesh. The success and popularity of these kinds of cinema premieres and awards ceremonies underline the importance of the star system, and are indicative of the transnational nature of Nollywood's popularity.

The payment of Nollywood stars is an issue much discussed in the media around the industry, with Nollywood websites frequently carrying speculative articles on how much Nollywood actors earn, as well as 'top 10' lists of the highest earners.

On average, about 30 to 40 per cent of a film's budget would be spent on the stars, although for the most sought-after stars of the moment this percentage could increase to 50 or 60 per cent. Most of these types of productions would have secured product-placement agreements, private sponsorship and equipment partnerships in order to be able to raise a budget of which the cast fees constitute a significant chunk. Stars are of course very aware of their role in guaranteeing the success and profitability of a project, and they can be shrewd negotiators when it comes to settling fees and contracts. Barrot (2008: 39) references the *Nollywood* supplement of the paper *New Age* (8 October 2004), which dedicated a whole section to the salaries of the 11 most sought-after Nigerian actors. Among this list were Genevieve Nnaji and Jim Iyke, whose careers are discussed in further detail below. The article reported that Nkem Owoh earned 1 million naira (then $7,800, now around $6,300) for each of the two parts of the well-known Nollywood film *Osuofia in London* (2003). Similarly, the actress Omotola Jalade-Ekeinde considered 1 million naira to be the benchmark, refusing any role offered for less. Genevieve Nnaji's fees, however, had risen to 3 million naira by 2004. At the time the producer-distributors increasingly saw themselves as victims of a bidding system linked to celebrity culture which they themselves had created and, in an oft-repeated anecdote, in October 2004 they ordered a total boycott of the most highly paid actors, with Genevieve Nnaji, among others, being frozen out of the industry for a couple of years. Producer Eddie Ugbomah is quoted by Barrot (2008: 39) as saying: 'these monsters were created by the distributors'. Indeed, Morin (in Shingler 2012) describes stars as 'sacred monsters' – venerated public individuals who are above and beyond criticism by ordinary mortals.

More recent figures (such as those published on the African entertainment website afrogle.com, viewed in June 2013), show much the same as the figures quoted by Barrot in 2004. The article on afrogle.com claims that recent research suggests that speculation that some actresses earn up to five million naira per film is not true. The article lists Genevieve Nnaji as the top earner per film in Nollywood, with an average fee of 2 million naira. In fact, Nnaji was the first Nollywood actress to earn 1 million naira for a single film. It should be kept in mind that most top Nollywood stars supplement their earnings from acting by a host of extra-filmic activities, such as product endorsements and public appearances. James Uchenna, in an article published in September 2010 on nigeriafilms.com, lists Kate Henshaw-Nuttall as the wealthiest actress in Nollywood, with total earnings of 67 million naira; Nnaji was in second place, with a total fortune of 64 million naira. In an article published on answersafrica.com in 2013, actor Jim Iyke was listed as the second-wealthiest male actor in Nollywood.

The earnings of Nollywood stars are thus rather low in comparison to what stars demand and earn in other film industries, in particular Hollywood. In a blog published on nairaland.com in April 2013, it was claimed that Nollywood actors were among the lowest-paid in the global film market, despite the fact that the

Nollywood industry is worth almost $600 million annually. A fair speculation would be that distributors and producers often make far more money than actors, and that the potential profitability of the industry is further marred by piracy. Unknown actors earn as little as $70 per film, and even more popular actors are seldom paid more than $3,000 per film. Ajibade (in Krings and Okome 2013: 269) states that, while the well-known faces of Nollywood's star system claim to earn several hundred thousand dollars, which is probably an overestimation, some actors get as little as 10,000 naira (about $80) per film. Such is the fragility and precariousness of the industry that actors will often demand cash before they appear on set. Only a few, such as Genevieve Nnaji and Jim Iyke, who are discussed in the following sections, can claim higher earnings that can rise to around $30,000 per film for a top-end production.

Nollywood's Bad Boy: Jim Iyke

Born in Libreville, in Gabon, in 1976, and from Anambra State in Eastern Nigeria, James Ikechukwu Esomugha, or Jim Iyke as he is popularly known, is one of Nollywood's most famous male stars. He has featured in over 200 films since his entry into the industry in 2001, including some top-end internationally distributed Nollywood productions, such as Obi Emelonye's *Last Flight to Abuja* (2012). Iyke has constructed the public persona of a versatile artist and celebrity and, in addition to being an actor, he is also known as a producer, fashion model, musician, martial arts specialist and businessman. His public persona is also one of a playboy and womaniser, mainly due to the types of roles he is usually cast in, and a rebel, as he often relates his rags-to-riches backstory of being disowned by his family due to being directionless in his youth, despite having earned a degree in philosophy from the University of Jos. The website of the foundation he founded and owns states: 'Through sheer hard work, humility and unprecedented perseverance, Jim survived all odds, excelled in his chosen career and has since proved to be among the best' (Jim Iyke Foundation, n.d.). In 2008 Iyke was crowned sexiest man in Nigeria, and he has won many best-acting awards. He also features in his own reality television show, called *Jewel for Jim*.

Known as Nollywood's 'bad boy', he is often at the centre of controversies, mostly around apparent public displays of arrogance and aggression, his relationships, female fans and paternity claims. The website nigeriafilms.com carries a large amount of gossip on Nollywood actors, and published eight stories on Iyke in November 2013 alone. Like the tabloids in the UK and US, gossip publications and blogs speculate continuously about Iyke's private life: his recent relationship with the well-known Ghanaian actress Nadia Buari, the European holiday he took her on, and the pink limousine he bought her for her birthday. In an interview published on the website naijamayor.com in December 2010, he claimed that there had been a calculated attempt by certain people to spread negative publicity

about him, and that this was mainly due to the fact that he is judged by his film roles:

> I think it's outrageous when people judge you according to what you act. It's only in a country like ours that things like this happen. You can't seek redress in court because the junk journalists know the inefficiency of the justice system. In a country where objective journalism is missing, anything goes.

Despite his protestations, Iyke often plays up to his celebrity status and playboy image in interviews. He describes himself as 'one of the most enigmatic showbiz figures' (iredia.8m.com), who drives around in tinted cars and wears fashionable clothes, but lives a reclusive lifestyle despite his popularity. He is very aware of his popularity with female fans in particular, and has described in interviews how women flock to him and send him emails, text messages and nude photographs. He claims, however, that he has never been a playboy in real-life, though he is paid to act as one.

His extra-filmic activities are widespread, and he owns the Untamed franchise which produces films under Untamed Productions and music under the label Untamed Records. The Jim Iyke Foundation raises funds for children with disabilities, and he often cites in interviews the importance of his charity work, and in particular his work with children. As a businessman he has interests in real estate and resource management.

Iyke is described in an online biography as the first Nollywood actor to produce a mainstream big-budget movie abroad. He was the only African on the set of *Between Kings and Queens* (2010), and has also produced two international movies – *Ebony* (2007) and *Good Evening* (2004). He describes his international work as a way to do more quality productions, thus recognising the fact that most Nollywood films are not internationally accessible due to their low production values and local narratives. This also reflects the fact that many Africans look to foreign, and especially to Western countries, as the epitome of wealth, success and progress. Thus Iyke's international film work serves to further cement his reputation as one of the most successful and talented Nollywood stars, and enhances his celebrity status.

Africa's Julia Roberts: Genevieve Nnaji

As opposed to the 'bad boy' image of Jim Iyke, Genevieve Nnaji has a much more of a 'girl-next-door' image as a wholesome, clean-cut and very private star. She was born in 1979 in Nigeria, and started her acting career as a child actress in a popular television soap opera called *Ripples* at the age of eight (genevieveofficial.com). She was signed up to a talent and modelling agency as a child, and featured in several commercials. Nnaji made her debut in Nollywood in 1998 at the age of 19, with the film *Most Wanted* (1998). She acted in several minor roles before her

breakthrough roles in Nollywood films such as *Last Party*, *Mark of the Beast* and *Ijele* (2009). She has since become a household name in Nigeria and beyond, and she is widely known all over Africa and in the African diaspora. She has received numerous awards for her acting, not only in Nigeria but also in the UK and US at African cinema and Nollywood awards ceremonies. Nnaji has featured in over 100 films, and is currently one of the highest-paid actresses in Nollywood.

Nnaji has also embarked on several endeavours outside of film, including modelling, in particular as the face of Lux, a well-known cosmetics brand in Nigeria, and the establishment of her own clothing line, St Genevieve, which donates a percentage of its proceeds to orphanages. She has been asked by the president of Sierra Leone to join him on the campaign trail. As one of the Nollywood actors sidelined by producers in 2004 because of their demands for extortionate fees, Nnaji tried her luck as an R&B singer and beauty consultant. Whereas most of the banished actors went back to shooting Nollywood films within one year, Nnaji held out the longest against the producers who had snubbed her, but by 2007 was back in the industry (Barrot 2008: 39).

Nnaji has aspirations, like many other Nollywood stars, to establish a successful international acting career, and in an interview with Obanor Chukwuwezam in July 2011 she explained her decision to act in fewer films as a way to ensure that she only takes part in quality productions. She stated that Nollywood initially favoured quantity over quality, but that the industry was evolving and improving and that she wanted to be part of this change. She has acted in the very successful Nollywood films *Ije* (2012) and *The Mirror Boy* (2010), which were shot and set outside Nigeria and directed by diaspora Nollywood directors. As part of 'New Nollywood' – a term attached to films with wider international and transnational appeal – these films have also been distributed and seen more widely than the standard Nollywood fare, and have certainly contributed to Nnaji's international fame among Africans across the continent and in the diaspora. Rumours were even circulating in 2011 that she would be appearing in the next James Bond film. In 2009 she was profiled on *The Oprah Winfrey Show* in an episode about the most popular people around the world. Winfrey famously referred to Nnaji as the 'Julia Roberts of Africa'.

Genevieve Nnaji has succeeded in creating and maintaining a respectable and wholesome public persona alongside a highly successful acting career, a feat that is not insignificant in a cultural context that does not generally regard acting as an honourable career for a woman; she has stated in interviews that her parents did not initially agree with her career choice. It is indeed not unknown for Nollywood actresses, as perhaps also in film industries elsewhere, to have to defend themselves against the sexual advances of male producers and distributors. Young Nollywood actresses have been known to exchange sex for roles. Furthermore, the Nigerian film industry has a distinct lack of professional structures for the training and support of actors, which means that Nollywood actors have to fend for themselves

when it comes to managing their careers and public image. Nnaji has successfully sidestepped the scandalous and sensationalist celebrity gossip that permeates the Nollywood industry, as in most celebrity film cultures worldwide, and she sees herself rather as an ambassador for her country who always speaks positively about Nigeria, and wears Nigerian designs when she travels abroad. In interviews she has described her fame as 'humbling' and 'overwhelming', and she ascribes her success to hard work and perseverance.

Conclusion

The differences between Jim Iyke and Genevieve Nnaji's public personas are clear from the above descriptions of their careers, and these also influence who their fan bases are: whereas Iyke appeals to female fans with his persona of a handsome playboy, perpetuated by the roles he is usually cast in as well as by 'news' of his private life played out on gossip blogs and in tabloid publications, Nnaji has the clean-cut image of a serious actress who protects her private life and values her role as an international ambassador for Nigeria and Africa. She appeals to young female fans, who admire her for her beauty and value system, and she is also desirable to male fans. The differences in the public images they have created for themselves are an indication that the full spectrum of celebrity personas found in most star systems across the world is also present in the Nollywood star system. An important aspect of Iyke and Nnaji's careers is the desire to establish themselves in the international film world. Both have acted in international productions, or international Nollywood co-productions, and this notion that the success of an African actor or celebrity is to be measured by recognition outside Africa, mostly Europe and America, is something commonly found in African cultures and societies. Iyke and Nnaji's international interconnectedness is clear from their fame across the African continent and everywhere where there are African diaspora communities who watch Nollywood films. They bring together African communities across the world whenever they appear at premieres or awards ceremonies, consolidating the notion of a 'post-colonial pan-African consciousness' created by Nollywood. Their success makes Africans proud of their heritage and collective cultural identity. It is also important to note that both of them recognise that Nollywood is not yet at a stage where it can compete with film industries that reach an international market, such as Hollywood, but they also both express the hope and belief that standards of production values and storytelling will rise in Nollywood, to create an industry of true international significance.

The success of Nollywood, as the first financially sustainable film industry in Africa with a huge fan base and extraordinary output, is to a large extent due to its successful development of a star system, and it thereby provides a template from which other fledgling African film industries could learn. Renowned African film scholar Manthia Diawara notes:

Another lesson I wish African filmmakers would learn from the entire buzz in Lagos concerning the banning of Genevieve Nnaji from Nollywood is how crucial the stars and the distributors are to any popular cinema. It is to the merit of the cultural workers in Nollywood to have realized that stars and distributors are as important as 'auteurs', if not more so. (2010: 190)

Acknowledgements

My sincere thanks to Obi Emelonye, Moses Babatope, Daniel Okoduwa, Chucks Mordi, Teco Benson and Tunde Kelani for their generosity in answering my questions on the Nollywood star system, drawing on their extensive experience in and knowledge of the Nollywood industry.

Notes

1. Ghana has a very similar video-film industry to that of Nigeria, also with an established star system, and co-productions between Nigeria and Ghana or Ghanaian stars featuring in Nigerian films, or vice versa, are not uncommon. But Nollywood is much more widely known internationally because of its huge scale and prolific output. The focus of this chapter on Nollywood should, however, not be seen as an indication that the Ghanaian video-film industry is of less significance.
2. Celluloid filmmaking in sub-Saharan Africa is usually linked to Francophone West Africa, which has a completely different filmmaking tradition than that of the Anglophone countries, due partly to France's support for the cultural industries of its ex-colonies after independence. Francophone West African cinema has also, historically, given rise to a much bigger body of scholarship.
3. The Nollywood film industry is about two decades old, and celebrated 20 years of existence with several international film festival retrospectives, awards ceremonies and other events in 2013.
4. These are just a few names, as new stars are regularly emerging and every Nollywood expert or Nollywood fan would have their own list of favourite or famous actors, with some overlap.
5. It is important to note that not all Nollywood directors follow this sure-fire method to success; the well-known and veteran director Tunde Kelani, for example, does not often use stars in his films, but selects actors based on the demands of the narrative. Some actors who have starred in his films have, however, achieved stardom afterwards by continuing to feature in popular films. Kelani's method is very much in the minority, though, and he could be regarded as more of an 'auteur' director, whereas the popularity of Nollywood stars mostly overshadows the director as the main controlling force of a film.

3

The Star of the East: Umm Kulthum and Egyptian Cinema

Ifdal Elsaket

The 1920s was an especially important decade in Egypt's cinema history: it witnessed an unprecedented increase in the import of foreign films and a flourishing of cinema venues across Egypt's major urban centres. The year 1923 marked the establishment of the first ever Arabic specialist cinema magazine, *Moving Pictures*, and it saw the release of Egypt's first feature film, *In the Land of Tutankhamen*, directed by the Italian resident Victor Rositto. Around this time, a talented 19-year-old girl from the Delta region arrived in Cairo. From a poor rural background, her name was Umm Kulthum Ibrahim al-Baltaji, and within only a few years she became the most famous star in the Arab world.

Umm Kulthum, endearingly known to Arabs as the 'Star of the East', has been the subject of much scholarly discussion. A vocalist whose career spanned more than seven decades, Umm Kulthum has provided an illuminating entry point for the study of Egyptian constructions of the nation, gender, and the intersections of culture and politics. Notwithstanding the bountiful scholarship on Umm Kulthum, there has been an absence of detailed examinations of her cinematic work (Danielson 1997: 87–91, 107–9; Armbrust 2001: 28–41). This is perplexing given that her foray into cinema, which lasted from 1936 until 1947, occurred during a formative period in her career.

This chapter examines the construction of Umm Kulthum's star image *vis-à-vis* Egyptian cinema, and interrogates the mass mediated interconnections, and cultural influences within which her stardom was embedded. In particular, it shows how Umm Kulthum's star persona hinged on a confluence of idealised femininity and working-class loyalty that was shaped by social and production processes. Drawing

on media representations and providing analyses of her films, the chapter sheds light on the social and industrial interactions that facilitated her star persona, and unpacks the textual and economic entanglements of which cinema formed a vital part. By the early 1930s, Egyptian vocalists and recording companies were capitalising on the expanding Egyptian cinema market in the hope of reaching a wider audience. The interplay between stardom and the Egyptian film industry was, therefore, based on a process of reciprocity and exchange between various cultural mediums. Umm Kulthum's work in the cinema embodied these processes and interactions, and can therefore provide a revealing case study for exploring the broader intricacies of star creation in Egypt in the 1930s and 1940s.

The Construction of Stardom

Despite her cinematic work in the 1930s and 1940s, Umm Kulthum is best remembered today as a classic musical figure of the 1960s and 1970s. Her performances of that period, bewailing the pangs of love, or glorifying God and nation, rooted themselves in the rhythms and memories of a generation of Arabs. Her monthly concerts were broadcast live across the region, uniting people from across a vast geographical landscape in an aural space of musical sublimity (Danielson 1997: 86). She became the symbol of a new post-colonial order, and her image was tied to a nation trying to reconfigure itself after decades of British occupation and monarchical rule. She formed a unique relationship with the charismatic Egyptian president Jamal 'Abd al-Nasser, one of the officers who led the coup of 1952 that overthrew the Egyptian monarchy, and emerged as the voice of the new regime. Publicly supporting one another, Nasser and Umm Kulthum bolstered each other's personas, each embodying the prevailing sentiment of Arab nationalism as their influence and popularity spread throughout the Arab world (Danielson 1998: 109–22). Umm Kulthum's death in 1975 unleashed a spectacle of public mourning. Images of weeping crowds swarming around Umm Kulthum's coffin were testament not only to the singer's stardom but represented an historical grief that bookended a period of decolonisation.

Yet the seeds of Umm Kulthum's unprecedented stardom in the 1960s and 1970s had been planted long before this time. Umm Kulthum rose to fame in Egypt's musical world in the 1920s. She arrived to Cairo in a context in which celebrities developed into the faces and voices of a new urban entertainment culture. Referred to as *nujum* (stars) or *kawakib* (planets), celebrities acquired considerable cultural capital, and took full advantage of the hundreds of magazines and newspapers in circulation to promote their work (Fahmy 2011: 31; Metcalf 2008: 341–416; Graham-Brown 1988: 189–91). Stars emerged in full bloom, therefore, at the junction at which the proliferation of the print media merged with a flourishing entertainment industry.

The mediated interconnections that gave rise to stardom in Egypt formed at a specific historical moment, which fundamentally determined how Umm Kulthum's image was represented. Umm Kulthum was deft in recognising the socio-political mood of the times and, through carefully formulated appearances, constructed her persona to reflect the attitudes of her generation. In particular, Umm Kulthum's public persona was bound to a neatly packaged narrative of her beginnings. The narrative tells the story of a young peasant who, against all odds, rose to incredible fame. It narrates the story of a daughter of a religious wedding entertainer, who, after recognising his daughter's vocal aptitude, dressed her as a boy and took her to various functions where she stunned spectators with her powerful voice and advanced vocal techniques. The narrative is replete with anecdotes of a simpleton, shy and awkward, trying to fit into the fast-paced Cairene world, where she moved with her family in search of success (Roustom 2006: 28).

Umm Kulthum's star narrative, therefore, located itself within the pangs of poverty and the blessings of success (Danielson 1997: 189). Her ability to connect with audiences on a socio-economic level at a time of perpetual economic and political hardship was a key characteristic of her stardom. Umm Kulthum's perceived rebuff of cultural elitism and her insistence on maintaining an aura of simplicity and labouring-class associations made her particularly appealing. Umm Kulthum's star trajectory also located itself in important historical moments, such as Egypt's 1919 revolution against British rule and local authorities. An Ottoman province since 1517, Egypt was occupied by the British in 1882 and declared a British protectorate in 1914, when Ottoman ties were finally severed. When, in 1919, the British refused to grant Egypt independence, and exiled its nationalist leaders to Malta, they precipitated the first major mass revolution in Egypt's modern history. Increased nationalist fervour characterised the years after 1919, as the nation demanded full political and economic independence and redefined what it meant to be Egyptian. This context was inscribed on Umm Kulthum's stardom, and often reproduced in media outlets.

One article written about Umm Kulthum in the 1930s clearly demonstrated this historical and political inscription. The article created a rigid demarcation of social classes by comparing Umm Kulthum, who 'knew poverty and deprivation', to other female singers who, according to the author, did not. Alluding to their elitism, the article rebukes these other singers for witnessing the 1919 revolution on the shoulders of their maids from their fathers' balconies (Danielson 1997: 188). These other female singers were, therefore, situated outside the historical experience of ordinary Egyptians. In contrast, the article firmly placed Umm Kulthum within the socio-political terrain on which Egyptians were struggling. Through allusions to her class, Umm Kulthum's star persona was adroitly tied, therefore, to what was at the time a prevalent romanticisation of tradition and ostensible local 'authenticity' (Armbrust 1996; Danielson 1997).

Umm Kulthum's Cinematic Debut

The expansion of local filmmaking and the growth of cinemas in Egypt in the 1920s opened up new avenues for Umm Kulthum to promote herself in a different medium. Indeed, despite having risen to fame in the decade before her films, it was during her cinematic career, as she combined visual and aural representations, that her star persona acquired sharp focus (Danielson 1997: 70–125). Between 1936 and 1947, Umm Kulthum starred in six films. Studio Misr, Egypt's first major film studio, produced her first film, *Widad* in 1936, directed by Ahmad Badr Khan, Fritz Krump and Jamal Madkur. She then teamed up with Badr Khan to make *Nashid al-Amal* ('Anthem of Hope') in 1937, *Dananir* in 1940 and *'Aiyda* in 1942. In 1945, she worked on the film *Salama* with Italian-Egyptian director Togo Mizhari, and in 1947 she ended her film career with *Fatma*, directed again by Badr Khan.

Like many other entertainers during this period, Umm Kulthum used the cinema, which both located itself within and reconfigured the economic and cultural networks of Egypt's entertainment and cultural networks, forming part of what Ziad Fahmy calls 'media-capitalism', to reach a wider audience and consolidate her public persona (Ali 2008; Marei 1998; al-Hadari 1989, 2007; Shafik 2007; Fahmy 2011: 16; Armbrust 2006: 298). The interplay between Umm Kulthum and Egyptian film companies was based on a relationship of reciprocity and exchange; she provided her already famous face, body and voice to film studios that in turn helped her to develop a broader fan base. Yet this reciprocity was not merely a characteristic of her early film career. As this chapter will discuss, it represented a sticking metaphor for Umm Kulthum's ability to fuse two nationalist symbols prevalent at the time: economic nationalism, on the one hand, and 'cultural authenticity' on the other.

Umm Kulthum's entry into the world of filmmaking was bound to the music industry, within which she had already staked a dominant claim. From the 1930s, as early sound-film productions began to dominate the market, the music industry played a key role in cinematic production. Recording companies benefited from the coming of sound films, and played a major role in cinematic production. Salwa El-Shawan has demonstrated that films provided recording companies with increased potential for commercial profitability as they rushed to capitalise on the popularity of the cinema by releasing film-songs on gramophone records (1980: 94). Umm Kulthum's film songs were released on gramophone records by the record companies Odeon, Parlophon[1] and Cairophon, and were reportedly very profitable (El-Shawan 1980: 118n.18).

Given the lucrative potential of the musical film genre, it is not surprising that in 1935 Studio Misr, Egypt's first major film studio, offered Umm Kulthum a contract to star in its first-ever film. Due to her already extensive fame in the music world, Studio Misr even gave Umm Kulthum substantial contractual leverage, agreeing

to work on a film plot that she conceived, titled *Widad*, and even giving her, in addition to a fixed salary, a 40 per cent share of the film's profit (capped at a certain amount) (Danielson 1997: 89).

Studio Misr's use of Kulthum proved lucrative. *Widad* ran for eight weeks, with tickets selling out for each of the four daily screenings ('Films in Arabic', *The Times*, 26 January 1937: 65). Umm Kulthum's connection with Studio Misr not only provided an avenue through which she could make films; it bound itself to constructions of her star persona, grounding it within a narrative of economic nationalism.

Studio Misr, Umm Kulthum and the Spirit of Economic Nationalism

Studio Misr emerged out of a particular economic and political environment of the 1920s and 1930s, and its creation is particularly important in any analysis of Umm Kulthum's stardom. This film enterprise in Egypt was embedded in nationalist ideological currents that aimed to improve Egypt's economic situation and pave the way for full political liberation (Armbrust 2001: 30). In 1920, boosted by the jubilant sentiments generated by the revolution of 1919, nationalist economist and industrialist Tal'at Harb established the first Egyptian-owned national bank, Bank Misr. The bank represented the pinnacle of Harb's nationalist activities, and became a metaphor for a wider nationalist consciousness centred on the concept of economic liberation (Tignor 1977). Through the funding of the bank, Harb established companies in the hope of diversifying the economy, and set up industrial initiatives that aimed to shift economic dominance into the hands of Egyptian nationals.

In 1925, recognising the potential profitability of a film industry, Bank Misr established Sharikat Misr lil-Tamthil wal-Sinima (the Misr Company for Acting and Cinema, henceforth, MCAC) (al-Hadari 1989: 191–3). True to its economic-nationalist roots, MCAC aimed to make short films and documentaries to promote Egypt and Egyptian industry. As an extension of MCAC, Studio Misr, Egypt's first major film studio, was formed in 1935 (Hasan 1986: 52). Unlike MCAC, Studio Misr focused its efforts on the production of feature films, and expanded the opportunities for films to be made, shot and edited within Egypt.

That Umm Kulthum's cinematic debut coincided with the launch of Egypt's first major film studio, Studio Misr, was therefore no trivial matter. The nationalist aura that surrounded Umm Kulthum was fundamentally shaped not only by the film characters she portrayed, which will be discussed below, but also by her off-screen link to Studio Misr. Walter Armbrust has made a similar point about Umm Kulthum's second film, *Anthem of Hope* (Armbrust 2001: 30–1). While in *Anthem of Hope* Studio Misr features in the actual narrative of the film, its association with Umm Kulthum in *Widad* can be gleaned from the press coverage of and advertisements for the film's release. The economics of Umm Kulthum's cinematic project were not lost on the press or on the film's promoters, whose visuals and articles

STARS IN WORLD CINEMA

40

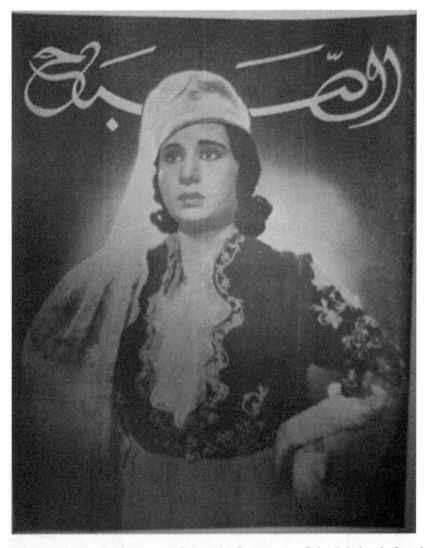

Figure 3.1. Umm Kulthum as Widad on the front cover of *al-Sabah* days before the film's release. Source: *al-Sabah*, 7 February 1936, front cover.

powerfully connected *Widad* and Umm Kulthum to the rise of Studio Misr and to the economic nationalism of Tal'at Harb. A brief examination of the advertisements and promotion of *Widad* in one magazine, *al-Sabah*, will illustrate this point.

From late 1935, advertisements and feature articles about *Widad* poured onto *al-Sabah*'s pages. The media campaign for the film was particularly aggressive, outdoing most other film advertisements in the magazine. Film advertisements took up two full pages, and Umm Kulthum appeared in full colour, and in character, on its front cover days before the film's premiere (see Figure 3.1).

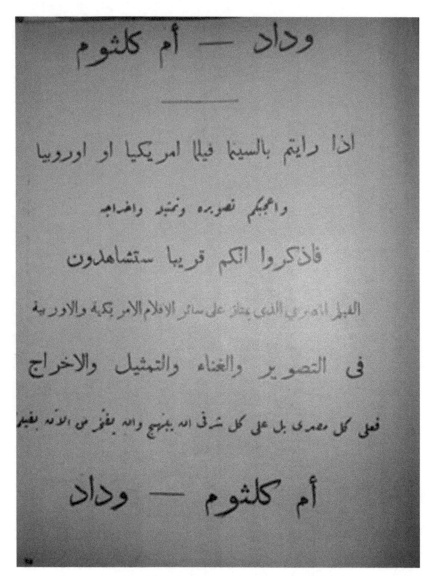

Figure 3.2. Advertisement in *al-Sabah*. Source: *al-Sabah*, 15 November 1935: 25.

In one advertisement for *Widad*, which took up an entire page, the film's promoters tapped into an economic–nationalist mood by representing *Widad* as a formidable entry into a film market dominated by foreign films (*al-Sabah*, 15 November 1935: 25). The advertisement guaranteed that *Widad* would be better than the American and European films showing in Egyptian cinemas, and called on Egyptians and 'Easterners' to be proud of the film (see Figure 3.2). Another advertisement highlighted the Egyptianness of *Widad*, and noted the pride that the film engendered among Egyptians (*al-Sabah*, 29 November 1935: 57).

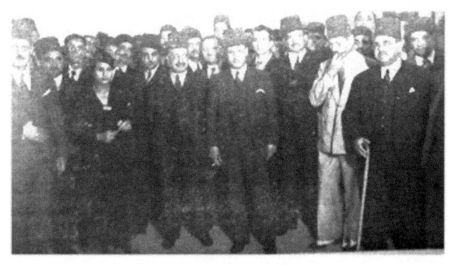

Figure 3.3. Umm Kulthum with economic heavyweights including Tal'at Harb and Finance Minister Ahmad 'Abd al-Wahhab. *Source: al-Sabah*, 18 October 1935: 44.

Hailed as a nationalist project, *Widad* was thus conceptualised as the product of an economic renaissance spearheaded by the man many saw as the father of economic liberation, Harb (*al-Sabah*, 18 October 1935: 44–5; 25 October 1935: 72). Articles in *al-Sabah* expressed pride in the studio's project, and gave their nod of approval to its choice of Umm Kulthum as lead actress of its first film (*al-Sabah*, 25 October 1935: 72). More significantly, the studio and the film were seen as tools that could help raise Egypt's international prestige, a central tenet in Egyptian anti-colonial rhetoric (*al-Sabah*, 8 November 1935: 64–5). One article in *al-Sabah* called *Widad* one of 'the most powerful means of propaganda for Egypt around the world' (*al-Sabah*, 22 November 1935: 59). Another article described *Widad* as one of Harb's achievements in his quest to raise Egypt's prestige (*al-Sabah*, 29 November 1935: 67).

Through the advertisements and articles, Umm Kulthum became inextricably tied to Studio Misr and, by extension, to the economic and political values it embodied. Umm Kulthum's name framed the advertisements, enmeshing her in the national industrial enterprise. In one edition of the magazine, Umm Kulthum was even photographed standing with Tal'at Harb and other economists (see Figure 3.3).

Studio Misr embodied the dream of economic independence, and Umm Kulthum, the naive young peasant girl from the Delta, became its first face. The dalliance between Umm Kulthum and Studio Misr was a match made in heaven, and embodied the nationalist spirit of the age that formed at the juncture of 'tradition', embodied by Umm Kulthum, and modern local industry, represented by Studio Misr.

National 'Authenticity'

Umm Kulthum's films functioned to heighten modes of nationalist subjectivity –
a fusion of Arab, Eastern and Egyptian (Armbrust 2004: 75). By articulating
this ideal vision of nationhood, Umm Kulthum's films tapped into the broader
understandings of Egyptianness prevalent at the time. Umm Kulthum made sure
that the characters she played did not undermine the persona she had built around
tradition and Egyptianness. As Virginia Danielson notes, Umm Kulthum had
immense control over her films, having a say in all areas of the production process.
Importantly, she stipulated exactly what type of characters she played. All her films
were to be grounded in what she called 'Eastern traditions' (Danielson 1997: 89).

The musical scenes in Umm Kulthum's films were central avenues through
which Egyptianness was highlighted. Umm Kulthum's films drew on the talents
of some of Egypt's most acclaimed poets and musical composers, who together
functioned at the very heart of Egypt's early cinematic culture. Not only did
these poets and composers create a new genre in the Arabic musical and poetic
tradition – that of film song – they significantly shaped Egypt's encounter with the
cinema by infusing it with traditional modes of cultural expression related to poetry
and music. Some of the best-known and most revered musical composers, such as
Muhammad al-Qasabji, Riyad al-Sunbati and Zakariyya Ahmad, who had played
a central role in defining the 'Egyptianness' of musical culture in the twentieth
century, composed the music for Umm Kulthum's films. They set their music to
the words of an army of lyricists drawn from a pool of Egypt's most notable poets,
such as Ahmad Rami and Bayram al-Tunisi (El-Shawan 1980: 89).

Umm Kulthum's film songs included a number of nationalist and Islamic-based
themes, some of which fused exaltations of tradition with celebrations of industry.
In the film *Widad*, songs about the greatness of Egypt and calls on God to make the
nation prosperous tapped into a wider desire for industrial prowess and economic
prosperity. Indeed, one of the film's musical numbers referred to the 'bountiful
crops' of Egypt. The theme of cotton, and the exaltation of the peasants as cotton
workers, featured in a great number of film songs throughout the interwar period.
In her 1942 film *'Aiyda*, Umm Kulthum serenaded cinemagoers with praise of
Egypt's cotton industry with her song *al-Qutun Fattah* ('The Cotton has Opened'),
accompanied by shots of peasants in the fields.

Umm Kulthum's 1937 film *Anthem of Hope* included an important nationalist
film song, known as the University Anthem or 'Ya Shabab al-Nil' ('O, Youth of
the Nile'). The song, which had very little to do with the development of the plot,
constituted a passionate call for youth perseverance and struggle. Released at a time
when student demonstrations rocked the country (Abdallah 2008: 39–61), the song
tapped into a dominant mood of nationalism, and rode the wave of youth politics.

On another level, praise of Islam in Umm Kulthum's films gave weight to claims
of cultural authenticity. Umm Kulthum's most Islamically orientated film songs

featured in the 1944 film *Salama*, directed by Togo Mizrahi. It was in *Salama* that Kulthum, for the first time on the screen, recited the Qur'an (she was in fact the first woman to recite the Qur'an on film). The *adhan* and regular quotations from the *hadith* also feature extensively in *Salama*, and worked to further Islamicise the soundscape of the film (Danielson 1997: 107). Religious songs and the musical techniques suited Kulthum's self-representation as deeply attached to Islam and Arab culture (Danielson 1997: 141–6; Danielson 1987: 26–45).

Embedded within their contexts, Umm Kulthum's film songs played a central role in heightening the Egyptianness and nationality of the film, and formed a prism through which audiences encountered 'Egypt' at the cinema. By creating meaning and signifying (and thus helping create) nationalist subjectivities, Umm Kulthum's film songs tapped into broader trends in Egyptian and Arab expressive culture, and represented an important avenue through which audiences encountered an idealised vision (and sound) of Egypt at the cinema.

In the Neighbourhood of Princes: Umm Kulthum as Lower-Class Hero?

Umm Kulthum's film characterisations as a hard-working, poor and chaste woman not only worked to enhance her personification of ideal Egyptian femininity (Danielson 1997: 87–90, 107–9), they were bound to a clear class delineation. In all of her films, Umm Kulthum plays a woman from a lower socio-economic background. In *Widad*, *Salamah* and *Dananir*, she plays a slave-girl, in *Fatma*, a poor nurse, in *'Aiyda*, the daughter of a poor man, and in *Nashid al-Amal*, a poor single mother. Her first and last films, more than a decade apart, exemplified similar social messages, and worked in analogous ways to uphold her image as the exemplar of Egyptian femininity.

In her first film, *Widad*, Umm Kulthum's off-screen persona of a humble woman spills onto the cinema screen. The famous poet Ahmad Rami wrote the film's screenplay with the assistance of Umm Kulthum, who came up with the plot (Danielson 1997: 88). Set in Mamluk Egypt, Umm Kulthum plays Widad, a meek, loyal concubine, who enjoys a deep reciprocated love with her master, the wealthy merchant Bahir. Bahir, however, suffers bankruptcy when bandits loot a caravan of his goods on its way from Syria. Out of loyalty and love, Widad convinces her master to sell her and raise the funds to lift himself out of bankruptcy.

Although she is sold to another man, the film does not allow room for speculation about her potential sexual infidelity. The man she is sold to is sick and old, and instead of entertaining him, she nurses him like a daughter. When a younger relative of the old man makes advances towards her, she is quick to shun him and maintain her 'honour'.

Advertisements for *Widad* in *al-Sabah* magazine closely associated Umm Kulthum with the character of Widad. One advertisement is framed above and below with the words 'Widad – Umm Kulthum', 'Umm Kulthum – Widad'

(*al-Sabah*, 15 November 1935: 25). Another feature article about Widad is flanked on one side by a vertical advertisement, which also subsumed Umm Kulthum and Widad into one entity. Without any embellishment or figures, and relying on repetition, the advertisement simply stated: 'Hitherto, the talk of the town is about the film Widad and Umm Kulthum, and Widad and Umm Kulthum and Widad' (*al-Sabah*, 22 November 1935: 63) (see Figure 3.4). What is interesting about this column is that the font of the word 'film' is significantly smaller than that used in the rest of the words in the advertisement. 'Film' is in the same point size as the word 'and'. The film itself thus becomes a mere medium through which the main attraction – Umm Kulthum as Widad, or Widad as Umm Kulthum – could be promoted (see Figure 3.4).

Fatma, Umm Kulthum's last film, also centres on a love affair between two characters from different class backgrounds, and associates her with virtuous femininity. The film revolves around the story of Fatma (Umm Kulthum), a working-class nurse, who falls in love with Fathi (Anwar Wajdi), a wealthy man who is only interested in sleeping with her. When she refuses, Fathi agrees to marry her without the knowledge of his family and, worse still, in an 'urfi' style marriage – that is, without legal registration. Fed up with Fatma's working-class family and friends, who he thinks are crude and uncultured, Fathi then leaves Fatma and returns to his jazz music–loving, alcohol-drinking former fiancée Mervat (Zuzu Shakib). Upon learning that Fatma had become pregnant during their marriage, Fathi refuses to acknowledge any relation to her or the child.

Throughout the film, the hard-working and caring working-class characters are juxtaposed to the frivolous and profligate wealthy aristocrats, with their endless parties and games. In her refusal to engage in premarital relations with Fathi, Fatma personifies female virtuousness. Nowhere is this more vivid than in the juxtaposition of Fatma with Fathi's former fiancée Mervat. Mervat is the epitome of the careless and playful *femme fatale* who chooses and loses her sexual partners with callous ease. Most strikingly, she even seeks Fatma's assistance in administering an abortion. Fatma, of course, flatly refuses to 'commit the crime', despite the large sum of money it could have secured her.

The film ends with a unification of Fathi and Fatma through the court system, upheld as a space in which the poor could voice their grievances. The brief dialogue between the characters towards the end of the film illuminates Fathi's integration into and acceptance of Fatma's working-class roots. The dialogue takes place as Fathi and Fatma leave the court and climb into a horse-drawn carriage to take them home. One of Fatma's neighbours asks Fathi: 'Where to Fathi Bey? Zamalek?' (an upmarket Cairene suburb where he lives), and Fathi replies, 'No, to "Harat al-Umara"' (Fatma's working-class neighbourhood, which literally means 'neighbourhood of princes'). Fathi has let go of his elitist ways, and the film ends with a joyous serenade about victory as the working-class residents dance in the street.

Figure 3.4. Widad and Umm Kulthum. Source: *al-Sabah*, 22 November 1935: 63.[2]

Umm Kulthum: A Hero of the Status Quo

While the films upheld the working and poorer classes as their true heroes, *Widad* and *Fatma* are most certainly not political odes to economic and social justice. In fact, Umm Kulthum's film characterisations, like those in many other films, sanitise and romanticise the struggles of the poorer classes in such a way as to depoliticise them. Both produced by Studio Misr, they articulate a message of loyal workers, and extend Umm Kulthum's association with national industrial initiatives. In fact, it is precisely through Umm Kulthum's portrayal of loyal femininity that an industrialist insistence on class loyalty emerges.

In a particularly conservative fashion, *Widad* articulates a capitalist narrative of merchant struggles and chattel sacrifices. In its raw simplicity, *Widad*'s plot revolves around the working relationship of a businessman and his ever-loyal slave who allows herself to be sold as capital to ensure his financial success. Indeed, threaded through the film are references to the virtue of patience in times of economic hardship and struggle. *Widad*'s story of slave loyalty to the business interests of a merchant class is a panorama of historical irony when read against the context of 1935/36 Egypt. The film was made and released amid simmering labour tension and student and worker strikes across the country. Indeed, Bank Misr, of which the production company of *Widad* was a subsidiary, suffered its own share of labour troubles in its spinning and weaving mill in the provincial city of Mahalla in 1935 (Beinin 2001: 103–6).

Similarly, *Fatma* romanticises the struggles of the working class, yet upholds the reality of class hierarchy and the institutional and legal structures of the state. Individuals such as Mervat are criticised, and neighbourhood camaraderie is praised, but the struggles of the working classes and the profligacy of the wealthy are not embedded in any structural flaw. As with *Widad*, reading the film against the context within which it was produced draws its historical irony into sharp focus. *Fatma* was a film about the simplicity and serene life of the working class, who use the incorruptible legal system – 'a place where all are equal' in the words of one of the characters – to demand their rights, during a time when those rights were being curtailed on other fronts (Beinin and Lockman 1988: 351). The film deradicalises class struggle and placates class agitation by ending with the unity of the ruling and working classes in a state institution. Much like *Widad*, the film was released at a particularly volatile economic moment in Egyptian history, in which strikes were increasing among factory and government workers across the country (Beinin and Lockman 1988: 310–62). Umm Kulthum thus plays the mediator in a class struggle.

Yet, despite these historical paradoxes, Umm Kuthum's characterisations res-onated with people precisely because they fused multiple narratives and gave relief to the tensions that embodied them. In her films, she symbolised national economic prosperity and lower-class struggles, successfully muting the frictions that

underpinned their relationship. Umm Kulthum was a powerful symbol of Egyptian cultural 'authenticity' at a time of rapid socio-political change and anxiety about the future. She engendered a longing for a romanticised simplicity, and a dream of national success and ascent to the top rooted in the growing disillusionment that haunted Egypt in the 1940s and 1950s.

Cracks in the Façade

An intermingling of various mediums and commercial interests, within which cinema formed a vital part, facilitated Umm Kulthum's carefully constructed persona. For over a decade, Umm Kulthum used the cinema to enhance her musical career, and through it she reinforced and crystallised the values around which her star persona was built. Gender and class formed the nexus around which ideal Egyptianness was constructed in her films, where ideal femininity was located in middle-class visions and romanticisations of lower-class struggle, couched in a broader context of socio-economic struggle and economic rejuvenation. Indeed, through her portrayal of the meek, loyal woman, Umm Kulthum did not merely present visions of ideal Egyptian femininity. The film's associations with Studio Misr, and with the commercial networks of which it was a part, sublimated the image of the loyal woman into visions of a compliant working class.

Despite her symbolic ties to experiences of ordinary Egyptians, cracks in the façade threatened to undo her carefully constructed image. The tensions inherent in her star persona can be detected in the 1920s when, far from the sweet and innocent country girl she was portraying, she was actually a shrewd businesswoman who had rid herself of her father and brother by paying them off, and by establishing contacts with prominent patrons and mentors (Danielson 1997; Lagrange 2009: 229). Her contradictions were exposed on a deeper level when, in the 1960s and 1970s, critiques of her elitism and political conservatism surfaced. In 1973, the Egyptian leftist poet Ahmad Fu'ad Nijm, for example, launched a scathing attack on Umm Kulthum in a poem entitled 'The Lady's Dog', which purports to tell the story of a young poor man bitten by Umm Kulthum's dog outside her mansion, and a corrupted legal system that values the rich over the poor. Umm Kulthum, the mythic star of the Arab world who played the working-class or slave girl in her films, was seen as a symbol of elitism by leftist activists.

Yet, despite these small cracks, and attempts to problematise her constructed persona, her public image has remained relatively intact to this day. It is precisely her success in embodying multiple and fluid narratives linked to certain social groups that ensured its durability. She continues to define the struggles of ordinary Egyptians. In 2011, amid the Arab revolutions, one of Umm Kulthum's fiery nationalist songs, 'I am the People', made the rounds on social media and even featured in a tribute advertisement by al-Jazeera Arabic. The song's title is an

apt one for a star who constructed her star persona around links to a struggling population.

Notes

1. Parlophon was the original German spelling of Parlophone.
2. 'Hitherto, the talk of the town is about the film Widad and Umm Kulthum, and Widad and Umm Kulthum and Widad.'

4

Setsuko Hara: Japan's Eternal Virgin and Reluctant Star of the Silver Screen

Mats Karlsson

Hara Setsuko (b.1920) was first promoted as a cute schoolgirl in braids and sailor uniform, before she was drawn into the maelstrom of national and world politics at the age of 15. From her early wartime roles as elder sister providing moral support to her brothers bound for the front, to the enlightened democratic heroines of the postwar era, and finally to the return, in her later career, to a nostalgic image of an idealised Japanese femininity rooted in the familial community, her transformations are emblematic of the social upheavals that Japan underwent around the middle of last century. Remaining constant throughout are Hara's screen incarnations of female virtue, which gained her the epithet of 'eternal virgin' (*eien no shojo*).

Even though Hara showed she could deftly adapt to the changing socio-political trends throughout her career, her characters all seem to contain an element of ambivalent elusiveness that makes her persona hard to pin down. Within film studies, much of star theory is based on the Western, Hollywood paradigm of film stars. The theory has at least the potential to apply in the different cultural milieu of the Japanese film world, in that Japan did have its own studio system, dominated by six main studios, which fostered contracted stars and would promote new films by starring actor rather than by director or title. On the other hand, though, star theory seems less applicable to Hara's reluctant anti-star type. In an interview, Hara commented that she strongly disliked intrusions into her life outside acting. Nevertheless, she held herself strictly to a standard of personal behaviour intended to protect the dreams of her fans (*Tokyo shinbun*, 20 February;

6 March 1959, 4). In the words of Saitō Tadao, a former publicity manager at Tōhō Studios Hara Setsuko was

> an unlikely, relatively taciturn actress who would not readily chat about ordinary things or be very sociable towards the mass media or the company publicity department. [She was] an actress who didn't associate with anyone after work but would go straight home; an actress who would pull away and withdraw when teased by male actors (Saitō 1986: 142).

If anything, her off-screen reclusiveness helped to promote a spotless star image. Her aloof character and her refusal to pander to fans in her private life helped to form an aura of dignity and grace around her person.

Making her debut in 1935, Hara appeared in 108 films before she quietly withdrew from the film world in 1962 to return to her real name of Aida Masae. Although Hara was first under contract with Nikkatsu Studios – introduced there by her brother-in-law, the director Kumagai Hisatora – before moving to Tōhō in 1937, she would work with all major studios during her career while remaining under contract with Tōhō: after the war her fame rose to the point where she could choose her films, despite the rigid studio system of the Japanese film world. For instance, Shōchiku Studios' main director, Ozu Yasujirō, had tried to 'borrow' Hara from Tōhō before the war, but was not given the nod until 1949 (Saitō 1986: 144). Conversely, in 1961 Hara pulled Ozu from Shōchiku to direct for Tōhō. This chapter weaves together political and personal elements with an analysis of selected film roles that illustrate the trajectory of her star image.

The Samurai Daughter

The year she was born, 1920, had also seen the 'birth' of the first female film stars of the Japanese screen. Until then, Japanese cinema had continued the theatrical practice of casting *onnagata*, specialist male actors, as women, but Shōchiku Studios now broke with this tradition in an attempt to foster female stars. Emerging from the second generation of actresses, Hara would go on to become Japan's biggest film star of her time, although this came about accidentally.

In early 1936 the director Arnold Fanck was visiting a studio in Kyoto in preparation for the German–Japanese joint film venture, *Atarashiki tsuchi/Die Tochter des Samurai* (1937), which was intended to commemorate the conclusion of the Anti-Comintern Pact. Hara had just finished shooting for the day for the renowned director Yamanaka Sadao, wearing traditional kimono in her first historical period film. She was asked to join in a commemorative photograph with the distinguished foreigner, but initially declined since she had already removed her makeup. The fresh appeal of the 15-year-old new face at Nikkatsu made such an

impression on Fanck that he decided to cast her, although Hara withstood repeated entreaties before accepting the role.

In *Die Tochter des Samurai* Hara plays the role of Yamato Mitsuko, who is engaged to be married to Yamato Teruo (Kosugi Isamu), a man adopted into the wealthy samurai family lacking a male heir. We first encounter a radiant Hara in a four-minute sequence in which her Mitsuko strolls through a Japanese-style garden dressed in kimono. A maid catches up with her to deliver the message that Teruo is returning home from a study sojourn in Germany. Mitsuko goes into transports of joy and performs pirouettes on the lawn, until she falls into some bushes beside a pond. Viewers used to Hara's subdued image in later Ozu films would probably be amazed at her dazzling portrayal here: her exuberant cheerfulness appears totally natural and unaffected by acting concerns.

But happiness proves to be short-lived as Teruo, influenced by Western ideas about the freedom of the individual, announces that he is unable to go ahead with the feudal practice of arranged marriage. The plot then centres on Teruo's reawakening and spiritual return to Japan, leading to the realisation of his filial duties and responsibilities towards his fatherland. His old mentor, a Buddhist monk, expounds to him (in an eerie German voice-over) how little his own life matters, except as a link in the long chain connecting past generations with future ones: his blood is but a drop in the eternal stream of life of his people. Meanwhile, Mitsuko, devastated by the cancellation of the nuptials, and dressed in her wedding kimono, is heading for the nearby volcano in an apparent suicide bid. Teruo interrupts Mitsuko at the last moment on the brink of the crater that is starting to erupt, and carries her to safety in his arms from the midst of the smoking inferno.

The film's final scene features a panning shot of Teruo sitting on a tractor ploughing a vast field in Manchuria, the 'new earth' of the Japanese title of the film.[1] Mitsuko appears with a baby in her arms. While Teruo cuddles the baby there is a close shot of Mitsuko, who looks at her husband and child with a loving expression and then turns to gaze up at the Japanese soldier guarding the farmers on the field. The film ends with a close shot of the soldier, who smiles at the young family, then stares straight into the camera with a sudden stern look, as if getting ready for unknown dangers to come.

Atarashiki tsuchi is an evident propaganda piece that celebrates racial notions about blood and earth and a sense of national destiny shared by Japan and Germany. It features an 'Orientalist' view of Japan steeped in ancient tradition and culture, yet excelling in industrial output and preparing for expansion abroad in search of *Lebensraum*. Viewed today, the film appears slightly bizarre, yet it enjoyed great success in both countries, and turned the teenage Hara into a star overnight. Interestingly, the film critic Yomota Inuhiko argues that the Japanese celebrated Hara as the ideal Japanese woman all the more because she was endorsed in

Germany as a woman who could be presented in the West with no need for embarrassment (Yomota 2011: 52–3).

In Tokyo the film was promoted like none before it, with a lavish preview at the Imperial Theatre sponsored by the authorities. In Germany, where Hara Setsuko had been taken to promote the film, the Nazis orchestrated its success. Hara arrived in Berlin on the morning of 26 March 1937, but *Die Tochter des Samurai* had already premiered three days ahead of schedule, so Nazi leaders could attend before leaving Berlin for the Easter holiday. Among these were Goebbels and Goering, whom Hara later met in person, and Hitler himself. She toured Germany with the film for two months, greeting audiences from the stage in broken German. The film was shown in 2,600 theatres across Germany, and its combined audience surpassed 6 million. Running until 18 May, it broke the German record for the longest premiere season (*Asahi shinbun*, 20 May 1937: 2). Hara and her team extended their promotional tour to Paris, London and Hollywood – though without success, as the propagandistic features of the film were clearly inappropriate in other political milieus.

Japan's Guardian Elder Sister

Back in Japan, Hara next appeared in a few adaptions of Western literary classics where her atypical, slightly Caucasian look (there are various rumours about her purported mixed-blood descent) made her the natural choice. It was with roles in a series of 'national policy films' (*kokusaku eiga*), however, that her career took off again. This genre was ushered in by the draconian Film Law of 1939, which was inspired by the 1934 Nazi Film Law; among other things it stipulated pre-production script censorship, mainly intended to screen out leftist tendencies. The modern, Western element in Hara's persona was no longer sought after, and she therefore downplayed it in favour of a more traditional image.

Since national policy films offered little scope to women, Hara mostly played supporting roles as an observer of the war effort. In the most famous Japanese morale-boosting war film, *The War at Sea from Hawaii to Malaya* (*Hawai Marē oki kaisen*, Yamamoto Kajirō, 1942), for instance, she appears in only a few indoor scenes in the home, basically to rejoice with her younger brother when their mother gives him her blessing to join the Yokaren Academy,[2] and to welcome him home when he is on leave. Smiling and encouraging, without a trace of worry, she gently tends to her younger brother, though she turns serious for a moment – as there are rumours of an approaching great war – when he is about to return to the training camp after summer leave in 1941. Her serious mien is seemingly meant to remind her brother of the gravity of the situation, and of the burden of responsibility for the nation weighing on his shoulders.

As pointed out by Peter High, Hara's 'women of spirit' evolved during the war from observers to more substantial roles: 'The characters she portrayed in

subsequent ... war films ... reflected the gradual evolution of Japanese women toward a more active (if still modest) role in wartime society' (2003: 251). Her emblematic war film role came with *Toward the Decisive Battle in the Sky* (*Kessen no ōsora e*, Watanabe Kunio, 1943), a propaganda film meant to entice young boys to enter the Yokaren Academy and to reassure their parents that their sons would be in safe hands in the protective care of the family state. Hara plays Sugie, whose role in the film is to encourage her sickly younger brother Katsurō to overcome his physical and spiritual weakness and join the pilot training course. A group of young cadets from the nearby academy have formed a club whose members for some reason frequent Sugie's family home during their free time. This plot device turns Hara's Sugie into a sort of surrogate older-sister figure for the cadets, and by extension for all young boys of Japan. The vitality of the cadets contrasts with the lacklustre Katsurō. After one of their visits, Sugie sits down beside her brother and coaxes him gently to boost his willpower:

Sugie: Today everyone gave up their precious Sunday for your sake, didn't they?

Katsurō: I'm so sorry.

S: Why do you think those boys are so lively?

K: I'm just hopeless ...

S: Why do you say that?

K: Because I'm weak ...

S: Why do you say *because*? Why don't you try to be energetic like them? ... I'm determined to do anything for you. Do you hear me?

 [Sugie's coaxing takes on a more serious nuance in the following scene.]

S: I'm always telling you, aren't I, there is nothing you can't do if you just set your mind to it.

This exchange turns out to be the turning point for Katsurō. Older sister has infused courage into brother, and under her firm but gentle guidance he gradually acquires the determination to take the entrance exam to the academy. Hara's sister rejoices unreservedly, although the film hints that an impossible suicidal *kamikaze* mission is awaiting her brother.

Given the roles of reliable and supportive elder sister that Hara Setsuko was cast in, it is no surprise that young boys entering the war reportedly took film stills of their Madonna-like guardian angel with them in their breast pockets when heading for the Front. Film historians have tried to gauge Hara's personal commitment to the war effort, but have been unable to put the matter beyond dispute because of her trademark reticence. On this point, the influence of her brother-in-law, the ultra-nationalistic director Kumagai Hisatora (1904–86), cannot be overlooked. Hara moved into his household at a young age, and she later starred in two of his wartime films. Even when his worldview was no longer opportune, she remained loyal to him.

The New Woman Role Model

On 15 August 1945 Japan accepted unconditional surrender, leaving the Japanese to make a 180-degree ideological turn overnight and cast off 15 years of ever-intensifying militaristic indoctrination. When the Americans landed in Japan to administer the occupation in the name of the Allied powers, they put in place strict film censorship that reversed the previous thrust, banning reactionary themes while promoting others like democracy and women's rights. Hara Setsuko was soon mobilised in this democratisation of the screen. Yomota has posed the question why no one pilloried her for her flagrant about-face, but he concluded that if anyone noticed it, they probably recognised that they themselves had to some extent pulled off the same kind of conversion (Yomota 2000: 132).

Needless to say, this ideological backflip phenomenon was not restricted to Hara's case but was spread through most of the Japanese film world. In Akira Kurosawa's 1946 *No Regrets for Our Youth* (*Waga seishun ni kuinashi*), though, Hara's transformation is blatant to the point of being comical, at least with her wartime screen persona still fresh in the mind's eye. This film fashions Hara as the archetypal woman of firm will. Here she plays the role of Yukie, the daughter of a Kyoto University professor whose liberal views render him *persona non grata* in the totalitarian atmosphere of the 1930s. Yukie is courted by two of his students: Itokawa, who personifies the loyal subject subservient to the national agenda, and the conscientious Noge, who represents the leftist movement of resistance to totalitarianism. Yukie, who gradually becomes fed up with her bourgeois upbringing and noncommittal attitude, decides on Noge and becomes his wife.

When the security police torture Noge to death she brings the ashes of her dead husband back to the home of his elderly parents in the poor farming village. Here she discovers that Noge's parents have been ostracised by the village community for having reared a national traitor. Yukie decides to stand up for the memory of her husband, and starts to work frenetically beside the mother in the rice paddies, overcoming extreme harassment by the villagers. When the war is over and the winds of democracy are blowing, Yukie resists her mother's wish for her to come home and decides to remain in the village and devote herself to the budding rural women's movement. Yukie, sitting smiling by the piano, says:

> I've put down roots in that village. Mother, look at my hands. They look so out of place on a piano now. Besides, there's still so much work left to do there. Their lives [*suddenly serious, looking aside with a contemplative expression*] – especially the women's lives – are brutally hard. [*Plucking up courage*] If I can improve their lot even a little, my life will be well spent. [*Smiling adorably again*] You could say I'm the shining light of the rural cultural movement.

In a newspaper interview, Hara identified her speciality as films with a moral or ethical purpose (quoted in Chiba 2001: 380). What is striking, though, is the schizophrenic split in Hara's screen persona that the war defeat occasioned – although, as Kyoko Hirano points out, this 'radical change in the actress's image was in keeping with the revolutionary spirit of the age' (Hirano 1992: 184). Hara herself retrospectively recast the issue as a problem of enunciation rather than of ideology:

> Anyhow, as a result of the sudden change of times the lines we were made to speak changed completely. For us who were used to the manner of talking during the war, these lines didn't seem to come out smoothly and we felt quite at a loss in the beginning. (*Tokyo shinbun*, 27 March 1959: 4)

As it turned out, this was the closest Hara ever got to publicly commenting on her wartime roles and subsequent conversion.

Hara Setsuko's career gained new momentum during the seven years of occupation. While she initially used to receive love letters from her fans, she now left the screen-idol stage behind to become Japan's leading actress, taking on more demanding roles. She was first called upon to play the roles of daughters of the vanishing aristocratic class abolished by the new constitution. Her fortunes peaked in 1949, when she starred in the best and second-best film of the year, according to the rankings in the influential film journal *Kinema junpō*. It was also during this time that the epithet 'eternal virgin' was coined, even though it goes better with her original promotion as a cute schoolgirl. Soon the demand was for a new sort of heroine: the image of the newly emancipated woman promoted by the occupation to reflect the upgraded status of women in the new constitution, which gave women the right to vote for the first time and guaranteed equality between the sexes.

A case in point is the record-breaking commercial hit and critically acclaimed two-part youth film *Blue Mountains* (*Aoi sanmyaku*, Imai Tadashi, 1949). Here, Hara plays the role of a high school teacher freshly arrived in a rural town from Tokyo. She takes it upon herself to battle the still lingering parochial ways of the town – for example, she slaps the school doctor in the face for insensitive sexual references about women – and to liberate the schoolgirls from repressive attitudes towards sex and romance. This film features a strikingly new side to Hara's star persona: the more actively assertive type of new woman. As the film historian Satō Tadao notes, 'In this way, Hara Setsuko appeared like a goddess who gently, beautifully, elegantly and reliably promotes the trend of post-war democratisation in place of men who had lost their self-confidence in the war defeat' (Satō 2006: 337).

In a typically didactic scene, Hara's teacher character writes the word 'love' (*ren'ai*) on the blackboard and asks the hysterically giggling schoolgirls about their views on love, the most important problem facing the girls, in her view. One girl

says that love used to be considered a bad thing in the past, but that it had been turned into something good after the defeat. The teacher encourages the girls to consider the problem more concretely as a personal question, the reason for the discussion being that they have turned against one of their classmates for walking side by side in the street with an older male student, which they see as a disgrace for the whole school. In the harshest possible terms, the teacher remonstrates with the now crying girls, delivering a crash-course in Occupation policies on individualism:

> I want you all to be more open-minded and extricate yourselves from old ways of thinking that say it's immoral to be acquainted with male students or to walk together with men. To associate with men with a beautiful and pure state of mind is not in the least a bad thing. To oppress lower-grade students or classmates in the name of praiseworthy ideals such as the school's honour, or to restrict each other's individuality and try to force people into one mould . . . that has been the greatest mistake in Japanese people's approach to life up until now.

In the next scene the teacher gives the victimised student a practical lesson in how to behave like a liberated woman. Walking among pine trees on a hill overlooking the ocean, she carelessly sends her high heels flying and drops abruptly onto the grass, explaining that on occasions like this what best fulfils your natural will is to sit down in the most ill-mannered way possible! The film became a national sensation that felt like a fresh breeze heralding a more liberal film climate after a decade of harsh censorship.

Also important in Hara Setsuko's postwar Occupation film *oeuvre* is a 1951 film by Naruse Mikio (1905–69) film *Repast* (*Meshi*), which is highly ambivalent in terms of the gender politics of the time. Here Hara plays Michiyo, who gradually becomes disillusioned with married life and the tedium of her middle-class household chores. If Ozu, as we will see, casts Hara in roles of women who are satisfied with their position in life, then Naruse's screen version of her has doubts about the status quo. In *Repast* Hara's character leaves her seemingly inattentive husband to think things over in Tokyo at her mother's home. A divorce is foreshadowed, and was in fact intended according to the original screenplay. But the Japanese screen was not yet ready for such radical measures, and Tōhō Studios instead chose to confine Michiyo within the institution of marriage. When the husband comes to visit Michiyo in Tokyo he shows signs of having improved his attitude towards her, and the couple return back to Osaka by train. Sitting by his side, Michiyo tears her unsent letter to him into pieces and lets them flutter away through the open window. The film ends with a monologue in voice-over by Michiyo, while she smiles gently towards her husband:

> I look across at my husband here at my side, his eyes closed, sleeping peacefully, tired from the daily drudgery of work. Each new day he continues to struggle

to make a life for us. To share one's life with such a man, to be at his side, to seek happiness in a life together, maybe that is where my real happiness lies. Happiness... a woman's happiness. Maybe that is where a woman truly finds happiness.

The ending was apparently intended as a happy one with mass appeal. From today's point of view, though, one might wonder whether the conditions for a happy life-ever-after were really present, or whether 'Michiyo's decision to return to her humdrum life is motivated only by the lack of options available to her' (Russell 2008: 215).

The Return to the Traditional Japanese Woman

As the occupation drew to a close in the early 1950s, and Japan put memories of the war behind it and started to look ahead, it seems there was no longer the same need for the new leader-type of woman, or the 'shining light' of the enlightenment movement. Hara Setsuko's star persona took on a new character in response to the changing times, transformed into a nostalgic image of a supposedly traditional Japanese woman, in what is difficult to read as anything other than a patriarchal backlash against her liberated heroines. This dominant image of Hara, imprinted on the memory of moviegoers as a symbol of the quintessential Japanese woman, is largely derived from the six films directed by Yasujirō Ozu that she appeared in between 1949 and 1961. In retrospect it appears ironic that Hara was called upon to portray a traditional woman in 1949, the same year that her screen career as a postwar enlightenment heroine and the shining democratic hope was at its pinnacle.

Ozu would cast Hara in one of two archetypal roles – the virginal, father-loving virtuous daughter or the Madonna-like self-abnegating widow, fleshed out in the following ways: a daughter reluctant to marry despite her father's wish finally relents (*Late Spring/Banshun*, 1949); a daughter resisting the match determined by her family instead marries the old friend of her dead brother, a casualty of the war (*Early Summer/Bakushū*, 1951); a widow reluctant to remarry despite the wishes of her parents-in-law (*Tokyo Story/Tokyo monogatari*, 1953); a daughter in an unhappy marriage resulting from a match that her father pressed on her returns to her father with her baby (*Tokyo Twilight/Tokyo boshoku*, 1957); a widow encouraged to remarry by her late husband's friends instead plots to have her own daughter marry (*Late Autumn/Akibiyori*, 1960); a widow resists a match set up by in-laws and chooses not to remarry (*The End of Summer/Kohayagawa-ke no aki*, 1961). At a glance these characters may seem defiant – but only as long as being defiant is commensurate with being chaste.

Unfolding like variations on a theme, or as pastiches of each other, the films interrelate endlessly in intriguing ways. *Tokyo Twilight*, for instance, can be read

as the sequel to *Late Spring*, accounting for how the arranged marriage played out afterwards, especially since the quintessential Ozu actor Ryū Chishū plays the father in both films. In addition, the reluctance of Hara's characters to marry or remarry becomes a *leitmotif* running through them all, which safeguards her chastity and guarantees that the virtue of her star image remains intact. Hara's characters all prefer to remain in their initial situation despite concerns for their future on the part of various patriarchal figures. In several of the films, she repeats, 'I'm happy as I am' ('watashi wa kore de ii no yo'), perhaps the iconic Hara Setsuko line. In these films Hara brilliantly enacts a nostalgic and conservative version of a self-sacrificing Japanese femininity, which had become outdated in the rapidly modernising society. In a sense, Ozu's version of Hara seems intended to help men accept the brunt of culturally alien modernisation by making them feel that 'their womenfolk' were to some extent shielded from it.

A good case in point is *Early Summer*, in which Hara's originally cheerful Noriko is left devastated by the end of the film for having broken up the extended family, even though it was the same family that insisted on her marrying in the first place. Filled with remorse, she abandons herself to her inconsolable tears. *Early Summer* is a celebration of the traditional extended family living under one roof, although the ageing parents move back to the country when their daughter marries into a new family. It is the idyllic version of traditional family life in a film played in a major key and ending on a mild tone of loss and sweet sadness. In Hara's next collaboration with Ozu, though, the key shifts to minor. The iconic *Tokyo Story*, which has become canonised as a masterpiece of world cinema, chronicles the effects of the break-up of the extended family into several nuclear households against the background of the modernisation and urbanisation processes. Hara, as the daughter-in-law Noriko, is the only character in the film who shows friendliness towards the ageing couple on their visit from the countryside, while their own blood relatives are too busy with their own lives to pay them due attention. While the sons and the daughter find their parents somewhat of a nuisance, Noriko upholds the virtues of filial piety through her compassionate care for the old couple.

Barbara Sato reads the film as an exploration of 'the disjunction between a stereotyped "traditional" Japanese woman and the complex identities that constituted the "modern" Japanese woman in the early 1950s', mainly through the conflicting images of Noriko, 'who outwardly exhibits the qualities of a working-woman active in a wider society [and who] yet conforms to female behaviour appropriate within the family' (Sato 2003: 2–3). Perhaps it is this conformity with traditional female behaviour, despite the social disjunction of the times, that renders her the object of sympathy in the film, at least from a patriarchal, solace-seeking perspective. Here, yet again, Hara is cast in a role that celebrates the self-sacrificing and undemanding Madonna, even though she vehemently rejects her father-in-law's praise for her after the funeral of his wife. The level of pathos reaches its zenith

in the climactic dialogue of the film, where Noriko faces her father-in-law Shūkichi (Ryū Chishū), shot in Ozu's trademark frontal shot – reverse shot technique, with the characters looking straight into the camera. Displayed in this scene we detect a trademark of Hara's screen persona – a subdued and restrained outward appearance from which an undercurrent of strong emotion threatens to erupt at any moment.

There is a slight but distinct queer streak in Hara's collaboration with Ozu that makes you wonder for whom her characters were really intended. In discussing the father–daughter relationship of *Late Spring*, film critics have even discerned an incestuous element containing features reminiscent of the Electra complex (Chiba 2001: 267). In retrospect it is hard to imagine that this Madonna-like persona would have been the object of contemporary female desire, especially given the new role of women in society. If the typical role that Hara was cast in during her late career was a construction of an idealised femininity, then it was hardly intended for female consumption, even though Donald Richie suggests otherwise: 'She had become an ideal: men wanted to marry someone like her; women wanted to be someone like her' (Richie 1987: 12).

Regarding another of her late films, Naruse Mikio's 1960 *Daughters, Wives and a Mother* (*Musume tsuma haha*), Chiba Nobuo quotes letters to the press from women who criticised the backwardness of her character: 'To sacrifice yourself in order to rescue others might be an admirable traditional custom for Japanese women, but others are better served when you take more active steps for your own happiness'; 'The oldest daughter's agreement to remarry according to her mother's wish, rather than with her own beloved, entails acting according to old morals and cleverly making use of feelings of sympathy, rather than according to a sense of responsibility' (Chiba 2001: 382). By now, though, when the films have all lost their original relevance, Yomota suggests that 'Hara Setsuko has been transformed into an object of national esteem within a conservative nostalgic mentality, as a rare woman personifying the female virtue that the Japanese lost somewhere along the way' (Yomota 2011: 196).

Conclusion

Even though Hara Setsuko was heavily criticised by her fans for abandoning her position as a national idol, in retrospect it even appears that she retired too late. Audience turnout peaked in Japan at above 1.1 billion admissions in 1958, before rapidly losing ground to television, the new medium of the day. As the low-key domestic drama (*shōshimin-geki*) of Ozu and Naruse was gradually overtaken by television series, and as the major studios ventured into more spectacular, violent and pornographic genres in order to attract audiences back from TV, Hara's types of character, with their strong didactic overtones, were fast becoming an anachronism during the 1960s. If, as Satō argues, Hara had once been a sign of hope for the Japanese people – who had lost their self-confidence and fallen into a state of

self-loathing as a result of the war defeat – through her fastidiousness, earnestness, nobility, gracefulness and gentleness, Ozu's – and, especially Naruse's – later casting of Hara had gradually restricted her *oeuvre* to darker and wearier roles. Ironically, the very success of films like *Repast* and *Tokyo Story* sidetracked Hara away from playing the dazzling heroine of melodrama, which she was still young enough to do – something which, according to Satō, left fans with a sense of having been deserted (Satō 1986: 125, 137).

Although not announcing her retirement, Hara quietly withdrew from the film world in 1962. She made a last appearance at the wake for Ozu Yasujirō in December of the following year, where she is reported to have cried uncontrollably. On that occasion she signed her condolences with her real name. After her retirement Hara continued living with the director Kumagai Hisatora and his family in their villa in Kamakura, outside Tokyo. On the director's death in 1986, it was rumoured that Hara might make one final public appearance at his funeral. But this never materialised. In Greta Garbo–like fashion, she vanished from the screen to disappear altogether from the public gaze, although the paparazzi targeted her home for decades, with very little luck.

As for her screen image, Japanese film critics tend to characterise her acting style as a clash between subdued expression and interior depth. In fact, it seems easiest to pinpoint her persona by examining situations where a mismatch arose between her star image and a particular film character, in what Richard Dyer has termed the 'problematic fit' (Dyer 1998: 129–31). A case in point is a rare, maybe unique occasion when Hara is allowed to be the object of the male desiring gaze – if only in a close-up of her naked ankle after a bath (although the director tried to persuade Hara to include a bathing scene as well) – in *Temptation* (*Yūwaku*, Yoshimura Kōzaburō, 1948). Another case is a kissing scene with renowned actor Nakadai Tatsuya (b.1932) – even if the actual kiss is hidden from the camera by Nakadai's back, since Hara refused kissing scenes throughout her career – in Naruse's *Daughters, Wives and a Mother*. In these scenes the miscasting is glaring enough to jolt the viewer. These scenes create an unexpected and unpleasant impression of complicity in an illegitimate voyeuristic act. Hara's star image is powerful to the point where breaches against it register as violations perpetrated against her own person.

Hara Setsuko originally wanted to become a teacher, but withdrew from school for financial reasons, and ended up entering the film world, in which several of her siblings were involved. Although she came to have serious intentions for her film career after the end of the war, and although she gradually thought more professionally about her acting, one cannot avoid the impression that she was never comfortable with her role as a national idol. Reading her various interviews and recollections, it appears she hardly ever enjoyed making films, but was always happiest as a private person relaxing or doing routine chores at home. With no

yearning whatsoever to be a film star, she wandered into a film studio by chance in 1935, to be drawn into a career her heart and soul were never really in. The rest is history.

Notes

1. Japan at the time promoted emigration to the Japanese puppet state of Manchukuo.
2. The Imperial Japanese Navy's preparatory pilot-training course.

Section 2

Stardom Mobility and the Exotic

5

Carmen Miranda: From Brazilian Film Star to International 'Tropical Other'

Lisa Shaw

Maria do Carmo Miranda da Cunha, better known as Carmen Miranda, was born in the rural north of Portugal on 9 February 1909, and emigrated with her parents later that year. She was just ten months and eight days old when she arrived in Brazil's then capital, Rio de Janeiro. By the mid 1930s she had become the most popular female singer in Brazil, and one of the nation's first film stars. In 1939 she became a star on Broadway, and just two years later was under contract with Twentieth Century-Fox studios in Hollywood. She was the first Latin American to inscribe her name, handprints and footprints (actually prints of her famous platform shoes) on the Walk of Fame outside Grauman's Chinese Theatre in Hollywood, on 24 March 1941, but her film career was tragically cut short on 5 August 1955, when she died of a heart attack in her Beverley Hills home at the age of just 46. When her body was returned to Rio on 17 August, hundreds of thousands of people lined the streets to see her coffin pass by, while others queued for hours to pay their final tribute as she lay in state at City Hall, in an unprecedented display of collective mourning. In her lifetime she had appeared in six Brazilian films and 14 US productions. Sadly, the only glimpses that today's audiences can have of her Brazilian screen performances are in the recently restored *Alô, alô, carnaval!* (*Hello, Hello, Carnival!*, 1935), and a tantalisingly brief clip from *Banana da terra* (*Banana of the Land*, 1938), in which she first wore on-screen what would become her iconic *baiana* costume and extravagant turban. Access to Carmen's screen performances is thus largely via the Hollywood productions in which she starred, generally in supporting roles, playing second fiddle to the likes of Betty Grable and Alice Faye

in terms of billing and narrative function, if not in terms of visual impact and entertainment value. This chapter will analyse Carmen Miranda's screen persona in her Brazilian and Hollywood film roles, and seek to explain the appeal and longevity of this still iconic star.

From Radio Star to Film Star in Brazil

Carmen, like many of the first film actors in Brazil, was already a star of popular music and the radio when she made the transition to the screen. This was a common move, since the majority of Brazil's first sound films were musicals, often based around the theme of carnival, which loosely integrated performances by famous singers and popular musicians. In 1930 her recording of the song 'Pra Você Gostar de Mim' ('So You'll Like Me'), better known as 'Taí' ('That's It') was the hit of the year, breaking all sales record, and was the song on everyone's lips during the Rio carnival celebrations that year. With this success she became the most famous female singer in Brazil, at just 21 years of age. By the end of the 1930s she had recorded almost 300 records. André Luiz Barros (1999: 56) points out that, even before she became an actress, she sang like one – that is to say, she performed songs with theatricality, lengthening notes for effect, and incorporating facial expressions and expansive hand movements. He cites Joubert de Carvalho, the composer of Carmen's first hit record, 'Taí', who when he first heard Carmen's voice said: 'It was as if, as well as hearing her, I was seeing her too, such was the striking personality that sprang out of the recording' (1999: 54). Zeca Ligiéro (2006: 67) notes that in her live vocal performances Carmen would often make witty asides, and favoured songs with humorous lyrics that allowed her to give free rein to her natural comic skills and love of exaggeration. Not blessed with a vast vocal range, Carmen relied heavily on theatricality when singing, playing with the sounds of language and introducing short spoken exclamations and asides to inject life into the lyrics, in addition to drawing on a wide range of facial expressions, eye movements and smiles (Ligiéro 2006: 68). Her engaging performance style as a singer hinted at the ease with which she would make the transition to the screen.

Carmen's film career in Brazil was closely bound up with the tradition of musical films that drew on the nation's carnival traditions, and the annual celebrations and musical styles of the city of Rio de Janeiro in particular. In the silent era, documentary films incorporated footage from the street carnival in Rio, and Carmen appeared in *O carnaval cantado no Rio* (*Rio Carnival in Song*, 1932), the first sound documentary on this popular theme. This film combined footage of the elite's costume balls and street carnival processions with scenes featuring popular musicians and performers, such as Carmen, performing in the studio. In her second film, *A voz do carnaval* (*The Voice of Carnival*, 1933), she was one of a roll-call of well-known singers and composers who presented the audience with the hit carnival sambas and marches (*marchas* or *marchinhas*) from 1933, interspersed with

real footage of street carnival celebrations in Rio, tenuously linked together by a plot filmed in the studio.

Carmen's next screen performance was in the musical *Alô, alô, Brasil!* (*Hello, Hello, Brazil!*, 1935). Amid scenes of carnival and shots of the city of Rio, the simple plot centred on a young man from the countryside who goes to the big city in search of a female radio star. Carmen's proven star status in the world of popular music was reflected in the fact that she was chosen to provide the film's closing number, the *marchinha* 'Primavera no Rio' ('Springtime in Rio'). Stills of this performance reveal Carmen's use of hand gestures and animated facial expressions, and by all accounts she stole the show with this number. A few months after the release of *Alô, alô, Brasil!*, *Cinearte* magazine (15 May 1935: 10) stated: 'Carmen Miranda is currently the most popular figure in Brazilian cinema, judging by the sizeable correspondence that she receives.' Countless readers wrote in asking the magazine to publish interviews with Carmen or photographs of her. Her imminent departure for Europe was announced on more than one occasion in the magazine, and her name was repeatedly linked to other Brazilian and Argentine film projects which, even though they never materialised, reflected the popular perception of her as a budding international film star.

The plot of Carmen's next film, *Estudantes* (*Students*, 1935), revolved around innocent love affairs set on an idyllic university campus during the popular 'June festivals' in Brazil, and yet again the storyline served first and foremost as a pretext for the insertion of hit musical numbers. In her one and only narrative role in a Brazilian film, for which she received very positive reviews, Carmen played Mimi, a young radio singer who performs two songs: Assis Valente's samba 'E bateu-se a chapa' ('And the Photo was Taken') and 'Sonho de papel' ('Paper Dream', by Alberto Ribeiro). In her recording of the former song – her first on the Odeon record label, made on 26 June 1935, just prior to the release of *Estudantes* and therefore a likely indicator of her performance in the film – two aspects are notable: first, her tendency to exaggeratedly roll the pronunciation of the letter 'r' (such as in the words *amor* ['love'] and *rapaz* ['boy']), delighting in the sonic possibilities of language as she later would in her Hollywood roles; and second, the speed with which she is able to deliver certain verbal phrases without hindering their intelligibility. At several points in the song the syncopated melody speeds up, challenging her to articulate the lyrics in time with the music. She clearly had a gift for doing so, however – something that Assis Valente would exploit in several of his compositions for her, and that would be a recurrent party piece in many of her musical numbers in Hollywood films.

Alô, alô, carnaval! (1936) and *Banana da terra* (1938)

Carmen was central to the success of the musical *Alô, alô, carnaval!*, which again featured a roll-call of star performers from the world of popular music and the

radio. The backstage plot provided the perfect excuse for the inclusion of a grand total of 23 musical numbers, and by the Brazilian standards of the day *Alô, alô, carnaval!* was a major production. The set reproduced the interior of Rio's plush Atlântico casino, where some of the scenes were shot, and the backdrops for certain musical numbers, including Carmen and Aurora Miranda's rendition of 'Cantoras do rádio' ('Radio Singers'), were Art Deco designs by the acclaimed illustrator J. Carlos (also known as Jotinha). The technical and budgetary constraints experienced by the nascent Brazilian film industry were still very much in evidence, however. Each musical number was filmed simultaneously in just one take by three cameras from different angles, with the finished product alternating between the resulting three shots in a rather mechanical fashion. Furthermore, performers were obliged to provide their own costumes, and thus Carmen's dressmaking and millinery skills, acquired when she had been a sales assistant in a hat shop, were to prove very useful. She created many of her own outfits, including the lamé trouser suits worn by her and her sister Aurora for the performance of 'Cantoras do rádio', one of the high points of the film. It is revealing of her inherent star status that the few close-up shots used in *Alô, alô, carnaval!* are of Carmen (otherwise the camera rarely moves, remaining fixed on full-body or half-body shots of the performers).

Carmen's final Brazilian film was the carnival musical *Banana da terra* (*Banana of the Land*).[1] Despite her performing just two musical numbers in the film, tellingly it is still Carmen's name and photograph that take centre stage in the production's publicity material. It was intended that the two musical high points of the film were to be her performance of 'Boneca de piche' ('Tar Doll', by Ari Barroso and Luiz Iglesias) in duet with the radio presenter Almirante, and her solo performance of 'Na Baixa do Sapateiro' (the name of a street in the city centre of Salvador, Bahia), also composed by Ari Barroso. At the eleventh hour, however, Barroso demanded more money for the use of his compositions, and it proved impossible to reach an agreement, so his songs were pulled from the film, even though the two respective stage sets had been created and the costumes and make-up planned. In keeping with the lyrics of 'Boneca de piche', Carmen was to adopt the persona of an Afro-Brazilian woman, with both her and Almirante appearing in blackface on the set of a stylised colonial slave quarters. For the performance of 'Na Baixa do Sapateiro' the set was a romanticised recreation of the eponymous street in Salvador, complete with mock colonial façades, a palm tree and a large moon. To save both time and money, Wallace Downey, the film's producer, decided simply to use the existing sets and costumes for the performance of two new songs, the *marchinha* 'Pirulito' ('Pat-a-cake') by Braguinha and Alberto Ribeiro (the film's scriptwriters) and 'O que é que a baiana tem?' ('What Does the *Baiana* Have?'), by little-known Bahian composer Dorival Caymmi. The only footage from the film that has survived to this day is the sequence in which Carmen performs Caymmi's song, in which she first wears on-screen what would become her iconic *baiana*

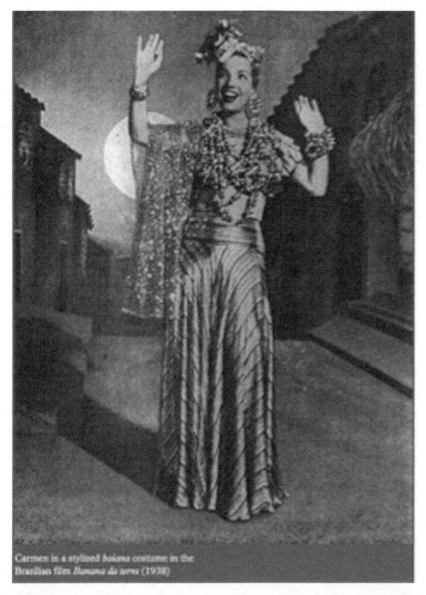

Carmen in a stylized *baiana* costume in the
Brazilian film *Banana da terra* (1938)

Figure 5.1. Carmen's nascent performance of 'Latin' alterity in *Down Argentine Way* (1940) and *That Night in Rio* (1941)

costume, which combined a fruit-laden turban with a midriff-revealing cropped peasant-style blouse, long bias-cut skirt and an excess of necklaces, bracelets and hooped earrings (see Figure 5.1).[2]

Broadway impresario Lee Shubert witnessed Carmen's *baiana* persona first-hand during her performance at Rio de Janeiro's upscale Urca casino in February 1939, and immediately set about signing her to his theatrical empire. Just a few

months later, on 17 May 1939, Carmen and her backing band, the Bando da Lua, arrived in New York. She premiered on Broadway in the show *Streets of Paris* on 19 June 1939, and, despite performing just three numbers, became an overnight sensation, as did her *baiana* costume. The columnist Walter Winchell reported in the *Daily Mirror*, in a column syndicated to newspapers all over the USA, that a new star had been born who would save Broadway from the slump in ticket sales caused by the popularity of the New York World's Fair of 1939. Winchell's praise for Carmen and her Bando da Lua was repeated on his daily show on the ABC radio network, which reached 55 million listeners (Castro 2005: 210). As soon as news of Broadway's latest star, the so-called 'Brazilian Bombshell', reached Hollywood, Twentieth Century Fox began to develop a film to feature Carmen. The working title of the project was *The South American Way* – the title of one of the songs she had performed to such rapturous applause in New York – and her performances in what would be later titled *Down Argentine Way* (1940) would draw heavily on her Broadway debut. This was the first of a series of so-called 'Good Neighbour' musicals starring Carmen, in which she functioned as a de facto Latin American envoy, personifying the official US policy of using popular culture, particularly film, to foster closer links and greater understanding between the United States and Latin American nations.[3]

Such was Miranda's frenetic schedule on Broadway that she was unable to travel to Los Angeles to shoot her scenes for *Down Argentine Way*, so the Twentieth Century Fox studios sent a film unit to New York and rented a sound stage in the city. She performs just three musical numbers in the film, for an appreciative diegetic audience in a nightclub in Buenos Aires, and appears for less than five minutes on-screen in all, although her visual and aural impact far outstrip her screen time, and she appears as third on the bill, behind only Betty Grable and Don Ameche. Without any introduction or contextualisation, Miranda abruptly confronts Hollywood audiences in the film's opening scene, where she appears in medium close-up singing 'South American Way' in a spectacular *baiana* costume, designed by acclaimed wardrobe artist Travis Banton, that exploits to the full the potential of Technicolor, not least in its combination of bright red and gold lamé fabric, from which her turban is also made, and the abundance of golden necklaces and bracelets that adorn her body. A notable feature of her opening vocal performance is her exaggeratedly accented English, with the word south becoming 'soused', a colloquial term for drunk, just as it had done in her renditions of the song on Broadway. The Fox studios were well aware that her mispronunciation of this word in *Streets of Paris* made audiences laugh out loud, as it had been widely reported on and mimicked in the press, with Carmen being instructed by Lee Shubert not to correct this mistake throughout the run of the Broadway show, even when her English had greatly improved (Castro 2005: 206). From the outset the Fox studios were clearly intent on manufacturing her linguistic difference as a key component of her 'Latin' alterity.

In her Hollywood screen debut she captivates us, the extra-diegetic spectators, in less than a minute with her visual and aural vitality and exoticism; but as the diegetic audience has not yet been revealed, we remain puzzled by what we have just seen and heard. The camera then cuts to establishing shots of Buenos Aires, as an extra-diegetic female chorus continues to sing 'South American Way'. In her analysis of this musical number, Shari Roberts (1993: 18) identifies self-parodic elements of Carmen's performance. On the surface she appears to be denied subjectivity by appearing in 'an excerptable clip which in fact works as a prologue for the film proper', singing only in Portuguese and having no dialogue or interaction with the other characters. However, Roberts argues, Carmen understands both her own body (which the audience is also obliged to 'read') and her words, and is in on the joke. In this debut screen performance in Hollywood, her smiles and winks create an immediate intimacy and empathy with us as spectators, drawing us into her performance, and their apparent spontaneity and naturalness stand in marked contrast to her later more overstated screen appearances, as the Hollywood studios began to mould her into an 'exotic' caricature, as examined in more detail below.

In her second Hollywood film, *That Night in Rio* (1941), Carmen is again the first star to appear on-screen, her position as third on the bill after Alice Faye and Don Ameche once again outweighed by her ability instantly to capture the attention of the diegetic and extra-diegetic audiences alike. A review in *Variety* (7 March 1941) acknowledged Carmen as the de facto star: 'Ameche is very capable in a dual role, and Miss Faye is eye-appealing but it's the tempestuous Miranda who really gets away to a flying start from the first sequence.' The extensive story notes made by Darryl F. Zanuck, head of the Twentieth Century Fox studios, reveal his vision for Carmen and how he sought to define her on-screen persona. For *That Night in Rio*, Zanuck instructed the cameraman not to cut away from her once she had started singing, clearly recognising that her vocal delivery was the forte of her performance and central to her star text. Against a nightclub stage set that evokes the coastline of Rio de Janeiro by night as fireworks explode in the sky, female dancers, in pale imitations of the glamorous *baiana* costume that Carmen is wearing, frame her as she performs the song 'Chica, Chica, Boom, Chic' in Portuguese. As Don Ameche, in a pristine white US Navy uniform, enters the duet and praises the 'common ties' that bind North and South Americans in the era of the 'Good Neighbour Policy', 'Carmen smiles, grimaces, and tickles his stomach in a provocative symbolic inversion of prevailing expectations' (Freire-Medeiros 2002: 58), using gestures that were central to her established performance style. Her vocals stand in stark contrast to Ameche's delivery of the English sections of their duet, her voice becoming a kind of percussion instrument as she makes sounds to accompany him. When she takes up the lyrics of the song again she is accompanied by a pronounced drum beat, which underscores the onomatopoeic quality of the refrain 'chica chica boom chic', and her 'Latin' exoticism is

captured in these sonic associations, as well as by her visual appearance and playful gestures.

Unlike in *Down Argentine Way*, Carmen is given a narrative role in *That Night in Rio*, as she would be in all subsequent Fox productions, and she sings most of her numbers in English. Her character is simply referred to as 'Carmen', thus blurring the distinctions between her off- and on-screen personas, and this role establishes the key facets of what would be her linguistic performance in subsequent Hollywood narratives: regular smatterings of unintelligible 'gibberish' in rapid-fire Portuguese ('translated' for non-Lusophone audiences via her flashing eyes and exuberant hand gestures), alongside comical malapropisms, unintentional double entendres and grammatical slips in fractured bursts of English – she calls her caddish love interest, Larry Martin, a 'grass in the snake', for example. Carmen's comic timing is excellent in this slapstick role, which differs markedly from her performances in the song-and-dance numbers, which are highly polished and not played for laughs. Her costumes for *That Night in Rio* were once again designed by Travis Banton, and are all adaptations of the *baiana* costume. They are characterised overall by the use of colours that maximise the potential of Technicolor, oversized beads and earrings, lamé and sequinned fabrics that catch the light, and extravagant turbans, variously decorated with brightly coloured feathers, artificial flowers or fruit. She is thus drawn in obvious opposition to the white US women who populate the film in their glamorous evening gowns and sophisticated hairstyles – not least leading lady Alice Faye.

Carmen's Increasingly Caricatured and Clownish Hollywood Roles

In Carmen's next three films, *Weekend in Havana* (1941), *Springtime in the Rockies* (1942) and *The Gang's All Here* (1943), she is given second-place billing and dominates the opening frames, evidencing her acknowledged audience appeal. Her musical numbers take precedence over her narrative roles, however, and serve primarily to underscore her 'Latinness' and its inherently laughable nature. Carmen's *baiana* costumes in these three films are characterised by their gaudiness, with clashing fabrics, increasingly adorned turbans and an excess of costume jewellery – a far cry from the more elegant designs of Travis Banton in her previous two Hollywood productions.

The scopic and musical climax of *The Gang's All Here* is Carmen's outlandish production number 'The Lady in the Tutti Frutti Hat', in which Busby Berkeley's trademark kaleidoscope choreography is taken to extremes (with the significant difference that, unlike Berkeley's traditional sequences, Carmen is afforded endless close-ups and transformed into the centrepiece of the visuals), and the *mise-en-scène* is dominated by oversized, swaying phallic bananas. Carmen's song begins with lyrics that overtly acknowledge her by now formulaic visual representation:

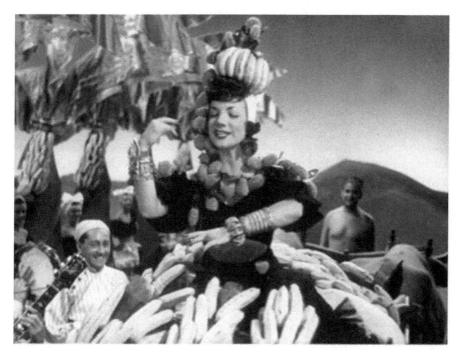

Figure 5.2. Carmen Miranda

> I wonder why does everybody look at me
> And then begin to talk about a Christmas tree?
> I hope that means that everyone is glad to see
> The lady in the tutti-frutti hat

Physical clowning is now the order of the day, with exaggerated facial expressions, winks, and rapid movements of the eyes and mouth emphasised by close-ups and the fact that all her hair is hidden beneath her headdress – the latter laden with a large bunch of what appear to be real bananas and oversized imitation strawberries (see Figure 5.2). She adopts a bug-eyed expression as she plays a mock xylophone made of bananas, and the number comes to an end with a close-up of her face, with the camera then pulling back to reveal her unfeasibly towering turban of bananas.

In *Greenwich Village* (1944), a Technicolor musical set in the eponymous New York City district in 1922, Carmen is top of the bill for the first time, ahead of Don Ameche and William Bendix. Her wardrobe in this film is a curious mélange, but the comical 'Latin' stereotype is still very much in evidence. She is out for what she can get, namely '*mucho* money', as she puts it (conveniently becoming a generic Latin American, rather than a Brazilian, via this code-switch into Spanish and not Portuguese). Yet again, Carmen's garbled English dominates her dialogue and is a source of easy humour, with a grammatical slip or a distortion of an idiomatic expression in almost every line. In her next film, the wartime Technicolor musical,

Something for the Boys (1944), she plays Chiquita Hart, one of three heirs (Vivian Blaine and Phil Silvers play her unlikely cousins, Blossom and Harry Hart) to a ramshackle plantation house in Texas. No opportunity is spared yet again to make visual jokes at the expense of Carmen's instantly recognisable costumes; the first image we see of Chiquita is a close-up of her head on an ID badge that she wears at the munitions factory where she works. On the badge and in the subsequent scene in the factory she is wearing a simple fabric turban as part of her uniform, and later, when she has been renovating the plantation house, she appears in the kitchen in overalls and a turban constructed of a white towel and decorated with a scrubbing brush.

Carmen's Lacklustre Performances in Postwar Monochrome Movies

After World War II, Carmen's films at Fox were made on black-and-white stock, reflecting Hollywood's diminishing interest in her and in the portrayal of Latin Americans in general, in keeping with the demise of the now strategically unnecessary 'Good Neighbour Policy'. A monochrome Carmen was not what audiences expected, and it undoubtedly contributed to reducing the box-office appeal of the backstage musical, *Doll Face* (1945), in which she was demoted to fourth on the bill. She plays the character Chita Chula, billed in the show-within-the-film as 'the little lady from Brazil', an endlessly cheerful comic sidekick to leading lady, Doll Face (Vivian Blaine), and she is given only one musical number and little dialogue. In her follow-up movie for Fox, made when she was no longer under contract, *If I'm Lucky* (1946), Carmen is again fourth on the bill, and all the stock elements of her screen persona are firmly in evidence: heavily accented English, comic malapropisms, and bizarre hairstyles that recreate her famous turbans.

When Carmen's contract with Twentieth Century Fox expired on 1 January 1946 she made the decision to pursue her acting career free of the constraints of the studios. Her ambition was to play a genuinely leading role and to show off her comic skills, which she sets out to do in the independent production *Copacabana* (1946) alongside Groucho Marx, to whom she is second on the bill. The idea for the film came from Monte Proser, owner of the New York nightclub, the Copacabana, established as a tribute to Carmen. Together with Carmen herself, he invested in the production, designed to promote the venue and its eponymous sister nightclub in Los Angeles (Castro 2005: 418–19). It was originally planned as a Technicolor production, and the costume designer Barjansky thus made extensive use of yellow and gold fabrics when creating Carmen's outfits, as publicity material for the film reveals. However, due to delays the film could no longer be released to coincide with the opening of the Los Angeles nightclub, so the decision was made to dispense with the services of Technicolor and to shoot the film on black-and-white stock at considerably lower cost (Castro 2005: 420).

In *Copacabana*, Carmen's character is also called Carmen (Novarro), as if she is asserting her 'Brazilianness' and her new-found independence by using her own first name. In some scenes she appears with her hair loose and unadorned, in a visual display of self-affirmation, and she also appears in disguise, with the aid of a platinum blonde wig and assortment of veils, as a French singer, Mademoiselle Fifi. Both characters, Carmen and Fifi, represent attempts by the real-life Carmen to throw off her stereotypical roles in previous Hollywood films. Key aspects of the 'pantomime *baiana*/Latin' remain, however: the comic malapropisms ('I have a nervous break-up!'; 'She's the grass in the snake!' – the latter re-hashed from *That Night in Rio*); and an overstated foreign accent. Furthermore, her stereotypical persona is parodied yet again, this time rather crudely by Marx, and their comic partnership falls flat as a consequence of a largely uninspiring script, while Carmen's five musical numbers strikingly lacked the production values of her Fox performances. *Copacabana* was, unsurprisingly, a box-office flop, and Carmen was thus forced to work under the control of the studios once more in her final three films.

Carmen at MGM and Paramount: Minor Roles and the Persistence of the 'Latina' Caricature

After *Copacabana* Joe Pasternak invited Carmen to make two Technicolor musicals for the MGM studios, *A Date with Judy* (1948) and *Nancy Goes to Rio* (1950). With the first of these two productions, MGM set out to portray a different image of the star, allowing her to take off her turban and reveal her own hair, styled by the legendary coiffeur Sydney Guilaroff, and set off by make-up by the equally renowned make-up artist Jack Dawn. Carmen's wardrobe for the film eschewed *baiana* outfits, and instead included elegant dresses and hats designed by Helen Rose (Castro 2005: 444). She was clearly no longer the star attraction, however, appearing as fourth on the bill, in the role of Rosita Cochellas, a rumba teacher, who makes her first appearance on-screen some 40 minutes into the film and has little dialogue. In spite of the best efforts of MGM to introduce innovations into her star text, her roles in both productions were peripheral, and largely watered-down caricatures of her earlier screen performances in Hollywood, which relied heavily on fractured English and over-the-top musical and dance numbers.

In her last film, *Scared Stiff* (1953), a Paramount production in which she appears alongside Dean Martin and Jerry Lewis, Carmen's scopic appeal was once again diminished by black-and-white film stock. Returning full-circle to her very first Hollywood film, *Down Argentine Way*, Carmen has virtually no narrative function in this film. A further slight comes in the form of Jerry Lewis's parody of her, as he mimes intentionally badly to her well-known song 'Mamãe eu quero' ('Mama, I Want Some'), which is playing on a scratched record, and eats a banana that he plucks from his turban. Similarly, Carmen, in the role of Carmelita Castinha,

Figure 5.3. United Fruit Company's logo Chiquita Banana

a Brazilian showgirl on a cruise ship, gives performances that verge on the self-parodic, with the variations on the *baiana* costume taken to absurd extremes.

The Commodification and Reproduction of Carmen Miranda

Having actively participated in the construction of her own 'star look' back in Brazil, Carmen was no doubt acutely aware of the potential that her show-business persona offered for lucrative commodification in the USA. While still on Broadway, but particularly after her move to Hollywood, Carmen's connotations of 'tropical' exoticism were appropriated to promote a diverse range of consumer goods, ranging from turbans, costume jewellery and platform shoes to children's colouring books and dolls. Her iconic look, as well as her voice, became a trope of 'Latinness', and by the end of the 1940s her stage and screen persona was already so ubiquitous in US popular culture as to render explicit reference to the star unnecessary in order to promote 'tropical' or 'exotic' products. This is best exemplified by the case of the United Fruit Company's logo Chiquita Banana (see Figure 5.3), a cartoon character that implicitly brought to the consumer's mind Carmen's brand of 'tropical' femininity, and her caricatural representations in the popular media in particular.

Carmen's image continues to be used as a marketing tool, being displayed on a wide range of material objects in various parts of the world. As recently as 2011, the

major US department store, Macy's, sought to use her image to promote a clothing line. In the appropriately titled article 'Carmen Miranda Inc.', André Luiz Barros (1999: 49) states that Carmen is literally about to become a trademark, patented by her family to market a line of products such as perfume and clothing. Her heirs reportedly receive an average of 20 requests per week to reproduce her image on objects that range from bikinis to children's books and from jewellery to fridges, and in December 2011 five cases of unauthorised use of her image were being pursued in the Brazilian legal system.

Carmen's comic screen persona in Hollywood, which increasingly relied on outrageous *baiana* costumes and mangled English, was a ready-made caricature of 'Latin Americanness', or an even vaguer 'tropical Otherness', and thus lent itself readily to parodic reproductions, which included impersonations by fellow stars of both genders, such as Mickey Rooney, Milton Berle, Imogene Coca and Lucille Ball (aided and abetted by Carmen herself in many instances), and by cartoon characters such as the Warner Bros creations Bugs Bunny and Daffy Duck. Dressing up and imitating Carmen Miranda has proved to be a particularly enduring way of paying tribute to the impact of the star, even if today she is most widely reproduced in the form of cross-dressed parodies which accentuate key features of her screen and stage persona that rely on caricature. More thoughtful impersonations, such as those of Erick Barreto in the film *Carmen Miranda: Bananas is My Business* (1994), underscore the constructed nature of social boundaries such as gender, and remind us of Carmen's own knowing challenges to the representation of 'Latin' women on-screen. Any cross-dressed impersonation is inherently carnivalesque, in that it upturns societal and gender norms and hierarchies, but it is the self-consciously manufactured nature of Carmen's own star text, and its inherent exaggerations and ambiguities (which the best impersonators capture) that make her a particularly meaningful icon for non-normative groups, such as gay men, and which ensure that her image continues to permeate popular culture across the world.

Conclusion

Carmen Miranda's performance style as a singer in Brazil was a training ground for her development of a screen persona. In her Brazilian film roles, she experimented with performance techniques such as flashing eyes, eloquent hand movements and engaging smiles to the camera, which would be honed and added to in Hollywood to create a recognisable repertoire of facial expressions and bodily gestures. In Hollywood she was able to draw on the comic skills she had displayed in live vocal performances back in Brazil, complementing her love of subtle innuendo with verbal and physical clowning. Her star text as it evolved in Hollywood relied on scopic and sonic elements in equal measure, and she provided a prime example of the complex 'configuration of visual, verbal and aural signs' that constitutes a star persona, and which, as Dyer (1998: 34) argues, must be particular to the individual

in question, making him or her easy to recognise regardless of the role he or she is playing on-screen. Hollywood's increasingly caricatured 'cartoon Latina' Carmen went on to multiply endlessly in consumer culture, and has continued to circulate well beyond both Brazil and the US. Like that of any star, Carmen's star text was created across a wide range of media and contexts, such as film performances, ladies' fashions and other consumer goods, radio and TV appearances, interviews and coverage in the press, and public appearances – but, somewhat unusually, its availability for comic parody and reproduction contributed greatly to the durability and familiarity of her star persona.

Notes

1. *Banana da terra* also means 'plantain' in Portuguese.
2. The term *baiana* literally means 'woman from Bahia', but more specifically refers to Afro-Brazilian women who, since colonial times, have sold food on the streets of Salvador and Rio de Janeiro, and to the priestesses of the Afro-Brazilian religion, Candomblé, with whom these vendors are often conflated in the popular imagination. Carmen stylised their typical attire, transforming the baskets of fruit and other produce that the vendors carried on their heads, atop their simple cloth turbans, into extravagantly decorated, artificial fruit–laden versions of the latter.
3. The 'Good Neighbour Policy' dated from the beginning of the twentieth century, but was re-activated in 1933 by President Franklin D. Roosevelt. With the outbreak of World War II the policy was intensified in a concerted effort to strengthen cultural, economic and political ties between North and South America in order to attenuate the financial and geo-strategic threats posed to the USA by the conflict. The Office of the Coordinator of Inter-American Affairs, created in 1944 and headed by Nelson Rockefeller, had a motion pictures division, which, in addition to sponsoring the production of newsreels and documentaries for distribution in Latin America, actively encouraged the Hollywood studios to produce feature films with Latin American themes, settings and stars.

6

'America is Home... America is her Oyster!' The Dynamics of Ethnic Assimilation in Alida Valli's American Star Persona

Antonella Palmieri

As Diane Negra has observed, European imported actresses offer a good standpoint from which to explore the ethnic and gender dynamics of American society at a given time. As the 'Other' in both ethnic and gender terms, they expose twice as forcefully the precariousness of the power associated with white patriarchal hegemony as an organising principle in social and cultural relations (2001: 1–24). Taking into consideration the discursive elements around Italian-born film star Alida Valli's American persona, this chapter aims to offer a critical insight into the intersection of Valli with discourses around whiteness and valued ethnicities in post–World War II American culture. I argue that Valli's image in American culture at a time of transition and readjustment evidenced a progression of ethnic integration that significantly mobilised her Italianness. This progressive social and cultural integration took place within discourses that tapped into a desire to maintain wartime values such as national unity and brotherhood in American society in the aftermath of World War II. I suggest that the potential threat represented by her ethnic 'Otherness' was defused particularly through an on- and off-screen process of ethnic assimilation that saw Valli's transition from the exotic 'Other', whose whiteness was on probation, to the 'good immigrant' she played both on-screen, in *The Miracle of the Bells* (Irving Pichel, 1948), and off-screen.

An Actress 'on Trial': Valli, Probationary Whiteness and *The Paradine Case*

The first Italian actress to accept work in Hollywood in the immediate post–World War II years, Valli had been one of the most eminent and representative stars of Italian escapist and spectacular cinema of the late 1930s and early 1940s. However, when World War II ended in 1945, she found herself unable to sustain her status as a film star in postwar Italy. Having successfully worked for a film industry that was massively supported and sponsored by Benito Mussolini's Fascist government, Valli's Italian star persona was inextricably linked with the culture the Fascist regime had produced in over 20 years of dictatorship since 1922. As a result, although she had turned down invitations to join the cinema of the Fascist Italian Social Republic in Venice when Mussolini fell in July 1943, Valli's hopes of resuming her career in Italy rapidly faded as she struggled to find a place in neo-realist Italian cinema, and she accepted the offer of American independent producer David Selznick to work in the USA on a seven-year contract (Pellizzari and Valentinetti 1995; Laura and Porro 1996). Valli was given the star role in Alfred Hitchcock's *The Paradine Case* (1948), that of Italian-born Maddalena Paradine, an enigmatic, nymphomaniac middle-class wife of modest origins and sordid past.

As Paul MacNamara, Selznick's director of marketing and publicity, stressed in Valli's studio biography, circulated at the time, Valli was plunged into her first dramatic role in Hollywood 'with no time for testing, coaching or indoctrination'. Behind such a decision, MacNamara enthused, there was Selznick's successful 'intuition'. MacNamara predicted that, thanks to Selznick's insight, Valli would certainly follow in the footsteps of Selznick's previous 'discoveries', who shot to Hollywood stardom in just one film. Among these stars were Ingrid Bergman, who became a star with her first Hollywood film, *Intermezzo* (Gregory Ratoff 1939); Joan Fontaine, who was launched from relative obscurity into a stellar Hollywood career with *Rebecca* (Alfred Hitchcock, 1940); and Vivien Leigh, who played the lead role in *Gone with the Wind* (Victor Fleming, 1940) (MacNamara c.1947b: 1–3). From MacNamara's comments, it is clear how Selznick's publicity machine worked to introduce Valli to the American public through an association with another European-born major film star of the time, Ingrid Bergman, who was successfully 'imported' from Sweden to America by the producer. Bergman, who had been considered for the role of Maddalena Paradine, had also acted for Hitchcock in *Spellbound* (1945) and *Notorious* (1946). Selznick's publicity department also aligned the Italian star with the beloved British-American Fontaine and her work in Hitchcock's *Rebecca*, and with the British Academy Award winner Leigh. Arguably, this strategy can be read as an attempt to cash in on the popularity and reputation of Selznick's previous successful 'discoveries', in order to ensure a positive reception for Valli's debut on American screens.

But I would suggest that this tactic also bespeaks the Hollywood industry's desire to link Valli to an ideal(ised) category of normative whiteness. In so doing,

I draw on Richard Dyer's argument in *White* (1997). Dyer suggests that a sense of belonging to the white race developed in the USA in the nineteenth century as part of the process of establishing US identity. This sense of being white played a fundamental role in unifying European settlers across different national cultures against the indigenous Native Americans and the imported African-Americans. The European settlers, regardless of which European nation they came from, would consider themselves 'white, not red or black' (Dyer 1997: 19), like the Native Americans and African-Americans, respectively. However, Dyer adds, while whiteness worked very effectively to unify various groups of European settlers, the idea of whiteness as a coalition of different groups also encouraged an idea that some whites were whiter than others. As a result, according to Dyer, as white normativity has been constructed in opposition to non-white and off-white 'Otherness', with the English, Scandinavians and Germans combining into an idealised Northern European (hyper)whiteness, other European-American ethnic minorities, such as Italian-Americans, Irish-Americans, Greek-Americans, Polish-Americans and Jews have been moving their positions along the American racial spectrum according to the dominant historical, ideological, political, cultural and social climate of a given time (Dyer 1997: 19). Within the white racial imaginary, then, less-than-white ethnic minorities have had to ascend the internal hierarchies of American whiteness through a process of assimilation into American society that requires them to bleach their ethnic identity and *become* white in exchange for economic mobility and social acceptance. It is difficult to disagree with Lipsitz's contention that a 'possessive investment in whiteness' (2006: 2) is responsible for the racialised hierarchies in American society. Lipsitz suggests that whiteness has a cash value to those who invest in it that guarantees power, resources, opportunities and material benefits – from better jobs and housing to better education and health care. From their arrival, he argues, European settlers in North America set up colonial and early national legal systems that encouraged a possessive investment in whiteness (Lipsitz 2006: 2). I therefore read Valli's association with an ideal(ised) category of whiteness represented by Bergman, Fontaine and Leigh as a reinforcement of white normativity within a conception of an ideal(ised) successful integration of the off-white immigrant within American culture.

Meanwhile, the extent to which Valli, saluted in Hollywood as 'the most sensational European import since Ingrid Bergman' (Maddox 1948: 37), 'didn't look Italian' came to be strongly emphasised in the contemporary American press. The September 1948 issue of *Photoplay* argued that valli was

> opposite your [*sic*] old idea of an Italiana – the operatic, combustious, cheribiribim of Napoli who asphyxiates you with garlic kisses and sings Tosca while milking the goat in the parlour. She is still, subtle and composed. Her voice is low and warm, and a little melancholy. (*Photoplay*, 1948: 99)

Along the same lines, Philip K. Scheuer finds that 'her accent is indefinably foreign, not at all the popular conception of the Italian dialect' (1947). In these accounts, the star's ethnic origin was associated with a stereotype of female Italianness that Valli was said to defy in that she did not conform to it. This, I suggest, bespeaks a need to assuage the threatening ethnic 'Other' that Valli potentially represented in American society of the time. Accounts such as the ones I have quoted seem to (re)present Valli as the 'exception' to a widely held expectation of female Italianness, ridiculed as an expression of uncivilised excess, that Valli's evident 'composure' and 'restraint' undermine. Arguably, within such discourses, negative stereotypes of female Italianness, while cited in order to be allegedly undermined, are ultimately reinforced, which in turn suggests a deep-seated concern about Valli's ethnic 'Otherness'. But, even more significantly in the context of my discussion, such accounts also draw attention to the fact that Valli's whiteness was perceived as not 'so secure as [that of those], whose racial credentials were rooted in the Anglo-Saxon "old stock"' (Negra 2001: 5), for she belonged to one of those European ethnic groups (Italians, Poles, Greeks, and so on) associated with a wave of new immigration in the early twentieth century.

I would suggest that, when the time came for Valli's persona to be shaped for American consumption, it was therefore necessary to counterbalance such a precarious position through a proliferation of discourses of integration in which Valli was narrativised as a good immigrant willing to assimilate. In an article that appeared in the *Los Angeles Times* in early February 1947, a few weeks after Valli's arrival, a notion of 'probationary or provisional whiteness' (Jacobson 1998: 95) is articulated in comments about Valli's being 'on trial' as a character and as an actress in her first Hollywood role. The article, significantly titled 'Actress on Trial Herself as She Plays Court Scene' (Scheuer 1947), recounts Valli's first day on Hitchcock's film set, and the 'mounting tension' felt by Hitchcock, co-star Gregory Peck and the entire crew as a result of the uncertainty surrounding Valli's mastery of the English language. When Valli eventually stepped onto the set, it was 'to everyone's relief' (Scheuer 1947) that she politely greeted everyone in English. She would then take her place opposite Peck to deliver her first English line ever.

'Forgive me if I've been difficult', Valli begun. 'I shall try not to be. It will not shock you, I assume, to learn that I am a woman – what would you say? – a woman who has seen a great deal of life.' Mrs Paradine was stating her case – from the script. Valli was stating hers (Scheuer 1947).

According to an eyewitness, everyone looked extremely pleased, as the line had been spoken flawlessly. As the article concluded that 'Mrs Paradine was "in", so was Valli, and so was Selznick's investment' (Scheuer 1947), a narrative of successful cultural inclusion and acceptance came to be developed quite 'literally'. This is but one example of the extent to which Valli as an ethnic Hollywood star stood (in) for the ideological tensions of her time. The remainder of this chapter is devoted to a critical investigation of the filmic and extra-filmic narratives within which Valli

functioned to express a reaction to cultural concerns about ethnic attitudes that emerged in American society after World War II.

'I Was So Eager to Come to America'

If Maddalena Paradine seems to elude a direct answer when she claims, 'I am a woman – what would you say? – a woman who has seen a great deal of life', Valli's past was a matter of preoccupation for Selznick as he prepared to launch her in the American market. Valli had lived in Rome during the Nazi occupation, and rumours had circulated after the liberation about Valli's alleged relationships with senior Nazis and Fascists (Pellizzari and Valentinetti 1995: 118–19). While no evidence for the allegations had been found, and the actress, cleared of collaborationism, had eventually been granted a visa to the USA, it is worth noting that the episode became part of the narrative within which Valli was introduced to the American public. Suggestions of Valli's potential role as a collaborationist were openly made in the press, only to be immediately counterbalanced by reference to the direct intervention of such illustrious figures as General Bernard Montgomery and General Harold Alexander, who allegedly wrote directly to Selznick to confirm that the allegations were false. The ultimate seal of approval would come from the Department of State, which gave Valli a clean bill and a passport (Scheuer 1947). Meanwhile, in Valli's studio biography, any suspicion of collaborationism was dispelled by an emphasis on the star's repeated refusals to join the Fascist Republican Party in northern Italy after the armistice and the occupation of Rome by the Germans. A measure of the dangerousness of the situation she had put herself in by her refusal, MacNamara added, was that her name had been included in a document found in the German Secret Service command in Rome by the Allies after the liberation. In the document, Valli was listed as one of the people the German SS was after (MacNamara c.1947b: 4–5). While her narrow escape from the German SS found a place in the press (Maddox 1948: 58), praise was publicly given to her patriotism. As Lewis K. Hill reported, 'Valli, by virtue of her dangerous refusal to make pictures for the Germans, stood in well with the democratic and resistance forces in Rome' (c.1948–49). For her contribution to the Resistance, Valli won an official recognition, a 'Solemn Praise', which, MacNamara claimed in an attempt to further distance the actress from any suspicion of collaborationism, Valli regarded as 'one of her greatest treasures . . . given to her for her patriotic efforts during the dark Italian war years' (MacNamara c.1947b: 6).

If the episode of the visa being temporarily withheld can be seen as supportive of an idea of Valli's 'probationary whiteness' – for it had to be proved that she was not a collaborationist in order for her to be granted access to the USA its positive outcome can be read as a first step towards Valli's successful Americanisation: a first step firmly grounded in the American policy of interventionism in World War II. According to Hill, while the Solemn Praise documents were not 'rare', the

one Valli had been granted '*absolved* her from suspicion of collaboration ... [and] made possible her friendship with *The Stars and Stripes*' (*c*.1948–49). The latter did indeed play a key role in Valli's journey to Hollywood. Selznick offered Valli a seven-year contract after seeing her playing the leading lady in *Noi Vivi – Addio Kira* (Goffredo Alessandrini, 1942). However, it was due to the intervention of David Golding, managing director of the Mediterranean edition of *Stars and Stripes*, that Valli could be located in Rome and put in contact with Selznick. Valli's studio biography made no reference at all to Golding. Arguably, this was because the studio publicity campaign centred on Selznick's successful intuition as a 'talent scout' as a means of predicting a stellar Hollywood career for Valli. This strategy would not make room for an acknowledgement that Valli was jointly discovered by Selznick and Golding, or that Selznick and Golding both played a part in bringing her to Hollywood. Instead, Golding and his role were given recognition in the press, and in particular in an article which appeared in the *New York Times* in January 1948, where Howard Taubman recalls how he helped Golding find Valli for Selznick at United Artists. Valli was located and invited to the Rome offices of *Stars and Stripes*, where she was informed of Selznick's interest and happily agreed to her pictures being sent to the producer in Hollywood. After that, Valli and her husband were repeatedly invited to the *Stars and Stripes* offices and, as Taubman put it, Valli 'accepted eagerly; it would give her a chance to become *au courant* with our movies and help her to learn English' (Taubman 1948).

An acknowledgement of Valli's alleged eagerness to master the English language, and an appreciation of 'her rapid advancement to [America's] requirements' (Maddox 1948: 58), played an important part in the tailoring of Valli's persona for American consumption. Perry Lieber from RKO, producer of *The Miracle of the Bells*, remarked how rapidly Valli switched from Italian to English using the services of a language coach, embarking with determination and rigour upon a monumental reading task. 'Today' – he claimed – 'she speaks fluently in her adopted tongue' (Lieber n.d.: 2). The studio publicity materials released at the time of *The Paradine Case* presented Valli as an eager student, seizing any opportunity to practise which included conversations in English with her drivers (Selznick Publicity Department *c*.1947: 79). Significantly, it was also claimed that her child Carlo had an English-speaking governess (arranged by Selznick), spoke English as well as any other two-year-old, and, in a crucial sign of the process of Americanisation, answered only to 'Charlie' (Miller *c*.1948–49: 81). 'Already he is American', Valli was reported to have proudly said of her son (*Photoplay* 1948, 99).

Of course, mastering the language was a fundamental requirement for a foreign star wanting to succeed professionally in the American film industry. However, the emphasis placed on Valli's becoming almost fluent in English in a very short span of time, and especially on her adopting English instead of Italian with her family, bespeaks the need to counterbalance the anxiety evoked by the ethnic 'Other' with reassuring evidence that a fast and successful process of Americanisation was

taking place – a further indication of which was the reference made repeatedly in the promotional press to Valli's enthusiasm for all things American – Dorothy Manners, for instance, wrote that Valli 'loves' the USA, Hollywood, swing music, jitterbugging, television, football and baseball, also taking care to observe that Valli 'does not even look particularly Italian' (c.1948–49). Meanwhile, Valli's alleged enthusiasm for her new life in the USA was 'sanctioned' by the news that 'Alida Valli will apply for American citizenship and make California her home' (Anonymous 1948). In addition, the star herself was quoted as enthusiastically declaring: 'Charlie will grow up here. America is home' (*Photoplay* 1948, 99).

Willing to Be a Proper Guest of America: Valli as a Civic Role Model

The foregoing makes clear the extent to which Valli's American star image incorporated a willingness to integrate and a desire to make America her new home. I have read such narratives of successful incorporation as a response to the potential danger posed by the ethnic 'Other'. I have also suggested that an idea of 'whiteness on probation' was displaced onto Valli's persona. Building on this, I wish to argue that Valli served a more precise ideological function, which was particularly apparent in the studio publicity discourse developed around her at the time of *The Paradine Case*, and further reinforced by her role in *The Miracle of the Bells*. In the materials released by Selznick's studio publicity department, Valli was constructed as the European 'good immigrant' – a model of good behaviour to be emulated in order to be accepted by and in American society. Such a narrative was presented within an 'Open letter to artists waiting for boats' released by the Selznick studio (all the quotations that follow in this paragraph are from this letter, and the emphases are mine; see MacNamara c.1947a). This letter discussed the right attitude to be adopted by all those 'foreign artists awaiting passage to Hollywood and a new career' in postwar America. Although the studio's 'word of advice and . . . wisdom' was meant to benefit hopeful artists, arguably it stood for and spoke to ideas with more general cultural significance, potentially applying to any immigrant 'wish[ing] to be acceptable to America'. The language MacNamara uses in the 'Letter', of which Selznick's publicity department released various versions, each with virtually identical content and wording, is particularly powerful in conveying notions of inclusion and exclusion, acceptance and rejection, appropriateness and unsuitability. It therefore makes unmistakably clear what a foreigner in the USA should do in order to be respected and welcomed. The 'Letter' opens with MacNamara lamenting the fact that many foreign artists, from actors and directors to writers and cinematographers, who had arrived in Hollywood in the aftermath of World War II with the goal of obtaining a long-term contract, have already gone home, 'defeated by their own dumbness and the bad impression they created'. A view that foreign personnel have to prove that they 'deserve' acceptance is conveyed as MacNamara firmly warns that 'in some sense, you are *on trial* . . . but

the trial is a fair one; you can exonerate yourself overnight'. Selznick's director of publicity then declares that he has spent a long time looking for an artist 'to support my faith that people of great talent can *behave* well and *fit* themselves pridefully [*sic*] into a new land and its people'. Here he cites Valli as exemplary. She sets the standard for everyone else in that she is 'reserved, polite, *willing and eager to be* [*a*] *proper guest of America*'. Because of her 'flawless' behaviour, MacNamara argues, the studio workers – carpenters, painters, hairdressers and cameramen – on *The Paradine Case* are glad to work with her. Hers is 'the pattern to follow', for Valli arrives on time for work and cooperates with fellow workers, from the grips to the director. Indeed, MacNamara adds, when studio workers 'have to put up with "star temperament", life can be very unbeautiful'. But not only did Valli function within the studio discourse as 'the exemplary (star) immigrant' at work, she was also offered as a civic role model within a narrative that resonated with the specific socio-economic concerns of the time – namely a housing crisis, inflation and a still-active black market in the USA in the aftermath of World War II (Renov 1988: 20). MacNamara praises the Italian star for living a life in the USA 'of daily self-denial', going without rather than contributing even in the slightest to a system that she had seen destroy her country. He mentions, for example, that, in need of a car to go to work, Valli bought a five-year-old sedan rather than a new and more comfortable 1947 car, and that she took a small and unpretentious house for her and her young family rather than paying 'under-the-table' bonuses for better deals. Valli is presented as taking pride in having contributed in this small way to the fight against the black market, and MacNamara is open in encouraging his fellow Americans, as well as any foreign 'guest' to the country, to join Valli in the fight against illegality and 'a Black Market potentially as vicious as the one that wrecked [Italy]' (MacNamara *c*.1947a).

Thus, while on the one hand Valli comes to embody a model of civic behaviour in the country of which she is a 'guest', her Italian identity functions to substantiate the truthfulness of her account, for her native country, like the rest of Europe, was suffering from scarcities of food and other basic commodities to almost the same degree as in wartime, as Americans were aware (*New York Times* 1947, 10). In this light, fighting against the black market, which in turn becomes a moral question of choosing legality over illegality, is presented as proof of good citizenship, and even as a way in which love and care for one's country, whether a new country to which one has moved or the country in which one was born, can be demonstrated. Again, the message is conveyed through Valli's 'voice', working to reinforce her role as a good immigrant, particularly in the heartfelt pledge that closes the 'Letter': 'I am not going to hurt this country. I want to keep it healthy and decent.' To this MacNamara warningly adds, addressing any hopeful artist wishing for a career across the Atlantic: 'Will you and can you say as much when your boat docks in New York and when your airplane puts you down, at last, in Hollywood?'

Promoting Americanisation: *The Miracle of The Bells* and the Construction of Valli as the 'Good Immigrant'

If Valli functioned in the studio discourse within a narrative that constructed her (as in the 'Letter') as a *guest* of the USA observing a pattern of behaviour that would one day enable her to become a new citizen of her adopted country, she was also framed within a filmic narrative that constructed her as a 'good immigrant'. The film in question was *The Miracle of The Bells*, which Valli started filming right after finishing her work on Hitchcock's set, in a dramatic switch from the 'utterly urbane, sophisticated beauty' (Miller *c.*1948–49: 81) of *The Paradine Case* to a Polish-born girl with a heart of gold, Olga Treskovna, who gets the chance of a lifetime when she is cast in place of a temperamental film star in the leading role of Joan of Arc in a big Hollywood production.

In *The Miracle of the Bells*, Valli's ethnic femininity serves to support a positive vision of American society in which 'good' immigrants get the reward of successful integration because they work hard and are law-abiding, adaptable and eager to take on board the values the USA stands for. Within a narrative that strikingly resembles the scenario depicted by Selznick's publicity department in his 'open letter', Olga is significantly given the life-changing opportunity of becoming a film star at the moment when she replaces the 'bad immigrant' Anna Klowna (Veronica Pataky), an Eastern European imported star. Klowna, depicted as temperamental and childish, quit the production of *Joan of Arc* after throwing a tantrum and spitting on the film producer Marcus Harris (Lee Cobb). Anna, her delivery marked by a thick Eastern accent that is a further sign of her unwillingness to integrate, loudly expresses how much she despises America and Americans' lack of manners and education. Her outburst is contrasted with the American producer's composed and civilised reaction. His reply powerfully conveys a positive vision of American nationalism and absorptive capacities. He claims that he is very sorry that Anna does not like America, while observing that many of her co-nationals have learnt to love America over the years, and sagely expressing regret that she cannot see anything nice 'in such a wonderful country'.

Valli's ethnic femininity also helps to develop a theme of salvation within *The Miracle of the Bells*, whose narrative concerns the extreme sacrifice of a woman, Olga, who selflessly gives her life in an attempt to bring hope back to her hometown. Olga elects to finish work on *Joan of Arc* even though doing so will result in her death, because she has tuberculosis (caused by exposure to coal dust as a child). In dying, Olga manages to change the lives of those she has left behind, as her death draws people together and prompts the town's priest to help fight for the release of *Joan of Arc* (shelved by the studio, reluctant to release a film with an unknown dead star). The transformation of a spiritually impoverished community into a community of re-born faith and brotherhood is the 'miracle' Olga performs. In this respect, *The Miracle of the Bells*, based on Russell Janney's best-selling novel of

the same title, clearly bespeaks a desire to maintain the ideological construction of wartime at a transitional time in American history – the immediate postwar years. With the end of the war came uncertainties and various manifestations of social discontent, including the increasingly widespread cultural paranoia of the Cold War. These were years that witnessed a resurgence of the divisions that wartime had repressed in the name of the common, restricted goal of a victorious end to the war: the defeat of Fascism in Europe and the end of the war in the Pacific. An insistence on a need for a cultural message of 'wholesomeness, faith, and unity and spiritual brotherhood', particularly in terms of 'goodwill among people of different faiths', is increasingly evident in '*The Miracle of the Bells*: suggestions for editorials', RKO's promotional booklet for the film, which emphasises, for example, that the film's source novel has provoked 'the most enthusiastic comment from religious leaders of every faith' (Kamins *c*.1947). I argue that the film's narrative reads as an appeal for ecumenism: 'brotherhood and understanding' through religious tolerance. Three creeds well established in American society are represented in *The Miracle of the Bells*. Bill Dunnigan (Fred MacMurray), the film's hero, who falls in love with Olga and fights for *Joan of Arc* to be released, is a Protestant, as he tells Olga when they casually meet on a snowy Christmas Eve. First-generation Polish immigrant Olga is a lovely young Catholic girl who, as described in dialogue in the film, 'believed in God...wanted to help the people of Coaltown [and] worked and died for them'. Father Paul (Frank Sinatra), the honest and humble priest who lives by St Michael's example and helps Dunnigan, is also Catholic. Marcus Harris, the studio mogul whom the film entrusts with an openly patriotic pledge of love for America, is figured as Jewish. Meanwhile, an idea of different religions existing and operating together in harmony is conveyed by a newspaper headline shown on-screen that reads: 'all denominations to observe the star's funeral with prayers while a day of mourning is celebrated nationwide'. As Father Paul receives much-needed offers of help and money for his parish from the length and breadth of the USA, Dunnigan's faith is reinvigorated as his life is given true meaning by his battle to fulfil the girl's last wish against all odds. Significantly, if Father Paul is cautious about acknowledging the 'miracle' – the seemingly spontaneous turning of two statues towards the casket on the day of Olga's funeral – and provides a rational explanation for the statues' turning, it is Dunnigan who insists that, despite the reasonable explanation given for the incident, God has manifested Himself and given hope to the people filling the church – such a hope, he argues, should not be taken from them. Meanwhile, the pragmatic but likeable businessman Harris eventually shows his spiritual side as he is emotionally awakened by the events. Promising to build a hospital in Coaltown in Olga's memory, in order to find a cure for tuberculosis, Harris also declares his faith as he provides his interpretation of the miracle of the bells in a final scene that visually evokes ecumenism, in that Dunnigan, Father Paul and Harris, each of them embodying a different religious creed, eventually come together. As Harris puts it: 'I don't know how all this

started but in my religion when something good happens that makes the world a little better place than it was before, then I know that God has something to do with it.' This prompts Father Paul to agree: 'In my religion, too, Mr Harris.'

The RKO promotional booklet not only emphasises the extent to which *The Miracle of the Bells* promotes and celebrates unity among religions through greater cooperation and understanding. It also openly praises the film as providing 'a great lesson in Americanism' – and presents the studio's output in general as showing how film can find a purpose in 'fighting intolerance' and promoting peace. Particularly noteworthy are the final remarks that define 'motion pictures [as] a major force in spreading the lesson of democracy everywhere' at a time when 'so many millions here and abroad [are] crying for peace and brotherhood' (Kamins *c*.1947; all quotations in this paragraph are from this booklet). What is also significant here is that the studio's acknowledgement of Hollywood's role as a vehicle through which lessons of Americanism can be imparted at home is matched by a similar awareness of Hollywood's function of teaching democracy abroad.

Conclusion

In making female Italianness, as embodied by Valli, meaningful within narratives that supported the 'American Way of Life' myth, the Hollywood industry defused the potential threat represented by her ethnic 'Otherness', particularly through the on-screen and off-screen Americanisation of Valli's persona. Within such assimilationist discourses, Valli's persona underwent a transition: from a stage of 'probationary whiteness' upon her arrival in the USA to play Italian-born Maddalena in *The Paradine Case*, to the exemplary foreign 'guest' of postwar America willing to integrate and live by the rules, and finally to the 'good immigrant' who has proved she deserves acceptance and can enjoy the social, cultural and material benefits of successful assimilation – the epitome of how 'foreigners' in postwar America should behave in order to be awarded full incorporation into American culture. As Dyer has observed, 'looking at stars as a social phenomenon indicates that, no matter where one chooses to put the emphasis in terms of the stars' place in the production/consumption dialectic of the cinema, that place can still only be fully understood ideologically' (1998: 34). With this in mind, I suggest that the Hollywood industry's construction of Valli's persona was ideologically fraught. Valli entered US film culture at a time of transition and readjustment marked by a strong desire to maintain wartime values such as unity and brotherhood (which 'usually meant Americanisation' – Koppes and Black 1993: 164). These values imbued the narrativisations of Valli's star persona. Placed as it was within a culture characterised by an increasing homogeneity due, among other things, to a decline in competition from ethnic cultures, Valli's American image articulated cultural fantasies around female Italianness that were supportive of whiteness as the norm.

7

Spanish Stars, Distant Dreams: The Role of Voice in Shaping Perception

Anne L. Walsh

To take part in the business of making films is to live on the borderline between reality and the creation of dreams. Though living in the real world, while on-screen, actors must allow their audiences to suspend disbelief, for otherwise the dream may be broken and the fictional bubble burst. This, at least, was the thinking behind the Hollywood creation of the great stars of the 1930s, 1940s and 1950s: Marilyn Monroe, Elizabeth Taylor, Bette Davis, Grace Kelly, Clark Gable, Humphrey Bogart, Cary Grant. Their remit was to sell a fictional version of themselves, and ultimately to bring audiences and movies together. They were not overly concerned with such ideas as national identity, for they were part of a dominant culture and did not have to bear the weight of a country's expectations on their shoulders. When looking at the relationship between Spain's audiences and their actors, however, the story is not so clear, for, as with all things Spanish, national identity can never be ignored.

National identity is a concept that is fraught with controversy. The very definition of a nation is sometimes fluid and often indefinable. This is all the more true when a nation attempts to view and define itself. Often, what is exported may stand in place of the discourse on nation/state. Such is the case of products (French wine, German cars) and politics (EU crisis), and it is no less so in other areas of culture: Italian opera, New Zealand Rugby, Hollywood films, Irish dance. The case of Spain, however, is less clear, with its exports (whether cultural or economic) often labelled at best as 'Hispanic' – no less so than when considering its films and film stars. What outsiders consider to be 'Spain' is formed of 17 au-tonomous communities as diverse from one another as is Germany from France or

New Zealand from Australia. Each community has its own traditions, including in some cases, such as Cataluña, Galicia and the Basque lands, its own language, and certainly its own historical perspective. Each, though, has experienced one of the most critical events that has shaped its present, namely the Spanish Civil War (1936–39). This one event – and its aftermath, the Francoist regime, lasting until 1975 – has influenced every facet of life within the borders of Spain, as well as its relationships with foreign lands. Of particular interest here are its effects on the Spanish film industry and the people involved, particularly its stars. The following discussion looks at the notion of stardom in the Spanish context, and will examine why it is so undermined when viewed within Spain, with the answer lying, at least to some extent, in Spain's past and the memory of the Spanish Civil War and its aftermath. Spain's actors view themselves, as do their public, as workers doing a job, with the trappings of stardom seen as alien. To explain these ideas further, two film stars will be considered: Antonio Banderas and Viggo Mortensen. The first actor is considered in Spain as an export, and a success story in part, the second as an import, a successful foreign actor, linked closely with the American film industry,[1] star of *Lord of the Rings*, who tried (and some would say failed) to bring the notion of stardom to Spain when he played the title role of *Alatriste* (2006). Expectations were high that the well-loved character of Captain Alatriste, first created by writer Arturo Pérez-Reverte in 1996, would come to life on-screen as the epitome of a Spanish hero of old: fearless, righteous, living by his own personal code of honour, stoic in the face of danger, and very aware of the flaws of his would-be superiors.

For the Francoist regime, films were useful for two particular purposes: to entertain (and so distract from political and social issues) and to put forward their view of what Spain should and could be – in other words, to act as a vehicle for propaganda. To be involved in filmmaking meant, consequently, to side either with those in power or to become subversive or oppositional, thus splitting Spain yet again into two camps: those who wished to maintain the status quo for whatever reason, and those whose main objective was to destabilise that very status quo. Such a division, it will be seen, had consequences that are still visible in Spain's films and its attitude to those involved, particularly the actors, which have to do with the broader expectations audiences have of their actors. They have to do with the film industry's origins and development in Spain, which have caused even its highest earners to shun the trappings, or at least the celebrity, often unavoidable elsewhere. While it is expected that they appear, often, on the pages of celebrity magazines, not least among them being the well-known weekly magazine *¡Hola!* or *Hello!*, they do so with the aim of proving that they are no different from any other worker: they are working class, though with added style! Antonio Banderas, an actor who is the frequent subject of lengthy interviews in all the celebrity media, sums up his own view as follows: 'I don't believe in careers, I just picture myself always as one

of those old actors from the nineteenth century who go from village to village in their repertoire.'[2] As Peter W. Evans has explained, though specifically referring to Spain's female stars: 'The ordinariness of the star – no longer in more democratic times as out of reach as before – is more in evidence than ever' (1999: 273). To explain this phenomenon, one element of the Spanish film industry is key. Due to the diversionary tactics of the Franco regime's use of film, oppositional film makers of the 1950s, 1960s and 1970s sided strongly with the working class, viewing themselves as part of the same group who were striving to oppose a dictatorship keen to rid Spain of their kind. Having to deal with censorship, the rules of which were not often clear, these filmmakers used covert strategies to circumnavigate dangerous waters. They became adept at hiding their views in symbolism and metaphor, speaking to their audiences in a code that was understood but could be denied if and when they were called to account.[3] Once the dictatorship collapsed, after Franco's death in 1975, filmmakers continued to side with the Left. It became accepted that filmmaking was a job like any other, crucial to the rebuilding of Spain in just the same way as any of the other professions were. Any actor who wished to be accepted dared not flaunt a lifestyle that jarred with such a political stance. Indeed, it became the stance of many, perhaps led by the director Pedro Almodóvar, to concentrate on the art rather than the lifestyle, contrary to the story often sold by Hollywood, in which lifestyle became part and parcel of the brand and actors were bound contractually to live up to the image rather than their own reality. The difference, for Spaniards, was clear, as Antonio Banderas again explains:

> The big difference between a star and an actor is someone who knows the technique, who knows how to learn from everything that happens to him. A star is acting himself all the time. You have to have the energy for that and a nice character. I don't know if I'm that brilliant the whole day ... I can't all the time be making this beautiful smile, faking that I'm someone else, because that's insane. ('Antonio Banderas', IMDb)

Stardom, then, was not politically correct in the Spain of the dictatorship years, and it certainly remained unacceptable as Spain transformed itself into a democracy in the 1980s.

Once cinema was freed from the constraints of censorship in 1977, two years after the demise of the Francoist dictatorship and five years before the end of what came to be known as the transition to democracy in 1982, it became a focus of expression for all that had been silenced before. As the types of films produced with the regime's approval were seen to be either lauding those ideals held dear by the regime or intentionally distracting from those ideals by being light on content, any film that seemed to continue in either vein was not afforded a large audience or any great critical acclaim. This reaction perhaps explains Pedro Almodóvar's initial lack

of success at home, for his first films were seen to be 'lite', slapstick, and thematically far removed from the political concerns of their times.[4] But Almodóvar became the iconic focus of *la movida*, as the club scene in Madrid was called in the post-regime years and into the 1980s, seen as a counter-balance to *el movimiento nacional* (the National Movement),[5] the name given to Francisco Franco's ruling political party from 1939 to 1975 (formally abolished in 1977). This social and cultural revolution centred on urban nightlife, particularly in the early 1980s, and was predominantly part of the youth scene. While it was fed by the removal of censorship in 1977, it was a paradoxical phenomenon in that it was evidence of the complete freedom of the individual to explore previously taboo activities (sex, drugs, and rock and roll) while also evidence of a lack of hope for the future. Franco was dead but, by the time the 1980s had taken hold, it was clear that the new political arena in Spain was not living up to expectations. Political corruption was still in evidence, while there was little political will to face up to the crimes of the past. Instead, a pact of silence was entered into; a pact whereby the past was to be left in the past, with the idea that Spain's democracy was far too fragile to support debate about its historical circumstances.[6] All that was left to the youth of Spain was to react to their new-found freedom by concentrating on breaking barriers and pushing boundaries. Almodóvar became an icon of the time, and those actors associated with Almodóvar were also seen as part of this revolution. The word 'revolution' is used with intent here, for all the players of the time were conscious that a change was afoot. No one knew what that change would bring, but most were sure that they wished to create a new, free Spain, unrestrained by moral barriers imposed by others.

As mentioned earlier, two well-known personalities are to be discussed here so as to clarify and explore further the present situation of the perception of stardom in Spain. Antonio Banderas, the epitome of Hispanic characteristics when viewed from abroad, will be seen to be an actor who shuns the trappings of stardom. On the other hand, Viggo Mortensen, again not renowned for courting celebrity, will act as a foil, to show how Spain's audiences react to others who would enter the relatively closed world of Spain's own films. The two men are clearly of different nationalities though neither can be definitively categorised, at least when on-screen. They may be considered contemporaries, though the significance of their dates of birth (1960 and 1958, respectively) is greater for Banderas, placing him directly as a child of the Francoist regime (1939–75), whose formative years and education occurred under the diktats of that regime, and who reached his initial acting years when *la movida* was at its height.[7] The young Banderas's film viewing would thus have been highly circumscribed by censorship and Francoist control. For example, the content of film was subject to many restrictions, finally made explicit by the *Normas de censura cinematográfica* ('Rules for the Censorship of Film') in 1963. While these rules attempted to put into words what had for years been implicit, they still allowed censors freedom to ban any film that was thought

to be morally corrupting, even if it did not contravene any specific rule. They were therefore both very detailed and very sweeping for, on the one hand, they could never include

> all possible cases, while, on the other, they must be sufficiently specific so as to serve as guidance, not only to the Organisation directly responsible for applying them but to authors and producers and all those participating in cinematic production, distribution and exhibition.[8]

These norms – 37 in total attempted to give 'guidance' and clarification (seven general rules, 12 specifically aimed at production, nine regarding films for minors, and nine complementary rules) and governed all cinematographic productions in Spain from 1963 to 1977. Banderas's first experience of film-viewing would thus have been shaped by these norms, which became the target of post-regime filmmakers, and specifically those movies directed by Almodóvar in the early 1980s. Banderas, therefore, is considered in Spain as part of the movement to dismantle the legacies of the controlling dictatorship of Francisco Franco.

He is also considered 'the first Spanish actor to make the crossover [from Spain to Hollywood] since the silent era' (Kinder 1997: 5). His initial roles could not be further removed from those awaiting him in the US, where he was limited to a generic 'Hispanic' in films such as *Mambo Kings* (1992), *The House of the Spirits* (1993) and *Miami Rhapsody* (1995). Almodovarian Banderas, or the 'chico Almodóvar' (Almadovarian boy) (Perriam 2003: 46) instead delved deep into the blurred lines of gender, morality and sexual boundaries, becoming 'the young male whose body is used as much for violence as for sex' (Perriam 2003: 46) or 'the disturbed hustler whose body is the focus of pleasurable attention intra- and extra-diagetically but which is the locus of betrayal and self-destruction' (Perriam 2003: 47).[9]

The contrast between American and Spanish audiences' expectations of Antonio Banderas surely could not have been greater, causing some to question how this actor could 'sell out' and lend himself to a cultural ambiguity whereby he became 'the foreigner', the stereotypical Latin lover, the 'Other', regardless of what specific role that required. As Evans explains: 'Banderas's Almodóvar films have led to international recognition and roles as the Latin lover stereotype in a wide variety of Hollywood films ranging from thrillers like *Desperado* (1995) to comedies like *Two Much* (1995)' (1999: 275).

At the very least, Banderas has been seen as playing to, and with, media interest in his persona. As Perriam explains: 'Banderas is complicit – even in his ambivalence – with the publicity machine throughout the 1990s' (2003: 66). That publicity machine, of course, was dominated by the US, with Spanish celebrity magazines (*¡Hola!, Semana, Diez Minutos,* and so on) and TV programmes (*Corazón* and the

like) buying into similar techniques of attempting to create myth around movie stars. Banderas's constant response was, and still is, to answer all questions about his image with a wry irony, denying any sense of being different from the average person in the street, in words that are filled with playful self-deprecation.[10] Such an attitude placed him in a perfect position to accept casting as the cat in *Shrek 2* (2002), which led in its turn to stardom with a twist. Some might not consider it true, but being offered the title role of *Puss in Boots* (DreamWorks Animation 2012) marked a new stage in Banderas's career from a critical point of view. For this is one role in which voice rather than body image was key. For Banderas, the most significant factor was the recognition of that voice, not because it was *Hispanic*, but rather, because it was Banderas's own. He had made his cat debut joining the cast of *Shrek* in October 2002. On account of his reputation, particularly in the title role of *The Mask of Zorro* (1998) and from the success of *Shrek 2*, in which his character is a clear parody of that role, the cat, once a supporting character, became a star in his own right.[11]

Irony is at play here on several levels. The tale of 'Puss in Boots' started out as a morality story, published in the 1690s by Charles Perrault who was inspired in turn by previous tales by Giovanni Francesco Straparola and Giambattista Basile.[12] Its European roots are thus revived through the presence of Banderas. Since then, it has undergone many transformations, not least on-screen, appearing in several film adaptations, including Walt Disney's version in 1922 – in which the cat became female, complete with handbag. Secondly, an actor whose on-screen persona traded flagrantly on his sensuality and body image now trades in such an image for that of an animated ginger cat. Thirdly, Banderas himself dubbed two versions of the movie in Spanish, voicing 'Puss in both Spanish (but with an Andalusian accent, which sounds funny to the Spanish) and Latin American (with a Castilian accent, which sounds funny to Latin Americans) versions' (Beck 2005: 250). Clearly, even in the English version, the voice was intended to speak to the audience's internalised views regarding accent and regional profile, for why else would two Spanish versions be required? Andalucían, to non-Andalusians, and Castilian to non-Spaniards, play on perceptions of the 'Other'. The implications are clear, as explained by John D. Sanderson:

> the choice [of accent] would suggest an intention of presenting Puss in Boots as an alien in the dubbed-into-Spanish imaginary world of *Shrek* but carrying with it important cultural implications, since the transference of the portrayal of Hispanic 'otherness' by the Hollywood master narrative to the Spanish screen would also reveal the target culture's own perception of stereotypical features associated with cultural identities within its own country: the perlocutionary act of exclusion in the source text is recreated in the target text by performing a local transformation. (2010: 67–8)[13]

Therefore, it was vital in the original, English-language version of *Puss in Boots* for Puss to be 'Other' – not to belong to the dominant cultural group, although adopted into that group. Thus, though the general background is familiar as belonging to that broad, all-encompassing term that is Hispanic to any movie-goer familiar with a classic Western, Puss could not be other than a wandering soul, whose final scene sees him ride off into the sunset in the tradition of many other Wild West heroes before him. It should be mentioned that, though Puss is an outsider, it is not particularly his Hispanic traits that set him apart. Kitty Soft Paws, played by the Mexican actor Salma Hayek, plus the setting of an unidentified but clearly Mexican border town, gives credit to a dominance of the Hispanic theme in this movie, a clear shift in cultural focus from the previous *Shrek* movies in which Puss appears.

Accent, too, has played a remarkable role in the career of the second actor, of Viggo Mortensen. Viewed from Spain, in 2006 Mortensen's career highlight was his role as Aragon in the *Lord of the Rings* trilogy (2001–03). He was, and still is, an actor who is consistently introduced as a Danish-American. However, in the same year that he had reached global fame for his part in the *Ring* trilogy, he was cast as a character who had lived only in the pages of the *Alatriste* series. This is a series that, to date, consists of seven novels, and was begun in 1996 by Arturo Pérez-Reverte and his daughter, Carlota, with the aim of rescuing Spain's Golden Age past for younger generations of Spaniards who had not come to value the memory that past. The heroic Captain Alatriste was beloved by many readers as the embodiment of all that was great about the Spanish psyche: he was heroic, individualistic, a loner, true to his own codes of ethics, a man of action rather than words, a true friend though a mortal enemy, and, for all his qualities, a credible person despite all his flaws. He came to life on-screen in the movie entitled *Alatriste* in 2006, with Mortensen in the title role. His casting was controversial, and was initially criticised, since it was thought that the part should have gone to a Spanish actor, and that perhaps his presence was a way of globalising (or making more commercial) a singularly Spanish story.[14] Mortensen was categorised as American, from the US, an imported 'Other', and even an imposter with a strange Spanish accent. It transpired that this strange accent was Argentinian,[15] and that the actor was a fluent Spanish speaker, having spent many of his formative years in Argentina. A visit to any online blog confirms that the controversy is an ongoing one, with much debate as to whether he is 'really' fluent in both languages (English and Spanish) and, if so, how this could be, since he is 'really' a Dane.[16] Adding to the actor's challenge was the fact that the role called for him to embody a man of few words, causing each of those words to be analysed and criticised.

This intense interest interest may be explained by the role of accent within Spain. In Mark Allinson's words, 'Accent plays an important part in the identification of Spanish national identity and, in particular, of regional identity, a highly prominent political and cultural subject in Spain' (2001: 44). Allinson continues:

Argentinian accents testify in *Pepi, Luci, Bom* [Almodóvar's first feature film] to a time when Latin Americans were highly visible in Madrid. Elsewhere, most common is the Andalusian accent, considered the most humorous accent in Spain for reasons too complex to investigate here. (2001: 44)

With his Argentinian accent, Mortensen recalls that past, at least on a subliminal level, while Banderas's own accent is redolent with extratextual links to the complexities of relationships between the various autonomous regions of Spain. Franco's use of Andalusia as an idealised version of Spanishness did nothing to aid a less forgiving view of the South of Spain when viewed from the North or centre, as is clear from its ironic parody in *Bienvenido, Mr Marshall/Welcome, Mr Marshall* (Berlanga 1953). Thus, it becomes vital to locate individuals according to accent, in order to identify their loyalties and their social and cultural grouping. When it seems challenging to do so, as in Mortensen's case, or when an individual seems to betray such classification, as with Banderas playing a stereotypical Hispanic, then there is more at play that just an individual's ambitions or career moves. Accent as an identification of nationality can be contradictory, as Song Hwee Lim note, in regard to the director Ang Lee:

Like passing a test, one has to also pass as native/authentic ... This position, however, is a double-edged one, as one's acquisition of the accent/language could be judged to have passed (in both senses) and thus welcomed into the host family, or the remnants of one's original accent/language could be celebrated under the logic of multi-culturalism so that one's cultural difference is not perceived as a hindrance to integration, but, paradoxically, as hybridizing and rejuvenating the host culture. (2012: 134–5)

What the analysis of these actors indicates is the dichotomy existing between the perception of what is 'us' and what is 'Other'. Both Banderas's and Mortensen's voices have been used to exclude them and define them as 'Other', as belonging to a different cultural group. In some cases, the exclusion has also included a sense that they are betraying either their roots or their formation by attempting to insert themselves outside their normal habitat, so to speak. Both Banderas, by leaving Spain and working to become accepted on the Hollywood scene, and Mortensen, by leaving that scene and challenging acceptability in Spain, have pushed the boundaries. What is interesting is that both have finally achieved that acceptance – Mortensen by filming his fourth Spanish-language film,[17] and Banderas by reaching global recognition as both cat and international movie star. Lim's words, again referring to Ang Lee, seem equally fitting here, since these actors may be seen as evidence of a growing trend whereby they are no longer part of 'accented cinema' but have, without rejecting their own identifiable accent, rather 'gained

full citizenship in mainstream filmmaking' (2012: 140). The idea of 'accented' and 'unaccented' cinema is borrowed from Hamid Naficy, who defines it as cinema that

> has been in a state of preformation and emergence in disparate and dispersed pockets across the globe. It is, nevertheless, an increasingly significant cinematic formation in terms of its output, which reaches into the thousands, its variety of forms and diversity of cultures, which are staggering, and its social impact, which extends far beyond exilic and diasporic communities to include the general public as well. If the dominant cinema is considered universal and without accent, the films that diasporic and exilic subjects make are accented. (2001: 4)

Furthermore, accented cinema 'is not monolithic, cohesive, centralized, or hierarchized. Rather it is simultaneously global and local, and it exists in chaotic semiautonomous pockets in symbiosis with the dominant and other alternative cinemas' (Naficy 2001: 19). This simultaneous existence fits well with the careers of the two actors under consideration here, though not necessarily with all of their films. In a way, their curricula vitae may be seen to expand the notion of 'accented film', showing that the term may encompass films that are part of dominant cinema, facilitated by what may be termed 'accented actors'. In other words, there are no longer – if, indeed, there ever were – clear boundaries between accented and unaccented films.

Arguably, in the 1990s and Spain's more contemporary times attempts have been made to rebrand some actors as stars, but it simply has not worked. Such a case can be seen in the treatment and behaviour of both actors under consideration here. Both have gained a strong reputation within Spain's borders; both have shown that stardom is not their motivation which, rather, springs from the challenge brought to them by the roles they play. They play similar roles that centre on identity, calling for passion, virility and action. Their films are based on adventure, but neither is averse to parodying any overt machismo demanded of them. It could be said that both represent a certain duality, whereby they have challenged expectations and attempts to categorise them as either this or that, either Spanish or non-Spanish, part of a national group or outsiders to that group – in a word, 'Other'. In that way, they represent well, perhaps, the post-modern age, proving that they can be both star and worker; ordinary with a tinge of the extraordinary; of the real world with all its challenges, but also of the screen where stars can twinkle with just a hint of magic. Stardom, in the sense of actors becoming distant and mysterious through separation from their audience's reality, is not a common occurrence in Spain. The case of these two actors illustrates that much is bound up in the perception of stardom, for, through their work, they have prompted debate on identity, nationality, and what it is to work in the creation of illusion, in the creation of distant dreams.

Notes

1. Mortensen's filmography prior to *Alatriste* includes *A History of Violence* (dir. David Cronenberg 2006), *Hidalgo* (dir. Joe Johnston 2004) and *28 Days* (dir. Betty Thomas 2000). While it is challenging to classify any film as of a particular nation, these films, viewed from the perspective of a Spanish audience, would have categorised Mortensen as part of the American star scene.

2. Other examples of this actor's views on the subject of acting are:

'For me [Los Angeles] is a working place'; 'Everything here in Los Angeles is masks, metaphors, unreality. Everything is concerned with image, the box office, stars ... What I love about Americans is how pragmatic they are. They don't think and obsess in a sick way about doing something. In Europe, you can feel the weight of many years of history. In a village eight kilometres away from another village, people speak a different language, have their own culture that they want to preserve';

'I had done dozens of movies in Spain where, to survive, you have to do a lot of jobs, to jump from movie to movie because they pay you so few dollars to do any movie. You have to keep working, sometimes pick some things that you are not interested in, just because you are a professional. So, I am coming from a work world which is completely different. In Spain, they are proud of me because I am considered like an international soccer player. I have to win a battle outside so that I can represent my country. In a way, they are going, "Antonio, don't blow it!"'

All quotes are to be found on IMDb, 'Antonio Banderas' (n.d.). The ideas voiced here are interesting, in that they reveal a view of filmmaking in Spain that encompasses such diverse issues as job insecurity, low pay, professionalism, representing one's country abroad, history, and tradition.

3. Such filmmakers include Luis García Berlanga (*Bienvenido Mr Marshall/Welcome Mr Marshall*, 1953); Juan Antonio Bardem (*Muerte de un ciclista/Death of a Cyclist*, 1955; *Calle Mayor/Main Street*, 1956); Carlos Saura (*El jardín de las delicias/Garden of Delights*, 1970; *La prima Angélica/Cousin Angelica*, 1974); Victor Erice (*El espíritu de la colmena/Spirit of the Beehive*, 1973). What unites these directors, and many others, is that they produced popular films during the dictatorship that also managed to criticise life under the dictatorship, often at great personal and economic cost. They did so by seeming to focus on individual stories and the social consequences of what seemed to be personal decisions, but using symbolism to make the particular say much about the general political situation. They could thus remain part of mainstream filmmaking but also be part of a countercurrent of opposition to the dictatorship.

4. Such films include: *Pepe, Luci, Bom y otras chicas del montón* (*Pepe, Luci, Bom and Other Girls like Mom*, 1980); *Laberinto de pasiones* (*Labyrinth of Passion*, 1982) *¿Qué he hecho yo para merecer esto?* (*What Have I Done to Deserve This?*, 1984); and *Mujeres al borde de un ataque nervioso* (*Women on the Edge of a Nervous Breakdown*, 1988). Of course,

while it is true that Almodóvar excels in creating melodrama with plenty of slapstick and chaotic humour, the essence of his type of melodrama is the contrast between humour (usually black) and the dark side of life, as evoked in Almodovarian films such as *Matador* (1986), *Átame* (*Tie me Up, Tie me Down*, 1990) and *Kika* (1993), not to mention his later films, such as *Todo sobre mi madre* (*All About My Mother*, 1999) and *La piel que habito* (*The Skin I Live In*, 2012). What concerned audiences and critics most, it would seem, was Almodóvar's reluctance to tackle politics and the issues of the transition from dictatorship to democracy for, as David G. Gies notes, this filmmaker 'has manifested a lack of interest in the Franco regime by opting for the depiction of Spanish postmodernity' (1999: 619).

5. Núria Triana Toribio defines *la movida* as a 'backlash against the politization of Spain's cultural life in the late '70s and throughout the '80s; from this reaction it derives its apoliticism' (2003: no p. no.) Furthermore, according to Triana Toribio, the title *movida* was 'a defiant, slangish pun on the Francoist *movimiento*' (2003: 275).

6. Two texts that narratively explore the concept of *la movida* and its context are Hooper (2006) and Tremlett (2006).

7. Banderas had first appeared on-screen in *Pestañas postizas* (*False Eyelashes*) (1982), directed by Enrique Belloch. His first Almodovarian role was as Zadec in *Laberinto de pasiones* (*Labyrinth of Passion*, 1982). But he came to public attention as Ángel in *Matador* (1986), Almodóvar's seventh film (see IMDb, 'Antonio Banderas' [n.d.]).

8. Author's translation. Sourced from the Government of Spain, *Boletín Oficial de Estado*, 8 March 1963, *Normas de censura cinematográfica*.

9. Perriam is referring to a range of films including *Laberinto de pasiones* (*Labyrinth of Passions*) (Pedro Almadóvar 1982); *El placer de matar* (*The Pleasure of Killing*) (Félix Rotaeta 1987); *27 horas* (*27 Hours*) (Montxo Armendariz, 1986); *Bâton Rouge* (Rafael Moleón, 1988) and an episode of *Delirios de amor* (Félix Rotaeta 1986). Other less controversial roles are seen as 'examples of cultural grounding' – for example, in a light opera–type role in *La corte de Faraón* (*Pharaoh's Court*) (José Luis García Sánchez 1985) or as a peasant activist in *Réquiem por un campesino español* (*Requiem for a Spanish Peasant*) (Francesc Beltriu 1985) (Perriam 2003: 46–7).

10. The following is but one example of Banderas's view of stardom and his relationship with it: 'I am not that brilliant. You see, I'm not a star because I am not someone who is playing myself in front of the world. I am not criticizing being a movie star, but I think that to be a star requires you to be brilliant 24 hours a day. That is something that is not in me' (Banderas quoted at IMDb, 'Antonio Banderas' [n.d.]).

11. This is a paraphrase of Antonio Banderas's own words in 'Purr-fect Pairing: The Voices Behind the Legend', an extra to the DVD of *Puss in Boots: The Three Diablos* (DreamWorks 2012). His exact words are: 'He was a supporting actor. Now he's a star.'

12. For an interesting analysis of the on-screen use of fairytale, including *Puss in Boots*, see Zipes (2011).

13. Sanderson makes explicit the Andalusian archetype as perceived from outside: 'their comic nature, their willingness to sing and dance Flamenco at any occasion, and their

profound religiosity, externally manifested by devoted worshippers who carry heavy statuesque images of bloody crucifixions in processions' (2010: 67). Puss plays overtly to some aspects of such views, particularly in his musical talents.

14. Mortensen, when explaining how he came to accept the role offered to him in Berlin while promoting *Lord of the Rings: The Return of the King*, revealed his awareness of the controversy: 'I decided to do it, against everyone and against everything' (cited in Martín [2006]). Curiously, the role was first offered to Antonio Banderas, but talks between the actor and the producers fell through.

15. The strangeness was compounded by Mortensen's efforts to adapt his speech to the Castilian of the seventeenth century.

16. A few examples of the online argument will suffice to show the emotions involved: 'Viggo Mortensen's voice is completely inappropriate. Yes, he speaks Spanish; but he does so with a (completely understandable) foreign accent. You can't believe a character SO supposedly Spanish with that voice. A major error in my opinion' (cited in Anon. [2006]). Or: 'Many Spanish find his voice strange, perhaps due to a slight Argentinian accent but I rather think they're just not used to the original voice of Viggo' (ibid.). Finally, this opinion, obviously from a non-English speaker: 'I've never heard the voice of Viggo when acting in English, but I think it's better than Spain. I suppose if you have not seen the original movie will not be a problem, but in the film his first words that the movie people laugh and make some observations' (cited in *Simap Project* 2012, original errors included).

17. His other Spanish-language films are *Gimlet* (dir. José Luis Acosta, 1995); *La pistola de mi hermano* (*My Brother's Pistol*) (dir. Ray Loriga 1997) and *Todos tenemos un plan* (*Everyone Has a Plan*) (dir. Ana Piterbarg 2012). It is curious that controversy regarding his casting in a Spanish film only surfaced in *Alatriste*, following his success in *Lord of the Rings*. It would seem that the LOTR trilogy fixed his persona firmly in the Spanish public's mind as 'Other', compounded by his taking on the iconic Spanish role of Captain Alatriste.

8

Dancing with Hollywood: Redefining Transnational Chinese Stardom

Sabrina Qiong Yu

During the past decade, China's box office revenues increased from $162 million to $2.7 billion, and in 2012 China finally overtook Japan to become the world's second-largest movie market.[1] At the same time, China also became the biggest overseas market for Hollywood. It is therefore unsurprising that Hollywood has started to tailor its products for the Chinese market by incorporating more Chinese elements, such as Chinese locations and Chinese actors. Not only is a modernised China frequently featured in recent Hollywood blockbusters (e.g. *Mission Impossible III* [2006]; *Skyfall* [2012]), but China's top female stars also take turns appearing in the latest Hollywood hits, including Yu Nan in *The Expendables* (2012), Li Bingbing in *Resident Evil: Retribution* (2012), Xu Qing in *Looper* (2012), Zhou Xun in *Cloud Atlas* (2012) and Fan Bingbing in *Iron Man 3* (2013). Hollywood probably never saw more Chinese faces than in 2012! However, many Chinese audiences lament the insignificant parts and fleeting appearances of these female Chinese stars in Hollywood blockbusters, and call them Hollywood's 'soy sauce' – a way of mocking their trivial status in Hollywood. Chinese stars' journey to Hollywood has never been easy, and has mostly been accompanied by negative reviews and controversies most of the time. In this chapter, I hope to deviate from some conventional ways of evaluating transnational film stardom and suggest some new angles from which transnational Chinese stars can be discussed. In order to do so, it would be useful firstly to point out a few issues in the current discussion of transnational stardom.

The existing studies on transnational stars focus, with a few exceptions (e.g. Tim Bergfelder's examination of Anna May Wong's European stardom; Ora Gelley's discussion of Ingrid Bergman's work in Italy), on transnational stars' Hollywood careers, as indicated by the title of an edited collection, *Journeys of Desire: European Actors in Hollywood* (Phillips and Vincendeau 2006). Indeed, as I argue elsewhere (Yu 2012), transnational stardom indicates one-way traffic – that is, stars moving from other parts of the world to Hollywood. However, while today's Hollywood is still the destination of various journeys of desire for many non-Hollywood stars, Hollywood cannot claim full authorship of transnational stardoms. Unlike their predecessors, contemporary trans-border stars often choose to travel between their home countries and Hollywood to make films in both industries. Consequently, their star status is no longer solely determined by their Hollywood performance. In the following pages I argue that, in order to make sense of a star's transnational stardom, their star status in their home country should be considered, alongside the conventional investigation of their Hollywood career. This is not to suggest that we should make a simplistic distinction between the 'positive' or 'authentic' star image in one's home country and the 'negative' or 'inauthentic' star image constructed in Hollywood. Rather, I think more research should be undertaken to reveal how these two aspects of a transnational star's career interact with, influence and determine one another, thereby mutually shaping the star status and star image of a transnational star.

Another noticeable tendency in work on transnational stardom is the dominance of the discourse of representation. Take the study of transnational Chinese male stars as an example. Most discussions have focused on such questions as: In what ways have these male stars challenged or reinforced Chinese male stereotypes on the Western screen? In what ways have they functioned as a source of empowerment for disadvantaged social groups? This kind of interrogation has certainly contributed to our understanding of the cultural meanings of transnational stars. In Hollywood, it is not only Chinese stars who are viewed through the lens of stereotypes; stars of all other ethnicities are also closely associated with national stereotypes. The discussion of representation and misrepresentation is valuable, but the overemphasis on the politics of representation has not only created a series of critical clichés (e.g. transnational stars are selling out in Hollywood by compromising their acting skills and reasserting racial stereotypes), but also led to the neglect of other dimensions in the phenomenon of transnational stardom. One of the under-addressed areas is the economic aspect of transnational stardom. It is easy to forget the fact that Hollywood's predominant purpose in bringing in foreign talent is not to diversify its cultural representation, but to maximise its profits. In an industry that treats stars as 'symbolic commerce' (McDonald 2013), it is the belief that certain foreign stars can attract audiences into the cinema that paves the way for the crossover of these stars. In this chapter, I attempt to address this imbalance in current critical

discourse by highlighting the importance of exploring the economic dimension of transnational stardom.

Finally, the scholarship on transnational stardom is dominated by the discussion of European stars, while the unique features of transnational stars from other cultures, such as those from Asia, are less frequently explored. This is partly because there have been more trans-border European than Asian stars in film history. The only Asian stars who were able to establish a transnational career and who have attracted a broad and solid international fand-base are probably Chinese kung fu stars, in particular Bruce Lee, Jackie Chan and Jet Li, thanks to their martial arts skills – an irreplaceable global currency. A considerable amount of work has been devoted to the analysis of the star images of Lee, Chan and, to a lesser extent, Li. However, these stars have been mainly discussed either within the discourse of representation (e.g. the remasculinisation of previously emasculated Chinese men), or according to Hollywood-orientated critical models, such as the authenticity of their (physical) performance or the male body as spectacle. Their contribution to the transnationalisation of cinema has not received much scholarly attention. The newly emerged transnational Chinese stars mentioned above are different from their predecessors in that their star status in Hollywood has not yet been, and perhaps will never be, established in the same way. Can they be called transnational stars at all? This chapter seeks to interrogate the concept of transnational stardom through a close examination of transnational Chinese stars from the past to the present and, in particular, their star status as informed by the different types of capital they hold in their transnational careers.

In his discussion of the expanded notion of capital, Pierre Bourdieu (1986, 1998) identifies four forms of capital. Economic capital can be converted directly and immediately into money, while cultural capital refers to the skills, knowledge or educational qualifications a person obtains over a period of time. Social capital is 'the aggregate of the actual or potential resources' (1986: 51) accrued through belonging to a social group, network or class. Symbolic capital is any form of capital that is perceived as such by social agents who recognise and value it, and is embodied in prestige, honour, reputation and personal authority. All types of capital can be converted into economic capital, and symbolic capital plays an important role in facilitating the conversion of social and cultural capital into economic capital. Although a certain degree of overlap exists in Bourdieu's classifications, the theory of capital provides a useful theoretical tool for the discussion of star phenomena. Stars usually possess economic and symbolic capital. The latter can be equated with the fame and fantasy arising from their star status. Stars' symbolic capital can be easily transformed into economic capital when they are used to raise investment, ensure distribution and secure profits. Precisely in this sense, stars, as McDonald points out, are 'signs of economic value' (2013: 1). However, only some stars hold cultural capital, namely those whose acting skills are widely acknowledged or who build their star image around particular skills, such

as dancing. Even fewer stars can claim social capital, because stars characterised by individual charisma and success are not usually associated with a form of capital produced by social connections or networks, unless in cases where certain stars have become involved in politics (e.g. Clint Eastwood, Arnold Schwarzenegger) or philanthropy (e.g. George Clooney, Audrey Hepburn), using the resources they have accumulated over a usually very successful acting career.

After a brief introduction of Bourdieu's theory of capital in relation to the discussion of stardom, I would like to differentiate three stages in the history of transnational Chinese stars according to the presence or absence of different types of capital. As I have noted, film stars do not usually possess social capital. This is even more the case for transnational stars. Portes identifies four negative consequences of social capital, and one of them is the 'exclusion of outsiders' (1998). Despite being better paid than most, immigrant stars in Hollywood are a marginalised and isolated social group. Due to their identity as outsiders, they have very little access to social capital aggregated through social networks. I will therefore exclude social capital from my discussion of transnational stardom.

The first stage of transnational Chinese stars is marked by Bruce Lee. Lee is the first, and probably the most internationally well-known, Chinese star. With a total of merely four films, Lee stirred the kung fu craze in the US and indeed the entire world in the early 1970s, and became a cultural icon of the twentieth century. In many ways, Lee is an exemplary transnational star who perfectly combines cultural, economic and symbolic capital. Arguably the most influential martial artist of all time, Lee's martial arts skills are undoubtedly the most visible element of cultural capital contributing to his transnational stardom. Martial arts can be seen as a form of embodied cultural capital, in that they are physical skills acquired over time and have become an integral part of the person who practises them. As the founder of Jeet Kune Do, a hybrid and non-conventional martial arts system, Lee was the first martial arts star to make people believe that he was exhibiting *real* fighting skills on-screen. The cultural capital Lee embodies is unique, and has been accrued by only a small number of screen performers in the history of cinema. But the symbolic capital Lee possesses – revealed by such titles as best on-screen fighter, most famous martial arts philosopher, actor who rewrites the screen image of Asian people on the Western screen and the cultural ambassador who helped to inspire a great interest in Chinese martial arts and Chinese culture in general – will probably never be accrued by any other film star.

It is worth noting that neither the symbolic nor the economic capital of Lee's transnational film career were gained during his lifetime. As many critics point out, Lee's premature death before the release of *Enter the Dragon* (1973) contributed significantly to his unprecedented popularity and 'expedited his elevation to myth' (Hunt 2003: 76). In the Western popular imagination, Bruce Lee is at one and the same time a synonym for Chinese kung fu, a legend, and a myth. His posthumous stardom is built precisely upon this symbolic capital, which was heavily capitalised

on by both Hong Kong and Hollywood film industry. Numerous hastily made Hong Kong kung fu films were imported immediately following Lee's death, to fill what Kwai Cheung Lo calls the hole 'punched out by [his] body' (1996: 110), including 'Bruceploitation films' starring various Bruce Lee clones. Even many years after his death, Lee still enjoys the symbolic and economic capital in Hollywood that many living stars cannot attain, as demonstrated by two well-received Bruce Lee biopics produced in 1993 – *Dragon: The Bruce Lee Story* and *The Curse of the Dragon*.

The second stage of transnational Chinese stardom is exemplified by Jackie Chan and Jet Li, the two most famous kung fu/action superstars after Bruce Lee. Jackie Chan was first introduced to the West as another 'Bruce Lee' in the early 1980s. The failure of his initial attempt to break into Hollywood was to a large extent predictable, because as well as lacking symbolic capital he had no pre-existing cultural capital there. Although he had emerged as a new kung fu star in Hong Kong thanks to *Drunken Master*, made in 1978, his unique fighting style – comedic kung fu – had not been fully established. And, more importantly, the Jackie Chan 'brand', characterised by Chan's execution of all his own stunts, was yet to be invented. Ironically, the outtakes of stunts gone wrong, shown at the closing credits, were to endow Chan with cultural capital – that is, martial skills obtained through many years of harsh training. Chan's own words most precisely describe this cultural capital: 'You can make anyone fly like Superman or Batman, but only we special people can do my style of fighting' (quoted in Reid 1994: 2). Similarly, Jet Li claims this cultural capital via his title as a five-time national martial arts champion who started martial arts training at the age of seven, and made his name from martial arts virtuosity in his film debut, *Shaolin Temple* (1982). During the time when Hollywood action filmmaking faced a growing staleness and an absence of new action stars, the cultural capital Chan and Li carried – the capacity to display martial arts skills on-screen 'authentically' – brought freshness and excitement into the genre, and made the two stars bankable in the eyes of American producers.

However, although Chan and Li starred in more American films and attracted more revenue than Bruce Lee, neither of them ever reached the same level of stardom Lee had achieved a few decades before. Among these three transnational Chinese kung fu stars, only Lee was able to build an off-screen persona in the West that undoubtedly surpassed his on-screen persona. As Leon Hunt observes, 'the Bruce Lee publishing industries extend well beyond his comparatively modest cinematic output – biographies and, more frequently, hagiographies, collections of his essays, interviews and letters, and discussions of his "scientific streetfighting" (2003: 77). By comparison, although Chan and Li do sometimes appear in newspapers or talk shows in the West, they do not really have an off-screen persona. Western audiences are interested mainly in their films – in particular, in their ability to display genuine martial arts on-screen, while little media attention has been paid

to their personal lives. In this sense, we might even claim that Chan and Li are not Hollywood stars in the conventional sense. The main reason for this, in my view, is that they lack the symbolic capital that Lee holds. It is their cultural and economic capital that have been exploited in their Hollywood careers.

There were also other Hong Kong stars, such as Michelle Yeoh and Chow Yun-fat, who crossed over to Hollywood around the same period; and later Mainland Chinese stars Gong Li and Zhang Ziyi were cast in American productions. All of these stars are top stars in Chinese-language cinema, and enjoy a certain level of international fame. But none of them has been able to succeed in breaking into Hollywood in the way that their kung fu contemporaries have. I would argue that this is largely because they do not have the transnational cultural capital possessed by Li, Chan and Lee, although Yeoh, Chow and Zhang, with complete disregard to their diverse acting backgrounds, have been predominantly cast in action roles in their Hollywood work. Stars like Chow Yun-fat do hold considerable cultural capital in Chinese cinema that derives from their excellent acting skills (demonstrated, for example, by the numerous acting awards won by Chow). But in their transnational careers, they are almost never awarded a role that can exhibit their acting skills. Consequently, the cultural capital they once held is sadly lost in transition.

Although the majority of transnational Chinese stars from stage two are still making films in Hollywood (e.g. Michelle Yeoh in *The Lady* [2011], Jet Li in The *Expendables* series [2010–14]), I would like to suggest that transnational Chinese stardom has entered a new era in the past few years, with more and more Chinese stars having been given the chance to appear in Hollywood blockbusters. This new stage is marked by Hollywood's changed strategy of employing Chinese film talent. While the second-stage Chinese stars usually play the leading role in medium-budget star vehicles, the current crossover Chinese stars are without exception cast in minor, supporting roles in big-budget films that target the global market. Their roles are in no way compatible with their star status in Chinese cinema, providing little space for any serious acting and hence little chance to grow their reputation on the world stage. Today's Hollywood relies more on its overseas markets than its domestic market, among which the Chinese market is the fastest-growing. It is therefore unsurprising to see these transnational Chinese stars' domestic stardom being exploited, and their being used as a way to capture revenue in the Chinese market. To some extent, Hollywood's Chinese faces could be anyone who has a visible star status in China. They do not carry much cultural capital, not to mention symbolic capital. And their economic capital is limited in that it only takes effect in the Chinese market. Compared with their predecessors, the new generation of crossover Chinese stars has the least capital to play with in their Hollywood adventures.

Even Chan and Li seem to have exhausted their leading-man status in Hollywood. After *War* in 2007, Li has not played any leading roles in Hollywood

films. His role in the two *Expendables* films is indeed expendable. Similarly, since 2007 Chan has starred in only two Hollywood films. The decline in their careers in Hollywood results on the one hand from the fact that both have shifted their focus back to the Chinese film industry in recent years, which I will discuss further below, and, on the other, is due to their reduced cultural capital. As analysed above, their physical ability has been highlighted as their main selling point in Hollywood. However, with the increasingly heavy use of digital technology in martial arts/action films that can make a non–martial artist look like a superior fighter on-screen, the position of kung fu stars in the genre has been somewhat weakened. Furthermore, both stars' sustainability has been put into doubt due to their ageing (at the time of writing, Chan is turning 60 and Li just turned 50). Their long-lasting careers as kung fu/action stars has left them with numerous physical injuries. Both Chan and Li have intimated in different ways and on different occasions that they would gradually stop making action films. This has inevitably damaged the cultural capital they have claimed throughout their transnational careers.

From the perspective of the history of transnational Chinese stardom, the capital transnational Chinese stars possess in their journey to the West has gradually reduced from symbolic/cultural/economic (stage one) to cultural/economic (stage two) to economic (stage three). This trajectory results from the changing industrial context of Hollywood, but also reveals some inherent features of transnational stardom. Theoretically speaking, all transnational stars, including transnational Chinese stars, should share at least one type of cultural capital – that is, their 'foreignness', which is gained by living in their own culture for many years and which their American counterparts are unable to obtain. Ideally, transnational stars can use this cultural capital to function as 'cultural broker' in their border-crossing performances. According to Jezewski and Sotnik, cultural brokering is 'the act of bridging, linking or mediating between groups or persons of differing cultural backgrounds for the purpose of reducing conflict or producing change' (2001). Transnational stars can be seen as cultural brokers if they reveal their own culture to people in another culture through their films, and facilitate cross-cultural understanding and exchange.

However, it is probably never the Hollywood industry's intention to use foreign stars to represent their own culture, let alone via an accurate representation. Apart from the fact that imported stars can play national stereotypes more convincingly and make the Hollywood construction of 'Otherness' more covert, it is the exoticism brought by foreign stars that is exploited by Hollywood studios. In a way, exoticism can be seen as a kind of cultural capital transnational stars hold in Hollywood – but often at the expense of the cultural capital they obtained in their own country, and in the form of simplifying, stereotyping and 'othering' these stars. Hence it represents a negative and reductive form of cultural capital and a quick way to make profit. Furthermore, assimilation is always the most important mechanism

in Hollywood's intake of foreign talent. In order to survive in Hollywood, a foreign star has more or less to compromise his or her own cultural identity and prepare to be Americanised. Because, as Phillips and Vincendeau point out in their discussion of transnational European stars, while these actors 'could certainly use their European-ness as a selling point, they understandably did not want to be subordinated into "otherness"' (2006: 16). Since Hollywood's crossover politics render transnational stars' most natural cultural capital ineffective, their function as cultural brokers is largely constrained, and often depends on the combination of their personal agenda and the extent of their success in Hollywood.

Bruce Lee, the first transnational Chinese star, was very conscious of his role as cultural broker. According to Donovan, 'Lee had always looked to kung fu films as a way of introducing the world to the Far East, as a first step in whetting the appetites of film audiences for a much larger dose of Asian culture and all it had to offer' (2008: 96). Lee obviously succeeded in achieving this goal. With only one transnational production, Lee stirred up unprecedented interest in Chinese martial arts across the world and opened the West's door to Chinese-language films. In this sense, Lee can be considered a cultural broker. Lee's cultural agenda was shared by Jet Li. As early as 1991, Li articulated his enthusiasm for spreading Chinese martial arts through film in an interview (quoted in Yang, 1991: 24). Since the transnational success of *Hero* in 2004, Li has been trying to foreground the cultural rather than physical side of Chinese martial arts by declaring on various occasions that the deeper meaning of martial arts in Chinese culture is actually to stop fighting. However, none of Li's Western roles seems to have helped him to convey this message. Li, as well as Chan, has to a large extent been reduced to a fighting machine on the Western screen. As Pham rightly notes, the so-called Asian invasion facilitated by Hong Kong action stars' crossover to Hollywood just 'enhances Hollywood's image as a racially inclusive, equal opportunity, global industry', and 'Asian actors and filmmakers are not invading Hollywood as much as they are finally being admitted into Hollywood – under very specific conditions and for very specific roles' (2004: 122). Rather than disseminating the cultural meanings of Chinese martial arts to the West, the significance of transnational Chinese stars from stage two, Jet Li and Jackie Chan in particular, probably lies more in their contribution to film performance – namely, in introducing martial arts as a form of film acting.

For transnational Chinese stars from stage three, the title of cultural broker seems even more unreachable, given that they have been mainly cast in minor, dispensable roles by Hollywood studios out of commercial considerations. Their previous star image and film background are completely neglected in their transnational career. Instead of being used as human agents who might facilitate cross-cultural understanding, these new crossover Chinese stars function in Hollywood purely as, borrowing Barry King's (2010) term, a money form. My argument is supported by Hollywood's latest strategy to strive for the Chinese market: to

produce an alternative version of their big movies specifically tailored for Chinese audiences. The major difference revolves around the star appearance. For instance, Xu Qing gets a bit more screen time in the Chinese version of *Looper*, while in its international version she does not even get a chance to speak. The Chinese version of *Iron Man 3* features Fan Bingbing, one of the hottest Chinese actresses, but she is absent from the version shown elsewhere. Hollywood's use of Chinese stars is definitely creative, but ultimately money-driven.

This observation of current transnational Chinese stars functioning as a pure money form can be more or less applied to transnational Asian stars in general. If, in the twentieth century, Chinese and Hong Kong stars were shaping Western audiences' perception of Asian stars, in the new century stars from Japan and South Korea have joined the category of transnational Asian stars, including Lee Byung-hun in the *G.I. Joe* sequel, Jeon Ji-hyun in *Blood: The Last Vampire* (2009), Doona Bae in *Cloud Atlas* (2012), Rinko Kiduchi in *Babel* (2006) and *The Brothers Bloom* (2008), and Ken Watanabe in *The Last Samurai* (2003), *Batman Begins* (2005) and *Inception* (2010). Compared to the Chinese stars from stage three, these Korean and Japanese stars probably have a little more presence in these Hollywood hits, but the way they are exploited by Hollywood is hardly different. For example, Hollywood's importation of Korean stars is clearly associated with the dazzling success of South Korean cinema since 2000, both domestically and internationally. The bankability of South Korean film stars has significantly increased in Hollywood partly because they have developed a large fan base in the East Asian region, as Hong Kong stars did two decades ago. The box office success of *G.I. Joe* (2013), involving South Korean star Lee Byung-hun, provides a telling example. This film came out top not only for South Korea's first-weekend box office, but also for first-week box office in Mainland China, Taipei and Hong Kong. Apart from Bruce Willis's star appeal to Asian audiences, Hollywood's strategy of incorporating a top Asian star also presumably contributed to its box office triumph.

From cultural broker to money form, I have depicted a dystopian picture of Chinese stars' transnational journey. However, as I argued earlier, their American performance is only part of their transnational career. The discussion of transnational stardom should abandon a Hollywood-centred approach and consider their transnational career in different film industries and cultural contexts. Here, I am going to exclude Bruce Lee from my discussion as he did not get a chance to go back to the Chinese film industry after his Hollywood debut. I will still use Jackie Chan and Jet Li as examples, since they are the two most successful transnational Chinese stars after Lee. Between 1998 and 2004, Chan made six American films altogether, and some of them (e.g. the *Rush Hour* series) were box office hits. However, after three box office disappointments in a row (*The Tuxedo* [2002], *Shanghai Knights* [2003], *Around the World in 80 Days* [2004]) and Chan's alleged dissatisfaction with being pigeonholed in Hollywood as 'only' an action star, he gradually moved back to the Hong Kong film industry, while continuing to make

Hollywood films. In his Hollywood adventure, Chan turned his comedic action style into an international brand, but the lament over the apparent demise of his Hong Kong persona had never ceased. His returning film, *New Police Story* (2004), which tried to reclaim the glory of his trademark *Police Story* films, did a decent job both at the box office and at film festivals. More importantly, in this film Chan started the transformation, in his own words, from an action actor to an actor with action skills, by playing a less heroic role in which he shows many emotions and even cries a few times – a role quite different from his usual comedic screen personality. In his subsequent Hong Kong films, Chan has continued to diversify his screen image by taking up a series of non-action roles, such as an archaeologist in *Myth* (2005), a thief in *Robin-B-Hood* (2006), an illegal immigrant in *Shinjuku Incident* (2009) and a revolutionary in *1911* (2011). Although the films Chan has made in the past decade have not achieved the same phenomenal success as his Hong Kong films from the 1980s and 1990s, most of them did well financially, and Jackie Chan films are still a guarantee of box office success. Chan's latest film, *Chinese Zodiac* (2012), which he starred in and directed, was the second-highest-grossing film in the history of Chinese cinema. Despite his age, Chan has proved himself still to be a top star in China, and also has the potential to become a versatile actor. In this sense, although his Hollywood performance seems less impressive, Chan can be considered as having succeeded in his transnational film career.

This is even more true of Jet Li. After four Hollywood appearances with a lukewarm reception, Li made his triumphant return to the Chinese film industry in *Hero* (2002), a sensational hit both in China and overseas. Despite its controversial political message, this film, described as the first Chinese blockbuster, not only opened a new golden era for Chinese filmmaking, but also became the most successful Jet Li film to date in the US. Following the success of *Hero*, Li started to travel between different film industries (Mainland China, Hong Kong, Hollywood and France) to make films in both Chinese and English, including *Danny the Dog* (2005) which teams up Li and French producer Luc Besson for the second time, and was widely viewed as Li's best Western role; and *Fearless* (2006) and *The Warlords* (2007), two Hong Kong productions, both critically acclaimed and commercially profitable. The former brought Li the first acting award of his career – Best Actor at the 2007 Hong Kong Film Critics Awards – as well as nominations for Best Actor at the Hong Kong Film Awards and China's Hundred Flowers Awards, while the latter won him Best Actor at the prestigious Hong Kong Film Awards in 2008. As I argue elsewhere, 'these nominations and awards are significant given that Li has long been criticised for his "lack of acting skills" and that kung fu stars in general are hardly ever given credit for their acting ability' (Yu 2012: 187). *The Warlords* also made Li the highest-paid star in Asia at the time. It is worth mentioning that both *Fearless* and *The Warlords* received mainstream releases in the West. Notably, like Chan, Li also showed an intention to break with his image as a kung fu/action star by playing a non-action role – in his case in *Ocean Heaven*

(2010), which received positive reviews. Considering these facts, Li's transnational career appears much more prosperous and promising than if we look only at his Hollywood films.

The examples of Li and Chan demonstrate that, for today's transnational Chinese stars, Hollywood is no longer the ultimate destination. In their cases, it is actually their home market that consolidated their status as transnational stars. This is not to underestimate the role Hollywood has played in their transnational career. Their Hollywood presence, however moderate, endows them with the title of 'Hollywood star' or 'transnational star'. These titles have functioned as symbolic capital in their home country, and provided them with prestige and authority, besides significantly increasing their bankability at home. Had Jet Li not been to Hollywood as an action star, he might not have got the opportunities to collaborate with renowned art cinema directors like Zhang Yimou and Peter Chan; had Li and Chan not been to Hollywood, they might not have become the top-earning stars in Chinese cinema. After returning from Hollywood, Li established the 'One Foundation', which is the first as well as the most successful private charitable fundraising organisation in China, while Chan was recently appointed to the top political advisory body (National Committee of the Chinese People's Political Consultative Conference) by the Chinese government. The Chinese career of two transnational kung fu stars shows clearly how symbolic capital can be converted in to other forms of capital, such as economic and social capital. Presumably because of the symbolic capital associated with the titles of 'Hollywood star' and 'transnational star', Li and Chan are willing to maintain their Hollywood presence, even by playing supporting and formulaic roles.

This can also explain why so many A-list Chinese stars are keen to play minor parts in Hollywood blockbusters. A disposable role might not help them to develop an international career in any significant way, but the fact that they are invited to play in a Hollywood blockbuster alongside big Hollywood stars alone can bring them more publicity at home, and subsequently more parts and higher income. Phillips and Vincendeau argue that, for European actors in Hollywood, the '"journey of desire" was always bound up with the myth of reinventing oneself and the desire for global exposure' (2006: 17). I would contend that, for recent Chinese actors making an appearance in Hollywood films, the desire for global exposure is probably the same, but instead of trying to reinvent themselves on the global stage, they tend to use the opportunity of working in Hollywood as a pathway to greater stardom in China. Nowadays, Hollywood appeals to Chinese stars more as a place where they can gain some symbolic capital that will be beneficial to their career in their own country than as a place where they might make more money or establish an international career. Although they can hardly be seen as Hollywood stars, their star status in China, and the fact they make films in both countries, makes them transnational stars.

In summary, I argue, firstly, that the Hollywood-centred approach to transnational stardom needs to be amended. A transnational star's career in his or her home country is just as important as its counterpart in Hollywood. Without scrutinising both aspects, it would be difficult to make a balanced evaluation of a star's transnational career. As demonstrated by the case study of transnational Chinese stars, a moderate presence in Hollywood can sometimes lead to a successful transnational career. In other words, one does not have to become a Hollywood star first in order to become a transnational star. Furthermore, the study of transnational stardom challenges some fundamental assumptions in star studies, such as the duality of star image as constructed on- and off-screen and star power. If Jackie Chan and Jet Li can been seen as Hollywood stars, neither of them has much off-screen presence in the West; nor do they hold much star power due to their identity as imported Chinese stars.

Secondly, I have tried to point out the insufficiency of the discourse of representation in the discussion of transnational stars, given that they are mainly used as a money form rather than as human agents. Through an application of Bourdieu's theory of capital to the discussion of transnational Chinese stars, I have suggested that the success of a transnational star depends on whether or not all other capitals they might possess can be converted into economic capital. While today's Hollywood tends to exploit an imported star's economic capital in order to secure its overseas profit, the 'symbolic capital' associated with Hollywood in turn increases the bankability of a transnational star in his or her home market.

Thirdly, confronting the popular and somewhat clichéd perception that the significance of transnational Chinese stars lies in their challenging a previously negative Chinese screen image in the West, I have argued that the contribution of transnational Chinese stars needs to be understood more in relation to their irreplaceable role in the process of film transnationalisation. While imported films from prestigious non-Western directors used to be confined to art cinema releases in the West, it is transnational kung fu stars who have helped to bring Chinese-language films into mainstream cinema. Meanwhile, they have also helped to reinvigorate the American action genre with their unique martial arts performances. As Donovan neatly observes, transnational Chinese kung fu stars 'made their films for the mainstream, middle-American strip mall audiences and they changed the look and feel and tempo of one of Hollywood's biggest genres at the same time' (2008: 221). In an opposite direction but with a similar effect, Chinese stars involved in recent Hollywood blockbusters have helped American films to bypass China's strict quota on foreign films, and to reach a wider range of Chinese audiences.[2] There are reasons to predict a more dynamic star traffic between China and Hollywood in the years to come. More Chinese stars might be invited to make Hollywood films, and hopefully will play more important roles in them. Meanwhile, more Hollywood stars might join Chinese productions, after

Christian Bale's starring performance in Zhang Yimou's *The Flowers of War* (2011), and Tim Robbins and Adrien Brody's involvement in Feng Xiaogang's *Back to 1942* (2012). Dancing with Hollywood inevitably results in the co-existence of challenges and opportunities. However, with an increasingly prosperous domestic film market, Chinese stars might continue to redefine transnational film stardom.

Notes

1. The data were obtained from 'Theatrical Market Statistics 2012', published by the Motion Picture Association of America, available at www.mpaa.org/wp-content/uploads/2014/03/2012-Theatrical-Market-Statistics-Report.pdf (last accessed 1 July 2013.)
2. If a film is deemed to be a Chinese-American co-production, it is not subject to the foreign film quota. However, in order to gain the status of co-production, among other requirements, the involvement of Chinese actors is mandatory.

Section 3

The Politics of Stardom

9

I'm Ready for My Close-UP Mr Ayatollah! The Ideology of Female Stardom in Iranian Cinema

Michelle Langford

Throughout the history of Iranian cinema, stardom has played a relatively marginal role when viewed against the central place stars hold in many of the world's major commercial film industries. Early in Iran's film history, a range of tensions and anxieties emerged around the cultural legitimacy of film, which also impacted on perceptions of acting and stardom. Recent international acclaim for Iranian films and the emergence of several high-profile female stars has brought with it an intensification of these tensions and anxieties. This chapter will engage briefly with the history of Iranian film stardom, before examining the emergence of three contemporary female stars of the post-revolutionary Iranian screen: Niki Karimi, Leila Hatami and Golshifteh Farahani.

Stardom in Iran: From the Early Years to *Film Farsi*

Fictional feature filmmaking in Iran ostensibly began with the production of *Mr Haji the Movie Actor/Haji Aqa, Aktor-e Sinema* (Ovanes Ohanians, 1933). This film, which tells the story of a sceptical but pious man (a traditional *haji*) being transformed into a movie lover advocating the production of films for educational purposes, also contains a self-reflexive contemplation of stardom. At the film's climax, the *haji* is lured into a cinema where a film in which he has unwittingly played a starring role is screening. At the film's conclusion, Mr Haji is greeted with the applause of an adoring audience, and at this point declares not only his love of film but his hopes that he will be blessed with many grandchildren who

will go on to become movie stars. Films such as this not only played an important role in establishing the cultural legitimacy of cinema as a form of entertainment, but also modelled ways of effacing tensions between tradition and modernity that were brought about by the country's rapid modernisation in the first decades of the twentieth century.

Iranian cinema was deeply caught up in this drive for modernity, often becoming an advertisement for it. Where *Mr Haji the Movie Actor* showed the transformation of the traditional haji into a syncretically Westernised movie-lover, Iran's first Persian-language talking picture *The Lor Girl/Dokhtar-e Lor* (Ardeshir Irani and Abdolhosain Sepanta, 1933) was explicitly shaped by the state's modernising agenda (Zeydabadi-Nejad 2010: 31). This is evidenced by both the film's narrative trajectory and its central female protagonist. The narrative revolves around a romantic couple – a café singer and a government official – who flee Iran for India after being terrorised by a gang of bandits, only to return when they hear of the ascension of Reza Shah and his efforts to modernise the country. Like *Mr Haji the Movie Actor*, *The Lor Girl* promotes the transformative and progressive potential of modernisation for Iranian society. This agenda is extended to the depiction of Golnar, the film's central female protagonist, a café singer who is represented as the kind of liberated, modern woman imagined by state gender policies, but is only ambivalently realised due to the prevailing 'traditional patriarchal, communal and religious elements of society' (Sadr 2006: 28). Ruhangiz Saminezhad, the untrained actress who played Golnar, may be considered Iran's first female star. She was at the very least the first Iranian-born, Persian-speaking actress of the talking film era. Through her role as Golnar, Saminezhad became both an emblematic role model and an object of desire, but inadvertently became deeply embroiled in the gender, cultural and national politics of the time, which, together with the artisanal nature of the industry, effectively shut down her potential stardom. On screen Saminezhad's Golnar – who sang, danced, rode a horse and appeared unveiled, but nonetheless vehemently protected her chastity – was the emblematic vision of female modernity promoted by the Shah, and provided a point of identification for women whose public presence was in the process of being transformed. Naficy notes that 'efforts to bring women into the public space of the cinemas far preceded the Shah's sartorial reforms' (Naficy 2011a: 263), and Golnar's unveiled appearance certainly foreshadowed these, which by 1936 included the forced unveiling of women. According to Issari, Saminezhad was quaintly idolised by female fans, becoming 'very popular with Iranian audiences', while 'her sweet Kermani accent was soon imitated by people throughout the country' (Issari 1989: 107).

Reports of Saminezhad's off-screen experience, however, paint an altogether contradictory experience for this modern Iranian starlet-in-the-making. Her on-screen emancipation was not matched in her personal life. Sadr notes that, upon her return to Iran from India, where the film was produced, she 'was forced to

change her family name to protect herself from public scorn, and was socially ostracised because of her involvement in cinema' (Sadr 2006: 28). Appearing in only one more film, and credited only by her first name, Saminezhad's potential for stardom was thereby foreclosed by a social context that was not in step with broader ideological and political changes.

The social scorn faced by Saminezhad as one of Iran's pioneering screen actresses reveals tensions between state discourses regarding women's emancipation and public perceptions about acting, which was not considered an appropriate profession for Iranian women, who had long been prohibited from acting in the theatre. With the introduction of film to Iran in the early twentieth century, filmmakers had a limited pool of female actors to draw upon, most of whom were, like the pioneering filmmakers themselves, either foreigners or members of a religious minority. The producers of these early films recognised the need to train more female actors, and attempts were made to establish acting schools to nurture local talent. This situation made Fakhrozzaman Jabbarvaziri, who starred alongside Saminezhad in *Shirin and Farhad / Shirin va Farhad* (Ardeshir Irani and Abdolhosain Sepanta, 1934), a significant trailblazer as, according to Naficy, she was 'the first born-and-bred Muslim Iranian actress' (Naficy 2011a: 241). However, her career and potential stardom would be cut short by the artisanal state of this fledgling industry, which did not manage to produce a single feature film between 1937 and 1948 (Naficy 2011a: 208).

As in the 1930s, during the *film farsi* era, which began in the late 1940s and continued until the revolution in 1979, the on-screen representation of women was intimately tied up with the drive to increase women's participation in the public realm; but in this later period commerce, entertainment and stardom also played a much more central role. Sadr argues that 'the revival of Iranian cinema was dependent on its female stars' (Sadr 2006: 46). He claims that, while some male actors, among them Behrouz Vossoughi, Naser Malekmotii and wrestler-turned-superstar Fardin, achieved massive popularity, 'most of the successful films of the 1950s were romances and melodramas dominated by female stars' (Sadr 2006: 84). Naficy, however, points out that despite their immense popularity, female stars never acquired the kind of power and 'multifunctionality' afforded to male stars, with their impact 'limited to their on-screen presence and magazine covers' (Naficy 2011b: 207). Indeed, several male stars attained the power to shape their own star personas by establishing controlling interests in production and exhibition. According to Naficy, both Fardin and Vossoughi 'owned film studios and movie houses and produced their own movies; they chose their co-stars and controlled scripts and setups; and they had the "final cut"' (Naficy 2011b: 207). The women, by contrast – especially those who appeared in comedies, 'stewpot' (domestic melodrama) and 'tough-guy' films – were encoded in a highly sexualised fashion by an objectifying and fetishising male gaze, constructed by both the camera and a male-dominated diegetic audience (Naficy 2011b: 208).

Female stardom was inextricably linked to genre, and provided women with a limited range of stereotypical roles: devoted mothers, good girls, fallen women, party girls, vamps and prostitutes. According to Sadr, 'the party girl served as a national palimpsest inscribed with contradictory social meanings' (Sadr 2006: 80). On the one hand, she was socially visible and active; on the other, her sexual allure made her morally flawed and inherently transgressive. The narratives of popular genre films frequently mirrored social mores and fears about the new socially active woman by either punishing her (by death) or redeeming her (through marriage).

While female stars might not have had the industrial or social capital to shape their films and roles to the extent of their male counterparts, several female pop stars, including Delkash, Pouran and Googoosh, also became the most enduring movie stars of the period. This was aided by the high degree of convergence between the film and popular music industries. The inclusion of musical sequences performed by female stars in a range of Iranian genre films evidences some of the ways in which the state doctrine of syncretic Westernisation made its way into the cinema through what Naficy calls 'syncretic adaptations of European and American movies, stories, characters, *mise-en-scène*, and filming styles, mixing them with Iranian elements' to form a 'cross-cultural amalgamation' (Naficy 2011b: 176). Such syncretism is evidenced in Googoosh's screen debut at the age of nine. *Hope and Fear/Beem va Omid* (Gorji Ebadia, 1960) was an important star vehicle for the young ingénue Googoosh, who in a key scene demonstrates her vocal prowess by singing in a seemingly endless array of cross-cultural musical styles (Breyley 2010: 207–8). While her successful film career was cut short by the 1979 Iranian Revolution, Googoosh remains a beloved superstar within the Iranian diaspora, still performing abroad to sell-out crowds.

Alternate Configurations of Stardom in the Islamic Republic

With the overthrow of Mohammad Reza Shah in the 1979 Iranian Revolution, the successful *film farsi* industry was brought to an abrupt halt, and most of its stars and directors were prevented from working – many of them, like the Shah and his family, leaving Iran forever. The Revolution ushered in a radically altered ideological climate, with the establishment of an Islamic theocracy that opposed the Westernisation introduced by the Pahlavi Shahs and a re-Islamicisation of virtually all spheres of society. The association of *film farsi* with sex and sin brought initial condemnation of film; however, Ayatollah Khomeini, Iran's newly installed religious leader, declared that cinema could indeed be used for educational purposes, and that such a cinema would be 'compatible with the healthy scientific and moral growth of society' (Haghigi 2002: 112). Thus an entirely new type of cinema emerged within a few years of the establishment of the Islamic Republic.

This new Iranian cinema was ostensibly cleansed of the corrupt and immoral qualities of *film farsi*, including much of its commercial value and its female

superstars. Sadr writes: 'In clichéd terms, revolutionary cinema was a cinema at war with imperialism. This kind of filmmaking excluded profit, the star system and competition' (Sadr 2006: 173). More incisively, Naficy writes: 'By banning the actors' and stars' voices, faces, and bodies by legal and illegal harassments, impediments, lashings, and confiscations of their persons and properties, the new regime was not only going after the Pahlavi-era stars but also dismantling its star system' (Naficy 2012a: 43). The purification of the film industry would have a significant impact on female roles. Until the mid 1980s, women barely made an appearance on the screen, and when they did they were invariably static and filmed in long shot rather than close-up, and were rarely the central protagonists (Naficy 2000: 564–6; Lahiji 2002: 215–26). It would be many years before a new generation of female stars would emerge.

The virtual disappearance of women from the screen allowed very little opportunity for female actresses to attain the kind of screen presence required to construct them as stars. For numerous film theorists, the close-up plays a crucial role in the formation of stars and their consumption. Jean Epstein, Béla Balázs and Roland Barthes have all pointed to the ways in which the close-up of a face can heighten the emotional, sensual, erotic and psychological connections between viewer and star, creating a sense of immediacy, proximity and intimacy (Doane 2003). The virtual absence of the female close-up in Iranian cinema during the first decade of the post-revolutionary period may in part be explained by the problems this implied intimacy between screen and viewer posed for modesty.

Only after the end of the Iran–Iraq war would women begin to achieve much greater screen presence and star power. The last two decades have seen the emergence of numerous female film stars, including Niki Karimi, Leila Hatami and Golshifteh Farahani. While these women might be said to hold a powerful place in Iranian society – many of them are recognised as important artists, beloved public figures and national role models – they are at the same time heavily scrutinised by the authorities and public alike, particularly when they move from the national to the international arena.

Reflection and Refraction

With her small, dainty frame, angelic face and prominent round eyes, Niki Karimi quickly became the darling of the Iranian cinema in the early 1990s. Her first major screen appearance, *The Bride/Aroos* (Behroz Afkhami, 1990), was a box-office hit, instantly making her a star. Appearing in the immediate post-Iran–Iraq war context, the film's colour and playfulness provided much relief from the austerity of wartime filmmaking. Naficy has highlighted the important role close-ups and the female gaze played in this film: 'Afkhami did not shy away from using alluring close-ups that fetishized the attractive bride (Niki Karimi) gazing with desire at her husband (Abolfazl Pururab)' (Naficy 2012b: 127). Despite this suggestion of desire and the

use of a much more active female gaze, Karimi has, for the most part, maintained a highly modest persona on and off the screen. If *The Bride* made audiences fall in love with 19-year-old Karimi, it was her appearance in two films by Dariush Mehrjui – *Sara* (1992) and *Pari* (1994) – that consolidated her reputation as an actress capable of displaying a range of emotional intensities using little more than her face and eyes, skills that served her well in the lead roles she played in Tahmineh Milani's 'Fereshteh Trilogy': *Two Women/Do zan* (1999), *The Hidden Half/Nimeh-ye penhan* (2001) and *The Fifth Reaction/Vakonesh panjom* (2003).

The close-up, combined with her innocent, girlish face and acting style, has been key to Karimi's unique star image. After her portrayal of the playful bride in *The Bride*, Mehrjui helped to shape Karimi's image into that of a young woman who was at once suffering and vulnerable, but also capable of intense thought and action, even if in the end she could not effect change. Sadr notes that women in these films of the 1990s reflected the 'official mood': 'Women were still technically second-class citizens, remaining the virtual property of men' (Sadr 2006: 261). But despite reproducing many dominant attitudes about women's rightful place as dutiful wives and mothers, these films also offered some limited degree of social critique by demonstrating the need for achieving 'self-awareness'. Karimi's primary role as a star was to glean from audiences compassion towards her protagonists, so that they too might share in that 'journey towards self-discovery' (Sadr 2006: 262). The close-up plays a significant role in this process.

With reference to Béla Balázs's conception of the close-up, Mary Ann Doane has written: 'It is barely possible to see a close-up of a face without asking: what is he/she thinking, feeling, suffering? What is happening beyond what I can see?' (Doane 2003: 96). The close-up invites us to bear witness to outward displays of emotion, and also signals us to look beyond the merely visible, to recognise that 'there is something there that we cannot see'. We must, according to Balázs, 'read between the lines' (Balázs cited in Doane 2003: 96). Throughout her career, Karimi has developed a unique ability to show varying emotional intensities through a flood of tears, a furrowed brow, a pensive stare or a playful flick of the eye. At the same time, Karimi holds something back, hinting at forces beyond the frame and even beyond the screen. This something-beyond is often emotional, but equally, the demeanour of her face may point towards the conditions of filming in Iran. Karimi has perfected the downcast eyes that denote modesty, and frequently her headscarf will frame her face so tightly that not even a wisp of hair may be seen. Thus abstracted, and effectively always in close-up, her face often points beyond the frame, the scene, even the film, to the broader socio-political situation. As much as she may serve as a mirror for female viewers in particular, who may see something of themselves in her and identify with her suffering at the hands of a diegetic patriarchal world, Karimi's face may also function as a lens through which a refracted view of the world beyond the frame may be interrogated. Indeed, as I have argued elsewhere, Karimi's work with Tahmineh Milani was crucial in facilitating

a 'double consciousness'. That is, through Karimi as both reflective surface and refractive lens, audiences could see themselves and the world both as it is and as it could or should be. Through these roles, Karimi's star image crafted her as the ultimate melodramatic heroine (Langford 2010).

Leila Hatami has recently risen to international fame as the female lead in Asghar Farhadi's Oscar-winning film *A Separation/Jodaeiye Nader az Simin* (2011). However, in Iran, she has been a household name and one of the country's most loved and respected actresses since she appeared in Mehrjui's *Leila* in 1997. Perhaps what most separates Hatami's star persona from that of Karimi is the air of womanly sophistication that pervades many of her on-screen roles, as well as her off-screen star presence. Hatami is the daughter of one of Iran's most respected directors, Ali Hatami, and actress Zari Khoshkam. Hatami made her first screen appearance at age 12 in her father's *Kamalolmolk* (1982), but it was not until returning from her university education in Switzerland that *Leila* would not only secure her a place as one of Iran's shooting stars but also link her to an enduring image of strong, inviolable womanhood.

For many Iranians, Hatami is still synonymous with her on-screen namesake in Mehrjui's film. In contrast to Karimi's girlish and occasionally naive woman prone to outbursts of hysterical emotion, Hatami came to be associated with a range of qualities befitting a strong, loving and caring woman. In *Leila*, Hatami plays the devoted and loving wife of Reza (Ali Mosaffa). Upon discovering that she is unable to conceive, Leila, after a period of resistance, is finally persuaded by her mother-in-law to agree that Reza should take a second wife in order to provide them with an heir. This is a tense domestic drama that ends well for no one. The film has been variously criticised and praised for either condoning or condemning polygamy, and to some extent the narrative is open enough to enable a reading either way. On the other hand, the themes of polygamy and family pressure are focalised so strongly through Leila's perspective that viewers are encouraged to learn something of the emotional consequences of the situation. Unlike many of Karimi's characters, Leila's inner turmoil is rarely shown through an outward display of emotion. Apart from a few moments of laughter, for the most part Hatami's face remains pensive, her head tilted slightly downward and her eyes soft and demure. This does not, however, render her weak or emotionless. Rather, a sense of great inner strength is achieved through a combination of voice-over, framing, lighting and *mise-en-scène*. At moments of greatest emotional turmoil, Hatami's face is invariably cast in shadow; or, when fully lit, she will be isolated against a dark background, emphasising the ambivalence and loneliness felt by her character. At other times, she is framed peering out from behind a doorframe or a curtain. Mehrjui also uses objects to express Leila's inner turmoil: a teapot overflows, a broken string of pearls spills into the sink, signalling the desperation of her situation.

Importantly, these techniques promote viewer identification with Leila – the character and the star. Mehrjui allows us to see and know things about Leila's

inner life that remain largely unknown to the other characters. Direct identification is forged by the use of voice-over, which gives us privileged access to Leila's innermost thoughts: her love, her ambivalence, her turmoil and her pain. Hatami's voice, which is at once sweet and full of gravitas, serves to construct the impression of a woman coming to self-awareness about the place society has marked out for her. It is perhaps this sense of intimacy forged through a combination of Hatami's performance and Mehrjui's use of cinematic techniques that enabled this role to set her on the road to stardom. Furthermore, in a socio-political context where Iranian films were only beginning to place women at the forefront of the narrative – like Karimi, and other female stars such as Hediyeh Tehrani, who rose in the 1990s – Hatami must be considered important not so much for providing simplistic ideologically correct role models, but as an on-screen consciousness through whom women's experiences could be refracted.

In an industry in which stardom is made more through on-screen appearances than through off-screen antics and publicity, Mehrjui has been a central force in the production of many post-revolutionary female stars. Golshifteh Farahani made her screen debut at age 14 in Mehrjui's poetic drama *The Pear Tree/Derakhte Golabi* (1998). Farahani represents a younger generation of female stars. Farahani's star image has largely been constructed through a range of dramatic and romantic roles in films such as *In the Name of the Father/Be name pedar* (Ebrahim Hatamikia, 2006), *M for Mother/Mim mesle madar* (Rasool Mollagholi Poor, 2006), *Santoori* (Dariush Mehrjui, 2007) and *About Elly/Darbareye Elly* (Asghar Farhadi, 2009). She even starred as a stunt-riding motorcyclist in *The Wall/Divar* (Mohammad-Ali Talebi, 2008). Through many of these roles, Farahani has developed a star persona that is at once sweet and loveable, strong and at times defiant. Both these qualities came together in Mehrjui's *Santoori*, where she played Hanieh, the wife of a drug-addicted musician named Ali, played by Iranian heartthrob Bahram Radan. Despite having been banned in Iran, *Santoori* circulated on DVD on the black market, becoming an unofficial hit and consolidating Farahani's fan base. This fan base would, however, become polarised as she began to explore an international acting career.

Red Lines and Red Carpets: Accommodation, Adaptation and Resistance

In my overview of the careers of Karimi, Hatami and Farahani, I have placed an emphasis on their screen roles, as it is primarily on screen rather than through media coverage that stars are made in Iran. Magazines, TV programmes and websites dedicated to film news and criticism also contribute to stardom. However, in the officially sanctioned press and media, which like the film industry are subject to strict censorship, there is little discussion of stars beyond providing basic biographical information and appraisal of their performances. Unlike the voracious global media organisations that feed off the personal lives, relationships, affairs,

breakups and scandals of stars, for the most part the Iranian press upholds a strict separation between public and private spheres, which is a key characteristic of Iranian society. In publicity for the films, stars feature on posters and billboards; however, at events such as film premieres, stars invariably share equal limelight with directors.

Indeed, the downplaying of hype around stardom may be evidenced by the controversy raised over recent attempts to introduce red-carpet events to the country. According to the Iranian film journal *Film International*, the first red-carpet event in the history of Iranian cinema took place in 2009. Arranged by the Iranian film news website *Cinemaema*, the event was intended not merely to promote Masud Kimiai's new film *Trial on the Street/Mohakeme dar khiaban* (2009), but to celebrate Kimiai's 40-year filmmaking career. This represents a tentative move towards what *Cinemaema*'s managing director Nima Hassaninasab called 'modern methods' of publicity to attract more people to the cinema. However, he added that it was necessary to adapt such an event to suit Iranian culture and customs. While the event was covered by numerous Iranian media organisations, it was criticised on Iranian state television primarily on ideological grounds, as a 'Western phenomenon', as well as for posing a threat to public safety due to the fear of crowds forming to catch a glimpse of their favourite stars (Anon. 2010: 37). This controversy around the red carpet highlights some of the ongoing cultural and political tensions surrounding the phenomenon of stardom in Iran, which is at odds with revolutionary ideology.

In conceptual terms, the international red carpet has in recent years served as an important threshold onto which all three of the stars discussed here have stepped, with varying consequences. Apart from its role in the publicity apparatus of films and film festivals, in the Iranian context we might view the red carpet metaphorically as a manifestation of the 'red lines' of censorship. Over the last three decades, the success of Iranian films at international festivals has brought with it numerous invitations for Iranian filmmakers and actors to attend red-carpet occasions, and to serve on the juries of some of the world's most renowned festivals, including Cannes, Venice and Berlin. As the female actors became more prominent on screen in the 1990s, so too did their international profile increase; however, along with this international publicity has come greater scrutiny and censure.

Niki Karimi was the first of the actresses discussed here to tread the red carpet abroad, and while she has on numerous occasions appeared without a headscarf at such events, she has rarely been subject to criticism by either the Iranian authorities or religious conservatives. In contrast, in recent years, both Leila Hatami and Golshifteh Farahani have been subject to criticism and censure by the authorities and hard-line opinion-makers. While much of the critical discourse has been directed at their appearance, this, I would argue, is less a question of how or whether they appear veiled, and more a matter of increased ideological tension between Iran and 'the West', and the shift to more conservative domestic politics

following the election of Mahmoud Ahmadinejad in 2005, and his contested re-election in 2009. In addition, however, certain textual and contextual aspects of their recent appearances have also contributed to this.

Hatami's rise to international acclaim came with the spectacular entry of Asghar Farhadi's *A Separation* onto the international film-festival circuit. Together with Farhadi and her co-star Payman Maadi, Hatami has made numerous trips down the red carpet. From February 2011, when the film premiered at the Berlin Film Festival, to the Oscars in February 2012, the Cannes Film Festival in May 2012, the Rome Film Festival in November 2012, and all the places in between, including Hong Kong, Santa Monica and Marrakech, Hatami's star image has undergone significant modification. In undergoing this change, her public image has exhibited varying degrees of accommodation and adaptation as she has moved from the primarily film-centred star persona developed within Iran to the more overtly glamorous and publicity-based expectations of international media. This is evidenced primarily through styling: clothes, make-up, hair and manner of veiling. As with any cross-cultural encounter, Hatami has been careful to ensure this styling accommodates Iranian expectations about female modesty: covering her hair and wearing long, loose-fitting clothing. Throughout most of her many public appearances during 2011 and 2012, Hatami was seen wearing simple but elegant dark-coloured clothing, luxurious fabrics such as velvet and silk, and elaborate embroidery adding a touch of colour and glamour.[1] In most instances she wears a simple, dark scarf draped over her head, wrapped loosely around her neck and shoulders and showing but a wisp of hair. Her appearance at the Governors Ball amidst the hype of the 84th Academy Awards, however, marked a significant shift. Hatami appeared in a long, white, flowing gown crafted from layers of silk, lace and chiffon. Long sleeves and a high collar accommodated Iranian modesty rules, enabling her to wear her long scarf draped over her head, but not wrapped around her neck. Ringlets of hair teasingly spilled out from the confines of the veil. With its close resemblance to an Iranian-style wedding dress, this particular outfit in some ways signified an excess of modesty re-framed for the international arena. It would be at the Cannes Film Festival later in 2012 that a more dramatic transformation of her appearance would cause controversy at home in Iran.

Hatami's two major red-carpet appearances at the Cannes Film Festival reflect a much more daring attempt to adapt to the high-fashion world of international celebrity culture. On 26 May she appeared in a billowing green dress, her hair pulled back and covered by a green scarf tied at the back, rather than draped around her neck and shoulders, a ruffled neckline substituting for traditional modest drapery. Social media was awash with varying opinions about this daring fashion choice, which included a pair of silver platform shoes. Numerous fans complained that she should hire a stylist; others suggested she should be more demure; and still more expressed their loving admiration of her and praised her elegance.[2] The very next day, her red-carpet appearance at the closing ceremony

would cause an even greater stir. Her outfit might be described as the epitome of syncretic glamour: a long-sleeved white satin blouse tucked at the waist into a long, flowing black taffeta skirt, a blush of colour provided by a red rose pinned at her waist and, uncharacteristically for Hatami, bright red lipstick. Her hair was tucked into a black scarf tied at the back. This appearance drew the attention of loving fans and censuring authorities alike. Shortly after her appearance in Cannes, Iranian news site *Entekhab* reported that social affairs minister Bahman Kargar had expressed outrage about her 'obscene' dress (Anon. 2012a). Later, in July 2012, the UK-based *Daily Mail* reported that Iranian attorney general Gholam Hossein Mohseni-Ejei had called for a travel ban on Iranian actresses who failed to correctly observe the Islamic dress code at international awards ceremonies (McDermott 2012). Even more defamatory opinions were expressed on the hard-line Rajanews website. The anonymous article accused Hatami of becoming the plaything of Zionists, comparing the black-and-white outfit she wore at Cannes with that of an Orthodox Jewish woman. The article goes on to conflate her international appearances with her role in *A Separation*, casting her as a woman who just wants to turn her back on her country, religion and culture (Anon. 2012b). Her subsequent appearances on the red carpet at the Rome Film Festival in November 2012 show a return to a much more demure look. These declamatory reactions highlight the ongoing tensions faced by Iran's female stars, particularly as they cross the threshold from Iran onto the international stage.

While Hatami appears to have weathered this storm of controversy and maintained both her dignity and her popularity, Farahani's aspirations to broaden the scope of her acting career have involved overt resistance to the Islamic state's attempt to place tight boundaries around female stars. This has come at the price of exile. The highly paternalistic attitude towards female stars is demonstrated by the public and government reaction to her unauthorised role in Ridley Scott's *Body of Lies* (2008), and her unveiled appearance at the film's premiere in New York (Erdbrink 2008). This led to her being advised not to return to Iran. Farahani subsequently became embroiled in unprecedented controversy when she appeared topless in French glamour magazine *Madame Figaro* in January 2012. The provocative black- and-white images show her in various states of undress. This was followed by the release of a short video promoting the Cesar Film Awards. In the video, *Corps et âmes/Body and Soul* (Jean-Baptiste Mondino, 2012), Farahani appears along with other rising stars of French cinema. From shot to shot, each peels off an item of clothing and recites a poetic line relating to the theme of body and soul. Problematically, Farahani is the only female actor to appear nude, and unlike the other actors, who speak their lines direct to camera, Farahani's voice is heard only in voice-over, saying, 'De vos rêves, je serai la chair' ('I will be the flesh of your dreams'). The video spread quickly via social media, and polarised her immense fan base in Iran and abroad. Now living in exile in France, Farahani is on her way to becoming a European film star, and her face and figure have graced some of

Europe's most glamorous fashion and celebrity magazines, often constructing her as an exotic beauty, and admiring her for what is perceived as active resistance against the Iranian regime. Problematically, yet another set of ideological expectations have been attached to her star persona, which is in danger of being conscripted even further into the antagonistic relationship between Iran and the West.

As I hope to have demonstrated, female stardom in Iran has long been fraught with social, cultural and ideological tensions and contradictions. At each stage of Iranian film history, the place of women on-screen, as in society, has been subject to intense scrutiny and control. From the modest beginnings of an artisanal industry through the popular period of *film farsi*, female stars frequently served as role models for a society undergoing rapid modernisation and social change. In the post-revolutionary era, female stardom is underpinned by the requirements of modesty dictated by the country's strict censorship. Importantly, however, Iran's contemporary female stars rarely function merely as role models reflecting state ideology. Rather, through the work of some of the country's key filmmakers, the identificatory mechanisms of cinema are also used to construct these women as refractive lenses through which alternate ideas about Iranian womanhood may be expressed. As they move into the international arena, however, Iran's female stars are heavily scrutinised, and with this intensified scrutiny comes evidence of various strategies of accommodation of the Iranian government's heavily conservative view of women, but also varying degrees of adaptation to the glamorous world of the international red carpet. But such accommodation and adaptation are not always easy. In many ways, Farahani's banishment from Iran for her 'transgressive' behaviour in the international arena is not terribly unlike the perceived transgression that led to Saminezhad's banishment from Iranian screens and the social ostracism she faced for appearing unveiled on screen some 80 years ago. Iran's rising female stars may very well be ready for their close-up, but their cinematic image remains heavily circumscribed by prevailing ideology.

Acknowledgements

Thanks to my research assistant Sanaz Fotouhi, and also to Laetitia Nanquette, Mahsa Salamati and Reza Taheri for their invaluable discussions on this topic.

Notes

1. An extensive photographic record of these appearances may be found on the entertainment news website Zimbio (www.zimbio.com/photos/Leila+Hatami – last accessed 12 April 2013).
2. Comments on a Leila Hatami Facebook community page provides evidence of these varying opinions in English and Farsi (www.facebook.com/Cinema4Peace/posts/430587380293753 – last accessed 26 March 2013).

10

BEWARE FILM STAR! Towards a Performance and Cultural Analysis of Innokenty Smoktunovsky as Soviet Film Star

Ludmila Stern and Greg Dolgopolov

> For our deprived generation Myshkin/Smoktunovsky legitimised the individual's right to being unusual, to not matching the habitual, in a word, to being an individual.
>
> Nikolay Svanidze (Maslo 2008)

Soviet film stars articulated a contradictory relationship between the state and popular culture. While individualism was eschewed as bourgeois, the regime needed its heroes and model citizens. What did it mean to be a star under a regime with such contradictions? The most popular stars in the 1920s USSR were Western actors: Chaplin, Pickford and Fairbanks (Taylor 1993: 76). The Soviet star system that emerged from the 1930s sought to construct the ideal Soviet citizen, but the postwar star Innokenty Smoktunovsky (1925–94) was neither glamorous nor the ideal Soviet citizen. His uniqueness in capturing the mood and values of the Thaw – the period from the mid 1950s to the mid 1960s that followed Stalin's death and that saw a liberalisation in politics and the arts – made him the most celebrated actor of his time. In this chapter we examine the emergence of Smoktunovsky as a Soviet star of the Thaw. We argue that his stardom was a synthesis of his extraordinary acting talents, spontaneous audience adulation, formal state patronage, the burgeoning of the film industry, and his complex articulation of the informal cultural and spiritual themes of the Thaw.

Smoktunovsky's performance style simultaneously articulated and gave a tangible form to the themes of the Thaw, while also emerging as a symptom of the social and cultural context of the time. We also examine Smoktunovsky's role and performance style as an articulation of the key themes of the Thaw in *Devyat' dney odnogo goda*/*Nine Days of One Year* (Romm 1961). In our study of Smoktunovsky's stardom, we were inspired by Vincent Bohlinger's (2012) methodological approach to the Soviet film star's production in the public sphere in the 1920s and 1930s, and especially his focus on the performance style.

The Soviet Star System

Unlike in the West, in the Soviet Union the state was the primary studio, producer, exhibitor and critic. Through a network of agencies, it also took over the creation of state-approved 'idols': their promotion through TV, interviews and meetings with spectators, postcards, articles and reviews, and awards (Pyatigorskaya 1990: 162). As official promotion through state-controlled media was the only way of elevating a celebrity on the hierarchical ladder, only an officially approved celebrity could become a star (Pyatigorskaya 1990: 163–4).

The 'red stars' of the 1930s were rewarded

> with the full panoply of patronage accorded to the Stalinist *nomenklatura*. They enjoyed privileged access to food supplies, welfare services, housing, cars, travel and holidays denied to the population at large. They received official honours and their films received official prizes...But their role was not confined to the screen. Like all Soviet artists they were expected to tour factories and collective farms, workers' and peasants' clubs, to work in support of Soviet cinema and its message...Red stars were...the property of the state, of the Party.... (Taylor 1993: 82–3)

One of the features of creating Soviet stars was the tension between audience popularity and official recognition. Socialist Realism in the 1930s emphasised public life and relentless optimism with ideal types, robust gender traits and a daring, valiant or romantic quality. Performance was secondary to heroic potential. During the Stalin era, Soviet ideal types were harder to vary, because they were politically and ideologically dictated and not determined by audience tastes (Youngblood 1992: 95). While there were many gifted Soviet actors, few became 'stars' other than the immensely popular Lybov Orlova, Faina Ranevskaya and Nikolai Cherkasov.

In contrast, the film stars of the Thaw era transformed many of the established Soviet requirements. There were 'de-monumentalised' film subjects and new roles with unusual, authentic and humane heroes. Actors like Aleksei Batalov,

Tatiana Samoilova, Tatyana Lavrova, Oleg Yefremov and Mikhail Ulyanov won audience popularity and official acceptance. The link between popularity and official approval was now based on a value and a labour system whereby it was almost impossible to become a film star without developing professional authority and respectability through a theatre career. Highlighting the cultural specificity of stardom, the Soviet star's images of the 1960s circulated in a limited variety of forms, and their visibility outside performance was limited. Contrary to the assertion that 'a film star's image is not just his or her films' (Dyer 1986: 3), Soviet stars materialised through the textuality of their performances, not their private lives. Soviet stars of the Thaw needed to negotiate the sometimes incompatible relationship between official approval and popular fondness, based on symbolic resonances of specifically progressive roles interpreted by various audience communities. Stardom was based on the confluence of supreme acting performance and appropriately liberal roles that allowed for the symbolic articulation of the cultural and social hopes of the era.

Smoktunovsky's Status as a Star

Innokenty Smoktunovsky was a Siberian-born son of formerly deported peasants. Drafted into the Red Army during the Great Patriotic War (1941–45), he survived German captivity, escaped, and returned to the army. To avoid a likely postwar arrest as a former POW, he began his acting career in provincial theatres, only coming to Moscow in the mid 1950s. His years of rejection by the major theatres, fortunate meetings and perseverance constitute an important part of his biography – he was a self-made actor who worked hard to maintain his status.

Smoktunovsky's first film performance, in Alexander Ivanov's *Soldiers/Soldaty* (1956), got him noticed and led to his being cast as Prince Myshkin in an adaptation of Dostoyevsky's *The Idiot* at the prestigious Bolshoi Drama Theatre (1957–58). This role brought Smoktunovsky overnight celebrity status as an 'actor of a new type', marking the beginning of his spectacular ascent as a theatre and cinema star of the Thaw period. After years of rejection, Smoktunovsky was in high demand by the Soviet Union's leading directors for films that were seen by millions in the Soviet Union and abroad.

Smoktunovsky's nearly-40-year career as a star straddled the periods of Khruschev's Thaw, Brezhnev's Stagnation, Gorbachev's *Perestroika* and Yeltsin's post-Soviet film-industry crisis. Never refusing an invitation, he performed in approximately 200 films and plays, sometimes poorly but mostly brilliantly, starring and playing cameo roles, reciting poetry, narrating off-screen and dubbing foreign films in all the available media and genres: cinema, theatre, television and radio. Film director Sergei Solov'yov claimed that 'Smoktunovsky was the only actor who played geniuses in Soviet cinema [Tchaikovsky, Hamlet, Mozart, Pushkin, Lenin].

How do you play a genius?...I think because he was a genius' (*Islands* 2010).[1] Given Soviet cinema's predilection for high-cultural biopics, it is noteworthy how often Smoktunovsky was entrusted with performing leading historical figures. The cultural significance of those roles played an important part in constructing the legend of Smoktunovsky.

As Bohlinger suggests, the analysis of performance allows scholars of film stars to examine elements of the star's performance that are widely identifiable as consistent from film to film despite changes in character and storyline (2012: 2). The focus on the 'Thaw intellectual' may distract us from examining the uniqueness of Smoktunovsky's performance style – sensitive, confessional, even spiritual, with unexpected interpretations of roles. Making this task even more difficult is the fact that critics, directors and fellow actors all agree that Smoktunovsky exhibited a remarkable gift for transformation that was born of meticulous preparation, and an often combative relationship with his directors.

Several factors contributed to his non-formulaic style, creating a unique spiritual effect: his naive wide-open eyes, his memorable gestural language, and his unusual vocal expressiveness. The director Eldar Ryazanov explained the effect of his performance by calling Smoktunovsky

> a confessional artist. He was the first in our cinema who laid bare his soul to such an extent and tore off his skin. Before him, there were many brilliant artists, but the inner life, the inner feelings, the inner tenderness before him was closed. And Smoktunovsky in this sense launched a new form of acting in our cinema. (*Lest We Forget* 2002)

Indeed, Smoktunovsky's fluid gestures would stand out against other actors' more conventional and reserved gestural economy, and create a quiet revolution in the actors' circles. He had a profound effect on his fellow actors, who either worshipped him or sought to emulate his trademark performance style: softly spoken, unusual, individual and naive. The effect of his performance style was such that, according to his contemporaries, it gave individuals the right to be themselves, liberated from the obligation to appear ordinary.

Smoktunovsky was aware of his 'branding' as good, naive and spiritually focused. In the last of his numerous recorded interviews, he explained his artistic success by connecting his roles to his off-screen persona: 'My naiveté, my, well, honesty, and my natural (sorry, to say this) kindness...all these qualities, perhaps, sat comfortably with Dostoevsky's writing' (*Recollections in the Garden* 1993). This focus on kindness, which was antithetical to the prevailing sentiments of the age, was the actor's signature style and philosophy. Even in his 'cruellest' roles, he unearthed a narrative of goodness in each of those characters, to the point that audiences empathised more with his Salieri than the tragic Mozart (*Little Tragedies/Malen'kiye tragedii*, Shveitser 1979).

Thaw Themes – 'The Actor Who'd been Long Awaited'

Smoktunovsky's rise to stardom became emblematic of the Thaw – a spasmodically and inconsistently liberalising post-Stalinist period remembered for the rehabilitation of political prisoners and cultural figures, the return of surviving ones (Solzhenitsyn) and the dismantling of Stalin's personality cult. Even though the liberalisation was partial and fragmentary, a spirit of hope and optimism in society positively affected literature, theatre, film and other aspects of cultural life and production. Among the many celebrated actors of the Thaw, Smoktunovsky was singled out as 'the actor who'd been long awaited' (*The Actor Who'd Been Long Awaited* 1986), reflecting the need for a focal point for cultural transformations.

The 'yearning . . . for honesty, truth and for real art' (Stites 1992: 126) spoke across popular and high culture to different audiences, from the intelligentsia to the masses. However, the main thrust against the old system came from the technical, literary and artistic intelligentsia as audiences and producers. The focus on the individual experience and everyday life was representative of a rejection of the party-state monumentalism and the mythology of the monolithic masses. Smoktunovsky's original contribution to the progressive discourse of the Thaw occurred through the interpretative nuances of his performances. It was the symbolic power invested in his roles, as well as the interpretations and the projected context of reading between the lines of his performances, that created a powerful nexus between audiences and Smoktunovsky.

During this period, the Soviet cinema industry saw its production boosted with increased investment, the diversification of film genres and a greater focus on what audiences wanted. Cinema attracted a range of professions – writers, composers and theatre actors – and had a great influence on the public consciousness (Fomin 1998: 9–10). If the 1920s films were populated by characters that typified workers and peasants, and the 1930s portrayed 'heroic leadership models' (Taylor 1993: 71), the Thaw films moved away from monumental heroes to embrace 'individual human beings' and positioned 'humanist values before ideological concerns' (Beumers 2009: 112). The Soviet New Wave, starting with Mikhail Kalatozov's *The Cranes are Flying* (1957), was celebrated internationally for its astounding ethical and stylistic innovations. Some of the standout films of the era included Grigory Chukhrai's *The Forty First* (1956) and *Ballad of a Soldier* (1959) and Georgy Danelia's *Seryozha* (1960). The search for authenticity led to the search for new heroes. It is remarkable that, of the many great actors who emerged during this period, it was Smoktunovsky who is best remembered as the 'actor of a new type'.

The breaking of the prevailing stereotypes of Socialist Realism began with the repertoire in which Smoktunovsky appeared. His first film, *Soldiers* (1956), reflected the changing 'cinematic landscape' of the Great Patriotic War, consonant with the Thaw ethos of 'de-heroisation' of Soviet history. The 1957–58 play *The Idiot* was adapted from the book by the recently proscribed writer, Dostoyevsky.

Hamlet was a play that Stalin considered it unnecessary to perform, and Grigory Kozintsev's 1964 interpretation pointedly demonstrated why, with its harsh analysis of totalitarianism.

These productions were pregnant with allusions to the beginning of a new era, ideological renewal and political connotations of the freedom of the spirit. The stage production of *The Idiot* (Tovstonogov 1957) was highly metaphorical, and described as heralding the Thaw:

> Prince Myshkin as performed by Smoktunovsky is 'the spring of light', that early spring that begins in the air and in the light, preceding the spring of water, animals and forest, followed by that of the man. (Berkovsky 1958/69: 561)

Similarly, in Kozintsev's symbolic adaptation of *Hamlet*, King Claudius was identifiable with Stalin, and the setting of Denmark appeared as a high-surveillance prison. In portraying a virile struggle against a perverse authority, Smoktunovsky's performance highlighted the key themes of the Thaw and delivered international recognition for 'perhaps the best Hamlet' (Pennington 1996: 16). Demonstrating his remarkable capacity to transform, Smoktunovsky's performance is very different from his other work in that there are none of the childish, kind or delicate moments, but a savagery, brutality and decisiveness that combine into a surprisingly unique interpretation of a traditionally indecisive hero.[2] The film led to national and international recognition, and Smoktunovsky was awarded the Prize of the Soviet Union of Cinematographers (1964) and the Lenin Prize (1965).

Smoktunovsky's characters did not typify Soviet heroes: shock workers or jolly peasants. With his odd demeanour, big eyes, gangly physique and soft-spoken voice, he did not fit any of the popular Soviet myths: romantic hero, exemplary citizen, ordinary man (Pyatigorskaya 1991). In the times of 'de-monumentalised' heroes (Stites 1992: 139) typical of the Thaw, his characters were also different from the 'boy-next-door' charismatic yet traditional positive characters, such as those portrayed by another star of the Thaw, Alexei Batalov. Smoktunovsky's characters were multifaceted, psychologically complex and unusual. They conveyed the ideas of truth, justice and humanity that were contextually novel, while steeped in a recognisable reality. His masculinity was defined not by action and physicality, but by stoic values and internal determination. His characters, Lieutenant Farber or Prince Myshkin, Hamlet or scientist Kulikov, and even car thief Detochkin, appeared as members of the intelligentsia: thinking, reflexive and morally decent contemporary men. His Farber was the antithesis of a war hero – a bespectacled Jewish maths teacher who, despite his 'unheroic' portrayal, has the courage of utmost honesty (Yegoshina 2004: 12). Smoktunovsky believed that his own wartime experience dictated his identification with the character. 'I played this part well. I didn't play anything but decided, "I will be, I'll exist, I'll live". I didn't act' (*Recollections in the Garden* 1993). Smoktunovsky's eccentric Prince Myshkin had

the appearance and gestures that alluded to the recently returned political prisoners (Yegoshina 2004: 18):

> His entire gestural movement [was] a bit apologetic, as if he anticipated if not a blow then perhaps some other violent assault ... He filled Myshkin's character with it. (Smelyansky in *The MKhAT Men. Not of this World* 2012).

These features of goodness, spirituality and longing to act humanely, even if going against the laws of the land, were almost parodic in the tragicomic role of Detochkin (*Beware of the Car* 1964). Smoktunovsky produced his then-signature qualities of purity, naivety and childlike yet principled commitment to fighting injustice with his stooping figure, shuffling step, seemingly untamed vocal expression and trusting, wide-eyed grin. However, in Mikhail Romm's *Nine Days of One Year* (1961) he created a character of contrasts – a sophisticated, polished (even pampered), reflexive and outwardly cynical scientist Ilya Kulikov. If stars are 'a reflection in which the public studies and adjusts its own image of itself' (Durgnat 1967: 137–8), the audiences' interpretation of Smoktunovsky's performance was critical in the formation of a web of cultural imagining of the Thaw.

Official Recognition and the Making of a Soviet Star

Smoktunovsky's branding as a reflexive actor and an intellectual was important in redefining the post-Stalinist liberalisation during the short period of the Soviet intelligentsia. Acquiring a distinctive voice in the debates about the country's past and present, he joined the ranks of those who influenced audiences and shaped the values of the 1960s' thinking viewer.

However, it would be inaccurate to portray Smoktunovsky as an activist and a rebel. Like other popular artists, especially film and theatre actors, without the backing of the state he would not have had the opportunity to reach a broad audience.

While his success, at least initially, was spontaneous, his subsequent rise to star-like status was shaped by and depended on official recognition and patronage. The state promotion machine generated favourable film reviews, posters and even short publicity roles, and after years of non-recognition Smoktunovsky willingly participated. His eccentric off-screen persona, combined with his Thaw-era role selection, and the values associated with his performances created an unusual but compelling combination for a state-supported People's Artist.

Approved by the state, he was the most awarded actor of his generation, winning the Lenin Prize (1965), awarded the title of the People's Artist of RSFSR (1969) and of USSR (1974) and the Hero of Socialist Labor (1990), as well as gaining three Lenin orders and many other awards. He was rewarded with exceptionally high actor's fees and other material rewards, including a then rare prestigious car, quality apartment, country house and regular foreign tours.

Despite his private hostility towards the regime, these rewards were important to Smoktunovsky and demonstrated the power of the state in creating, if not 'red stars', then at least acceptably liberal heroes who cooperated with the authorities. Rejecting the official commissions was impossible, and Smoktunovsky reluctantly agreed to play Lenin when Party officials made it clear to him that the Lenin Prize nomination for *Hamlet* would otherwise be withdrawn.[3] He fulfilled his obligations, portraying Lenin twice on film (in *On the Same Planet/Na odnoy planete* 1965 and *The First Visitor/Pervyy posetitel'* 1966), and in celebration of Brezhnev's seventieth anniversary he was the narrator for *A Tale of a Communist/Povest' o kommuniste* (Bessarabov 1976).

Smoktunovsky's responsibilities extended to off-screen official engagements: meeting with regional officials, and even making convincing speeches about local achievements in industry and agriculture, 'with his generous smile and his wide-open arms' (Smelyansky in *Not of this World* 2012). Casting for all film roles, especially for stars, needed to go through official channels for approval. Smoktunovsky's portrayal of Lenin made him sacrosanct, generating official anxiety when he was cast as the crook Detochkin in Ryazanov's *Beware of the Car*, which the then minister for culture, Romanov, tried to block (Ryazanov 1986: 101). Smoktunovsky negotiated a fine line between nurturing his professional career and his adoring audiences and fulfilling his political and state obligations, while maintaining the status of a complex Soviet star.

Of the film roles that made Smoktunovsky a recognisable star domestically and internationally, we will examine *Nine Days of One Year* (Romm 1961), in order to demonstrate his interpretative performance strategies in creating a complex contemporary character symbolic of the Thaw themes.

Nine Days of One Year

Nine Days of One Year was a key film of the Thaw era, which highlighted Smoktunovsky's innovative character interpretation that went against accepted professional personality types. 'The theme of scientists experimenting in a nuclear physics laboratory was highly topical at the time, when the H-bomb was tested on Novaya Zemlya' (Beumers 2009: 133). Innovative for Soviet cinema, *Nine Days* was not atypical of the Thaw ethos: an intellectual melodrama featuring scientists, a love triangle, a focus on individuals' choices, and a text that was purposefully left open. Smoktunovsky demonstrated a capacity to create a different character from his preceding roles and emphasise his performative difference from other established film stars.

Dmitry Gusev (Alexei Batalov) is an experimental physicist in charge of a thermonuclear laboratory in the Novosibirsk Academgorodok. Irradiated twice, he doggedly pursues his experiments for the greater social good. His 'antipode' is theoretical physicist Ilya Kulikov (Smoktunovsky), who works successfully in

Moscow, where he entertains a much more sceptical view of scientific discoveries taken over by pragmatic, non-scientific agendas. Caught between them is Lyolya (Tatiana Lavrova), who, after an on-again-off-again relationship first with Gusev and then Kulikov, eventually marries the terminally ill Gusev as his health deteriorates and his nuclear experiments repeatedly fail.

Gusev is dedicated, selfless and single-minded in the pursuit of his goal – a role that is close to a traditional Soviet positive hero stereotype. Batalov's acting is earnest, intense, serious and self-focused, but with an occasional gentle humorous touch, which appears to carry the legacy of his positive hero from *The Cranes are Flying* (1957), all too ready to sacrifice himself for a cause. In contrast, Smoktunovsky's Ilya Kulikov is a more self-satisfied man, lulled by success and the materialist opportunities offered to scientists. Many actors who auditioned for this role considered Kulikov to be not only a secondary but a 'slimy' character 'whose mentality was different from ours [i.e. Soviet], a negative character' (Smoktunovsky 1979, quoted in Dubrovsky 2001: 120). Smoktunovsky, on the contrary, saw Kulikov as a positive hero, in fact, *the* hero of the film, and the role as 'relevant, fresh and unusual for that time in its humane characteristics' (Smoktunovsky 1979, quoted in Dubrovsky 2001: 114).

Smoktunovsky's approach, as reflected in his memoirs, was to develop a modern, authentic and multi-layered character. Together with the director, Romm, he fleshed out a character of 'high intelligence, light but not flighty, a man with a complex nature: profound, beautiful and infinitely vulnerable in a childlike way' (Smoktunovsky 1979, quoted in Dubrovsky 2001: 114).

The film was well received. It was watched by 23.9 million people, and director Mikhail Romm received the largest number of audience letters for any film (Romm 1962: 75, quoted in Dubrovsky 2001: 122). At the thirteenth Karlovy Vary Film Festival it was Smoktunovsky, not Batalov, who was awarded the prize for best male actor. A group of eminent physicists all agreed that Kulikov's character was authentic and had been captured very accurately (Romm 1962: 78, quoted in Dubrovsky 2001: 121):

Almost all the film reviews said that Ilya Kulikov turned out to be one of the luminous and kind, if not the kindest, characters in the film. Perhaps I didn't succeed in creating a theoretical physicist of the right degree but I think it was impossible to miss a profound, subtle person and a kind and loving friend. (Smoktunovsky 1979: 133 in Dubrovsky 2001: 121)

Through the character of Kulikov, Smoktunovsky introduced audiences to a new, complex and much more nuanced character mode – that of 'capriciousness, touchiness and his rather inappropriate striving for elitist status' (Yefremov 1975, quoted in Dubrovsky 2001: 122).

Performance and Transformation

Smoktunovsky adapted his theatrical grounding exceptionally well to the camera, and despite his reputation for effusive gestural work did not overwhelm the *mise-en-scène*. His co-star Batalov described him as 'a most technically skilled and experienced actor, even too professional for his age' (Aleksei Batalov 1984, quoted in Dubrovsky 2001: 115). Smoktunovsky's Kulikov was different from his earlier theatre performance of Myshkin. He was not odd and strange, but spoilt and entitled. His voice was no longer softly spoken, but was demanding, petulant and confident. Smoktunovsky was driven by his compulsion for continually creating new and authentic characters. This demand for character actors was clearly articulated by the celebrated actor and director Oleg Yefremov, who warned of the danger, for any actor, of turning one's original 'discovery' into a 'trademark,' a method (Yefremov 1975, quoted in Dubrovsky 2001: 122). In *Nine Days*, Smoktunovsky succeeded in creating an entirely unique and modern character that was not reminiscent of Farber, Prince Myshkin or his earlier performance as another scientist, the geologist Sabinin, the hero of *Letter Never Sent* (Kalatozov 1959).

One of the most captivating passages in the film, which clearly demonstrated the uniqueness of Smoktunovsky's performance in the context of the era and the differences between his and Batalov's style, was the supper scene in the lavish Aragvi restaurant. Smoktunovsky's Kulikov stands out with his blond hair, elegant light suit (contrasting with Gusev's and Lyolya's dark-coloured hair and clothes) and his agitation as he turns and twists in his chair. His demanding tone when speaking to the waiter (after all, he is a celebrity, recognised in airports and hospitals!) alternates with sulky complaints about his hunger. His expressive hands complement his fidgeting manner, while Gusev and Lyolya sit still, patiently observing their friend. The cosmopolitan Kulikov appears strangely foreign in this setting. Speaking with an air of estrangement and superiority, he later refers to the entire dining room full of Russians and foreigners as Neanderthals.

When Kulikov, who briefly leaves the table to defeat his intellectual opponent at an adjoining table, comes back he is transformed – his step light, almost jumpy and boyish as he returns from a world unrelated to Lyolya's and Gusev's drama.[4] Full of confidence, Kulikov sets the tone of the conversation, and somewhat unexpectedly invites Gusev to join his Moscow-based theoretical physics laboratory, offering him an apartment as a lure. This triggers a debate revealing the two men's contrasting perspectives on the social role of science (Gusev's dedication to progress and Kulikov's challenge to and misgivings about inventions that feed the war industry), which complement their contrasting performance styles and the associated moral values.

It is easy to confuse Kulikov's scepticism in relation to the misuse of scientific discoveries with cynicism.[5] He is transformed physically, too, and is equally convincing, whether comfortably reclining on the back of his chair or leaning

forward, 'lecturing' Gusev and Lyolya with grand gestures and occasionally turning to include the uninvolved Lyolya while addressing Gusev. His rational counter-arguments challenging Gusev's assertions of the necessity of his experiment are animated by an array of facial and vocal expressions and mannerisms: sardonic laughs, clearing of his throat, head thrown back in disbelief – all on the verge of the exaggerated, but never less than entirely credible and realistic. Had the viewers not been privy to the context of the scene, Kulikov could have appeared a childish, self-centred egotist rather than a complex, nuanced modern man with a conscience.

Cataloguing the features of Smoktunovsky's performance style – his gaze and smile, his hand gestures, his voice and posture – would be limiting in an attempt to explain his hyper-naturalistic technique of creating credible contemporary characters (Otto Preminger 1962: 66–7, quoted in Dubrovsky 2001: 123). What is noticeable is that, within a span of seconds, Smoktunovsky displays a vast range of rapidly changing moods, emotions and expressions, living up to his reputation of being able to externalise the internal and remain expressive even when silent in creating a multi-layered complex character. If Smoktunovsky's acting style did have a recognisable feature, it is exemplified in his capacity for total transformation, beyond recognition, and a rich palette of subtle, expressive means of portraying rapid changes of the character's moods in response to changing dramatic contexts.

Conclusion

We have argued that Smoktunovsky's star status was the outcome of a complex combination of his emergence during a period of significant cultural transformation, his masterful performances across a range of media, his extraordinary versatility, his charisma, an intricate circuit of interplay between informal audience popularity and a formal, state patronage for an erstwhile symbol of cultural liberalism of the Thaw. While he did not produce any unofficial writings or commentary on the era, it was his interpretative choices, his exposed confessional and deeply spiritual performance style, that articulated symbolically, between the lines, a new type of actor and a new type of much-desired Soviet ethics, in which humanity and kindness were fundamental. Smoktunovsky's star status emerged from this period because he acted out 'aspects of life that matter to us' (Dyer 1986: 19). Smoktunovsky's roles and his performances of deeply revealing psychological realism touched on those aspects of constant human existence – spirituality and the values of the everyday – that had been trampled under Stalinism. Smoktunovsky resurrected the significance of the intelligentsia based on cultural capital and the relationship to the emerging middle class, broadening the scope of what an intellectual could be and transforming audiences from an undifferentiated mass in to discerning, selective appraisers. Smoktunovsky saw his relationship with the Thaw as a bearer of spirituality in messianic terms, and it was interpreted as an opposition to an amoral regime by his audience.

Smoktunovsky was well aware of being a Soviet star, and understood the cultural and political responsibilities along with the benefits that this entailed. That he was aware of his status and was ready to parody it (for example, as Detochkin in *Beware of the Car*) only added to his star mythology. He was unusual in that his capricious character (especially when arguing with directors and fellow actors) did not appear to undermine his professional career. Smoktunovsky was aware of making himself into a 'brand' and a commodity in the later years, producing and reproducing himself under the conditions of maturing socialism with two auto-biographies, numerous promotions and self-promotions, and countless interviews and documentaries replete with his colleagues, elaborations of his myth.

Smoktunovsky was unusual even within the Soviet star system. He was neither glamorous, nor inaccessible, nor the ideal Soviet citizen. His private life filtered into the public domain in the later years, but his focus was on his family, thereby denying opportunities for gossip. He became 'the provendor of dreams' (Morin 2005), enabling Soviet audiences to dream differently of the Thaw.

The Thaw produced numerous celebrities and renowned actors whose rep-utations and *oeuvres* have stood the test of time and continue to feed present-day nostalgia for the best of Soviet cultural life. Yet Smoktunovsky appears a mythological figure at the top of this select group, thanks to his cultural impact in resurrecting humane values in a remarkable career at the very top of a bitterly competitive profession, over 40 years and across four radically different epochs. Twenty years after his death, it appears from audience responses and his continued adulation as a Soviet star that his messianic drive and spiritual significance retain their impact.

Notes

1. All the translations from Russian are by the authors.
2. While Smoktunovsky worked intimately with directors on the development of roles, he was also known for arriving at an interpretation independently of his directors, and would often insist on his own vision of a character. Smoktunovsky was one of the few Soviet actors who enjoyed that freedom.
3. Lenin prizes for outstanding works of literature and art were considered by a committee under the Council of Ministers of the USSR that awarded the prizes (Gershanov 1979b).
4. Critics also noted his gait and his detachment from the others (Solov'yova and Shitova 1966: 229).
5. Academician Andrei Sakharov would later say that Kulikov's, and not Gusev's, position regarding the dangers of scientific discoveries was close to his own (Victor Dubrovsky).

11

Filmmaking on the Edge: Director Shin Sang-ok and Actress Choi Eun-hee

Leonid Petrov

Two Korean cinematographers, the late director and producer Shin Sang-ok (1926–2006) and his wife the actress Choi Eun-hee (b. 1926), are considered real

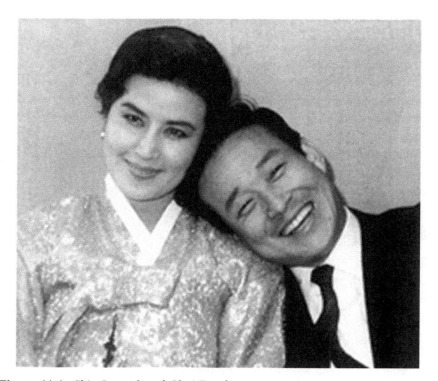

Figure 11.1. Shin Sang-ok and Choi Eun-hee.

legends in Korea, and well beyond. Both of them became rare figures in film history, destined to be as much renowned for their life as for their work. Kim Jong-won, a professor of Korean film history at Dongguk University in Seoul, called them 'two giant stars' that shone together: 'it's impossible to discuss the history of Korean cinema without discussing Choi and Shin' (Chun Su-jin 2007).

Shin was a maverick who introduced new aesthetics and techniques to the emerging South Korean film industry of the 1950s and 1960s. He enjoyed both mass-market success and critical acclaim, and even went on to make seven films in North Korea under the aegis of the then young leader Kim Jong-il. The circumstances of his arrival in North Korea remain disputed by both the North and South Korean governments. Pyongyang has always insisted that the couple went to the North voluntarily, but Seoul argues that both Shin and his wife, Choi Eun-hee, were kidnapped by North Korean intelligence agents in Hong Kong. Some critics also tend to believe that Shin's escape from South Korea was voluntary, and related to the earlier kidnapping of his wife by North Korean intelligence agents in Hong Kong (Tetsuo 1988; Schönherr 2012). Whatever the truth, three- and-a-half years of Shin's solitary confinement and Choi's secluded life in a guarded guesthouse were followed by four years of their joint creative work for the oppressive regime. Eventually, Shin and Choi succeeded in fleeing to the West, and lived in the United States until the 1990s, returning to South Korea only after its military dictatorship was voted out of office.

This chapter will look closely at the nature of the relationship that existed between the famous filmmaking couple and the political regimes in Korea at the end of the colonial occupation, and during liberation, the civil war and democratisation. Special attention will be dedicated to their years in North Korea (1978–86) and their relations with Kim Il-sung and Kim Jong-il, the late leaders of the Democratic People's Republic of Korea (DPRK), also known as North Korea. The autobiographical books by Shin and Choi, which were published in California and South Korea (Choi and Shin 1988; Shin and Choi 2001; Choi 2007; Shin 2007), are used as the primary sources of information on their lives and views regarding the turmoil of the continuing inter-Korean conflict.

Korean Cinema Liberated

Shin Sang-ok (1926–2006) was born during the Japanese colonial occupation into the family of an affluent doctor of Chinese medicine in the city of Cheongjin in North Hamgyeong Province, in the northern half of the Korea Peninsula. As any child of the silver-screen era would be, he was fascinated by the first Korean silent film *Arirang* (1936) and by Charlie Chaplin's prewar masterpieces (Schönherr 2012: 72). In 1944, at the height of war in the Pacific, a talented adolescent hailing from a wealthy family, Shin went to Japan to study art.

He was admitted to the Tokyo Fine Arts School in Ueno, the predecessor of the National University of Fine Arts and Music in Tokyo. There he quickly fell in love with Surrealism and the French cinema of the 1930s. In April 1945, just months before World War II's final showdown, Shin returned to Korea from Japan, which was struggling with the Fire Storm bombing campaign of the USA. Fortunately, a sudden illness helped him dodge mandatory conscription into the Japanese Imperial Army, sparing his life and talent for the new art of a free and independent Korea.

Shin loved film, and initially made a living by drawing cinema posters. After the August 1945 liberation, he started his film career as assistant production designer for Choi In-kyu's film *Viva Freedom!* (1946). It was the first Korean picture made after the country achieved independence from Japan, and focused on the Korean Peninsula's anti-Japanese resistance. The film was completed in a fortnight, but for Shin Sang-ok it became the formative time in which he learnt from Choi In-kyu the basics of filmmaking and directing. Soon after that, he began producing films independently, and even the outbreak of the Korean War in June 1950 failed to dampen his enthusiasm. In his first film, *The Evil Night* (1952), Shin raised the issue of Korea's colonial past by showing a prostitute who tells the story of her life as a 'comfort woman' – a victim of the sex slavery, which was established by the Japanese Imperial Army during World War II. One of the minor female roles in this film was played by an aspiring young actress, Choi Eun-hee.

Choi Eun-hee was born in 1926 in the town of Gwangju, Gyeonggi Province, and in 1943 joined the performing troupe 'Arang' to avoid the Japanese Imperial Army, which was forcefully drafting young Korean women to be 'comfort women'. Tens of thousands of women in Asia and the Pacific were forced into prostitution and abused in Japanese military brothels. After the liberation of Korea in 1945, Choi began her career in film, appearing for the first time in *A New Oath* (1947). But the chaos and confusion of the Korean War (1950–53) left her estranged from her violent husband, cinematographer Kim Hak-seong. After foraging for food around communist-occupied Seoul, Choi was forced to go to North Korea to serve in an entertainment troupe for the Korean People's Army. Before long, she managed to escape, but was caught and raped by a South Korean officer near the front lines. He threatened to kill her because she had served for the Communists.

Permitted to return home, she found that relations with her husband were growing worse. In contrast, a meeting with director Shin Sang-ok during work on the film *Evil Night* (1952) forever changed her life. While working together on a semi-documentary, *Korea* (1954), Choi and Shin became colleagues, soul mates, and soon husband and wife. They rented a room in downtown Seoul, where they lived for years in the prime of their filmmaking careers. In her recent memoirs, Choi recalls this time as her happiest, though her only regret was that she could

not have children. Instead, the couple adopted a son and daughter. Choi was often dubbed Korea's Ingrid Bergman, who was then in the limelight for leaving her husband for Italian film director Roberto Rossellini (Chun Su-jin 2007).

For the next 20 years Choi and Shin were destined to be the biggest stars in South Korean cinema, making some 130 films together. The first success of their artistic alliance was brought by *The Flower in Hell* (1958), a story of moral downfall filmed against the backdrop of the ruined capital, Seoul. The leading role of a prostitute, Sonya, was played by Choi Eun-hee. Shot in a resolutely neo-realist mode, this film showed the aftermath of the Korean War, when Seoul became a city of destitution and despair. The presence of American troops in South Korea resulted in the development of black markets and a murky underground world – a world in which smuggled goods, hostess bars and various forms of violence complemented each other. For her role in *The Flower in Hell*, Choi became the winner of a Best Actress award at the 2nd Buil Film Awards, a South Korean film awards ceremony annually hosted by the *Busan Ilbo* newspaper between 1958 and 1973.

Shin Sang-ok's documentary-like pessimism gave rise to a new trend in the Korean film industry, and heralded the first days of the 1960s golden age in South Korean cinematography. During this period, Shin worked prolifically. He often directed two or more films per year, and earned the nickname 'the Prince of Korean Cinema'. During the 1960s the production company he started, Shin Films, completed around 300 movies, many of which were acknowledged by domestic awards. Shin's early dryness and aggression, which can be commonly found in American *noir* movies of the 1930s, soon disappeared, and his films became more static, best exemplified by *My Mother and her Guest* (1961), and in the historical drama *Eunuch* (1968). Choi Eun-hee had the versatility to shine in most films, being able to play a Korean prostitute in *The Flower in Hell* and an innocent widow in *My Mother and her Guest*.

During the early 1970s Shin's cinematographic activity began to wane. This was in part due to the fact that the Republic of Korea (ROK) was being ruled by a military dictatorship, and its film industry in general was subjected to strict censorship. During its heyday, Shin Films was producing some 40 pictures per year, employing hundreds of filmmaking staff. Shin used the most modern filming and editing techniques of the time, and tried to introduce more eroticism in his works. But most of the films Shin directed during that period ended up in failure because they did not comply with the strict censorship regulations that forbade distributors from buying films with overt erotic scenes. Difficulties with finding venture capital were exacerbated by the increasingly intrusive government interference. Shin personally knew South Korea's President Park Chung-hee, and tried to raise with him the issue of censorship in the art and filming industry. However, this action, accompanied by Shin's love for artistic freedom and his

growing involvement in domestic politics, did nothing but upset the dictator, who finally closed Shin's studio in 1976 (Shin and Choi 2001: 38–41).

The mid 1970s was also a rocky period in the private life of the filmmaking couple. Rumours that Shin was having an affair with a young actress, Oh Su-mi, reached Choi. Initially she refused to believe it, but when she read in the press that Oh had had two babies with Shin, Choi Eun-hee filed for divorce (Choi 2007; Chu Su-jin 2007). Nevertheless, Choi continued to be committed to many international projects that had been initiated by the defunct Shin Films. In January 1978 she went to Hong Kong to discuss an acting job, but was allegedly lured to a private boat moored in Repulse Bay by North Korean agents. The kidnapping operation, as it turned out later, was ordered by the future DPRK leader Kim Jong-il, who wanted to develop a modern film industry in the North. The importance of the plan prompted Kim to go to Nampo port personally to greet the South Korean film star.

Between two Dictatorships

Shin Sang-ok was preparing to immigrate to the US when he learnt about the disappearance of his estranged wife, Choi Eun-hee. He travelled to Hong Kong to investigate, but fell under the suspicion of local police and the South Korean Central Intelligence Agency (KCIA). The South Korean government refused to extend his passport, and Shin had to wait in Japan for his American visa. While in Tokyo, he was in contact with the Korean Democratic Unification Union, an association closely linked to the prominent opposition leader and future president, Kim Dae-Jung. Shin had been asked to produce a film about the 1972 KCIA's abduction of Kim Dae-Jung from a hotel in Tokyo, his attempted assassination, and his last-minute release due to US government interference. However, a shortage of funds and the sensitivity of the topic did not permit him to carry out the project. Shin left for Europe, hoping to collect his US immigration permit there.

Soon after, the US embassy in Paris refused to provide Shin with an entry visa, suspecting that the disappearance of Choi Eun-hee may have been a murder case, and that it was Shin who had killed his ex-wife. Shin was desperately looking for a place to immigrate, and seriously considered settling in West Germany or West Berlin. But the omnipresent KCIA began harassing him and the close friends he visited in Europe. As most of his savings were kept in Hong Kong and his business interests were focused in Singapore, Shin left Europe to promote his films across South East Asia. In his memoirs he recalls that in July 1978 he felt like 'a lost dog', and was ready to return to Seoul, but fell victim to a kidnapping plot. Shin was told that he could buy a passport from a South American country, but was actually lured into a trap set for him by DPRK agents. In his memoirs, Shin claims that

one night, while going to dinner, he had a sack filled with chloroform pulled over his head before being loaded on a ship bound for North Korea (Shin and Choi 2001: 63–5).

After the abduction, Shin Sang-ok was told by the North Korean agents that his ex-wife Choi Eun-hee had been murdered in Hong Kong by South Korean spies. Shin was put up in a comfortable guesthouse and offered a filmmaking job, but tried to escape twice in desperation. One day he borrowed a car and drove to a railway station, where he hid among tinderboxes. He even managed to sneak aboard a freight train, but was caught the following day and soon found himself in a North Korean prison camp. Yet even in the camp he was protected from afar, which was indicative of his VIP status (*The Economist* 2006). When Shin tried to starve himself to death, a prison guard would force-feed him through a funnel, something that was very unusual for North Korea. Shin's incarceration in Prison No. 6 of the Department of Public Security continued for more than four years. He lived on a diet of corn, salt and grass, and soon contracted hepatitis. But the most difficult thing was that he did not know exactly why he had been taken to North Korea.

During his period of incarceration, Shin had many fortuitous encounters, including one with the prominent Korean historian Yi Na-yeong. By that time, Yi had spent 16 years in prison and, like Shin, was also unaware of the nature of his guilt or the length of his sentence. Deprived of access to any historical materials, Yi kept writing a new Kim Il-sung–centred version of Korea's modern history using only his memory and imagination. He created a heroic saga about the invincible clan of the Kims, the saviours of the nation (Choi and Shin 1988: 456–7). From these encounters Shin learnt about the dramatic changes that North Korean political culture had suffered during the 1960s, after the introduction of *Juche* (national self-reliance) ideology.

After four years of imprisonment, during which he wrote a series of apologetic letters sent to the North Korean Great Leader Kim Il-sung and his son and official heir, Dear Leader Kim Jong-il, Shin was released. Known for his penchant for film and theatre, Kim Jong-il orchestrated a scene of reunion for Shin Sang-ok and Choi Eun-hee in 1983. They were both brought to a dinner party in the capital, Pyongyang, where they met face-to-face for the first time after their five years of separation. Until that moment Choi, like Shin, had not known that the other was in North Korea. Kim Jong-il knew how to make things cinematic, and ordered Shin and Choi to re-marry, offering a huge party and an apology.

Kim himself was a great enthusiast for cinematography, possessing a massive (at least 15,000-copy) collection of films in various formats. He was openly a big fan of *James Bond* films, and of the *Rambo* and *Friday the 13th* franchises. Naively, Kim believed that cinema was the way to elevate the image of the DPRK in the eyes of the world. Over the years he worked on dozens of films, even publishing a number of books on the subject (Kim Jong-il 1973; 1987). But by 1978, Kim had become

profoundly disappointed with his own Mt Paektu Creative Group and other state-owned studios, despite their strict compliance with the 'monolithic guidance' of the Workers' Party.

It seemed that once again Shin Sang-ok and Choi Eun-hee's talents could be put to good use. According to their memoirs, Kim Jong-il was worried that films produced in the capitalist and decadent South were better than those produced in the communist North. Kim genuinely believed that this was because North Korean cinematographers relied too much on the state and did not care enough about the quality of their artistic output. Kim admired the atmosphere of free competition in South Korea, where actors and directors had to sweat to make their films artistically attractive and commercially successful (Shin 2007: 125). While not assuming that there was anything wrong with *Juche*-style socialism, Kim also lamented that North Korean film studios were technically far behind their South Korean competitors.

'The North's filmmakers are just doing perfunctory work. They don't have any new ideas. Their works have the same expressions, redundancies, the same old plots. All our movies are filled with crying and sobbing', complained Kim Jong-il (Shin and Choi 2001: 261–2). The Dear Leader admitted that North Korea did not have the proper pool of talent to make great films, and he therefore arranged to procure a real filmmaker. He kidnapped Shin and gave him millions of dollars, four filming pavilions with audio-recoding rooms, and more artistic freedom than any North or South Korean director had ever enjoyed before (Gorenfeld 2003). Shin and Choi, who remarried soon after their reunion in the North, were free to visit East Berlin for location shots, though constantly shadowed by ever-present North Korean security agents.

Remembering that Shin's filming company in Seoul had been shut down by the South Korean dictator, in 1983 the North Korean dictator established a film production company in the middle of Pyongyang, also named Shin Films. Shin worried that Kim Jong-il would force him to make political propaganda films for regime adulation. Instead, he was given a budget of US$3 million each year to produce high-quality feature films. His hosts were friendly enough, and Shin would later say that the North Korean film crews were fine, and made up of good people. 'Just 200 or so were evil, and they were in charge', he later confided to The *Guardian* (Gourevitch 2003).

Recently, Pyongyang has admitted to the abduction of 13 Japanese citizens in the late 1970s and 1980s in order to act as cultural advisers (Kyodo 2012). However, even today the DPRK authorities still deny the kidnapping accusations in relation to Shin and Choi, claiming that they went to North Korea willingly. At some stage of their captivity in the North they both had to give a press conference to 'admit' that their choice to leave South Korea had been voluntary. While Shin's personal situation prior to the incident was very complicated and his leaving looked politically motivated, Choi's confession seemed less credible. During their captivity in North Korea, the couple would risk their lives on many occasions to make secret

audio recordings of conversations with Kim Jong-il. This was done to support their story that they were innocent abductees, and to save their reputations.

Propaganda and Masterpieces

Between 1983 and 1987, Shin Sang-ok directed seven films in Pyongyang, with Kim Jong-il acting as an executive producer and Choi Eun-hee playing the lead roles. The first film directed by Shin in North Korea was *Emissary Who Didn't Return* (1984). It was the saga of a Korean envoy desperately trying to attend the 1907 Second Peace Conference in The Hague. The script was allegedly written by Kim Il-sung himself, which contributed to the major distortion of historical truth. Even the shooting location was faked: instead of The Hague, which was out of reach for North Koreans, the Brandov Film Studio in Czechoslovakia was chosen. Shin was so unhappy with the outcome that he named Choi Eun-hee the director. Ironically, the Karlovy Vary Film Festival in 1984 awarded Choi the Special Jury Prize for this film as Best Film Director. The film was also well received in Japan for its unmistakable European flair (Schönherr 2012: 77).

In 1984 and 1985, Shin undertook two bold attempts to offer new renderings of the classical Korean novels *The Tale of Chun Hyang* and *The Tale of Shim Cheong*. He gave the first film a sensational title according to prudish North Korean standards: *Love, Love, My Love* (1984). In contrast with his earlier cinematic version of *Song Chun Hyang* (1961), with Choi Eun-hee as leading actress, Shin created a musical and even managed to show a barely veiled on-screen kiss. In *The Tale of Shim Cheong* (1985), the masked dancers looked distinctly Western in their style, which led one scholar of Shin's cinematic work to conclude that it had been filmed in Munich Bavaria Studios (Chung 2008: 195). Despite the didactic themes of loyalty and filial piety, both films were designed as entertainment. Choi was the star on both occasions, taking on the role of the mother of loyal Chun Hyang and filial Shim Cheong.

Perhaps Shin's greatest cinematic moment in North Korea came with arguably his finest film, *Runaway* (1984). It told the tragic story of a Korean family wandering around Manchuria in the 1920s, suffering from Japanese oppression and the dishonesty of their neighbours. The following year, another masterpiece, *Salt* (1985), was created by the kidnapped couple. Continuing on the same theme of the anti-Japanese armed struggle in Manchuria, Shin appealed to the sentiments of all Koreans with in and outside the divided peninsula. For her part in this film, Choi received the award for Best Actress at the 1985 Moscow International Film Festival. Despite their North Korean affiliation, Shin and Choi were already known to Soviet film critics as South Korean stars. That explained the sudden improvement in the quality of North Korean films, and made the *Perestroika*-minded Russians hopeful for an early reconciliation between the two parts of the divided peninsula.

During the shooting of *Runaway*, an interesting episode took place in which Shin needed to create a scene with a train explosion. Shin submitted a proposal directly to Kim Jong-il, saying that he wanted to detonate and derail a real train to enhance the movie's special effects. Kim's approval came immediately, and Shin was impressed, stating: 'this is only possible in North Korea. It's the first time I experienced a film shoot so spectacular (Shin and Choi 2001: 339–40). He understood that such consideration was only possible because Kim Jong-il himself was a film enthusiast, who not only used films for a political agenda but also wanted to create something new, original and extraordinary. When describing this episode in her ground breaking book, *Illusive Utopia* (2010), Suk-young Kim calls it the highest point in Shin's entire directing career (Kim 2010: 328).

In 1985 Shin produced a very different genre of film, *Pulgasari*. It was a 'Kaiju' or Godzilla type of movie set in fourteenth century Korea during the Goryeo dynasty. The plot was about a small doll that magically comes to life when it touches blood, and is eventually transformed into a metal-eating monster that helped the local peasants overthrow their feudal lord. Eventually, its constant demand for metal overwhelms the farming community, who need to feed the monster with their metal tools to satisfy its appetite. Finally, the beast that saved them must be destroyed. Perhaps the plot is a subtle allusion to the story of capitalism running amok: efficient but hungry for resources. Another explanation can possibly be attributed to Shin's hidden message: any messiah, like Kim Il-sung, who once saved the nation, will sooner or later turn into a monster.

Pulgasari was notable for featuring man-in-suit effects by Teruyoshi Nakano, the special effects director of the original Godzilla movies from Toho Studios in Japan. Nakano brought his team of technicians with him, including Kenpachiro Satsuma, who had played Godzilla in numerous films (Faraci 2011). But the fact that the Dear Leader himself was executive producer and that capitalism was the primary target did not save the reputation of this first monster movie in the DPRK. It was shortly before the completion of *Pulgasari* that Shin Sang-ok and his wife defected from North Korea to the West. The film was banned by the regime, and was credited to the assistant director, Chong Gon-jo, as author, instead of Shin Sang-ok. *Pulgasari* was made for export, but the screening rights were not sold until 1998, when it became a cult classic, first in Japan and then in the US. This film remains the only North Korean movie to have become widely known to Japanese and Western audiences.

While working in Pyongyang, Shin claimed that the main obstacle to advancing North Korean cinema was created by the Great Leader's 'instructions'. He was otherwise very frank in dealing with Kim Jong-il, sometimes even dangerously risk-taking. In the movie *Salt* (1985), for the first time in North Korean cinematic history, instead of Kim Il-sung's quote, Shin inserted a passage from the Bible: 'You are the salt of the earth. But if the salt loses its saltiness, how can it be made salty again?' (Matthew 5:13). Among other important landmarks, Shin's

movies depicted the first nude scene, a sensational novelty for militaristic North Korean cinema. Shin was also the first to introduce the list of cast and staff at the end of his films, to acknowledge the work of individual actors and cinematographers.

The movie *Genghis Khan* was intended to become another collaborative project for Shin Sang-ok. Shin had long wanted to embarrass Howard Hughes's movie *The Conqueror* (1956) by making an authentically Asian version of the story. Choi Eun-hee would play the role of Bortae, the first wife of Genghis Khan. Naturally enthusiastic about themes of invasion and tyranny, Kim Jong-il would be the perfect producer for this film. Apparently, Shin and Kim agreed that this project would be the follow-up to *Pulgasari*, and intended primarily for export. Even though the idea was not given preliminary approval by Kim's father, plans were being made for a joint venture with a company in Austria to distribute the future blockbuster worldwide. Kim trusted Shin and Choi enough to permit them to travel to Europe to discuss the details.

Yet the stifling atmosphere of the totalitarian state could not satisfy these true artists. They had no doubts about leaving their gilded cage: 'To be in North Korea living a good life ourselves and enjoying movies while everyone else was not free was not happiness, but agony', Shin and Choi wrote in their memoirs years later (Shin and Choi 2001: 6). Nevertheless, Shin evaluated his own work in North Korea as a unique experiment of which he was ultimately proud: 'I believe that the films which I made in North Korea were not contaminated by ideology, but became examples of pure collaboration between the North and South Korean filmmakers' (Shin 2007: 133).

Johannes Schönherr, who has evaluated the work of famous South Korean filmmakers in the North, notes that:

> Shin introduced new genres like the martial arts film and the monster movie, and brought fantasy and eroticism into North Korean cinema. The domestic success of his productions was staggering but his films also played well on an international level. (2012: 5)

The international aspect of Shin's work was initially restricted to the countries of the Eastern Bloc, but later became known in the West and eventually worldwide.

Finally, in 1986, the filmmaking couple managed to escape Kim Jong-il's clutches while attending a film festival in Vienna. In an actual car chase, the two raced to the American embassy, where they applied for political asylum. Shin was reluctant to go home for fear that the ROK's secret police would not believe his film-like story, and suspect him of being a communist sympathiser. At that time, the National Security Law remained a convenient tool in the hands of dictators. But the audiotapes with the voice of Kim Jong-il, which Choi had secretly made

during one of the audiences, were particularly useful for their case, which made possible their return to South Korea in 1994.

Unification Through Film

Suk-young Kim believes that, if all Kim Jong-il wanted was to innovate North Korean cinema and achieve international claim, he could have made exceptions by sending a few North Korean directors to the Western world to bring back advanced filmmaking technology or by inviting directors from Japan or other Western countries to North Korea for a limited time. Instead, Kim Jong-il decided to choose South Koreans, for reasons dictated not so much by the aesthetics of filmmaking as by the ethnicities of the filmmakers. The fact that Shin and Choi were Koreans must have been a determining factor for Kim's decision, precisely for the reason that Kim envisioned the couple functioning as a cultural buffer, filtering and bringing in Western cinema through the disguised forms of Korean ethnicity (Kim 2008: 206).

Indeed, the saga of Shin Sang-ok and Choi Eun-hee's malicious abduction and fortunate escape is most extraordinary. It reveals many aspects of the country's cultural and political life. It also encapsulates the tragedy of the Korean conflict and hints at the possibility of reconciliation. As in most good films, both the victims and villains have shown their human side, real intentions and readiness for compromise. Even the happy ending in this particular story itself adds much optimism to the continuing drama of the ongoing Korean stand-off.

Before being abducted by Kim Jong-il's secret envoys, the acclaimed film director was on the run from South Korea's dictator Park Chung-hee and his military government. Shin was also in contact with the opposition movement led by Kim Dae-jung, who had once been a victim of the abduction organised by the KCIA, discussed above. Their misadventures should be understood in the context of the ongoing protracted Korean War, which has deep roots in the colonial past, Allied occupation and Cold War politics. Moreover, the absence of radio, postal or telephone contacts between the North and South is primarily responsible for a huge and growing cultural gulf, which in turn hinders dialogue and mutual understanding.

Tragically, abductions and defections have remained the only possible way for Koreans to visit the other part of their once great country beyond the DMZ. The longing for national unity usually coincides with the claims for exclusive legitimacy of only one political regime in Korea. This leads to the usual denial by the other regime. A decade before Kim Dae-jung announced his 'Sunshine Policy' of peace and reconciliation, the director Shin and actress Choi became the first messengers of peace, understanding and reconciliation from the South – although they also inadvertently found themselves in the North and participated in the creation of a

new Korean cinema. Their movies were national but not nationalistic, ideologically neutral, and accepted both within and outside Korea: a point of which all Koreans should be proud.

With their hard work and talent, Shin and Choi not only improved the quality of DPRK cinema, but also created excellent new cinematic productions, which would never have come to fruition in the South during that same period. They also taught North Korean filmmakers and learnt from them at the same time. More importantly, they showed their compatriots and the world that, despite their ideological differences, North and South Koreans have much in common. Their shared history, language, traditions and other cultural attributes made the films produced during Shin Sang-ok's captivity universally accepted as Korean films. Despite Western influences, as well as ideological censorship, Korean features remained.

The North Korean leader's hopes for the future were surprisingly similar to those of many South Korean filmmakers. This became particularly apparent on 1 January 1985, when Kim Il-sung personally met with Shin and Choi, specifically asking them to create films 'which would be acceptable after unification' (Shin and Choi 2001: 364). Kim had long advocated a plan for a confederation between the capitalist South and communist North, with two separate governments and administrative arrangements. Kim also referred to his conversation with China's leader, Deng Xiaoping, about the future of Hong Kong and the 'one country, two systems' thesis. Addressing Shin and Choi, Kim Il-sung readily admitted the ambiguity of many historical developments, but strongly encouraged them to see the future of Korea through the eyes of 'one nation, two systems' (Shin and Choi 2001: 365).

It is symbolic that the concluding sections of Shin and Choi's memoirs, *Our Escape Has Not Ended Yet* (2001), were written in the form of open letters to Kim Jong-il and Kim Dae-jung, the incumbent leaders of North and South Korea at the time. Shin and Choi frankly conveyed their opinions to their former captor, spelling out what should be done to make North Korea a better place for people to live in, which included ending the pursuit of superiority, improving the country's economy and abandoning the nuclear programme.

In their address to Kim Dae-jung, the filmmakers warned him about the continuing conflict within South Korean society, and criticised him for not accomplishing the goals that had brought him the glory of a Nobel peace prize. Shin and Choi shrewdly explained the reasons why Kim Jong-il could not visit Seoul, listing the fears and phobias of any North Korean leader. Among these fears was, of course, the presence of US troops on the Korean Peninsula. They also warned both leaders about the dangers of a new civil war and the fallacy of unification plans. The two filmmakers-turned-peacemakers used this opportunity to deliver messages from one leader of a broken nation to another.

Kim Dae-jung, Kim Jong-il and their messenger Shin Sang-ok have all passed away. New political leaders in the North and the South continue repeating old mistakes while creating new crises, as if there had been no positive experience from inter-Korean cooperation and dialogue. In her recent book entitled *Confession: A Life More Dramatic than a Film* (2007), Choi Eun-hee calls upon all sides to forgive and reconcile. She further talks about her personal experiences, but rightly assumes that confessions are needed from all participants of the Korean drama that unfolded in the twentieth century and continues today. In the sea of ideological confrontation and distrust, the films created by director Shin and actress Choi will remain rare phenomena that can help heal the wounds of the past and facilitate the long-cherished dream of peace and harmony shared by all Koreans.

12

Indigenous Icons and Teaching Balanda: From *Walkabout* to *Ten Canoes*: Art, Activism and David Gulpilil

Karen O'Brien

Indigenous Activism, Film and Teaching Balanda

This chapter explores the influence of cinematic images of indigenous Australians on world audiences, and presents an analysis of the representation of indigenous identity, culture and knowledge through the cinematic roles portrayed by the Yolgnu artists of Ramingining country, David and Jamie Gulpilil. It also reviews their attempts to teach Balanda (non-indigenous people) about Yolgnu culture and the damaging outcomes of racial discrimination in Australia.

Over the past 40 years, cinematic images of indigenous people have been influential on world perceptions of Australia. The groundbreaking film *Ten Canoes* (Rolf de Heer, 2008) marked a significant innovation in the history of indigenous Australian cinema by giving its dialogue entirely in one of the many Yolgnu languages, narrated by David Gulpilil, with the lead role being performed by his son, Jamie Dayindi Gulpilil. It was selected for official screening in the 'Un Certain Regard' category at the 2006 Cannes International Film Festival, where it won the Special Jury Prize. The images of indigenous actors shown on screen have the power to shape the opinions of spectators and to influence global perceptions of indigenous identity. In considering how influential the Gulpilils' teaching through screen images has been on the world audience, it is important to examine the ways in which indigenous actors have communicated cultural knowledge. Through their screen roles, indigenous actors often take the opportunity to make political

statements. For example, as an actor-activist David Gulpilil states that the roles he plays in film provide a channel for educating international audiences about the inequalities that exist between indigenous and non-indigenous Australians. During Sorry Day celebrations, when signing autographs, he expressed his sadness for those who lived in poverty in the remote indigenous communities. In speaking of his stardom, he stated: 'I can go anywhere I like. Because I'm David Gulpilil, I know where to go. They know my name around the world. But other people, out of Darwin, they've got no jobs, they drink and they've got nowhere good to live. That's wrong' (Wilson 2006: 2). As a star of international standing, he recognises the potential that cinema holds to inform the public about indigenous politics and rights. David Gulpilil is a man rich in knowledge of his country and in Yolngu knowledge. His work as an actor has not only broken ground for other indigenous actors, but has also introduced indigenous Australia to the world. Having starred in 13 films, he has appeared in other popular international films besides *Ten Canoes*, such as *Storm Boy* (1976) and *Rabbit Proof Fence* (2002). Like his father before him, he is a ceremonial dancer. It was in *Walkabout* (Roeg 1971) that he first drew world attention through his performance and expression of love for a non-indigenous female protagonist.

Ten Canoes is an important film, in its the director and actors made significant attempts to convey the complexity of Yolngu culture and knowledge systems. In this film, the indigenous community influenced the way in which their knowledge would be presented. David Gulpilil and Rolf de Heer worked together closely on the film. David's role was that of an invisible storyteller whose story lured the audience back a thousand years to witness a group of his ancestors build canoes. The film was shot in black-and-white and was inspired by anthropologist Donald Thomson's 1937 photograph of a canoe, 'The Goose Hunters of the Arafura Swamp'. The script was produced by Rolf de Heer and was arranged to encompass the Yolngu storytelling tradition as well as to appeal to a Western audience. It was a difficult process, as kinship complexities presented many filming problems. The complications that were encountered during the process of making the film are the subject of the documentary *Balanda and the Bark Canoes* (de Heer 2008). The documentary presents insights into the making of *Ten Canoes*, and demonstrates the input of the Yolngu community, who selected the cast according to kin relationships and not acting ability (Riphagen and Venbrux 2008). Through the film *Ten Canoes*, Yolngu peoples intended to elicit the respect and understanding of non-indigenous audiences. The film has been criticised, however, for focusing on cultural loss. It has been suggested that such an emphasis only serves to undermine the vibrant continuing Yolngu culture, and that a more striking visual representation of historical tradition might have attended to the living, active world of Yolngu law (Riphagen and Venbrux 2008: 268). Jamie Gulpilil expressed the hope that *Ten Canoes* would safeguard the traditions of the Yolngu peoples and that it would teach the world about indigenous Australian culture: 'I hope the film

will teach Balanda – white people – my culture, dancing and ceremony' (Scobie 2006).

Indigenous cultures have been recording their knowledge for 80,000 years in song, dance and icons, and more recently in canvas paintings, photographs and film. Through iconic representation, indigenous 'artists' reveal knowledge and then tell it the way it is intended, as a visual story – through the artistic medium functioning as an instrument for revealing the inner and outer reality of the indigenous world and as a communicant of ancient and continuing knowledge. However, there is a transmission problem inherent in the process involved with the visual representation of indigenous knowledge. When indigenous modes of representation are enacted on-screen, non-indigenous audiences are not able to fully understand the indigenous world, because the mode of self-representation is so different from the non-indigenous way of seeing the indigenous world. Indigenous performers have made significant efforts to teach non-indigenous audiences about their cultural knowledge, but because of the predominance of the iconic mode of communication audiences are frequently unable to comprehend indigenous cultural knowledge. Consequently, there exists a gulf in cultural understanding that arises from the notion that indigenous knowledge and what Western audiences perceive to be 'art' is the same entity (O'Brien 2011). Because the non-indigenous audience sees the indigenous world David Gulpilil presents as 'art' – that is, primarily as entertainment to be enjoyed for its aesthetic value – when indigenous peoples perform, non-indigenous audiences expect the performance to correspond to Western stereotypes. The limitations of Eurocentric observation are based on essentialist interpretations and colonialist 'scientific' ways of knowing indigenous peoples (Said 1978; Bain and Attwood 1992; Gould 1981). The outcome of this fixed way of seeing the world means that non-indigenous observers may not be aware that a cultural demonstration of knowledge exists that is different from their perception of what is art and what is knowledge (O'Brien 2011; Lydon 2005). Their understandings are susceptible to Western-constructed imaginings of what *they* perceive indigenous identity *should* be. For non-indigenous people to understand the complexities of an indigenous worldview, they first need to know what it is that the 'artist' intends to convey through performance. Illustrating this point is a scene in *Walkabout*, when David Gulpilil performs a love ceremony for a non-indigenous woman, and his ritual expression of love in dance form is completely overlooked by the female lead character. In Yolngu rituals or in a love ceremony like this, the ceremonial dancer, actor or narrator expresses a range of meanings. When David Gulpilil dances on stage or screen, he is not primarily entertaining; he also embodies a Yolngu cosmos in a highly condensed arrangement of song, dance and painted body images. In indigenous cultures, the traditional arrangements of songs, icons and steps are those that language and writing cannot express with sufficient subtlety of meaning. The painted body images of remote indigenous communities are also present in other iconic forms – in rock art and

in restricted form in paintings. These icons are favoured by David Gulpilil as an actor, painter, dancer and choreographer, and are smoothly reassigned to the screen through dance, song and narrative. Directors such as Rolf de Heer have worked closely with David Gulpilil, where the aim has been to achieve an accurate portrayal of indigenous Australian cultural integrity through film and to share this vision with an international audience.

In considering Indigenous icons in global cinema, David Gulpilil's rise to world fame through film is a subject worthy of investigation. In over 40 years as a prolific actor and star of stage and screen, his acting and activism have become well known. But to what extent has his performance educated global audiences? David Gulpilil appeals to the collective conscience of a global audience to support his aim of establishing social and economic equality in indigenous communities. In view of such political action, it is also important to consider how successful his endeavours have been in the role of political activist, as well as in the presentation of indigenous knowledge and worldviews.

David Gulpilil became an instant international film star through his role in *Walkabout*. He is now a world celebrity, having walked the red carpet in Cannes, London and Los Angeles. Through his position in the world of stardom, he has met British royalty and joined the stars of cinema, among whom he is recognised for his acting in many international film roles. His accomplishments are similarly celebrated in Australia, where his peers recognise his world achievements as an actor, painter, dancer and choreographer. In May 2013, the Australia Council's Aboriginal and Torres Strait Islander Arts Board presented him with the Red Ochre Award, Australia's highest peer-assessed award for an indigenous artist, at the sixth annual National Indigenous Arts Awards at the Sydney Opera House.

In evaluating the global outcomes of David's plea for racial equality, a useful subject for consideration concerns the concept of Aboriginalism. Aboriginalist interpretation – the view that Indigenous peoples are primitive – has been influential in the production of photographic images of indigenous Australians, and there are strong corresponding interconnections between photographic and film images. Such imaginings have in turn influenced world audiences. The essentialist view has been challenged through the indigenous agency that is presented by indigenous photographers such as Ricky Maynard, in his work *Mutton Birds* (1985) and *Urban Diary* (1997), and Michael Riley, in *Sacrifice* (1993) and *Cloud* (2000), as well as through the influence of filmmakers such as Warwick Thornton in *Samson and Delilah* (2009). Through cinematic roles as an actor, and similarly through his role as a producer of *One Red Blood* (Johnson 2002), David Gulpilil has made celebrated efforts to teach non-indigenous audiences about his culture. The kinds of media favoured by the actor to demystify essentialist interpretations of indigenous Australians are those that communicate indigenous knowledge through ceremonial dance, song and narrative. In film, these tools of knowledge communication hold the utmost potential. Such images are powerful conveyors of

indigenous knowledge, and when properly incorporated into film and understood by the public, they contain power, embrace agency and invalidate Eurocentric interpretations of indigenous experience. It has been suggested that David Gulpilil worked very well with Nicholas Roeg because Gulpilil was a good dancer, and because he had a distinctive knowledge of movement and an instinctive insight into how to use light to the best advantage (Agutter 1999).

It is in the documentary *One Red Blood*, about David Gulpilil, that the actor explicitly aims to inform non-indigenous peoples about indigenous philosophy. He reveals culture from Country, introducing audiences to the cultural world of Indigenous people. 'Country' is the English term that is commonly used to express the complex and holistic cultural relationship to land. Through the use of the metaphor of red blood as a perceived universalising element, David Gulpilil aims for global unity. In the documentary, he states: 'We are the brothers and sisters of the world. It doesn't matter if you're bird, snake, fish or kangaroo. One red blood.'

Of his role in *The Tracker*, as reported in *The Age* (McGuirk 2002), he described his satisfaction at reaching out to the people of the world and introducing them to his culture:

> I'm very happy [with the role]; I deserved it; that's what I've been waiting for. I've been doing it for everybody – the Indigenous people of Australia. I talk about the culture, songs, and the land that I come from, here Ramingining.

As there is significant discrimination in indigenous and non-indigenous Australia today with respect to indigenous mortality rates, deaths in custody, living conditions and human rights transgressions, to name some examples, it is a reasonable proposition to ask about the extent to which Australian society has been able to understand David Gulpilil's political statements and to question whether it is possible for a film to educate a global audience about *Garma* (public law and knowledge). *Garma*, a repertoire of designs, dances and songs, has many sacred elements and purposes (Langton, quoted in Perkins and Fink 2007: 67). Yolgnu life is loaded with ceremony and abundant in learning. When enacted on stage or screen, David Gulpilil's performance contains profound meanings of knowledge of the sacred core, and it is this knowledge that David performs on stage and screen and through his acting and narrative in film. The kind of knowledge he wishes to impart is that of Yolgnu culture, with the aim of achieving an appropriate appreciation of the integrity of the culture he belongs to.

It has been argued that the significant contribution David Gulpilil has made to the world of cinema is not reflected in the earnings he has received from appearing in films (Scobie 2004). However, his contribution to world cinema has not gone unrecognised; he has received many awards, such as the award for best actor in *The Tracker*, at the Cinemanila International Film Festival. In 1987 he was awarded the Medal of the Member of Order of Australia for his services to the arts. He

received an AFI award for *The Tracker*, and the inaugural Don Dunstan award for outstanding contribution to the film industry. In spite of such international success, his financial circumstances are not equivalent to those of non-indigenous actors of similar standing in world cinema. For example, *Crocodile Dundee* (1986) made $4 million at the box office, and for his performance David Gulpilil received $10,000. For *Walkabout*, he reputedly received $1,000 (Scobie 2004: 18).

David Gulpilil has also more recently taken his message of racial inequality to the theatre. In the play *Gulpilil* (Neil Armstrong 2004), the actor laments the fact that governments are slow to act when it comes to recognising indigenous rights. In this play, co-written with Reg Cribb, about the alienation he experiences as a Yolngu man living in an alien dominant culture, he is explicit in stating his political position: 'I'm David Gulpilil, born with two legs. My part of life is another foot stand in my country and another foot stand in whitefellas' world. That's my life' (O'Brien 2004: 1). He dramatises grief by acting out, in a personified theatrical representation, the story of his life as a member of a marginalised culture. In this way David Gulpilil alerts the audience to the psychological pain that he experiences at the hands of politicians who ignore the inequalities that exist in Australia:

> My play is the true story about how I cope all alone. Its message is to understand everybody ... For people to understand me you have to learn about my land my language ... I live in a humpy house. The Australian government has to wake up and look at how people like me are living. The Prime Minister is doing his job for [white] Australia; why can't they look at what's going on in black Australia? (O'Brien 2004: 1)

David Gulpilil points out the psychological problems presented by being a First Nation person in an alien dominant culture. He expresses the cause of his feelings and his sense of alienation as that which he experiences when he sees the inequalities that exist in Australia. When he speaks about his mandatory participation in the rituals of the dominant culture, the description of his situation reflects the ideas of Frantz Fanon and his explication of the concept of 'blackness', according to which cultural values are internalised or 'epidermalised' into consciousness (Fanon 1967: 109). According to Fanon, 'not only must the black man be black in relation to the white man, the black man has no ontological resistance in the eyes of the white man' (Fanon 1967: 110). For example, the actor explains that he must participate in the rituals of a dominant culture: 'I have to join in whitefellas corroboree sometimes' (Scobie 2004: 19). However, he has paid a high price for such alienation, as it has caused depression and alcoholism, the outcome of which was a jail sentence.

In *One Red Blood* he communicates his complex relationship with Ramingining country, and explains the physical pain of another kind of alienation – that which characterises separation from his homeland. In doing so he appeals to the audience's

humanity, exhorting people to recognise the effects of discrimination and offering his own personal experience as an example:

> I feel it here I can feel the spirit of the land – message coming through my body, may be my son calling me ... I feel it there (*indicates arm*) ... I sit on the land and start singing. I feel the spirits around me ... I cry for my people ... I want change, make it equal between Balanda and Yolgnu people ... Black and white – one red blood. (O'Brien 2004: 1)

The challenges presented to a Western audience in understanding the indigenous worldview require some reflection. A non-indigenous person will often have an essentialist view of the indigenous world even when they are intent on challenging inequality and racism. The restrictive colonial gaze is deeply entrenched, and it is persistent. It is owing to such lack of understanding that indigenous communities are deeply conflicted about allowing public access to their knowledge. Some communities wish to continue to preserve sacred knowledge, believing that the non-indigenous world is not yet capable of understanding it.

The persistence of the colonial gaze, the influence of Aboriginalism and the normalisation of scientific racism clearly contribute to many filmed versions of indigeneity. This is the reason why, after 40 years of acting on the screen, and regardless of significant political action, non-indigenous audiences are not yet able to fully understand the world that David Gulpilil conveys. They do not recognise indigenous knowledge and are therefore unable to value it.

Knowledge 'Written' on Canvas

There is a need to understand and interpret the signs of indigenous knowledge systems so that the non-indigenous world can understand indigenous worldviews. The soundest starting point for real understanding between two different cultures is to recognise their common ground. However, as theorists Rigney (1999) and Martin and Mirraboopa (2003) suggest, motivation does not always guarantee a successful outcome. To understand indigenous knowledge and worldviews, it is important firstly to identify and then challenge the 'us' and 'them' Eurocentric dichotomy that fosters cultural opposites. It is this division into separate cultural entities that continues to dominate indigenous affairs. Western cultures traditionally express knowledge in writing, while indigenous cultures of remote locations and communities articulate it in symbols and signs. The situation is further complicated by the diversity present in indigenous cultures. Indigenous peoples who do not live in remote areas express their cultural identity in a different way to David Gulpilil. The difficulties of cross-cultural communication will continue unless there is appropriate facilitation and inclusive measures are taken to include indigenous knowledge systems within the formal processes of education. Working more

closely with indigenous communities to bring about mutual cultural understanding is strongly advocated by indigenous elders, who have expressed concern that the ancient patterns and designs that come from Country may be lost if they are not passed on (Marawili 2011). Painting images on canvas is an effective medium of expression that ensures a continuum of indigenous knowledge. Paintings alone are a rich mine of indigenous knowledge of systems of culture, medicine, psycho-geography, cosmology, ecology, art, cartography, biography, kinship, ritual interconnection and law. They record matters of national ecological significance such as the geography and knowledge of natural water sources – soaks and rock holes. When the female protagonist of *Walkabout* asks, 'Where do they keep the water?', the water necessary for her survival is provided by David Gulpilil's character, and the answer to her question is most certainly to be found painted into the canvases of the communities of the far western desert, as this is the way indigenous people communicate their knowledge.

The indigenous knowledge that is expressed in restricted form in paintings is also presented in diverse forms of performance. Indigenous paintings that are a visual scheme of recording for important cultural information record knowledge that language cannot express. Paintings are merely the condensed versions of a more extended knowledge that is conveyed in performance in song, dance and ceremony, as David Gulpilil demonstrates through his film performances. Some indigenous communities want the world to understand the ancient designs that appear in paintings, to make certain that the knowledge that the elders want to preserve is protected for future generations. The Dreaming contains these designs as well as a system of caring for the knowledge. Paintings of Dreamings are particularly important, because they are jam-packed with meanings. *Tjukurrpa* (Dreaming) is intended to inform future generations about the intricacies of country. It is a complex ideational structure that presents a single framework of perception that gives expression to the ways in which knowledge is attained and enacted (Ryan 2011). It represents a means of communicating a procedure of continuity that aims to ensure an ongoing system of care and ownership. Within *Tjukurrpa* there also exists a complex political system of care and custodianship, and indigenous communities dance, sing or paint this knowledge. In recent years the West has realised the significance of indigenous paintings. For example, Rolf de Heer, the writer and director of *The Tracker*, chose to frame the film within a series of painted backgrounds of the Flinders Ranges. The painted representation of the environment set the scene for the violence that followed. The role of the tracker was played by David Gulpilil, who received great accolades for his performance, while Archie Roach sang the soundtrack. Set in the 1920s, the tracker of the film title demonstrates great knowledge of the barren landscape and demonstrates superior sensory and environmental skills. The film tackles the issue of the massacre of indigenous people and attends to the issues of indigenous law-making and the racial codes, conflicts and hostilities of the time.

Paintings of Country similar to those that appear in *The Tracker* proliferate in indigenous cultures. The production of knowledge through art is integral to life in most indigenous communities. For example, a person's life history is often mapped onto the landscape, whereby the landscape is an objectification of the self, because the linear sequencing of language is not flexible enough to describe the subtleties of meaning, and indigenous art has many meanings. A validation process safeguards them while at the same time permitting a wide range of possible meanings, thus providing for more subtlety of expression (Peterson 2009: 133). This visual code and way of seeing the world is unlike the Western system of binaries and classification into species or gender. Western historical methods of chronology exclude such indigenous modes. Clearly, Western modes of understanding influence the kinds of roles indigenous actors play. When an indigenous star such as David Gulpilil plays a role in a movie, he is usually typecast according to Eurocentric scientific ideas about indigenous identity. The actor expressed disappointment in his earlier acting days when he won his first role in *Walkabout*, and was typecast to conform to the Western imaginings of indigeneity:

> Yeah, I thought I was going to be a cowboy like John Wayne but you know it was different. It was just me... I was the best because I danced and I did movements and I did spear-throwing and hunting. (Schwartz 2005)

Western Knowledge Production, Colonisation and Essentialism

In the non-indigenous Western world, the formulation of knowledge is often perceived as having a rhetorical function and as bearing the intention of presenting one's own values in the guise of so-called 'scientific disinterest'. Foucault proposes that knowledge equals power, and describes ways of controlling the subject by means of defining and therefore knowing it. This theory applies directly to colonialism, Western knowledge production and the ways of 'knowing' indigenous peoples (Foucault 1980). It is also a reality that indigenous peoples and cultures have essentially become 'known' through the academy (Moreton-Robinson 2000; O'Brien 2008). However, indigenous communities and scholars reject Western racial categorisation, and are sceptical about the kinds of knowledge transmitted by university disciplines such as anthropology, physical and social archaeology, history, linguistics, demography and museology. Said's theory of Orientalism has been influential, and produced the concept of Aboriginalism (Said 1978: 1–28; Arnold and Attwood 1992). Scholars since the 1960s have been persistent in their critical evaluation of Aboriginalist interpretations of indigenous contexts. Such critical assessment takes place in the academy, in art and in literature to form part of an evaluation of essentialist understandings of indigeneity. For example, it was suggested by Arnold and Attwood that the concept of Aboriginalism produces 'authoritative and essentialist "truths" about indigenes', and that such concepts might exist in

three possible forms: firstly, in Aboriginal Studies; secondly, in the dichotomy between 'them' and 'us'; and thirdly, in exercising authority over indigenous peoples (Arnold and Attwood 1992: 1–6). A significant focus of such a critique involves a continuing effort to dismantle the internalisation and reproduction of scientific blood quantum categories applied to indigenous peoples and introduced by Enlightenment thinkers. The persistence of Western stereotypes not only restricts indigenous peoples' activities to ascribed Western identities, it also prevents the public from attaining an accurate interpretation of indigenous experience.

Aboriginalism, Performance and Decolonising Scientific Thinking

Moreton-Robinson writes about colonisation practices. Her theory is critical of anthropological methods that have misrepresented indigenous women because they are based on Western scientific ways of understanding (Moreton-Robinson 2000, 2004). Decolonising strategies hold potential where an unequal power relationship exists between non-indigenous and indigenous peoples. In order to contribute to a continued critique of Western knowledge systems, scholars working in the field of indigenous studies present an alternative to Western knowledge production, and have effectively formulated decolonising methodologies (Smith 1999; Martin 2003; Iseke-Barnes 2003; Rigney 1999; Smith and Wobst 2005; Foley 2003; Wilson 2008; Janke 2009; Moreton-Robinson 2000).

Aboriginalist discourse not only controls and maintains an unchanging view of indigenous experience. It also works to fix and sustain a non-indigenous audience's expectations of indigenous Australian performers. Scholars influenced by Moreton-Robinson's theories of feminism and whiteness have further challenged this process. In her exploration of indigenous performance, for example, Barney (2010) refers to the influential texts of 'white anthropologists' and their representations of indigeneity, and discusses the ethics of scholarship in relation to anthropological research and the publication of restricted women's information. With reference to indigenous performers, she suggests that 'indigenous women who perform are acutely aware of Aboriginalist stereotypes and use a range of strategies to work within, against and around these Aboriginalist constructions' (Barney 2010). As an example, she highlights the ways in which indigenous women, such as Deb Morrow, who uses performance as a platform on which to challenge racism, challenge Western Aboriginalist representations in performance and in visual imagery. According to Barney, she does this by 'refusing to include any typical musical elements, such as a didjeridu or clapsticks' (Barney 2010: 229).

Challenging Western Knowledge Production Through Legal Testimony

The colonialist representation of indigeneity presented by Western knowledge production is challenged by indigenous self-representation, legal testimony and

narrative. Such first-hand accounts are important in enabling a full understanding of Indigenous realities. Indigenous depositions are frequently relied upon to provide evidence, in particular, witness testimonies in the report on the Stolen Generation, *Bringing Them Home* (Australian Human Rights Commission 1997), and crucially where witnesses' reports establish a continuity of land occupation in Native Title legal claims. David Gulpilil is well known as a storyteller, and in *Ten Canoes* he preferred narrative technique above acting.

Through their various screen roles, David and Jamie Dayindi Gulpilil continue to convey cultural knowledge about indigenous practices. The interconnection of film with the global public holds great potential for the future. However, there is also a need for global audiences to possess a greater awareness of indigenous knowledge systems. The actors' aims to convey Yolgnu knowledge might yet prove effective by encouraging a greater awareness and understanding of indigenous modes of self-determination, and by incorporating valuable community-driven indigenous knowledge initiatives into film to inform the global audience. By encouraging an effective approach to understanding the complexities associated with indigenous performance as knowledge and its representation in film, and by appealing to the greater public in world cinema, there is an opportunity to achieve a greater understanding of indigenous cultures and at the same time encourage the possibility of social justice in Australia. According to director Warwick Thornton, there is strong potential for international cinema to educate and to communicate indigenous knowledge:

> Cinema is performance, that's how us blackfellas have connected with it. It's where we come from, with our storytelling. A lot of dreaming stories are about moral stories and news and teaching . . . that's the way Indigenous filmmakers are thinking. (Thornton 2009)

Section 4

Stars, Bodies and Performance

13

Sharon's Noranian Turn: Stardom, Race, and Language in Philippine Cinema

Bliss Cua Lim

In Lino Brocka's 1975 film, *Maynila: sa Mga Kuko ng Liwanag* ('Manila in the Claws of Neon'), a work that ushered in the social-realist aesthetic of the Philippine New Cinema, a menial construction worker named Benny dreams of escaping poverty. Given to the cheerful habit of singing on the job, Benny hopes to become a famous singer one day, like his movie star idol Nora Aunor. Benny is killed in a construction accident, dying in mid-song. To evoke the harsh fate of rural migrant workers in Manila, the camera lingers on Benny's broken body and on a star image that immediately voices his unrealised hopes: a songbook cover of Nora Aunor.

The scene powerfully condenses the way in which, in the late 1960s and early 1970s, Nora was an immediately legible icon for poor rural and urban media audiences in the Philippines. National Artist for Literature Nick Joaquin calls Nora the 'lowly *morenita* from Iriga', a brown-skinned teenage girl who rose to superstardom from an impoverished provincial childhood (de Manila 1965: 6–7). The allusion to Nora's rags-to-riches mythology in *Manila in the Claws of Neon* underscores the redemptive, if unrealised, horizon of Noranian fandom: a collective yearning for social transformation, for things to be other than they are (Flores 2000b: 79). This is the very horizon of fan reception that an emerging elite-identified *mestiza* star, Sharon Cuneta, Nora's eventual 'successor in popularity' (Cervantes 2000: 20) would attempt to emulate in the 1980s, over a decade after Nora's phenomenal rise.

This chapter seeks to understand the racialised allure of the two most important female stars in Philippine cinema's post-studio era: Nora Aunor and Sharon

Cuneta.[1] Broadly, the argument I present here has three moments. The first section traces decisive shifts in racialised star embodiment in popular Philippine cinema. In the post-studio era, Nora, the first 'brown beauty' of Philippine cinema, forced an unprecedented break with the film industry's reliance on *mestizo/a* stardom, the practice of casting fair-skinned actors with foreign features in leading roles. I suggest that Nora Aunor changed the racial terms of Philippine stardom so profoundly that, by the 1980s, Sharon Cuneta, an elite-identified *mestiza* celebrity, resorted to the appropriation of Nora's biographical mythology in her bid to become the next Filipino superstar. This refashioning, which I call Sharon's 'Noranian turn', points to shifts in language, '*mestizo* envy' and 'white love' in Philippine cinema. The second moment of my broader argument situates both stars in the context of the national language debates in the 1960s and 1970s, and the rise of Taglish as the new *lingua franca* of popular culture after the 1980s. A continual code-shifting between the vernacular language of Tagalog and the colonial languages of English and Spanish, Taglish is a linguistic analogue for the racial ambivalence that constitutes *mestizo/a* identity (Rafael 2000: xi–xii, 162–7).

Given the prolific film output of Nora and Sharon (both are still active in the film industry today), it becomes impossible to confine either star to any single period in their career, whether the height of Nora's popularity in the late 1960s to the early 1970s, or Sharon's Noranian turn in her mid-1980s melodramas. In juxtaposing these phases in the careers of two Filipina icons, my aim is not to reduce either star to these decisive moments. Rather, I seek to challenge monolithic conceptions of class-segregated film audiences in the Philippines by retracing the path of two cross-over stars. Accordingly, the third section of this chapter suggests that the disruptive form of star embodiment Nora actualised and Sharon appropriated led to an unexpected convergence between class-stratified audiences in Philippine cinema.

Race and Stardom in the Studio and Post-Studio Eras

The studio era of Philippine filmmaking stretched from roughly 1936 to 1961, with a hiatus from 1941 to 1945 due to World War II. The Philippine studio era saw the rise of large commercial film-production outfits, a durable star system and genre films. The 1950s through to the early 1960s, dominated by the 'Big Three' studios (LVN, Sampaguita and Premiere), have been dubbed the 'Golden Age' of Philippine cinema because of the aesthetic and technical achievements of Filipino filmmaking in this period (Tiongson 1992: 27–9).

By 1965, the dissolution of the studio system was well underway. The mid- to late 1960s ushered in the excesses of post-studio-era filmmaking in the Philippines: quickie filmmaking financed by inexperienced producers; films of poor technical quality and low prestige in comparison with big studio productions; and the unprecedented power of the freelance star (or star-producer), who is able to

command inflated talent fees unheard of in the days of studio contracts (Lacaba 1983b: 176; Celino 1966: 38–9). Arriving on the movie scene from nationwide success on radio and television in 1967, Nora both deviated from and intensified the star system of the studio period that preceded her: she became the first non-*mestiza* star of Philippine cinema and, at the peak of her popularity, the most powerful star in its history.

The daughter of a provincial train porter, the 12-year-old Nora Cabaltera Villamayor won a regional amateur singing contest wearing a second-hand dress her mother had altered. Her destitute family listened on a neighbour's radio as her victory was announced; the prize money she won that first evening was for an older sister's tuition (de Manila 1970: 6–7, 57–9). For her screen name, Nora would adopt 'Aunor', the last name of relatives who helped raise her (Pareja 1994a: 205). In 1967, at the age of 14, Nora won the grand finals of a nationally-televised singing contest, *Tawag Ng Tanghalan* ('Call of the Stage') (de Manila 1970: 7). In the years that followed, Nora emerged as a pop music sensation on radio, television, and film (Figure 13.1).

Nora embarked on a decades-long movie career that began with early teen musicals in the late 1960s, turning to serious prestige projects and commercial melodramas from the mid 1970s to the present. Nora is remembered for her roles as a virtuous but long-suffering woman who puts the needs and wishes of others before her own (Tadiar 2004: 227), as in the film *Atsay* ('Housemaid', 1978) (Figure 13.2).

Nora's work in the 1982 New Cinema film *Himala* ('Miracle') has been hailed as the finest performance of the period, and of Philippine cinema as a whole (David 1995: 58). Still professionally active at the time of this writing, Nora has been called 'the most accomplished transmedia star the Philippines has ever produced, spanning a career of four decades and counting' in music, television, film, and theatre (Flores 2000a: i).

Nora's superstardom is significant because she broke the mould of the *mestizo/a* stardom that preceded her. In the studio era, matinee idols were invariably mixed-race actors whose light skin and European or American features allowed them to be packaged as local approximations of Hollywood stars. As film historians have pointed out, Philippine film studios 'favored mestizas and mestizos for principal roles because they approximated the Caucasian features of American icons' (Tiongson 1992: 24). *Mestizo/a* movie idols embodied a neo-colonial mimicry of Hollywood, prompting Vicente Rafael to characterise Philippine film stardom as a social institution for 'the reproduction of a mestizo/a social order' (Rafael 2000: 189). In Philippine cinema, it is 'race mixture' – the *mestizo/a* star as 'the event of miscegenation' (Sexton 2003: 243) – that, far from unravelling the power of racialised logic by exposing the instability of racial categories, shores up the cachet of whiteness.[2] More than a name for race mixture, *mestizaje* in Philippine cinema sets off a circuit of spectatorial substitutions: the *mestiza* star is a local

Figure 13.1. In the late 1960s, Nora emerged as the Philippines' first superstar, a pop music sensation who crossed over into television and film. *Source: Asia-Philippines Leader* 1.3 (23 April 1971). Courtesy of the Rizal Library Filipiniana periodicals collection, Ateneo de Manila University.

Figure 13.2. Nora Aunor's iconic role was a maltreated but long-suffering female domestic servant in *Atsay* ('Housemaid', dir. Eddie Garcia, 1978).

placeholder for the 'white' Hollywood star or the elite descendants of Spanish and American colonisers; but at the next moment in the circuit, the *mestiza* star solicits identification from 'brown' lower-income urban audiences who comprise the bulk of the nation's filmgoers. The racially and linguistically hybrid *mestizo/a* star serves as an intermediary between racialised figures of privilege and disenfranchisement (Rafael 2000: 162–6).

In relying on *mestizo/a* stars, film studios had to manage the public's 'love-hate relationship' with the class privilege and colonial dominance such stars personified (Cervantes 2000: 18–19). Most *mestiza* stars were renamed to gentrify and 'indigenise' them. *Mestiza* stars were repackaged with Filipino screen names to erase their foreignness: Sigrid von Giese became Paraluman, Flora Danon was rechristened Rosa Rosal, Dorothy Jones was dubbed Nida Blanca and Susan Reid was renamed Hilda Koronel. In *mestizo/a* stardom, as Nicanor Tiongson has pointed out, the dynamics of indigenisation and imitation are inextricable (2000: 24–6). *Mestizo/a* stars were offered in mimicry of Hollywood: Rudolph Valentino's counterpart was the Philippines' own 'great profile', Leopoldo Salcedo; Elvis's double was Eddie Mesa, and Audrey Hepburn's was Barbara Perez. On the other hand, foreignness was indigenised: *mestizas* were costumed in nativist attire, playing down-to-earth barrio lasses and speaking a florid Tagalog heard only in movies (de Manila 1965: 7).

In the late 1960s, *mestizo/a* stardom was challenged by the ascendancy of Nora, upheld as *kayumangging kaligatan*, a 'smooth-complexioned brown beauty' (Velarde 1980: 8). Nora's defiance of the film industry's axiom 'white is beautiful' (Tiongson 1979: 17) was never to be replicated at such a scale by another Filipino film star. Nora's body defied a racialised politics of casting that enshrined tall, fair-skinned *mestizo/a* performers as the apex of physical beauty and cinematic glamour. In the era of Nora's superstardom, Noranian embodiment was a horizon of corporeal–aesthetic valuation that coalesced around her person, mapped on the axes of racial, class and gender allegiances. The popular valorisation of teen star Nora's diminutive 4 ft 11 in. body and 'coffee-brown skin', 'the color of the skin of the majority of movie fans' (Zapanta 1970: 43), amounted to a disruptive defiance of *mestizo/a* stardom in Philippine cinema. This performative defiance was not only enacted by the star, but also brought into being by her massive Noranian fan following among the urban and rural poor. Behn Cervantes describes the feminist and working-class sympathies of Nora's persona:

> The ascendancy of Aunor, the dark and underprivileged Filipina, coincided with the rise of rabid nationalism during the late 1960s and early 1970s. Her struggle against the mestizas was emotionally supported by the anti-imperialist, pro-*masa* [masses] sentiment brewed by activism. Furthermore, her story was cinematic in proportion, being [that of] a genuine Cinderella who rose from rags to riches. She was the Dark *Pinay* [Filipina] who toppled the White *Tisay* [*Mestiza*]!
>
> The Filipino audience was ripe for Nora Aunor. Domestic helpers, *atsays* [housemaids], cigarette vendors, store clerks, and everyone who identified with the diminutive beauty realized that for price of a movie ticket, they could make a difference. They were heard and noticed through Nora. Her smooth brown complexion and dark brown eyes legitimized their own skin and eyes. They became fanatically loyal (Cervantes 2000: 20).

In 1980, 13 years after Nora's sensational emergence, another 14-year-old singing sensation appeared on the pop music scene: Sharon Cuneta. Dubbed the 'jukebox princess', Sharon was, like Nora, a teenage recording star who would successfully cross over to the screen with a slew of profitable teenpics (Pareja 1994b: 225) (Figure 13.3).

In many ways, however, Sharon's path in music and film could not have been more different from Nora's. A child of humble origins, Nora proved her worth in provincial amateur singing contests, slowly inching her way closer to televised triumph in Manila. A child of considerable means, Sharon was a mayor's daughter with relatives in the television and music industries (Celino 1984: 20, 38). Sharon recorded a chart-topping single at the age of 12 and had two gold singles to her credit by the time she was 15. For her first film, a movie studio eager to make films targeting Sharon's emerging audience of educated middle-class teens offered her a

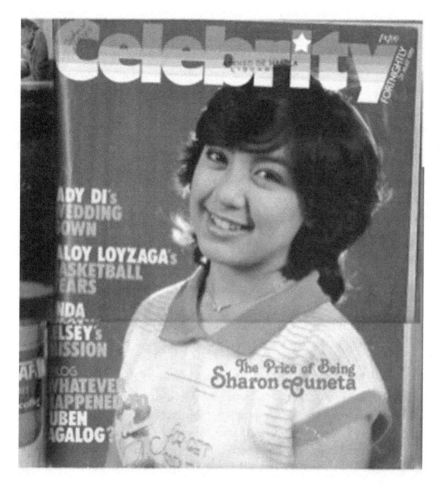

Figure 13.3. Dubbed the 'jukebox princess', Sharon Cuneta was a teenage recording star who began her film career in 1981, starring in a slew of profitable teenpics. *Source: Celebrity* (31 May 1981). Courtesy of the Rizal Library Filipiniana periodicals collection, Ateneo de Manila University.

talent fee rivalling that of top-tier female stars, Nora among them. Sharon entered the movie business in 1981 as 'the highest paid neophyte in Philippine history' (Constantino 1981: 22; Celino 1984: 20). Such crucial differences notwithstanding, parallels between Nora's and Sharon's rise to popularity are also instructive: both performers emerged against the backdrop of sexploitation films by crafting star personae distinguished by youthful wholesomeness and martyr-like suffering (Villanueva 1970: 38; Constantino 1981: 22); both began as adolescent singers who crossed over into film via romantic teenpics; music remained prominent in both their film careers.

Sharon's first two films, the teenpics *P.S. I Love You* (1981) and *Dear Heart* (1981), introduced a new kind of *mestiza* star to be simultaneously hated and loved. Sharon's early teen films focused on parental obstacles to teen romance and the problems of a poor little rich girl who was both enviable and sympathetic. In the early 1980s, Sharon's new brand of *mestiza* stardom was defined by the auditory glamour of her speech, a nonchalant peppering of Spanish, English, and very little Tagalog. This is the Taglish of the *colegiala* – a stereotypically affluent Catholic college girl – whose lilting speech folded English and Tagalog words and syntax together. The figure of the *mestiza colegiala* in the Filipino popular imagination evokes the 'convent-educated young woman' whose 'inability to speak proper Tagalog' results in 'her need to resort to Taglish' (Rafael 2000: 257). Despite being parodied as an emblem of a neo-colonial elite's alienation from national culture, the *colegiala mestiza* elicits popular desire (Rafael 2000: 257). The *colegiala* vivified by Sharon was, in the 1980s, Philippine cinema's most visible embodiment of a subcultural *mestizo* elite.

Though Taglish has since risen to prominence as the *lingua franca* of Manila-based popular culture, it was seldom heard in Philippine movies before Sharon's rise. The brand differentiation of Sharon as a new kind of Filipino teen star was precisely the unmistakable authenticity she brought to her linguistic performance of *colegiala* Taglish – the revelation of the habitus of her class in the auditory flourishes of her linguistically hybrid speech. In a Philippine context in which social stratification corresponds to linguistic hierarchy, the cultural distinction of Taglish – the symbolic profit of sounding like a wealthy, private-school-educated young woman – was also the commodity signature of Sharon and her films. If, since the 1980s, Taglish has become the new *lingua franca* across classes in Metro Manila, permeating even the day-to-day vocabulary of the urban poor, it is partly because a historical association with *mestizaje* underpins its allure.[3]

What I am calling Sharon Cuneta's 'Noranian turn', a retooling of her star persona through the appropriation of Nora Aunor's populist appeal, began in 1984. Sharon's upper-class teen roles had made her a star, but the teenpic cycle was exhausted, and such roles were now considered too escapist. Some predicted that Sharon would be forced to take on sexually risqué projects in order to preserve her career, while others advised a pronounced shift to realism (Dumaual 1983: 8–9; Torre 1983: 4). By 1984, Sharon had abandoned her *mestiza colegiala* roles. That year and the following one, she starred in the spectacularly profitable *Bukas Luluhod ang Mga Tala* ('Tomorrow the Stars will Kneel', 1984) and *Bituing Walang Ningning* ('Star Without Sparkle', 1985). *Bukas* and *Bituing* are both melodramas of social ascent that track the oppression and eventual vindication of an indigent girl whose beautiful singing voice lifts her into superstardom. These films rehearsed not Sharon's off-screen biography but the instantly recognisable script of Nora's life: the incredible-but-true story of a street vendor rescued from poverty by her own prodigious singing talent. This Noranian turn, a calculated re-imagining of Sharon's

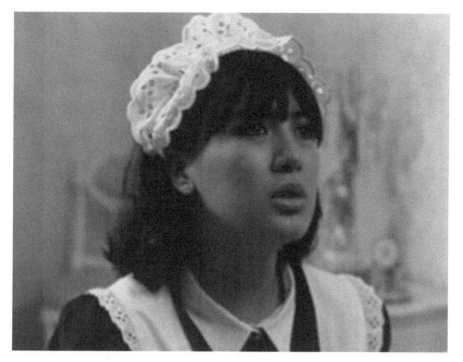

Figure 13.4. *Pati Ba Pintig ng Puso* ('Even the Beating of My Heart', dir. Leroy Salvador, 1985) appropriates and romanticises Nora Aunor's iconography as a long-suffering *atsay* or housemaid who becomes the object of her male employer's sexual advances.

persona via Nora's mythology, is made explicit in a scene in *Bukas*. Sharon's young character wins an amateur singing contest; street kids tell her that she reminds them of Nora. Noranian allusions persisted across other Sharon films in the same decade: the motif of Sharon as a slum-dweller who wins an amateur singing contest is repeated in *Pasan Ko ang Daigdig* ('The World is My Burden', 1987) (Barrios 1989: 2–8) and the Noranian iconography of an *atsay* sexually harassed by her male employer is romanticised in *Pati Ba Pintig ng Puso?* ('Even the Beating of My Heart', 1985) (Figure 13.4). Sharon's Noranian turn was acknowledged in a scene in *Bituing*: poised for her promotional debut as a recording star, Sharon's Dorina receives a makeover while seated under a photographic enlargement of Nora (Figure 13.5). Sharon's appropriation of Noranian mythology proved enormously lucrative. *Bukas* did well at the box office, and was the first of her two most conspicuously Noranian films, the second being the following year's *Bituing*, which set a new box office record (Rapadas 1985: 8, 28). Sharon was declared 'the new movie queen' of 1980s Philippine cinema (Villasana 1986: 7).

In *Bituing Walang Ninging*, Sharon plays Dorina, a street vendor who avidly follows the career of her favorite *mestiza* star, Lavinia (played by Cherie Gil). Dorina

Figure 13.5. In *Bituing Walang Ningning* ('Star Without Sparkle') (dir., Emmanuel Borlaza, 1984), Dorina, played by Sharon Cuneta, is given a makeover in the foreground; a photographic enlargement of Nora Aunor is visible in the upper right corner of the background.

begins as Lavinia's devoted fan; having launched her own successful recording career, however, Dorina ends by usurping and surpassing the *mestiza* star. As *Bituing* demonstrates, Sharon's *mestiza* teenpic persona was reinvented through the prior coordinates of Noranian mythology, transformed through a 'making-indigent' of Sharon's heretofore upper-class screen roles. This translative re-imagining of Sharon as the new Nora distanced Sharon from the wealth and neo-colonial privilege associated with *mestiza* actresses by emphasising an important confluence with the Noranian persona: cinematic success enabled by a prior adolescent career in music.

In Sharon's Noranian turn, the disruption of *mestizo/a* stardom introduced by Nora comes full circle, partly capturing Noranian mythology for an elite-identified star, but also partly reversing the terms of white love. In the post-studio era, two moments ensue, encapsulated by two stars, Nora Aunor and Sharon Cuneta: in the first, a brown-skinned (*kayumanggi*) superstar up-ends the rule of *mestizo/a* stardom. In the second, a decade after Nora's emergence, another star is born: a *mestiza colegiala*, Sharon, who mimics Noranian embodiment instead of Hollywood stars. In the crosscurrents of stars who invoke both whiteness and brownness, we glimpse

what Rafael has called the 'characteristic ambivalence of nationalist responses to the call of white love' (Rafael 2000: xii).

Philippine Cinema and the Language Wars

In 1969, the *Philippines Free Press* declared: 'Make no mistake about it: we are in the midst of a language revolution in this country' (Parale 1969: 15). The roots of the Philippine language wars stretched back several decades, to the government's creation of the Institute of National Language (INL) in 1936. Composed of scholars representing several Philippine regional languages (Visayan, Ilocano, Cebuano, Bicol, Moro and Tagalog), the INL selected Tagalog as the basis of the national language (Giron 1965: 15). From the 1940s onward, the Tagalog-based national language, rechristened 'Pilipino', was used as a medium of instruction in schools. The Filipino educational system thus embraced multiple languages: English, instituted in 1916 by American colonisers; Tagalog-based Pilipino, promulgated as a medium of instruction in 1946; and other major vernaculars, adopted as teaching languages in 1957 (Gomez-Rivera 1965; Aguilar 1966: 334–5). Vigorous regionalist objections to 'Tagalog-based Pilipino' in favour of English as the national language persisted for decades to come.

I revisit the language controversies of the 1960s and 1970s in order to sketch the larger cultural context of Nora's ascent and the significance of Taglish in the early career of her successor, Sharon. Since the advent of sound in the 1930s, Tagalog has dominated the Manila-based film industry (del Mundo Jr 1999: 30–1). The colloquial term for popular Philippine cinema, 'Tagalog movies', indexes the homogenising, nation-binding function of film, which helped establish Tagalog as the national language while relegating other vernaculars and regional film movements to off-screen space.

In the hierarchy of languages in the Philippines, English, the legatee of American imperialism, is still accorded the greatest social distinction, while Spanish continues to connote rarefied elite use. Tagalog commands less social distinction than English and Spanish (Rafael 2000: 169), although among Philippine languages, Tagalog is the most prestigious due to its association with Manila and with the Manila-based media industries (Llamzon 1968: 724, 735). In this context, Tagalog's dominance in one arena, movies, drives home the nationalising function of popular Philippine film: the cinema disseminates Tagalog-based Filipino as the *lingua franca* of popular culture, doing more to establish Filipino as a translocal language than state legislation (Tiongson 1992: 24). In the 1970s, Nora was often invoked as positive proof of the nationalising effect of popular cinema. Nora's image was everywhere on theatre marquees and the covers of weekly magazines; to cultural commentators, such popularity proved that Tagalog, the idiom of the movies, bound audiences across the diverse archipelago (Lacaba 1970: 7).

Such nationalist celebrations notwithstanding, other voices lamented the demise of English as Tagalog gained prominence in schools. A familiar motif in the language scene of the postwar period emerged: the long lament, often punctuated by condescending humour, regarding the inadequacy of 'Filipino English', a phrase considered synonymous with 'the deterioration in our spoken English' since the end of American rule in the Philippines (Catbagan 1966: 122–9, 134). Critiques of Filipino English were underwritten by nostalgia for the American colonial era, when Filipinos were taught English by American teachers (Thompson 2003: 21). 'Imperfect' pronunciation and problems with intonation and rhythm in spoken English loomed large in these accounts. Seldom framed as an expected consequence of multilingualism and a language variant in its own right, Filipino English was derided as a species of failure, and the speech clinic was the remedy of choice.

The deracinating logic of the speech clinic is one of helping Filipinos to learn how to sound like Americans (Sibayan 1966: 70–1). In an essay originally published in 1970, Jose Lacaba satirises the social climber who resorts to a speech clinic in order to unlearn her *bakya* (tacky, low-income or provincial) English (1983b: 122). The speech clinic becomes a figure in Lacaba's analysis for the nouveau riche's linguistic re-education in English, the language of the elite. In the mid 1980s, *Bituing Walang Ningning* staged this very fantasy of class rebirth through speech, with Sharon playing a poor singer who, en route to stardom, must first learn to speak English at a speech clinic. This surreal speech clinic scene stands out in the film that turned the tide for Sharon's film career.

The unintentional campness of this scene lies in the fact that the speech clinic instructor requires Sharon's character to recite impossibly complex tongue-twisters in English, which Sharon's Dorina, framed in surreal close shots, enunciates with astonishing facility. The heroine's capacity to speak English like the wealthy do far exceeds what can be motivated by the storyline, and points off-screen to Sharon's elite education, first in St Paul's College, a private Catholic school, and later at the American-run International School. Mindful of the low prestige value of Tagalog, private schools in the Philippines historically resisted the shift to the national language as medium of instruction, thus cementing English as a mark of *colegiala* distinction. The split between public schools, where the primary medium of instruction was Pilipino or Filipino, and private schools, which continued to teach in the prestige language, English, was lived in every Filipino student's linguistic habitus; one could hear the 'social cleavage' in Filipino education in actual speech (Anderson 1968: 57, 62).

In this context, the auditory distinction of Sharon's private school diction – whether in English or Taglish – stood out in sharp relief. It was precisely the sound of *mestizo/a* privilege that such scenes in *Bituing* trumpeted to unwittingly camp effect. On-screen, we witness the transformation of a street urchin into the toast of society, a demonstration of linguistic ability ranging from movie Tagalog

to *colegiala* English; however, this points to the off-screen knowledge that Sharon captivates precisely because of her upper-class habitus. Given this, *Bituing*'s speech clinic scene functions almost as an inside joke. For Filipino spectators familiar with her star persona, watching Sharon's character 'learn' how to speak 'proper English' hardly even invites a suspension of disbelief, since what the montage of Dorina's speech clinic classes more actively solicits is an appreciation of Sharon's class-inflected bilingual proficiency. This remarkable scene makes emphatic the ruse that underpins the Sharon films of this period: that of an elite star slumming as a Noranian figure, Sharon in drag.

Star-Crossed Audiences: *Mestiza* Noranians and the '*Bakya* Crowd'

In a 1970 article, 'Notes On "Bakya"', poet, journalist and screenwriter Jose Lacaba put forward a groundbreaking, redemptive discussion of *bakya* sensibility in Philippine popular culture, which Nora emblematised. The term 'bakya' originates from 'wooden slippers worn in lieu of shoes by the poor in the barrios', a synecdoche which comes finally, in the late 1960s and 1970s, to denote the 'style of popular culture, the sensibility of... masscult', disparagingly characterised by most as 'cheap, gauche, naive, provincial, and terribly popular' (Lacaba 1983b: 117–23; cf. Rafael 1995: 110–11).

The new configuration of the star system in the post-studio era meant that all other considerations became secondary to the star's power to lure the so-called *bakya* crowd to theatres. Pejoratively referred to as 'darling of the Bakya crowd' (Frades 1970: 20), Nora commanded a fan base of such scale that one critic described her Noranian fans as 'the biggest and most formidable unarmed force in the Philippines' (Guerrero 1971: 10). The affective-political horizon of Nora's spectacular fan following is what Tadiar calls the 'Noranian Imaginary', an exhortation to the feminised poor to believe in their own historical agency. Although the radical dimensions of Nora's star persona were eventually domesticated, 'subsum[ed] by apparatuses of capture' under both the Marcos regime and the government of Corazon Aquino (Tadiar 2004: 237, 259), the redemptive, if unrealised horizon of Noranian fandom remains: a shared yearning for what Patrick Flores describes as 'a virtue of collective action' (2000b: 85).

By 1970, Nora, the *bakya* pop icon, had begun to breach class boundaries, moving beyond lower-income audiences to attract urban, *mestiza colegiala* fans. Magazine coverage describes the superstar as crossing over to middle- and upper-class audiences: 'Nora is not purely bakya stuff. Not anymore' (Kalaw 1971: 27). One writer – coded by her linguistic and middle-class allegiances as a *mestizo/a*-identified audience member – declared her conversion to the virtues of Noranian embodiment: 'I too was hooked' (Mercado 1970: 56). Over a decade later, in 1984, Sharon's popularity with audiences began to cross class borders in the reverse

direction, spreading beyond her middle-class fan base to win over lower-income audiences. One writer calls Sharon an 'English-speaking bourgeois', a persona that hindered broad audience appeal (Agilada 1984: 18–19). Sharon's Noranian turn, however – her embrace of rags-to-riches roles and a more populist persona – successfully transformed her into a crossover star moving in the opposite direction from Nora. Having begun by addressing an elite-identified 'campus crowd' (Calderon 1982: 18–19; Constantino 1981: 22), Sharon eventually managed to win the devotion of the kind of spectator who first loved Nora – moviegoers who decades ago were dubbed *bakya*.

My final point about Sharon's Noranian turn in the mid 1980s, then, is that it points to a broader shift in audience patterns in Filipino popular cinema. At least until the 1970s, Filipino movie audiences had been split along class lines. In industry parlance, 'D and E' audiences – the two lowest-income categories – comprised the majority of audiences for popular Tagalog-language movies. In contrast, 'A and B' middle- and upper-class audiences watched primarily Hollywood movies (Matilac et al. 1994: 99–100).

Sometime between the late 1960s and the early 1980s, film historians tell us, divisions between audiences in terms of class and language started to become more permeable: the poor started to watch both Hollywood movies in English and locally made prestige pictures, while the professional classes started to patronise domestically produced films whose *lingua franca* was first Tagalog, then, increasingly, Taglish. The passing of the torch of superstardom from Nora to Sharon exposes shifts in both audience composition and language in popular Filipino movies. Historically, the majority of audiences for domestically produced films were lower-income filmgoers, the working class and the poor. By the 1980s, however, middle- and upper-class spectators were watching Philippine-made films as well, in part due to the penetration of Tagalog films into formerly English-only movie houses in the entertainment districts of Avenida, Cubao and Makati in the 1960s and 1970s (Matilac et al. 1994: 99–100).

In the early 1970s, Nora's movement from teeny-bopper movies to critically acclaimed social-problem films blurred the borders between *bakya* and quality film, and attracted fans across classes, from domestic workers to their middle-class employers. In the mid 1980s, Sharon's brand of *mestizo/a* stardom invited middle- and upper-class audiences predisposed to English-language Hollywood fare to watch 'Tagalog movies' and embrace a Filipino movie star. At a crucial juncture, Sharon served as bourgeois viewers' point of entry into the popular films they had once considered too *déclassé* to consume. Sharon's Noranian turn involves not only a *mestiza* star's appropriation of her rival's iconography, but also the making-palatable of Noranian embodiment and mythology to a bourgeois spectatorship. In an important lesson about the heterogeneity of audiences, as well as the facility of bourgeois tactics of supplanting, we realise that Sharon was, after all, not the first *mestiza* Noranian.[4]

Notes

1. In what follows, I will refer to Nora Aunor and Sharon Cuneta by their first names, Nora and Sharon, respectively, in accordance with how the movie-going Filipino public commonly refers to both stars. One may read this commonplace usage as signalling several things: first, the iconic stature achieved by both stars, to the point that last names become irrelevant (there is only one Nora); and secondly, the imaginary intimacy cultivated by both their star personae. It is important to note that the other common way both stars are referred to is as "Ate Guy" (for Nora Aunor) or "Ate Shawie" (for Sharon Cuneta). The word "Ate" means "big sister", and is then followed by each star's nickname. This usage, again stressing that the Filipino audience is on a first-name basis with each star, adds an element of familial intimacy.

2. Jared Sexton argues that 'the fundamental insecurity of racist reasoning' is that racial purity does not exist prior to miscegenation. Racialising discourse is always belied by the fact that 'we are all of mixed origin', an incoherence that racial categories strive to hierarchise, to enduringly powerful effect (Sexton 2003: 243–4).

3. For the concepts of habitus and cultural distinction, see Pierre Bourdieu (1984).

4. This is a shorter, revised version of an essay entitled 'Sharon's Noranian Turn: Stardom, Embodiment, and Language in Philippine Cinema', originally published in the journal *Discourse* (2009), Wayne State University Press. Wayne State University Press has generously granted permission to reprint it here. All translations from Tagalog or Taglish to English in this chapter are my own.

14

Traumatised Masculinity and Male Stardom in Greek Cinema

Vrasidas Karalis

The Historical Settings

The construction of a distinct cinematic language for gender representation, especially of masculinity, took place within the specific historical conditions that formed Greek historical experience. As a nation–state, Greece was fully integrated after 1922 following the monumental Asia Minor catastrophe. Consequently, social instability, political unrest and the failure of modernisation never allowed the articulation of a coherent set of image-making strategies within a thriving studio system. Most films discussed here became the *topoi* through which gender identity was reconstituted through challenging visual discourses, indicating the instability of gender perceptions and the fragility of dominant discourses about them. The vast majority of popular films produced did, however, articulate a normative, heterosexist and traditionalist image of gender and gender performance. However, as Laura Mulvey observed, 'once a frame of reference is lost, the "surface text" floats away from its historical context' (Mulvey 2012: 6). The failure of men in power to construct hegemonic discourses about their authority never allowed the consolidation of an enduring and viable system of male stardom as a system of representation in the public sphere; this was also assisted by the fact that the cinematic industry never developed its products as franchise or as sellable images of specific stars. The masculine image remained in discursive incoherence, without serious and enduring commodification within the film industry; whenever it took place, it was symptomatic, defined by certain circumstances, and never reached the 'industrial' proportions seen, for example, in Hollywood cinema with various celebrities. Consequently, no celebrity culture could be developed, and therefore

no star system was effectively established through the media, mass culture and oral memory.

In a pioneering study, Kaja Silverman explores films in which masculine representations reveal unstable identities and problematic self-perceptions. Such fragile power indicates, according to Silverman, a deep 'historical trauma', which she defines as 'an attempt to conceptualise how history sometimes manages to "interrupt" or even "de-constitute" what a society assumes to be its master narratives and an immanent Necessity' (Silverman 1992: 55). Most Greek films made after 1922 presuppose the 'historical trauma' of the Asia Minor catastrophe. The discrediting of the political order made possible the de-constitution of master narratives about the nation and the exploration of a fragmented reality, a reality that could not be valorised, as the political power had lost the authority to construct its hegemonic ideology.

Indeed, the representation of the male image as being under threat in public, and the sight of a masculine order itself collapsing before a powerful feminine presence, were going to be central forms of representing masculinity in cinema. The theme of a masculinity under threat resurfaced with the next most important Greek film, *Astero* (1929), by Dimitris Gaziadis, in the conflict between father and son that symbolically expresses the obvious ruptures in the patriarchal value system. The representation of such generational conflict also frames a Janus-like image of masculinity: the masculine character is like the male social order, under threat and challenged, but at the same time violent and unpredictable.

Astero epitomises the concessions that the patriarchal order was forced to accept within the context of the emerging class consciousness of the interwar period. Furthermore, although the film is about an idealised past of rural innocence and presumed authenticity, it was also intended for urban viewers who had already been raised in semi-industrialised cities. Not unrelated to this is the fact that the first true stars promoted by the magazines, newspapers and journals dedicated to cinema were women, and their public presence was a social event, especially that of Marika Kotopouli. *Astero* and a number of films produced between 1936 and 1940 articulated the first elements of the representation of a new type of masculine stardom that would become dominant after the end of World War II and of the civil war in 1949.

The male stars of *Astero*, Dimitris Tsakiris and Costas Mousouris, were the first genuine models of masculinity that were promoted through cinema – veritable *jeunes premiers*, as every male screen persona is called in Greece. They are both dressed impeccably in traditional *foustanella* attire that covers their bodies to the neck, but nevertheless allows glimpses of their hairy chests, and both move in a cautious, almost choreographed way. Mousouris encapsulates the wounded masculinity of the traumatised soldier who, on his return to his motherland, finds a completely different social environment, in which the war and its ruins have been deliberately forgotten by the urban population. In contrast, Tsakiris's style of

Figure 14.1. Dimitris Gaziadis, *Astero* (1929), Costas Mousouris and Aliki Theodor-idou.

presenting masculinity under threat can be clearly seen in his leading role in the first serious realist drama of 1929, *The Harbour of Tears / To Limani ton dakrion*, by Dimitris Gaziadis. Tsakiris, together with other male stars of the period, established the image of a self-conflicted masculinity, tormented by moral dilemmas as the patriarchal order of the country struggled to regain confidence after a series of challenges to the value systems of its hegemony. The Asia Minor catastrophe stripped male domination of its impregnable secrecy and the unmasterable mystique of its phallic prowess. The most important film of the period, Orestis Laskos' *Daphnis and Chloe* (1931), presented the first male nude scene in Greek cinema, which can be read as the first demystification of male authority. The male body, usually the source of an omnipotent gaze, was looked at: it became the *object* of the act of seeing, a passive recipient of intentions and desires, as well as of criticism and challenge. It was objectified and thus reified, becoming a manageable and controlled commodity for exchange.

The representation of an objectified masculinity was related to the unstable hegemonic structures of the 1930s. After the trauma of the Asia Minor catastrophe, the body politic became unable to invest its sense of grief and loss in a grand paternal figure or a powerful and empowering ideology. Greek political leaders, even

the charismatic Eleftherios Venizelos and the rather unimposing dictator Ioannis Metaxas, could not offer the compensatory sublimation necessary for 'working through' the trauma and loss that the monumental defeat inflicted upon Greek society. So, as previously in its history, Greek society consisted of 'perennial mourners' (Volkan 2006: 177), ruled by male leaders without power and lacking in authority. Furthermore, the disasters of World War II and the civil war seem to have established the image of a suffering, masochistic masculinity, as the collapse of a worldview and the continuing social crisis made impossible the consolidation of a legitimate political and social order. The inability to deal with the 'work of mourning' consolidated the image of generalised victimhood that the films of the postwar period would explore until the late 1970s.

Postwar Traumatised Masculinity

After the 1940s, the dominant form of masculine stardom was pieced symbolically together in a coherent narrative about its psychic structure. Elements of such masculine representation can be seen in the films by Yorgos Tzavellas, the first director to struggle to articulate a complex representational realism within the confines of popular genres like melodrama and war action movies. In his films after 1950, Tzavellas constructed heroes whose masculinity was validated through types of behaviour that could be characterised as feminine: Tzavellas was the first director to articulate a type of soft, gentle and sensitive masculine identity thinly disguised by a veneer of strong-minded, determined and assertive behaviour. His male characters in films such as *The Drunkard/O Methistakas* (1950), *Agnes of the Harbour/I Agni tou LImaniou* (1951) and *The Counterfeit Pound/I Kalpiki Lira* (1955) embody the image of a fragmented masculinity in search of a centre. His main actors were figures from Greek prewar theatre, Orestis Makris and Ilias Logothetidis, who, already past middle age, seem in most films unprepared to deal with the cunning of modernity. Makris represents the paternal figure unable to confront the traumas of history and be invested with the authority of his social status. Logothetidis embodies the image of a middle-aged man who wants to remain a *puer aeternus*, the eternal adolescent who, unable to resolve its Oedipal attachments through its identification with a father figure, falls victim to the 'predatory sexuality' of strong and determined women (as in the case of the sexualised presence of Ilia Livikou in *The Counterfeit Pound*). In all cases, the absence of strong paternal figures constructs masculine characters without origins, and with an incoherent relationship to reality. As Volkan observes:

> The absence of a supreme parent figure to consolidate Greece's new identity had a profound effect on its development. When a strong and lasting leader is present during a large group's passage from one political or social belief to

another, he confers legitimacy and establishes boundaries for the transition. (Volkan 1997: 129)

Such absence of boundaries established a decentred male subjectivity in rebellion against the 'law of the father', dominated by strong maternal presences and constantly disengaged from its own self. The image of an intense conflict between the public performance of masculinity and its psychic structure became the dominant undercurrent in the acting of all male stars after the 1950s; this decentred masculine image made impossible the establishment of a culture of stardom around male personalities.

Within the emerging studio system of the period, two actors seem to encapsulate the postwar spirit in what could be considered the first genuine stars: the handsome and sensual Alekos Alexandrakis (1928–2005) and the intellectual and seductive Dimitris Horn (1921–98). Tzavellas made use of both of them in *Agnes of the Harbour* (Alexandrakis) and *The Counterfeit Pound* (Horn), presenting them as 'moral characters' who not only accept the freedom of others to reject them, but also learn how to 'sublimate' their failure. Within the optimistic world of postwar reconstruction and the humanistic vision of Tzavellas' works, masculine types could be rational and self-reflexive, and in the end could take the dramatic leap towards adulthood, like decent and respected bourgeois family men – and that was their public persona in the rudimentary star system created by newspapers and magazines in the 1950s.

Alexandrakis and Horn established this kind of stardom, which dominated filmic representation until the end of the decade, without real challenge – especially in the case of Dimitris Horn, an actor who embodied bourgeois conservative, values and thus could never be a sex symbol. Horn, the Greek Jean Gabin, appeared in only ten films; in these he established the masculine type who is in control of himself and of the situations around him through the power of his intellect, his sense of humour and the force of his emotions. In his roles in Cacoyannis's films *Windfall in Athens/Kiriakatiko Xipnima* (1954) and *The Girl in Black/To Koristsi me ta Maura* (1958), as well as in Tzavellas's *We Live Only Once/Mia Zoi tin Ehoume* (1958), Dimitris Ioannopoulos's *Thieves Rejoice Only Once/Mia tou Klefti* (1960) and Alekos Sakellarios's *Alas for Youth/Alimono sta Niata* (1961), Horn's rise to stardom can be attributed to the fact that he made his first cinematic appearances in two films produced during the German occupation – D. Ioannopoulos's *The Voice of the Heart/I Foni tis kardias* (1942) and Tzavellas's *Applauses/Heirokrotimata* (1944), thus embodying and representing a living bond with that period not only of foreign subjection, but also of hope. It is interesting that Horn ceased making films after 1961, when male stars of a different kind became prominent. His stardom blurred the boundaries between screen and reality with his off-screen love affair with the actress Elli Lambeti, who appeared with him in a number of films. Their love affair

furnished the subtext of his performance, and titillated the voyeuristic desire of his audience.

The other star of the period, Alekos Alexandrakis, appeared in over 60 films over a 40-year time span, and encapsulated with his versatile presence a similar kind of masculinity that dominated Greek films until the end of the 1970s and the demise of commercial narrative cinema. His first major role in the provocative – for the mores of the period – film by Alekos Sakellarios, *Those Who Shouldn't Love/Ekeines pou den prepei n' agapoun* (1951), which presented the body image of a pin-up boy who falls for the charms of a wealthy and obviously older woman. His maleness appears to be manipulated by the powerful sexual attraction of domineering women, sometimes ruthless and beyond any social or moral control – although censorship forced a change to a happy ending. The depiction of masculinity anxious about its phallic authority, manipulated by cars, clothes and other gifts, was the ultimate subliminal subtext in this film.

A similar role can be seen in the pioneering film by the first female director, Maria Plyta, *Eve/Eva* (1953), in which Alexandrakis's youthful and virile body appears to burst with sexual desire. Plyta presented the young Alexandrakis as a local Jean Marais, a sensitive young man tormented by moral dilemmas and strong desires. His style of acting made Alexandrakis the most important benign male star of the period. His cinematic persona occupied the mainstream of male characterisation in the 1950s and the 1960s. His role in Cacoyannis's *Stella* (1955) as the weak and passionate lover was closer to the predominating affection for a sensitive and shy dreamer, which became the main reference point in the production of songs composed mainly by Manos Hatzidakis about melancholic and introverted adolescents (*palikari*).

Alexandrakis's later roles as a middle-aged man, in films mainly by Yannis Dalianidis, are also important, especially his impersonation of a cynical stepfather in his *Tears for Electra/Dakria gia tin Ilektra* (1966), a modern rendering of the ancient tragic story. In his comic roles as well, for example in *The Horafa Family/Oikogeneia Horafa* (1968) and *A Crazy . . . Crazy Family/Mia trelli . . . trelli Oikogeneia* (1966), Alexandrakis embodied the image of the decent and open-minded family man of modernity – an image that in the end defined his personal development as a star (completed with his participation in many television series after 1970). His own attempt at directing, however, shows that he was becoming aware of the gradual decline of the image of masculinity he had constructed, and its replacement by the model of the angry and rebellious male in search of a place in society and sexual identity. In his masterwork *Suburb the Dream/Sinoikia to Oneiro* (1961), Alexandrakis's persona was deprived of its usual charm and sensuality; his role as a petty thief with a good heart was the subversion of his previous persona as a tormented and sensual boy-man. Through the success of the film, his personal 'star image' was transformed into the personification of a settled bourgeois with

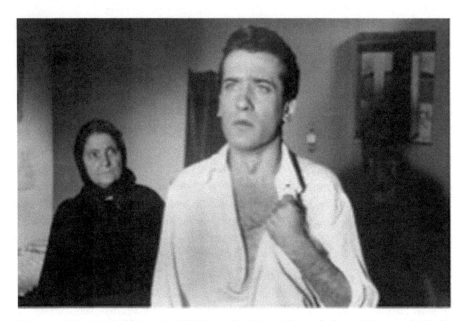

Figure 14.2. Maria Plyta, *Eva* (1953), with Alekos Alexandrakis and Smaragda Veaki.

an uneasy revolutionary past, indeed into the symbol of a subdued masculinity that nevertheless retained an unpredictable ambiguity, which meant the end of his star persona.

His main rival in representing masculinity was the protagonist of Michael Cacoyannis's *Stella*, Yorgos Foundas (1924–2010). Foundas, the Greek Humphrey Bogart, personified in almost all his appearances the antithesis of the dominant soft masculinity type. Achilleas Hadjikyriacou observes that in this film we see 'a constant renegotiation of gender and class identities, especially over questions around power relations and moral codes' (Hadjikyriacou 2012: 190). Despite the obvious vulnerability that permeates his acting in *Stella* and in *The Girl in Black/To Koritsi me ta Mavra* (1958), his image of a Greek macho within an urban setting is also worth studying, despite the fact that long before the end of the 1960s it had become formulaic and clichéd. His over-compensating machismo in *Stella* indicates the defence mechanisms employed by the traumatised generation of the 1940s in order to deal with the challenges of emerging identities (this is obvious in *The Girl in Black*). Foundas's screen persona reflected an alienated masculinity that had lost its authority; indeed, in Lacanian terms, he epitomised the ultimate symbolism of a penis without a phallus. In *Stella*, for example, we see his mother but his father remains absent, implying that the Oedipal identification with the mother has not been resolved and the missing name of the father arrests his development in the pre-Oedipal world of narcissistic identifications and mirror reflections.

Cacoyannis infused the film with material signs of the castrated male, culminating in the 'knife' that he holds in the final scene of the film. His ultimate

de-phallisation, and thus the exposure of the trauma, happens when the bride does not show up to the church for their wedding, the ultimate space in which the consecration of his authority over the feminine would take place. The knife that he holds in his hand is his desperate attempt to regain authority and becomes a substitute for the missing phallus – powerful but de-legitimised, indicating a structural asymmetry in the construction of heterosexual discourse: a hegemonic masculinity without social authority. *Stella* is predominantly a statement about masculinity, indeed entrapped masculinity, and not about feminism or the liberation of women: it articulates postwar male anxieties and phobias about an unproductive female body because of the very powerlessness of men's own traumatised masculinity. Foundas's machismo frames a displaced 'phallic panic' (Creed 2005: 67), indicating that, within patriarchal structures, masculinity without power is the source of an existential despair arising from the confines of a hostile or indifferent society.

Foundas's acting can also be seen in a film that deserves more attention than it has received – Costas Andritsos's *The Scum/To Katharma* (1964). The film is structured as a response to *Stella*, from the point of view of the lumpen-proletariat, as in the latter film Cacoyannis based his class distinctions in a bipolar division between the aristocracy and the working class. In Andritsos's film the whole *mise-en-scène* is situated in the underworld of prostitutes, pimps and criminals. At the end of the film the central female character (Maro Kondou) kills her pimp (Foundas) with a gun, in a reversal of the final scene of *Stella*. (Andritsos's films articulated the response of a Marxist ideologue to the dominant non-political aesthetics of the period – and deserve further study.) Foundas's acting style in these films embodies an extreme form of alienated hyper-masculinity that cannot be connected socially or emotionally with a meaningful narrative about male experience. In his filmic persona, the deep trauma of history inflicted upon patriarchal authority is replicated in a subversive way: although stressing the virility of the Mediterranean man, it at the same time presents him as a desperado, a man tormented by his own masculinity and its social performance, and unable to maintain a stable and coherent authoritative presence. In one of his last films, Dinos Dimopoulos's *Asphalt Fever/Piretos stin Asphalto* (1967), Foundas gave his own cinematic persona its ultimate fulfilment: a married policeman with a child in hospital is unable to procure the necessary blood for a transfusion because of the obligations of his profession. Foundas embodied here one of the few cinematic characters with an introspective subjectivity, an 'anti-star' persona whose social presence was crucial for the cultural imaginary of the period. In that respect Foundas's cinematic development presented its audience with their sublimated reality: the unruly masculinity that eventually becomes domesticated, and therefore tamed and controlled, because of its primal insecurity, the broken connection between the penis and the phallus.

This depiction became possible as the previous masculine type was already obsolete, and the new generation was looking for different forms of male

191

Figure 14.3. Costas Andritsos, *The Scum* (1963), with Yorgos Foundas and Maro Kontou.

representation. New 'faces', whose cinematic persona was predominantly invested with strong sexual energy, had already made their appearance before the end of the 1950s. Andreas Barkoulis, Kostas Kakavas, Dimitris Papamihail and Yannis Voylis, among others, provided a new representation of masculinity: vulnerable but sexually active, still timid but sexualised, and, one could claim, modelled on the cinematic image of Anthony Perkins. Around their well-dressed bodies, a thriving micro-industry of commodified images developed through women's magazines and newspaper scandals – but it did not last for long, and ended as the film industry itself started disintegrating with the arrival of television in 1967.

In short, they foregrounded a sexually appealing but not aggressive or violent masculinity, still invested with the symbolism of past authority, especially in its dress code, but occasionally also ready to disrobe and confront the audience with nudity. (An interesting point is that some of them reinvented their career in the soft-porn industry that was to thrive in the early 1970s – Barkoulis is the most prominent among these.) The male body started undressing itself during this period, even when it appeared in genre films such as the bucolic *foustanella* variety. In Dinos Dimopoulos's *Astero* (1959), a remake of Gaziadis's original film, Dimitris Papamihail created the new persona of a masculinity asphyxiated by internalised rules, as the feminine presence (so effectively represented by Aliki Vouyiouklaki's infantilised acting) disrupts his passage to adulthood. Their love affair in real life

was also the subtext in the film, one of the most commercially successful movies in the history of Greek cinema. The film also changed the financial position of actors: the emerging superstar Aliki Vouyiouklaki, the only real superstar of the studio system, was the first to receive not only a huge amount of money upfront, but also a certain percentage of the ticket sales. The film blurred the lines between cinema and life, discreetly infusing the cinematic actors with the psychodynamics of their actual life, something that would be repeated by other performers in the next decade, when the studio system became the dominant production mode.

It was a period during which the Greek economy was recovering from the devastations of the previous decade; a new middle class determined to enjoy the comforts of European modernity was emerging and new social spaces were being created: the old taverna was replaced by pubs or night clubs (soon to be followed by what were called *boîtes*), new ways of moving the body and dressing became sexually appealing (rockandroll dancing, the gradual abandonment of suit and tie, leather jackets and tight trousers), while at the same time masculinity was invested with new authority through its 'phallocratic' possessions (cars, motorbikes and money.)

The new symbols of re-phallicised masculinity found their best expression in the 'cine-persona' of Nikos Kourkoulos (1934–2007), the Greek Cary Grant. After his early films, in which his beautiful physique (he had originally been a swimmer) was abundantly exposed to the suspicious eye, Kourkoulos performed roles that invested masculinity with a phallic mystique; his roles as a love-tormented youth (*Downhill/O Katiforos*, 1961), a sexually frustrated married man (*The Journey/To Taxidi*, 1962), an aggressive rural fighter (*Blood on the Land/To Homa Vaftike Kokkino*, 1964), a sensitive criminal (*Lola*, 1964), a crook in search of redemption (*Ruthless/Adistaktoi*, 1965), in these and many other films, show his versatility as an actor, and at the same time his persona as the embodiment of a man of integrity and honesty, projecting all the positive virtues of a good middle-class family man. His performance in *Zero Visibility/Oratotis Miden* (1970), and most importantly in *The Trial of Judges/I Diki ton Dikaston* (1974), presented the ultimate consummation of his persona, in which Greek masculinity has regained its authority and has become a moral agent, a national authority figure – although not with genuine political empowerment.

In the same period, the most popular and commercially successful director of the sixties, Yannis Dalianidis (1922–2010), promoted a new kind of masculine sensitivity – a youthful 'fatherless' masculinity with secret desires, sexual frustrations and libidinal confusion, in search of personal identity and social status. In his early films, Dalianidis chose his male actors with the hidden libidinal frustrations of a closeted homosexual. In films such *Downhill/Katofiros* and *Law 4000/Nomos 4000* (1961), male friends form a closed circle of homosocial desire focused on male types full of indecision, insecurity and anxiety about their role in society and their sexual identity. Vangelis Voulagiridis, Phedon Yeoryitsis, Spyros Fokas,

Figure 14.4. Yannis Dalianidis, *The Sinners* (1971), with Haritini Karolou and Hristos Nomikos.

Yannis Fertis and Lefteris Vournas exuded a sexual ambiguity that both titillated and challenged. (Among them, Spyros Fokas was the first exported transnational sex symbol of Greek phallic strength in many international productions.) In his comedies, the innocuous masculinity of Costas Voutsas was equally significant, and somehow provocative. However, by feminising his central actors, Dalianidis gave a prominent role to powerful and determined female characters with a commanding presence over the weak males. Chloe Liaskou and Katerina Helmi became the ultimate symbols of a devouring 'monstrous' femininity.

However, in many films of his later career, such as *A Life's Story/Istoria mias Zois* (1966), *Stephania/Stephania* (1967), and most importantly *Under the Virgo Constellation/Ston Asterismo tis Parthenou* (1973), Dalianidis seems to have identified himself with the voluptuous and hyper-sexualised Zoe Lascari. Dalianidis, whom one could call the first *auteur* of Greek cinema, created a female persona of himself, producing what are in effect 'crypto-queer' films, which we read today in much the same way as the Rock Hudson films. His male characters in this period frame the overt objectification of the male body, as is the case with the fetishised masculinity of Costas Prekas, Costas Carras, Lakis Komninos and Hristos Nomikos, who seem to transform themselves into orgiastic gay fantasies in a cinematic world of inverted sexualities. They all impersonated straight heterosexual middle-class youths, whereas the hidden subtexts of their films were infused

with unsettling homoeroticism. Later in the 1980s, in an era of politicised de-eroticisation, Dalianidis projected his total homosexual fantasy on to the body of Panos Mihalopoulos. Through the intrusive gaze of the camera over his torso and between his thighs, Mihalopoulos became the star of many cult films for an underground audience consisting of spectators dissatisfied with the dominant art cinema that prevailed after the collapse of the studio system and the arrival of television in 1967.

Hyper-Masculinity and its Other

By the late 1960s, and the rise of the New Greek Cinema with Theo Angelopoulos's *Reconstruction/Anaparastasis* (1970), the male presence gradually becomes de-sexualised and de-libidinised, indeed de-psychologised, as the type of the 'man without qualities' seems to take over the presentation of conditions of living under a political system of ideological oppression and sexual repression. By then, also, the studio system had collapsed, and therefore public space for popular images of star personas were no longer available or even possible. Costas Prekas, a swimmer involved in real life in indiscriminate sexual adventures, imposed the cinematic persona of the patriotic fighter who sacrifices himself after fierce fighting for the motherland. His strong sexual aura libidinised the cinematic body, densely hidden under the ultimate symbol of phallic strength, the army uniform; however, his well-formed and protruding chest, his muscular arms and toned thighs, were always centred on the mystique of his manhood – a notorious image that Prekas later replaced with belligerent nationalism.

After the collapse of the dictatorship, the New Greek Cinema destroyed this image of the patriotic fighter with a series of films that depicted the problematic and dysfunctional sexuality of masculine domination. From the early 1970s male stars seem to lose their prominence, as indeed do female stars, and there seems to be no more confusion between the specular identities of screen personas and real life. In Pavlos Tassios's films, the question of masculinity receives its first serious prob-lematisation. In the most significant trilogy of the period, *Yes, but . . . Maybe/Nai, men . . . alla* (1972), *The Big Shot/To Vari Peponi* (1977) and *Request/Paraggelia* (1980), Tassios chose actors to represent types whose masculinity did not meet social expectations, and whose lives were thrown into a downward spiral of self-destruction. Fanis Hinas, Mimis Hrisomalis and Andonis Kafetzopoulos portrayed the vulnerable male, whose sexuality is an extremely private affair, as he struggles to reposition himself within a system of dominant values that has lost its prestige. There is no religious ritual, structural value or class status that can offer them a sense of a special, privileged position in society. Frustrated sexuality, political exclusion and social marginality also frame the inability of such masculinities to relate to others, and ultimately to themselves. They regain their power only within confined groups and closed spaces, such as the brothel, the union and the nightclub. Their

disempowerment leads to a symbolic disengagement of the penis from the phallus and the disappearance of the latter as a signifier; as Jacques Lacan indicated, this results in 'a centrifugal tendency of the genital drive in the sphere of love, which makes impotence much harder for him to bear' (Lacan 2006: 583).

After the demise of the dictatorship in 1974, the collapse of the previous political order coincided with the participation of most male actors of hyper-masculinity in soft-porn movies and the demystification of their phallus. At the same time, some of them were exposed to the gaze of homosexual desire, thus creating a new crisis in masculine representation: the male body now did not simply titillate repressed feminine desire, but also the inquisitive gaze of homosexual investment, thus becoming objectified, and losing its active and energetic primacy. The film that sealed the end of such masculinity was the first 'queer film' in the history of Greek cinema, Yorgos Kantakouzinos's *Angel/Angelos* (1982). In this film, all symbols of masculine power are 'incapacitated': the army, social status, motorbikes and social authority all collapse as the male body is sold and abused while pretending to be a woman. The tension becomes so strong that the transvestite, the feminised Mihalis Maniatis, takes a knife and kills the macho man, in much the same way as Foundas stabs Mercouri in *Stella*. The circle is completed: the victimiser now becomes the victim. The trauma of history is an open wound on the male body – and it is a lethal wound that symbolically ends its power and hegemony.

Last Men Walking

The representation of 'traumatised masculinity' has been one of the most dominant themes in Greek cinema since its inception. Furthermore, from Michael Cacoyannis's *Stella* (1955) to Panos H. Koutras's *Strella* (2009), a remarkable multiplicity can be detected in the representation of masculinity. Yorgos Foundas and Nikos Kourkoulos each had a decisive influence in constructing models of 'vulnerable masculinity', which expressed itself through aggression and machismo in the case of the former director, and high morality, in the case of the latter. However, as both were expressions of power dynamics in an imploding political system, they were gradually abandoned during the 1960s, when Greek cinema remained effectively without male stars. The substitution of a domineering masculine presence with an insecure, introspective and self-destructive form of masculinity in constant struggle against the public image of the male body occurred in the 1970s.

The 1980s were a period of total collapse in gender representations; Vouyouklaki's stardom was entirely eclipsed, and only the image of Melina Mercouri 'remained a threat to male power and control, and at the same time an inspiration of many Greek women struggling for emancipation' (Eleftheriotis 2001: 162). Mercouri herself, with her impetuosity and assertiveness, created a bridge between gender representations, as a feminine star with masculine authority (especially after she became a powerful minister for culture, in charge of state

funding for films). Indeed, she paved the way for the feminisation of men, almost the 'queering' of masculinity, by colonising patterns of male representation. Most recent films reconstruct the representational codes of a masculinity without authority, rejected by history yet clinging to its hegemony only through rituals and institutions that have lost their appeal and social influence. In films after 1980, new codes of masculinity were explored – the homosexual libidinal subject, for example, which still remains within the confines of masculinist anthropology. At the beginning of the twenty-first century, transsexuality or transgender identity appear as forms of existential escape from the confines of masculine subjectivity and self-perception.

In his pioneer essay on stars, Edgar Morin wrote: 'The modern stars are models and examples whereas the earlier ones were the ideals of a dream' (Morin 2005: 109). Both functions seem lost today, especially in Greek cinematography, as stardom implies discourses of national identification. Contemporary male stars like Nikos Kouris, Vladimiros Kyriakidis and Constantine Markoulakis presented the image of gentler and more feminised metrosexuals, which cannot be associated with any hegemonic model of normative gender identity. In the films of Constantine Yannaris, especially *From the Edge of the City/Apo tin Akri tis polis* (1997) and *Hostage/Omiros* (2005), the virile and muscular male becomes the object of a transparent and overt homosexualisation. As with Vincent Cassel in France, Stathis Papodopoulos's body frames the new star image, which cannot become a model or an example, as it invites identification with a specific sexual orientation while challenging the deepest fears of mainstream male power. Despite their strong heterosexual scenes, Yannaris's films frame visible signs for the gay spectator, and in some respects for the voyeuristic repressed heterosexual. However, as in Kassovitz's *La Haine* (1995), his male characters depict 'an image of their lack of potency' (Vincendeau 2005: 66). The image of a muscular male body as an object without desire delineates the new iconography of the traumatised masculinity that has dominated the Greek cinematic imaginary since its inception.

Today, in the internet age, such iconography cannot create star identities, and cannot impose them as canonical. Since Greece was never Hollywood and could never create its cinematic production along the lines of the entertainment business industry, filmmakers made predominantly independent productions that presented the uncanonical and the irregular. The nation found its true stars in athletes and soccer players, not in actors. With only one exception during the studio era, stars could not become real capitalist commodities in the country; male stardom in particular remained unpredictable and fluid, as masculinity itself was a symbol of failure and loss instead of triumph and success. Male stars retained their psychological power over their audiences only as images of absence and defeat, of a constantly deferred and therefore frustrated integration. The unstable structures of society and slow economic growth hindered the process of star-making itself; as Paul McDonald observed, 'the star becomes a form of capital inasmuch as his or

her image can be used to create advantage in the market of films and secure profits' (McDonald 2000: 14).

Traumatised masculinity found in Greek films its cathartic sublimation without ever losing its psychological tension, and thus could never become a sellable commodity and secure profit. As we conclude elsewhere:

> Movies confronted the nation with its worst fears by challenging established rituals and authorities, as expressed in its conformism and lack of agency. The mirror reflected the person in front of it – the person changed only when the holder of the mirror started to think on his/her self. (Karalis 2012: 288)

Representations of masculinity in Greek cinema always framed something missing, a pervasive lack, at the centre of Greek society. The hermeneutics of such absence probably need further exploration and discussion.

15

Star Embodiment and the Lived Experience of Ageing in Cinema: The Case of *Amour*

Michelle Royer

Being interested in stars is being interested in how we are human now.

(Dyer 1987: 17)

Cinema is part of consumer culture, and provides entertainment that reflects societal values, concerns and changes. It is also an essential medium in the construction of images that impact on the ways people perceive themselves and others: 'the very act of watching a film fosters new modes of behaviour and consciousness' (Markson 2003: 95). Recent research in film studies has gone even further, suggesting that cinema gives us an insight into epistemology and ontology and that films can open up new windows onto the very way in which we think about and construct our own realities (Elliott 2011: 1). Cinema, more than any other art form, provides immediate access to subjective experience, and it is an art form well suited to the task of faithfully capturing the plight of old age (Cohen-Shalev 2009: 9). With its manipulation of time and space, its flashbacks and flash-forwards, it hints at the 'human mind's difficulty with time and closeness to death' (Mulvey 2004: 3), and is a privileged cultural and philosophical site for the exploratory expression of old age. Yet the linkage between old age and film studies is still foreign territory, particularly for non-Hollywood cinema.

Several scholars have studied the representation of ageing in popular culture and Hollywood cinema (for example, Andrew Blaikie 1999) and criticised its wide use of stereotypes. Sally Chivers's book *The Silvering Screen* (2011), the first ever sustained discussion of old age in mainstream American cinema, brings together

theories from disability studies, critical gerontology and cultural studies to examine how the Hollywood film industry has linked old age with physical and mental disability. It shows that older men and women are underrepresented in mainstream films, most depictions of old age and ageing are stereotypical and degrading, and ageing characters are often ridiculed. This is particularly true in the case of older women. Scholars in gender studies have denounced the negative representations of older women in visual mass culture (Woodward 2006; Swinnen and Stotesburg 2012). Even in many art-house and *auteur* films, older women are portrayed as the Other (Royer 2012), and their lives more generally are shown as useless and meaningless. Studies of films that provide insight into the experience of time and finitude in later life through an innovative use of the medium are rare, and studies of ageing stars are even rarer. However, the 2012 Cannes Film Festival awarded its Palme d'Or to *Amour* (2012), by Austrian filmmaker Michael Haneke, a film that examines, in a very innovative way, the relationship of an old couple at the end of their lives, and the question of euthanasia. Equally interesting is the fact that *Amour* features Emmanuelle Riva and Jean-Louis Trintignant, two French stars aged well over 80. Both were awarded Césars for their performances in the film. With these awards, the film industry has recognised the importance of exploring senescence, questions about the last stages of life, and the essential role played by ageing stars in cinema. The way in which filmmakers use the experience, image, film career and personal life of ageing stars in their films will be the subject of this chapter. By focusing on the specific example of Michael Haneke's *Amour*, the chapter will examine how stars are used in the recording of human ageing. It will attempt to unravel the complex networks of intertextual references and extra-filmic links that come into play through the bodily presence of Riva and Trintignant – both famous for their acting, for their beauty and for starring in New Wave films in the 1960s. How does their presence contribute to the viewers' experience of time passing, the effects of ageing on the human and the filmic body, and the finitude of human life?

Before going any further, I will summarise the plot of the film. It begins with the scene of a brigade of firefighters breaking down the door of an apartment in Paris to find the shrivelled corpse of Anne (Emmanuelle Riva) lying on a bed, the pillow adorned with cut flowers. There then follows a long flashback about Georges (Jean-Louis Trintignant) and Anne, retired music teachers in their eighties who enjoy their life together. However, Anne has a stroke at breakfast, and this incident begins her steep physical and mental decline as Georges attempts to care for her at home, as she wishes. The couple struggles to maintain some dignity through their ordeal, but Anne loses any desire to continue to live and Georges, despite all his love for his wife, is overcome by his own weariness and Anne's desire to die. One day, when she refuses to eat, he loses patience and slaps her. At the end of the film, Georges sits at Anne's bedside and tells her a story of his childhood to calm her. As he reaches the story's conclusion, he picks up a pillow and smothers her.

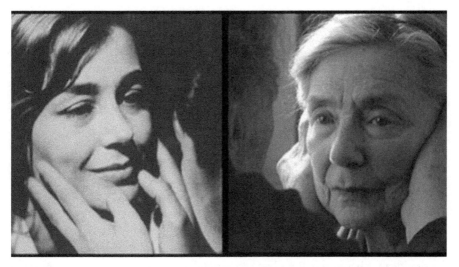

Figure 15.1. *Hiroshima mon amour* (Resnais 1959) and *Amour* (Haneke 2012).

Apart from the initial scene showing the firemen's discovery of Anne's body, the film consists of a long flashback (and within it short flashbacks of Anne playing the piano or doing the washing up). It is mostly set in the couple's Parisian apartment, and the story revolves around their daily life, only interrupted by the visits of a neighbour and their daughter, and by one visit of an ex-student of Anne's.

Amour, Ageing and the Filmic Body

Amour was co-produced by Les Films du Losange, a production company founded by New Wave filmmakers Barbet Schroeder and Éric Rohmer in 1962. The two main stars of *Amour*, Jean-Louis Trintignant and Emmanuelle Riva, also provide key intertextual links to the French New Wave. Riva's presence evokes memories of her part in Alain Resnais's fragmented love story *Hiroshima mon amour* (1959), a film which also explores questions of love, death and ethics. Trintignant brings to mind two New Wave films – Claude Lelouch's *Un homme et une femme* (1966), a love story in which both lovers are widowed and share memories of their deceased spouses, and *Ma nuit chez Maud* (1968), directed by Rohmer, in which he plays a man whose decision to marry an ingénue conflicts with his interest in a sexually more experienced woman.

The New Wave filmic bodies, to borrow Vivian Sobchack's (1992) expression, show their age in *Amour* which, as revealed by Haneke (2012: 316), used the latest technology. As pointed out by Laura Mulvey (2004: 143), twentieth-century cinema, for so long identified with both modernity and modernism, has aged. While *Hiroshima mon amour* is a New Wave film about young lovers played by actors in their prime, it is also considered nowadays to be an old film marked by

obsolete technology (it is in black and white, and the image is not very sharp, although a recent high-definition digital transfer of the film has rejuvenated it). Paradoxically, *Amour*, a film about the end of life featuring old film stars, employs a digital camera, sophisticated technology to control lighting and precise calibration, to produce a very clear image. Hence, *Amour* is not only a story about old age but, by its sheer existence and the presence of old stars, also highlights the fact that cinema has a history.

Intertextual Links with *Hiroshima mon amour*

While I have already mentioned *Amour*'s implicit references to *Hiroshima mon amour*, I will now analyse the intertext more precisely. The choice of well-known actors and stars is never an insignificant decision. It has many repercussions for the way the film is received and understood by spectators, and in *Amour* it has a particular significance because of the advanced age and iconic status of both stars. As noted by Richard Dyer (1998: 60), a star is an amalgam of several elements: the body and face of the real person, the off-screen presence of the star, the persona created by the media, and the characters played in films. As actors age, their identities become very complex and can be used by filmmakers, as they are by Michael Haneke.

Stars are stars only because spectators come to feel a very strong sense of familiarity with them through media exposure, photos, previous films, and so on. As explained by Ira Konisberg (2007), previous familiarity with a face plays a central role in determining our reactions, and our responses to a film character are influenced by how well we know that face and body. Hence it is only through the recognition of the star's body, gestures, facial expressions and voice, which create a sense of intimate connection with the star, that the intertextual, multifaceted process highlighted by Dyer can take place in films. However, the recognition of the star's body when the actor ages can be a very discomforting experience for spectators, as was crudely pointed out by French star Simone Signoret: 'I understand that when we change at the same rhythm as them, spectators feel shocked and saddened . . . deep down that's what gives them the shits: that we get old at the same time as they do' (Montserrat 1983: 270).

Through the filming of the faces and bodies of stars, cinema records, sometimes unintentionally, the effects of time: although cinema is an art of manipulation of the real, it cannot conceal ageing bodies; it can use them and groom them, but the body of the actor always escapes its complete control. Jean-Luc Comolli states that filming the bodies of stars and actors is the documentary part of every film, because

> imaginary characters have to be endowed with bodies, faces, looks and voices, bodies which are quite real, since they are those of the actors: the ones we see . . . The body of the imaginary character is the image of the real body of the actor. (Comolli 1978: 42)

For this reason, most stars, particularly women, retire before their aged bodies are exposed to the public gaze in film and popular media. However, French-speaking cinema is giving increasing space to elderly actors, with Jeanne Moreau, Gérard Depardieu and Catherine Deneuve, to mention only a few, agreeing to make their declining bodies the focus of attention of the media and the camera.

Film scholars have shown the complexity of the audiovisual experience in film, and that spectatorship is multimodal and synesthetic, and includes senses such as touch, smell and taste, all connected to sight (Elliott 2011). Cinema is thus an intimate lived bodily experience, as Vivian Sobchack in *The Address of the Eye* (1992) and Jennifer Barker in *The Tactile Eye: Touch and the Cinematic Experience* (2009) have argued: '[T]he film experience is meaningful not to the side of our bodies but because of our bodies' (Sobchack 2004: 60). The effect of casting ageing stars in a film has the potential to provoke a disturbing bodily experience in viewers, as stars who have provided spectators with the reflection of an ideal self are now 'lived' by spectators as simply human in the most tactile and carnal way. In her book *Old Age*, Simone de Beauvoir explains that old age is 'a time of painful contradiction, irresolvable schizoid splitting' (1972: 48), and that while the deterioration of the body is fatal and nobody escapes it, there is a clash between the ageing subject's ageless self-perception and the fact of old age: being old is revealed to the subject principally in the reactions of others (de Beauvoir 1972: 42). Stars in their mythical agelessness mirror spectators' resistance to their own acceptance of old age, but the revelation of the process of physical decline on-screen functions like a mirror for spectators, reflecting back to them their own inescapable deterioration, and thus altering their self-perception.

Amour opens with the discovery of Anne's dead body by firemen. Through the *mise-en-scène*, the acting (the smell of the dead body is made evident by the characters pressing tissues over their noses to avoid smelling the decayed body), the high-angle shot on Riva's face, the viewer is not only receiving the narrative information that Anne is dead, but is also experiencing being in the room of a dead person. The shot of her face, pale and shrivelled, and the imagined smell force spectators to experience death as a synaesthetic experience in which all our senses are summoned. Because the scene is placed at the beginning of the film, it is not well supported by narrative elements, so spectators have to perceive with their senses, although the scene immediately establishes the plot. The flashback that follows will explain the reason for her, death but will confront spectators with a realisation of the inevitability of ageing and the finitude of human life.

I will argue that *Amour* brings about this realisation by weaving in intertextual references to one of the actress's early films. *Hiroshima mon amour* is constantly in the background of *Amour*, at least as a faint memory that keeps resurfacing, and of course the similarity in the titles is hardly a coincidence. Haneke has explained his choice of Emmanuelle Riva for the role of Anne:

I had noticed Emmanuelle Riva when *Hiroshima mon amour* came out. It is one of my favourite films and one of the cult films of the Austrian 60s young generation. I have always thought that this actress was extraordinary, but after Resnais's film, we had not seen her in film in Austria. For *Amour*, I looked elsewhere ... My memory of her was always coming back. (Haneke 2012: 318)[1]

The memory of *Hiroshima mon amour* was obviously the main reason for Haneke's choice. Although over 50 years elapsed between the release of the two films, *Amour* replays fragments of the filmmaker's memory of Resnais's film and Riva's acting, and does so in several sequences. This process, I contend, reawakens the image of the actress's youth in spectators, and renders almost palpable the effects of time on the star's body.

Shower scenes are central in both films, although interestingly Riva shows less of her body in *Hiroshima mon amour* than she does in *Amour*, in which her sagging breasts are clearly exposed to the gaze of the camera.

Haneke thought that this scene was essential to capture the vulnerability of old age, and the shot of Riva's body is uncomfortably realistic for spectators who are witnessing a private scene they would not normally be entitled to witness even with their closest relations. The fact that the point of view is that of the carer, cold and professional, contributes a sense of discomfort. Asked about this scene, Haneke explains:

> As a director, it wasn't difficult for me. It was far more uncomfortable for her [Emmanuelle Riva]. But it was clear from the beginning that it was necessary to shoot this scene – to capture the fragility of her situation, what's forced up on you as a human being [in such circumstances]. My job as a director was to make sure I didn't betray her – that she wasn't shown critically or depicted in an unpleasant light, but just to show what people in such situations have to go through. (Haneke 2013)

However, in the same interview Haneke reveals that Riva was quite apprehensive about being filmed naked in the shower, but the filmmaker insisted on having the scene in the film:

> When I asked Emmanuelle Riva if she felt apprehensive about anything, she of course mentioned the scene where she has to appear naked in the shower. I replied that this nudity was essential. She understood it ... On the day of the shooting, after we had finished rehearsing the shower scene, when I indicated to the wardrobe assistant that she had to remove Emmanuelle's dressing gown, she tried not to have to do it. 'Do we really have to do this?' she asked. I reminded her about our conversation, and she didn't insist. (Haneke 2013: 319)

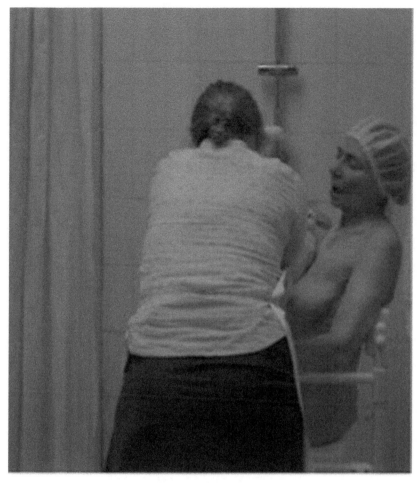

Figure 15.2. 'Shower scene', *Amour* (Haneke, 2012).

The difficulty and embarrassment felt by the star at being seen naked by thousands of spectators parallels that of the character at the loss of dignity that comes with the bodily decline inherent to old age. The issue of *Cahiers du Cinéma* devoted to *Amour* was highly critical of the film, of Haneke's treatment of Riva, and of the sadistic manipulation of spectators in that particular scene, calling the film 'a *Funny Game* that does not say its name' (Tessé 2012: 8). While it has been said by other critics (Vicari, quoted in McCann 2011: 28) that such strategies are all part of Haneke's rationale and the reason for the extraordinary performances the director is able to obtain from his actors, they raise ethical questions about the relationship between stars and filmmakers that will need to be investigated further by film scholars.

The shower scene in *Amour* is shot from much further away than the scene in *Hiroshima mon amour*, creating an optical shot, distant and informative, whereas

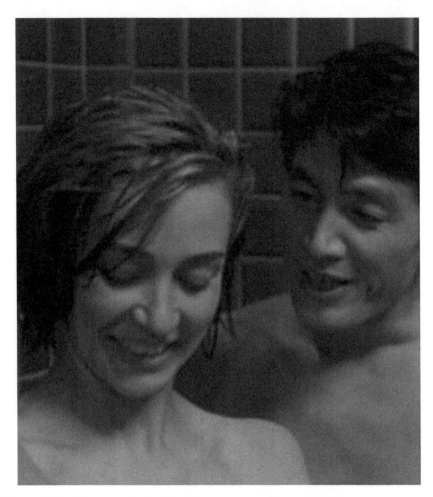

Figure 15.3. 'Shower scene', *Hiroshima mon amour* (Resnais 1959).

Resnais's, closer shot is more tactile, revealing details of the actors' skin texture and grain. Although the physical body is central to both scenes, expressions of love have shifted: caring for the other's declining body has taken the place of sexual desire.

Many scenes in the film have clinical connotations: Anne in the toilet or being massaged by Georges, for example. These shots raise the question of the spectator's gaze and the star's body as spectacle, although until recently they have been analysed in relation to desire and scopophilia. If the shower scene of Resnais's film triggers a voyeuristic pleasure, does the sight of Riva's aged body shift the spectator's gaze? Is it a way for Haneke to subvert stardom and tap into the spectators' necrophiliac desire to see decline and death, which the beginning of the film, showing Anne's dead body, had prompted?

Riva's voice has an important role in *Amour*, with Anne repeating her final plaint 'Mal...mal...mal...', which provokes distress in spectators as haptic aurality

Figure 15.4. *Amour* (Haneke, 2012).

comes over the optical shots. For Haneke (2000: 171) the ear 'provides a more direct path to the imagination and the heart of human beings' than the eye. Spectators' lived experience of old age comes from what Barker (2009: 15) has named the tactile encounter between film and viewers, and not simply from 'meaning and emotion', as viewers form connections with Riva's youth by hearing her voice unaltered by time. Her raised intonation at the end of sentences, always considered to be typical of Riva in *Hiroshima mon amour*, echoes the poetic and erotic female voice of Hiroshima, repeating 'Tu me tues, tu me fais du bien' (literally: 'You are killing me, you make me feel good'). The Hiroshima leitmotiv is materialised in *Amour* as Georges kills Anne to put an end to her suffering. The reverberating echoes between the two films exacerbate the change that is taking place in the life of the couple: death has ceased to be a metaphor for sexual pleasure; its presence is now literal. Intertextual references to *Hiroshima mon amour* operate a time compression that renders the effects of ageing on the body and the couple's relationship more sudden, acute and real, and hence more disturbing for viewers.

Through all these processes Haneke provides spectators with a 'lived experience' of the subjective time in human ageing, where meaningful phases and events are interpreted and reinterpreted within the sense of an anticipated finitude. The shot of Riva as the deceased Anne acts as a realistic and disturbing reminder of one's own mortality, and, as Simone Signoret so bluntly observed, what shocks and saddens spectators is the realisation that mythical stars age and die, just like the rest of us.

Hiroshima mon amour begins with extreme close-ups of bodies in an embrace – the skin, the flesh, the texture of the skin become so close to the spectators' gaze that it is no longer a voyeuristic gaze but a cinema of sensations, a sensuality that is experienced by spectators. The body and bodily pleasures are signalled as the

centrepiece of the film narrative. In *Amour*, the body takes on a new dimension: still the centrepiece of the narrative, it is now a disabled body, a suffering body and a constant hindrance, as Anne is unable to move freely around the house and has to be carried, washed, fed and continuously cared for. Acts of love consist in feeding her, washing her and massaging her legs. *Hiroshima mon amour* can be read not only as a fragmented love story, but also as the narrative of the physical relationship of a couple at a particular stage in life. *Amour*, through its intertextual references and the presence of a star like Riva, creates the notion of lifespan rather than just an exploration of the end of life.

A very decisive moment in the film is the scene in which Georges slaps Anne, who is lying powerless in bed; it is an act of uncontrolled violence that reveals Georges's frustration and anxiety at Anne's refusal to eat and drink – an expression of her desire to die, and therefore to leave him. This is another reference to *Hiroshima mon amour*, in which the architect slaps the actress to stop her dramatic outburst as she is telling him about her traumatic past in Nevers during the war. Throughout the film Georges resists facing Anne's desire to die, just as in *Hiroshima mon amour* the female character wants to leave to return to France, and her Japanese lover refuses to let her go. Georges eventually kills Anne, and thus honours the pact they had made not to send her to a nursing home. Through this last loving gesture, he accepts their ultimate and definitive separation. However, as I will show, the slap scene is also a reference to Trintignant's personal tragedy.

The Ageing Star Body and Off-Screen Elements

Jean-Louis Trintignant was one of France's greatest stars in the 1960s and 1970s, playing in *auteur* films with leading film directors (Roger Vadim, Louis Malle, Costa-Gravas, Claude Chabrol, Claude Lelouch, Éric Rohmer, Bernardo Bertolucci, Krzysztof Kieślowski, and so on). He won the Best Actor award in Cannes in 1969 for *Z*, and was nominated for many awards. In the 15 years up to the time of writing, he has had only one small part, in *Janis et John* (Samuel Benchetrit, 2003) where he appeared alongside his daughter Marie Trintignant.

Jean-Louis Trintignant's star status has made a public spectacle of some events in his life, especially the death of his daughter in 2003. Marie Trintignant died at the age of 41 from a cerebral oedema as a result of being violently slapped by her boyfriend Bertrand Cantat during a domestic dispute provoked by a text message. Cantat and Trintignant had been lovers for 18 months. Her death caused considerable emotion in France, where the popular media divided into pro- and anti-Cantat camps, and celebrity magazines were dominated for months by *l'affaire Trintignant*. Bertrand Cantat was sentenced to eight years in prison for manslaughter. After serving four years, he was released in October 2007 on a good behaviour bond, which is still considered a scandal by many. Trintignant, who was seen on television screens and in magazines devastated by the loss of

his daughter, became unwilling and unable to work in cinema. The media frenzy that followed the case alienated the star from the media, and he lived as a recluse in the south of France until he was offered the role of Georges in *Amour*. In an interview about *Amour*, he describes the circumstances that led him to come out of reclusion:

> Marie's tragedy sped up my return to the world of poetry. I think *Amour* is one of the greatest films in the history of cinema, and I don't say this lightly. Margaret Ménégoz, the producer of the film, was very insistent that I play in it. One day I said to her, 'I can't do this, my mind is not up to this, I'd rather think about killing myself.' Margaret answered, 'Make the film and then kill yourself afterwards.' (Trintignant 2012)

To come out of reclusion to star in a film whose action is happening behind closed doors may be a surprising choice. Moreover, Trintignant's return to cinema with a film about love, murder/euthanasia and ethics has echoes of his daughter's tragedy.

Haneke explains that he was very keen for Trintignant to play in his film, as he was always fascinated by his acting and physical presence:

> [H]e has always fascinated me, because . . . he seems to be hiding a secret. In addition to his physical beauty and his talent as an actor, he has something indecipherable. Is it because of his famous voice which everybody praises? I have always been struck by his expression. He stares at you while talking to you, and it can become quite uncomfortable. It is probably one of the reasons his face projects a silent strength, not only in *Z*, where he expresses a strong authority while staying calm, but also in *And God Created Woman*, where, behind the naive young man, one can feel a deep and inexplicable knowledge. It is the miracle of his personality, and what characterises a great actor: to express mysterious things that another actor wouldn't be able to express. In addition, his face, which is the face of a man who has lived, has great beauty and a richness that one never grows tired of watching. (Haneke 2012: 317)

The film history of the star is strongly present in Haneke's films, and shots of Riva and Trintignant standing in an embrace as he helps her move to her wheelchair, for example, echo the physical closeness of the young bodies of *And God Created Woman* (Roger Vadim, 1956). Haneke weaves the memories of his actors' filmic pasts into the life of the characters they play.

The image of Georges, hunched over, walking down the hallway of the apartment, slowly, painfully and silently, tired and burdened by age and life's toll, reflects diegetic as well as off-screen elements. The choice of Trintignant at this stage of his life and after his daughter's tragic death brings realism, an extra-cinematographic dimension, to the film, and adds interweaving layers of meaning.

While references to *Hiroshima mon amour* play an important role in the film, and *And God Created Woman* looms behind the scenes, biographical elements, especially Jean-Louis Trintignant's recent personal history, also come into play.

Trintignant explains that, while shooting the film, he had a fall and broke his hand, which he had to have in a cast. The director demanded that Trintignant remove his cast to shoot several scenes. 'Haneke knew immediately how to use the pain I was feeling. It is normal, he is a film director', says Trintignant (2012), who then makes a series of implicit associations about pain, his broken hand, Marie's death and *Amour*, although at no stage does he directly link the fictional and the personal tragedies. The role of the director in the anecdote about the broken hand functions as a kind of displacement of the site of suffering to a less tragic event. This is reinforced by another of Trintignant's anecdotes in the same interview, this time about the shooting of *The Conformist* (Bertolucci 1970):

> During the shooting of *The Conformist*, one morning I discovered Paulette, my daughter, dead in her cot. She had suffocated in her sleep. In a couple of words, Bertolucci found the right words and the shooting resumed. In this tragedy, the Italian director made the most out of my suffering. When you are a filmmaker, you have to use all the emotions of your actors. (Trintignant 2012)

The death of Trintignant's baby daughter by suffocation adds another biographical dimension to the Georges character, weaving together reality and fiction, intra- and extra-filmic events. Although the contexts of the fictional and the personal stories are very different, the physical actions – slapping, death and murder – produce resonances between the stories. Haneke, who wrote the script of the film, would have been aware of the details of Marie's murder, although he never mentions them in his interview. The use of elements of stars' biographies by filmmakers is not new, as Bandhauer shows in her analysis of Romy Schneider (see Chapter 16, below); but in this case it acquires a very disturbing dimension for spectators because of the ethical questions it raises.

According to acting theories, it is through bodily performance that the actor's 'emotional memory', something pertaining to the 'real', is embodied in the fictional situations of a film, as a result of a process which Rick Kemp has described in his book *Embodied Acting* (2012: 156–96). He cites Stanislavski's famous system of acting, in which it is said that emotion in fictional circumstances needs to be accessed through memory – in acting, 'there is no walking away from yourself' (Kemp 2012: 158); in acting, the emotion and feelings of a character are always expressed through embodiment; it is a body–mind performance in which the 'real' body of the star and his/her real emotion and memory embody the fictional character. Interviews by both stars confirm that Haneke used similar techniques to obtain the best performances from them in *Amour* but, as explained by McCann (2011: 28), in Haneke's preceding films the role of the director and sadist often

align, 'with an insistence on debilitating repetition and the stripping away of layers in order to extract a more truthful performance'.

In his analysis of acting and performance in Haneke's films, McCann concludes that

> film stars bring with them both star quality (charisma and unique personal characteristics that create a strong on- and offscreen presence which is often embraced by audiences as a separate, mythic persona) and craft (the ability to embody distinctly different characters through the use of strong acting techniques), two properties to which Bresson remained resolutely indifferent, and to which Haneke also remained impassive. (McCann 2011: 29)

However, in *Amour* Haneke subverts stardom by playing with the very star qualities of his actors, and with their off- and on-screen presence. The age of the stars defamiliarises the audience's common notions of stardom, and if spectators identify and sympathise with the stars or characters, the result is a confronting experience of ageing and its effects on the body that subverts the mythic persona of the stars. It is also through the use of the media fascination for stars' off-screen presence that Haneke's work raises ethical questions about euthanasia in old age.

Conclusion

Haneke insists that in cinema the filmmaker must show rather than explain, and in interviews he refuses to present an interpretation of his films, believing that the concept of uncertainty is inherent in life and hence in cinema. He therefore never attempts to comfort spectators with a particular interpretation of his films, but on the contrary wants to unsettle them. In *Amour* he has subtly planted elements in the plot, and viewers whose residual memory is triggered will make disturbing connections with the life of the stars and their film history, consciously or unconsciously. Many spectators and film critics have accused Haneke of cruelty but, as the director has observed about *Funny Games*, 'they [spectators] stayed, stuck to their seats because cinema has such a power of manipulation that, in spite of all the unpleasant things I made them endure, they wanted to know the end' (Haneke in Lepastier 2012: 10).

When spectators watch Trintignant and Riva in *Amour*, they do not simply watch the fictional story of an old couple's end of life, they also have an intimate bodily experience of old age and its effects through the presence of two ageing stars whose faces and bodies were once so familiar when they were at their most famous, in the 1960s and 1970s. The compression of time through intertextual links and the use of cinematic techniques such as flashbacks and close-ups provide spectators with the experience of human ageing and the inevitability of death. The numerous and subtle links to New Wave films through the stars' ageing bodies form

a background fabric of fragments of residual memory on which *Amour* is played out. The texture of Trintignant's and Riva's voices, the close-ups of their damaged skin, the shots of their bodies touching, provide simultaneously clinical information, haptic resonance and visuality of old age. If *Amour*'s ageing stars embody the history of *auteur* cinema and its stars, they also embody, for spectators, the ageing process itself.

Notes

1. All translations, unless indicated otherwise, are by the author.

16

'I Cannot Live Without Performing': Romy Schneider's On- and Off-Screen Embodiments of the Tragic

Andrea Bandhauer

In his study of stars, Richard Dyer notes that the uniqueness of a given 'star image' finds itself in the nexus between promotion, publicity, and films themselves, thereby creating a multifaceted force that unites the extra-diegetic persona with diegetic character (Dyer 1998: 60). However, stars are recognised as such only because spectators come to feel a very strong sense of familiarity with them through previous films, media exposure, biographies, autobiographies, documentaries and exhibitions. The intertextual and multifaceted process highlighted by Dyer needs the recognition of the star's body, its gestures, facial expressions and voice to create a sense of intimate connection with the star. Familiarity with a face, for example, triggers memory in our senses and body (see Marks 2000: xiii), causing us to 'experience' the 'lived body' of a star as we invest ourselves in the film.

In this chapter on Romy Schneider, I will show that the blending of the private and the screen persona created the authenticity, charisma and aura of this star. The fact that the audiences of some of her best-known films often considered the tragic destinies being performed by her on-screen characters to be projections of private aspects of her life created a physical sense of identification, a corporeal response to her star persona.

Figure 16.1. *Sissi* (Marischka 1955).

Romy Schneider: A Transnational Star?

The German actress Romy Schneider (1938–82) acted in more than 60 films, cast as a leading character in many of them. Born in Vienna in 1938, she was officially German, as Austria had been annexed by Nazi Germany by that time. Schneider often referred to herself as Viennese, although she held a German passport throughout her life.[1] It was in France, however, that she became not only one of the most celebrated actresses of French cinema but also was first acknowledged as an international star. Throughout her career, Schneider worked under famous directors such as Claude Chabrol, Otto Preminger, Claude Sautet, Bertrand Tavernier, Luchino Visconti and Orson Welles.

From one of her first roles as the young empress Elisabeth in the famous Austrian kitsch-trilogy *Sissi* (1955/56/57), in which Schneider first acted when she was only 16, to her last movie, *La Passante du Sans-Souci/The Passerby* (1982), made just before her tragic death at 43, Schneider's on- and off-screen persona was defined by her beauty and her often tragic life, which was eagerly followed and scrutinised by the media in Germany as well as in France.

Her 'escape' from Germany to France in 1958, and from the control of her actress mother, Magda Schneider, and her exploitative stepfather, the restaurateur Hans-Herbert Blatzheim, in order to be with the young and upcoming star Alain Delon, caused outrage. The German press branded her as disloyal, calling her a *Vaterlandsverräterin* ('traitor to the Fatherland')[2] and *Franzosenflittchen* ('floozy of the French') (Muscionico 2008: *Die Weltwoche* 29).

The innocent Sissi, symbol of everything postwar Germany and Austria had celebrated in their desire to forget the realities of their Nazi past, had 'defected' to a former enemy to be in a de facto relationship with one of France's rebel actors with a bad reputation. Schneider's break with her on-screen persona as the young and fresh-faced Sissi in love with her young emperor-husband, Franz-Joseph (Karlheinz Böhm), a persona that had been directly projected onto her off-screen image as the answer to the desires and dreams of millions,[3] was not forgiven by the German and Austrian press until fairly late in her life.

Today, Schneider has become one of the most celebrated stars in the history of Austrian and German film. Her anniversaries are celebrated with exhibitions, documentaries and books on her life and career, and in 2000 Germany issued a postage stamp with her picture on it. In 2009, the TV film *Romy*, with Jessica Schwarz cast as Schneider, was released on Germany's main television channel. Since 1990, the Austrian film and TV prize, the Romy, has been awarded annually. The trophy is a gilded statuette of Schneider from a scene in *La Piscine/The Swimming Pool* (1969), ironically the film that is seen as the most iconic collaboration between Schneider and Delon, the man who had 'abducted' her to France.[4]

If, during her lifetime, public awareness of Schneider as a serious artist in Austria and Germany was sketchy to say the least, her private life offered an abundance of material for the German press. Her private tragedies – her split from Alain Delon, her divorces, and her periods of unhappiness and drug abuse – were at the centre of the media's construction of her celebrity status at home. Numerous biographies were published, some written by colleagues who alleged they had known and understood her intimately, such as the patronising biography by fellow actress Hildegard Knef, *Romy Schneider – Betrachtungen eines Lebens* (1983) ('Romy Schneider – Reflections on a Life'), and some by people who claimed her for their own causes (Reichart 2009: 13–14). In her chapter on the creation of the Romy Schneider myth from the 1970s in Germany, Nina Zimnik (2005) shows that her star persona was instrumentalised by feminists as being both representative of the feminist movement[5] and an example of patriarchal victimisation. The most notable example of the latter interpretation is that of one of Germany's most well-known feminists, Alice Schwarzer, in the biography *Romy Schneider: Mythos und Leben* (1998) ('Romy Schneider: Myth and Life'). Other critics of Schneider claimed that she was a prime example of an apolitical woman who followed her passions without regard for consequences, and who exhibited a libertine streak that would become her downfall (Zimnik 2005: 260, 262–7).

While the German press regarded Schneider as being beyond help, the French seemed to adore the combination of strength and vulnerability together with an ironic distance that she often exhibited in her acting. In France, her career took off. She was celebrated as a great star and was awarded the inaugural César award for best actress in 1976 for *L'importance c'est d'aimer/ That Most Important Thing: Love* (1975), directed by the Polish filmmaker Andrzej Zulawski. A further award followed in 1979, for *Une histoire simple/A Simple Story* (1978), under the direction of Claude Sautet. The Prix Romy Schneider, the most prestigious award for promising upcoming actresses in the French film industry, was established in 1984.

The aura of a strong and beautiful woman who simultaneously seemed to exude a deep vulnerability increasingly dominated the star image created by her film roles and the media. Sautet, with whom Schneider worked in five films, said about her charisma as a star: 'She has a mixture of poisonous charm and chaste purity...she is very aware of the power of her body and her sensuality...She exhibits the complexity which is a feature of all great stars' (Krenn 2010: 235). In many of her on-screen performances, Schneider embodies both passion and tragedy, and at times, the tragedies befalling her on-screen characters seemed to reflect and replicate the drama of her private life.

Romy Schneider's On-Screen and Off-Screen Persona

For Schneider, who started performing at the early age of 14, starring in films became her way of life and – as she stated in an interview – during the process of making each movie, the crew and her fellow actors became her surrogate family. Travelling from set to set with her actress mother, the lines of her private and professional life became blurred (Schneider in an interview with Söderberg [1966]). This, as she commented time and again, had consequences for her ability to create a life for herself away from the imaginary world of movies. The childhood spent on set made it difficult for her to distance herself from her roles and her star persona. 'I am not capable of doing anything in life, but I can do everything on screen', she said, and in 1974 she noted in her diary: 'I cannot live without performing' (Seydel 2010: 286). With subtle, albeit bitter, irony, she remarked in 1977: 'I am 50 films' (Seydel 2010: 335).

Her first role, in *Wenn der weiße Flieder wieder blüht/ When The White Lilacs Bloom Again* (1953), already replicated her real-life situation to a certain extent. Schneider plays Evie, a girl brought up by her single mother, played by her real-life mother, Magda Schneider. When a popular singer comes to their provincial town, Evie's mother confesses to her that the star she adores is in fact her real father. Evie is ecstatic. 'Mister Perry? That's heavenly! Bill Perry is my father!' she exclaims. Her father, played by the popular star Willy Fritsch, schmaltzily accepts his parenthood, but leaves the town on a plane after his professional engagement is over. Evie, feeling proud about understanding her father's need to leave her

in order to pursue higher things, watches his plane disappear while wiping away tears. This scenario was indeed very familiar to details in Schneider's off-screen life. Her real-life biological father, the Vienna Burgtheater actor Wolf Albach-Retty, was an absent parent as well. After her parents' divorce when Schneider was six or seven years old, Albach-Retty left the family home in the Bavarian town of Berchtesgaden and moved to Vienna in order to pursue his career as a *Burgschauspieler* (actor at the Viennese Burgtheater). So considered, it is fitting how the critics praised Schneider's natural talent and the way she immersed herself in the role of Evie. 'She not only acts her part, she lives it' – as printed enthusiastically in the film journal *Mein Film* in December 1953 (Krenn 2010: 49).

Empathy

Actors and directors who worked with Schneider frequently refer to her ability to summon her feelings from deep inside and give the impression that she always also revealed something about herself in her acting. It is often argued that precisely this skill endowed Schneider with the very specific sensuality, sensitivity and, above all, vulnerability, which trigger strong emotional reactions in her audience. Her face, in addition, so frequently shown in close-ups, as well as her voice, are examples of embodiment and sensory representation in cinema.

More recently, film scholarship has begun to consider the role of sensual aspects in the film-viewing experience, namely of touch, taste and smell as all being connected to sight, which has resulted in a critical representation of the experience of film spectatorship as being truly embodied. Building on Sobchack's phenomenological theory of cinematic vision (see Sobchack 1992), among others, Jennifer M. Barker's study on theories of affect and sensuous experience in *The Tactile Eye: Touch and the Cinematic Experience* (2009) focuses on the tactility of cinema in order to explore the notion that viewing a film is an intimate and sensual experience. The tactility of cinema is not only skin deep, according to Barker, but is enacted and felt throughout the body (Barker 2009: 2). Schneider's accented voice, her Viennese-sounding German, her slightly accented French and English, all became a substantial part of her on-screen appeal. These, together with her ability to transmit feelings through her facial expression, seem to communicate to her audience her fragmented, and often troubled, real-life trajectory. The comment by the Austrian author Robert Menasse, that her on- as well as her off-screen presence makes one feel the real desire to rescue or even save her in an almost spiritual sense (Langer 2008: 87), is well reflected in the responses by Schneider's admirers to her star image. That the association of Schneider with the tragic elements of her numerous film roles seems to resonate most with her audience can perhaps be attributed to a complex blending of diegetic character and extra-diegetic persona.

Although her star image tended towards the tragic, Schneider herself often exhibited a great amount of wit and hilarity, as is evident in her diaries (see Seydel

2010). In her professional life, as well, she was able to show off her talent for comedy.[6] In many of her later movies, however, she embodied characters on edge, both strong and fragile, and on a road that often led to disaster. These characters corresponded with her French star persona.

Barker's notion of 'the fleshy, muscular, and visceral engagement that occurs between films' and viewers' bodies' (Barker 2009: 4) builds on theories of embodied spectatorship. In Schneider's case, this engagement between the embodied star on-screen, her real-life body and the spectators' gaze seems to be exceptionally strong. As a star who, as Schneider herself commented, needed the screen as a canvas in order to 'feel' her emotional and physical self (Seydel 2010: 336), her star image evolved from a physical sense of identification and the corporeal responses she triggered in her audience. Revisiting Menasse's reaction to Schneider, his desire to help her shows that 'meaning and emotion' do not simply reside in films or viewers, but 'emerge in the intimate, tactile encounter between them' (Barker 2009: 15). As Barker points out, 'all these bodies – those of the characters, actors, viewers and film – are entities whose attitudes and intentions are expressed by embodied behaviour' (2009: 10). Menasse's reaction is, I think, an example of much more than a response to Schneider's on- and off-screen persona. It seems to come from a point where he is touched in a bodily sense by an encounter with a star-body, that is, a body invested with his memory of Schneider's extra-diegetic persona and diegetic characters. He writes, somewhat ironically: 'I fantasised that I was able to do that [save her]. I have never met her so I couldn't save her. Since then, in the cinema, I have always been a widower' (Langer 2008: 87). A colleague of Schneider, the actor Jean-Claude Brialy, said in an interview with the journal *Der Spiegel* entitled 'The Queen of Pain', 'Romy unconsciously feeds on the suffering she encountered, and uses this in her film roles' (Matussek and Beier 2007: 161).

Vergangenheitsbewältigung: Coming to Terms with the Past On- and Off-Screen

La Passante du Sans-Souci, based on the novel by Joseph Kessel (1936) and directed by Jacques Rouffio, was Schneider's last film, a project very important to her and which she had long contemplated. One of the reasons she was interested in the material was her on-going engagement with her country's past. Having spent her childhood in rural Bavaria, Schneider was not directly affected by the war. However, her life was touched by the Nazi era. Her mother and father were both well-known film stars, whose careers not only survived the Nazi era but indeed flourished during a time when the German film industry experienced serious disruption. Schneider's mother, Magda Schneider, was admired by Hitler, who invited her to the Berghof, his retreat in Obersalzberg. Her father was an early supporter of the SS and joined the party in 1941, probably for career reasons, as biographers suggest (Krenn 2010: 27). Schneider's family home, Mariengrund, was

in Berchtesgaden, which is close to Obersalzberg, where not only Hitler but many of his party officials resided. Schneider's grandmother, the famous Burgtheater actress Rosa Albach-Retty, recalls in her autobiography that her granddaughter played with the children of high-ranking party officials (Albach-Retty 1978: 240). After Schneider's death, her mother, in a series for the tabloid *Bild* called 'Leb wohl, Romy' (1982) ('Farewell, Romy'), refers quite nonchalantly to the many birthdays Romy celebrated with the eight children of one of the most powerful and most feared men of the Third Reich, Martin Bormann (Schwarzer 1998: 42). Schneider's uneasiness about her origins became part of her stardom in France, according to many French directors who worked with her. In a letter dated 26 September 2007 to the author of a biography on Schneider, Bertrand Tavernier, who directed Schneider in *Death Watch/La mort en direct* (1979–80), remembers the deep shame and anger Schneider felt about her mother's past and the latter's unwillingness to confront her closeness to the Nazi regime (Krenn 2010: 23). Roles in movies addressing the events of World War II were therefore very important to Schneider. In *Le Train/The Train* (1973), directed by Pierre Garnier-Deferre, for example, she played the role of a mysterious German-Jewish woman (Anna Kupfer) fleeing from the Nazis who has a dangerous love affair with a French man (Jean-Louis Trintignant). In *Le vieux fusil/The Old Gun* (1975), directed by Robert Enrico, Schneider featured as a woman raped then killed by German soldiers. In her private notes, she remarks with regard to the past of her family and her country: 'I know some things through my mother. She knew this time and I have to learn from that' (Seydel 2010: 305). Schneider's role as Leni Gruyten in the movie based on Böll's novel, *Gruppenbild mit Dame/Group Portrait with a Lady* (1977), might have suggested to Schneider that she, as a German actress in a German production, could become part of the process of coming to terms with the German past not only in France, but also in Germany. While critics were, for the most part, more than unimpressed with the film, Schneider's standing as a serious actress was acknowledged, at least by some. As mentioned above, she received the 'Filmband in Gold' for this role. However, for the Germans, Schneider remained Sissi, adulated by the common public who loved and needed romance (the Sissi films have been shown on TV during Christmas time every year up to the present day) and rejected by the German intelligentsia, who expressed contempt for her in this role.

I would suggest that the reasons why 'serious' German directors would view her non-diegetic as well as her diegetic persona as frozen in the image of the innocent girl were not only connected with her early roles but also with her family background. There was the 'stain' left by her parents' absolute refusal to acknowledge their involvement in the Nazi regime. This might have been exacerbated as a result of the star image created during her early career, where she was presented as the middle-class child star, constantly accompanied by her over-protective mother and her nouveau-riche stepfather, who ostentatiously flaunted

his position as one of the beneficiaries of the post–World War II economic miracle (Schwarzer 1998: 93–4). The star image created during this time might have left the impression that she was unable to comprehend, let alone master, roles dealing with serious issues of Germany's past. I would suggest that Schneider's choices, even when it came to her private life, in part reflect her desire to confront her critics and actively reject this past.

In my view there are significant parallels in the respective relationship structures of Schneider's liaison with Delon and her first marriage to Harry Meyen. One of Schneider's and Delon's problems resulted from their different upbringings. Schneider had grown up as the protected child of privilege and was used to being a celebrated star from her early adulthood, whereas Delon came from a troubled background and had to fight for his career. This is what Schneider read about herself in Delon's book:

> She [Schneider] came from the social class I hate most in the world. It is not her fault, but, unfortunately, she is shaped by it . . . Just as there exist two, three, even four Alain Delons in me, there were always two Romy Schneiders. She knows that too. One Romy, I loved more than anything in the world, the other one I hated as strongly. (Seydel 2010: 184)

In Meyen's case there was a political dimension to their relationship. Meyen, whose birth name was Harry Haubenstock, was of Jewish descent through his father, who did not survive the Holocaust. As a half Jew, Meyen was arrested by the Gestapo when he was 18 and spent time in the concentration camp Fuhlsbüttel in 1942 (Krenn 2010: 193–6). Thus, his family history is diametrically opposed to that of Schneider. Meyen's deep trauma, which he fought through medication and alcohol abuse, played a role in the deterioration and end of Schneider's first marriage. Her consistent acknowledgement and problematisation of her countries' Nazi past is also reflected in the names she gave to her two children, David and Sarah, as well as in the fact that she was buried with a necklace with the Star of David around her neck.

La Passante du Sans-Souci

In *La Passante du Sans-Souci*, Schneider can be seen in a double role. She plays Lina Baumstein, the wife of Max Baumstein (Michel Piccoli), owner of a Swiss insurance agency and president of the humanitarian organisation 'Solidarité Internationale'. During a meeting called to plead for the release of a political prisoner, Max Baumstein shoots the Paraguayan ambassador, Federico Lego, and is tried for first-degree murder. As he explains his crime to his wife and during the court proceedings, we see flashbacks of his life as a Jewish boy in Berlin. After his father is killed and he himself is severely injured by Nazi thugs, Max is rescued

by Elsa Wiener, wife of a German publisher, also played by Schneider. Elsa and her husband, Michel Wiener (Helmut Griem), take in Max, who is suffering from a stiff leg as a result of the attack. Later, Elsa flees with Max to Paris in order to avoid repercussions from the Nazi regime. To enable them to survive, Elsa works as a cabaret entertainer in *Le Rajah*, drowning her worries about her husband with alcohol and drug abuse. By agreeing to sleep with a young, mysterious German (Mathieu Carrière), she eventually manages to save her husband from the clutches of the Nazis. She is reunited with her husband in Paris, but they are murdered by hit men commanded by the Nazi official Ruppert, the man to whom Elsa sacrificed herself. The ambassador, going by the apparent identity Lego and whom Max Baumstein kills, is this former Nazi official, responsible for the extermination of Max's adoptive family.

Max Baumstein escapes the murder charge and is given only five years probation due to the sympathy he elicits during the court case, and due to the testimony of key witnesses who were aware of the indescribable atrocities that Max experienced during his childhood. In the last scene of the movie, Max and Lina are seen in a happy embrace, while captions inform the viewer that both of them will soon be murdered by unknown assassins. The framework plot here repeats the main plot: while Elsa falls victim to the Nazis, Lina is assassinated by the new right-wing radicals.

I would argue that in this role, Schneider's real body, driven by 'real emotion', is – as one might put it – 'counter-acting' her memories of the sheltered youth enabled by her parents' practice of ignoring the Nazi regime and its crimes. By playing a victim of a regime that her parents were, to a certain extent, part of, Schneider seemed to act out her own *Vergangenheitsbewältigung* on screen. But, as Zimnik shows, it was not only her extra-diegetic persona as someone who needed to express their disgust towards the Nazi regime but also her private struggles that come together and are embodied by the character on-screen (Zimnik 2005: 251–2.).

There is yet another aspect that adds to the complexity of the interplay of the extra-diegetic and diegetic in Schneider's acting in *La Passante du Sans-Souci*.

On Sunday, 15 July 1981, Schneider's 14-year-old son, David, died in an accident when he was trying to climb over the wrought-iron fence of the house belonging to the parents of Schneider's second husband. Schneider, who had suffered several blows of fate in the preceding years – Meyen, David's father, had committed suicide in 1979, and her grandmother had died in 1980 – and who was already weakened by a kidney operation earlier the same year, as well as haunted by severe financial problems, collapsed. In spite of this tragedy, Schneider insisted on playing the double role of Lina/Elsa in *La Passante du Sans-Souci*. When the insurance company contemplated giving the part to another actress (Hanna Schygulla's name was mentioned), Schneider's last lover, Laurent Pétin, is said to have rung Rouffio, the director, begging him: 'Please shoot with her, otherwise

she will die' (Amos 2006: 26). Again, Schneider seems to find a life on screen preferable to confronting her destiny. Shortly after the French première of the film in April 1982, and before the movie was screened in Germany on 22 October 1982, Schneider collapsed at her desk and died.

The Crying Scene in *La Passante du Sans-Souci*

The 'crying scene', as I will call it here, takes place when Elsa, living with little Max (Wendelin Werner) in a hotel in Paris, agrees to step out of the seclusion of her room in order to have Christmas dinner with him. She can be seen walking through the dining hall, exquisitely dressed, guided by a proud Max. While they order dinner, a band of violinists ask her to choose the next song. Elsa asks Max, who had learnt how to play the violin, to play the *Song of Exile* (*Chanson d'exil*, composed by Georges Delerue) to her. While Max plays, accompanied by the band, the camera pans between Max and Schneider's/Elsa's face in close-up several times, finally resting on Schneider/Elsa.

In *Heavenly Stars*, Dyer notes that '[k]ey moments in films are close-ups, separated out from the action and interaction of a scene, and not seen by other characters but only by us, thus disclosing for us the star's face, the intimate, transparent window to the soul' (Dyer 2004: 24). According to Dyer, close-ups, as well as star biographies, create for the viewer 'a privileged reality to hang on to, the reality of the star's private self' (2004: 24). As numerous film theorists have commented, close-ups are confronting for the viewer because they eliminate the distance otherwise necessary in life for communication and for not becoming overwhelmed by the immediacy of emotions expressed by a face in intimate detail (see for example Meyrowitz 1986: 256). Epstein and others such as Balázs, and Barthes have all pointed out the various ways in which the close-up of a face can heighten the emotional, sensual, erotic and even psychological connections between viewer and star, creating a sense of immediacy, proximity and intimacy (see Doane 2003: 89–111). Epstein put it into words when he wrote: 'A head suddenly appears on screen and drama, now face to face, seems to address me personally and swells with an extraordinary intensity. I am hypnotised. Now the tragedy is anatomical' (Epstein 1993: 235). With reference to Balázs's conception of the close-up, Doane has written: 'It is barely possible to see a close-up of a face without asking: what is he/she thinking, feeling, suffering? What is happening beyond what I can see?' In other words, the close-up invites us not only to bear witness to outward displays of emotion, but also prompts us to look beyond the merely visible, to recognise that 'there is something there that we cannot see' (Balázs cited in Doane 2003: 96). We must, according to Balázs, 'read between the lines' (Doane 2003: 96).

Schneider's face has been the focus of numerous comments. In the chapter titled 'Ein Kameragesicht' ('A Camera Face'), Manuela Reichart gives an overview

of scenes in which Schneider's face would light up with a smile that touched her eyes, expressing deep desperation, softness, irony and sudden anger, all in one close-up (Reichart 2010: 17–19). Her features were clearly photogenic and extraordinarily expressive. Hans Jürgen Syberberg, then a young German director, shot a TV documentary of Schneider while she was holidaying in Kitzbühel/Tyrol in 1966. He called his documentary *Porträt eines Gesichts* ('Portrait of a Face'), and during their conversations the camera follows every movement of Schneider's physiognomy. When portraying Schneider in an article, the French film critic Françoise Audé's gaze seems to imagine her face and linger on it in a way that corresponds with the gaze of a camera dwelling on one perfect detail after another. She describes Schneider's beauty as follows:

> [The] upright way she held her head, the ideal lines of her nape and her neck, the gracious shape of her ears, her fine hair, which, even combed straight to her back and arranged in a bun, loosens in a way of sweet strains like baby down, the loveliness of her face with her short nose, with her perfect mouth, the firm form under the modelled roundness of her cheeks and of her chin, the glow of her grey-green eyes. . . . (Audé 1991: 221)

While looking at Schneider's face, Audé seems to be in some kind of 'truly intense sensory perceptual state[s]' in which, according to Goldberg, Haral and Malach 'the strong subjective feeling is of 'losing the self', i.e. of disengaging from self-related reflective processes' (Goldberg et al. 2006: 330). Audé/the critic, one could say, loses herself in Schneider's face.

While Schneider/Elsa watches little Max playing the violin for her, her face seems lit up with emotions of love and deep sorrow. She attempts a smile, and we see her eyes filling with tears, a teardrop running slowly down her cheek. Elsa, her facial expressions conveying loneliness and the uncertainty of living in exile, knows that her home country is succumbing to an evil that may kill her husband. There is also the motherly tenderness she feels towards Max, the child she rescued from the Nazis, and whose devotion towards her she is acutely aware of, as he seems reluctant to play at first but then succumbs to Elsa's wishes.

There is, however, an additional meaning attached to this scene. Aware of Schneider's painful loss of her son, who was exactly the age of the actor playing Max when he died, we as viewers ask: 'Who is really meant by the loving smile and tears?' While Schneider as Elsa is watching a child express love and devotion towards the woman he considers his mother, is she feeling the final absence of her own son? Where, one might ask – and this question has been posed by numerous biographers, journalists, colleagues and friends – did Schneider's strength to act in this scene come from (see for example Krenn 2010: 337)? The feeling of having watched facial expressions communicating 'real' pain, 'real' loss and sorrow rather than skilled acting is confirmed for the viewer when the closing credits are

Figure 16.2. *La Passante du Sans-Souci* (Roufio 1981–82).

shown: 'For David and his father.' Here, as Krenn remarks, the question regarding the blending of Schneider's on- and off-screen persona, which accompanied her career, beginning with *Wenn der weiße Flieder wieder blüht*, (When the White Lilacs Bloom Again) When the White Lilacs Bloom Again 'comes full circle ... actress and performed character seem to become one, for the audience and maybe for Schneider as well' (Krenn 2010: 336).

What we see during the close-up scene (and what is confirmed by the dedication at the end of the movie) is loaded with extra-diegetic meaning that elicits our empathy. First, the viewer will be confronted by Schneider's pain of losing her son just before the filming of this movie started. Secondly, the reference in the closing credits to her son David, and to his father, who was Jewish and had faced the trauma of the concentration camps, points towards Schneider's desire to attempt to undo the intransigent attitude of her own parents (and that of her home countries, Germany and Austria) towards the horrors of the Nazis. Finally, we see the last close-up of Schneider's face before her death.

La Passante du Sans-Souci functions as a kind of closure by drawing together all the tragedies of Romy Schneider's life. It epitomises her transnational stardom as an actress who tried to merge her German/Austrian origins with her status as a French star, her profound sensory connections with audiences and her formidable talent, to embody characters that reverberate and echo her life off-screen.

Notes

1. The fact that, to a certain extent, she seemed to identify herself as Austrian might have to do with her family's history as a dynasty of famous Austrian actors.
2. All translations, unless indicated otherwise, are by the author.
3. *Sissi* became an international success. During their European promotional tour for *Sissi, die junge Kaiserin* (Sissi, the Young Empress, 1956), Romy Schneider and Karlheinz Böhm, the actor playing her husband, were greeted as if they were real royalty. In Athens, they were officially welcomed by the Greek royal family and needed police protection to make their way to the movie theatre where the film premiered (Krenn 2010: 86–7).
4. It was after the production of this film that Schneider left Germany, where she had lived from 1965 to 1970 as the wife of theatre director Harry Meyen and mother of her son David, to go to France for the second time.
5. When Alice Schwarzer asked Schneider to take part in the campaign against Paragraph 218 (the anti-abortion law) in the popular magazine *Stern* in 1971, in which prominent German women 'admitted' to having had an abortion, Schneider unhesitatingly agreed (Reichart 2009: 13).
6. Such as *Feuerwerk/Fireworks* (1954), *Die Deutschmeister/March for the Emperor* (1955), *Scampolo* (1957), *Die Halbzarte* ('The Only Partly Delicate Woman') (1958–59), *Die schöne Lügnerin/The Beautiful Liar* (1959), *Ein Engel auf Erden/Mademoiselle Ange* (1959), *Good Neighbour Sam* (1963) or *What's New Pussycat?* (1964–65).

Bibliography

Abdallah, Ahmed (2008). *The Student Movement and National Politics in Egypt, 1923–1973*, Cairo: American University in Cairo.

The Actor Who'd Been Long Awaited /Aktyor, kotorogo zhdali (1986). Written and narrated by Aleksandr Svobodin, Head Editorial Office of the Literary and Dramatic programmes, Central Television.

Afrogle, African Entertainment, afrogle.com (accessed 25 November 2013)

Agilada, Rowena M. (1984). 'I Hope 1984 Will Be a Better Year – Sharon Cuneta', *Liwayway*, 2 January: 18–19: 31.

Aguilar, Jose V. (1966). 'Improving Teaching and Learning in Language Instruction', *Philippine Journal of Education*, 45(5), November: 334–6, 389–90.

Agutter, Jenny (1999). Video: *Going Walkabout: Jenny Agutter Talks About Filming "Walkabout" in the Australian Outback with Nic Roeg and His Travelling Circus*, London: British Film Institute.

Answers Africa, answersafrica.com (accessed 25 November 2013).

Ajibade, Babson (2013). 'Nigerian Videos and Their Imagined Western Audiences: The Limits of Nollywood's Transnationality', in Matthias Krings and Onookome Okome (eds), *Global Nollywood: The Transnational Dimensions of an African Video Film Industry*, Bloomington & Indianapolis: Indiana University Press: 264–84.

Albach-Retty, Rosa (1978). *So kurz sind hundert Jahre*, München, Berlin: Herbig.

Al-Hadari, Ahmad (1989). *Tarikh al-Sinima fi Misr: al-Juz' al-Awwal min Bidayat 1896 li-Akhir 1930*, Cairo: Nadi al-Sinima.

——— (2007). *Tarikh al-Sinima fi Misr: al-Juz' al-Thani min Bidayat 1931 li- A khir 1940*, 2nd edn, Cairo: Nadi al-Sinima.

Ali, Mahmud (2008). *Fajr al-Sinima fi Misr*, Cairo: Sanduq al-Tanmiya al-Thaqafiyya.

Allinson, Mark (2001). *A Spanish Labyrinth: The Films of Pedro Almodóvar*, London and New York: I.B.Tauris.

Altieri, Charles (2003). *The Particulars of Rapture: An Aesthetics of the Affects*, Ithaca: Cornell University Press.

Amos, Robert (2006). *Mythos Romy Schneider. Ich verleihe mich zum Träumen*, Neu-Isenburg: Wunderkammer.

Anderson, Digby and Peter Mullen (eds) (1998). *Faking It: The Sentimentalisation of Modern Society*, London: Penguin.

Anderson, Tommy R. (1968). 'How to Develop the National Language', *Philippines Free Press*, 61(27), 16 July: 5, 56–60.

Anon. (1980). 'Der Zauber einer schönen Frau', *Quick*, 51 (11 December).

Anon. (2006) 'Alatriste', www.grundlos.org/2006/09/17/alatriste (accessed 24 June 2013).

Anon. (2006). 'Triste Alatriste', gordopilos.org/?p=292 (accessed 24 June 2014).

Anon. (2010). 'Is Red Carpet a European Tradition? Back From Troy', *Film International*, 16(2): 36–9.

Anon. (2012a). 'Leila Hatami with Inappropriate Clothes and Shaking Hands with Men', 11 June, www.entekhab.ir/fa/news/66033 (accessed 19 April 2013).

Anon. (2012b). 'When Leila Hatami Becomes a Pawn for Zionist Jews', 26 August, khabarfarsi.com/ext/3254975 (accessed 19 April 2013).

Armbrust, Walter (1996). *Mass Culture and Modernism in Egypt*, Cambridge: Cambridge University Press.

——— (2001). 'Colonizing Popular Culture or Creating Modernity? Architectural Metaphors and Egyptian Media', in Hans Chr. Korsholm Nielsen and Jakob Stovgaard-Petersen (eds), *Middle Eastern Cities, 1900–1950*, Gylling: Aarhus University Press: 20–43.

——— (2004). 'Egyptian Cinema on Stage and Off', in Andrew Shrylock (ed.), *Off Stage On Display: Intimacy and Ethnography in the Age of Public Culture*, Stanford: Stanford University Press: 69–98.

——— (2006). 'Audiovisual Media and History of the Arab Middle East' in Israel Gershoni, Amy Singer and Y. Hakan Erdem (eds), *Middle East Historiographies: Narrating the Twentieth Century*, Seattle and London: University of Washington Press: 288–313.

Arnold, John and Bain Attwood (eds) (1992). *Power, Knowledge and Aborigines*, Bundoora, Vic: La Trobe University Press in association with the National Centre for Australian Studies, Monash University.

Audé, Françoise (1991). 'Romy Schneider – eine zärtliche Adoption', *CICIM: Revue pour le Cinema Francais*, 30–2, 221–31.

Austin, Thomas and Martin Barker (2003). *Contemporary Hollywood Stardom*, London: Arnold.

Australian Human Rights and Equal Opportunity Commission and National Inquiry into the Separation of Aboriginal and Torres Strait Islander Children from Their Families (Australia) (2007). *Bringing them Home: The 'Stolen Children' Report*, Human Rights and Equal Opportunities Commission, Sydney.

Averill, J.R. (1980). 'A Constructivist View of Emotion', in R. Plutchik and H. Kellerman (eds), *Emotion: Theory, Research, and Experience*, Orlando: Academic Press: 305–39.

Azzam, Nabil Salim (1990). *Muhammad 'Abd al-Wahhab in Modern Egyptian Music*, unpublished PhD dissertation, University of California, Los Angeles.

Barker, Jennifer (2009). *The Tactile Eye: Touch and the Cinematic Experience*, Berkeley and Los Angeles: University of California Press.

Barney, Katelyn (2010). 'Gendering Aboriginalism: A Performative Gaze on Indigenous Australian Women', *Cultural Studies Review*, 16(1): 212–39.

Barrios, Joi (1989). 'Kung Bakit Ko Pinapanood and mga Pelikula ni Sharon Cuneta', *Kultura*, 2(4): 2–8.

Barros, André Luiz (1999). 'Carmen Miranda Inc.', *Bravo*, 17: 48–56.

Barrot, Pierre (ed.) (2008). *Nollywood: The Video Phenomenon in Nigeria*, Indianapolis: Indiana University Press.

Beauvoir, Simone de (1972). *Old Age*, trans. Patrick O'Brian, London: Deutsch, Weidenfeld and Nicolson.

Beck, Jerry (2005), *The Animated Movie Guide: The Ultimate Illustrated Reference to Cartoon, Stop-Motion, and Computer-Generated Feature Films*, Chicago: Chicago Review Press.

Beinin, Joel (2001). *Workers and Peasants in the Modern Middle East*, Cambridge: Cambridge University Press.

—— and Zachary Lockman (1988). *Workers on the Nile: Nationalism, Communism, Islam, and the Egyptian Working Class, 1882–1954*, London: I.B.Tauris.

Bergfelder, Tim (2004). 'Negotiating Exoticism: Hollywood, Film Europe and the Cultural Reception of Anna May Wong', in Lucy Fisher and Marcia Landy (eds), *Stars: the Film Reader*, London and New York: Routledge: 59–75.

Berkovsky, Naum (1958). 'Dostoevsky na scene [Dostoyevsky on stage]', *Teatr*, 6: 69–80.

—— (c.1969). 'Dostoevsky na scene. "Idiot" v postanovke G.A. Tovstonogova (1958)' (Dostoyevsky on stage. 'The Idiot' directed by G.A. Tovstonogov [1958]).

Bessarab, Dawn and Bridget Ng'andu (2010). 'Yarning About Yarning as a Legitimate Method in Indigenous Research', *International Journal of Critical Indigenous Studies*, 3(1): 37–50.

Beth, Sarah (2007). 'Hindi Dalit Autobiography: An Exploration of Identity', *Modern Asian Studies*, 41(3): 545–74.

Beumers, Birgit (2009). *A History of Russian Cinema*, Oxford/New York: Berg.

'Black Market Plagues France' (1947). *New York Times*, 3 February: 10.

Blagg, Harold (2008). *Crime, Aboriginality and the Decolonisation of Justice*, Sydney: Hawkins Press.

Blaikie, Andrew (1999). *Ageing and Popular Culture*, Cambridge and New York: Cambridge University Press.

Bohlinger, Vincent (2012). 'Igor' Il'inskii: Movie Stardom and Performance Style before and after Stalin', *ASEEES Conference*, 16 November 2012, Panel 6–09 (Beauregard), unpublished conference paper.

Bordwell, David (2006). *The Way Hollywood Tells It: Story and Style in Modern Movies*, Berkeley: University of California Press.

Bourdieu, Pierre (1984). *Distinction: A Social Critique of the Judgment of Taste*, trans. Richard Nice, Cambridge: Harvard University Press.

—— (1986). 'The Forms of Capital', in J.E. Richardson (ed.), *Handbook of Theory of Research for the Sociology of Education*, trans. Richard Nice, New York: Greenwood Press: 46–58.

—— (1998). *Practical Reason*, New York: Polity Press.

Brady, Wendy (2000). '"Talkin' Up Whiteness": A Black and White Dialogue' in J. Docker and G. Fisher (eds), *Race, Colour and Identity in Australia and New Zealand*, Sydney: University of New South Wales Press: 270–82.

Breyley, Gay (2010). 'Hope, Fear and Dance Dance Dance: Popular Music in 1960s Iran', *Musicology Australia*, 32(2): 203–26.

Brooks, Clifford (2006). 'Wiluna', in John Carty, 'Drawing a Line in the Sand: the Canning Stock Route and Contemporary Art', in *Yiwarra Kuju: The Canning Stock Route*, Canberra: National Museum of Australia Press: 10.

Brooks, Peter (1995 [1976]). *The Melodramatic Imagination: Balzac, Henry James, Melodrama and the Mode of Excess*. New Haven: Yale.

Calderon, Enrique L. (1982). 'Sharon and William: Portrait of Achievers', *Focus Philippines*, 5 June, 10(28): 18–19.

Caroll, Noël (1997). 'Art, Narrative and Emotion' in Mette Hjort and Sue Laver (eds), *Emotion and The Arts*, Oxford: Clarendon Press: 190–211.

Carty, John (2010). 'Drawing a Line in the Sand: The Canning Stock Route and Contemporary Art', in *Yiwarra Kuju: The Canning Stock Route*, Canberra: National Museum of Australia Press: 23–77.

Castro, Ruy (2005). *Carmen: uma biografia*, São Paulo: Companhia das Letras.

Catbagan, Sophie M. (1966). 'How Bad Is the Filipino's Spoken English?', *Verge*, June, 1(1): 122–34.

Celino, Ross F. (1966). 'Busiest Stars of 1965', *Weekly Graphic*, 32(28), 5 January: 38–9.

——— (1984). 'The Sharon-Gabby Love Story: Mayabang, Antipatiko!', *Liwayway*, 15 October: 20, 38.

Cervantes, Behn (2000). 'The Mestiza Mystique in Filipino Movies', *Pelikula*, 2(1), March–August: 16–20.

Chakrabarty, Dipesh (2000). *Provincializing Europe: Postcolonial Thought and Historical Difference*. Princeton: Princeton University Press.

Chiba, Nobuo (2001). *Hara Setsuko: densetsu no joyū*, Tokyo: Heibonsha.

Chivers, Sally (2011). *The Silvering Screen, Old Age and Disability in Cinema*, Toronto: University of Toronto Press.

Choi Eun-hee (2007). *Gobaek: Yeonghwa beoda deo yeonghwa gat'eun salm* [*Confession: A life More Dramatic than a Film*], Seoul: Random House Korea.

——— and Shin Sang-ok (1988). *Jogugeun Jeohaneul Jeomeolli* [*My Motherland is Faraway*], Monterey: Pacific Artist Cooperation.

Chukwuwezam, Obanor (2011). Information Nigeria, 'Excerpts from an interview with Genevieve Nnaji', 5 July, www.informationng.com/2011/07/excerpts-from-an-interview-with-genevieve-nnaji.html (accessed 7 January 2014).

Chun Su-jin (2007). 'Film Icon Finally Writes Own Story', *Joongang Daily* (21 November), koreajoongangdaily.joinsmsn.com/news/article/article.aspx?aid=288297 (accessed 3 May 2013)

Chung, Stephen (2008). 'Sin Sang-ok and Postwar Korean Mass Culture', dissertation, Irvine: University of California.

Cohen-Shalev, Amir (2009). *Visions of Ageing: Images of the Elderly in Film*, Brighton: Sussex Academic.

Collins, Felicity and Davis (2004). *Australian Cinema after Mabo*, Cambridge: Cambridge University Press.

Comolli, Jean-Luc (1978). 'Historical Fiction. A Body Too Much', *Screen*, 19(2): 41–54.

Constantino, Ronald K. (1981). 'Sharon Makes Waves', *Focus Philippines*, 9(19), 4 April: 22.

Corrigan, John (2004). *Religion and Emotion: Approaches and Interpretations*, New York: Oxford University Press.

Creed, Barbara (2005). *Phallic Panic: Film, Horror and the Primal Uncanny*, Melbourne: University Press, Melbourne.

Danielson, Virginia (1987). 'The "Qur'an" and the "Qasidah": Aspects of the Popularity Sung by Umm Kulthum', *Asian Music*, 19(1), (Autumn–Winter): 26–45.

———(1997). *The Voice of Egypt: Umm Kulthum, Arabic Song and Egyptian Society in the Twentieth Century*, Chicago: University of Chicago Press.

———(1998) 'Performance, Political Identity, and Memory: Umm Kulthum and Gamal 'Abd al-Nasir' (1998), in Sherifa Zuhur (ed.), *Images of Enhancement: Visual and Performing Arts in the Middle East*, Cairo: American University in Cairo Press.

David, Joel (1995). *Fields of Vision: Critical Applications in Recent Philippine Cinema*, Quezon City: Ateneo de Manila University Press.

De Heer, Rolf, Molly Reynolds and Tania Nehme (2006). *The Balanda and the Bark Canoes: A Documentary about the Making of Ten Canoes*, Lindfield, NSW: Film Australia.

de Manila, Quijano [pseud. Joaquin, Nick] (1965). 'Don't Rock the Star System!', *Philippines Free Press*, 58(31), 31 July: 6–7, 30–2, 34, 36.

———(1970). 'Golden Girl', *Philippines Free Press*, 63(28), 11 July: 6–7, 57–9.

del Mundo Jr, Clodualdo (1999). 'Philippine Cinema: An Historical Overview', *Asian Cinema*, 10(2) (Spring–Summer): 29–66.

Dennison, Stephanie and Song Hwee Lim (2006). *Remapping World Cinema: Identity, Culture and Politics in Film*, London: Wallflower.

Diawara, Manthia (2010). *African Film: New Forms of Aesthetics and Politics*, New York: Prestel.

Díaz Yanés, Agustín (dir.) (2006). *Alatriste*, Estudios Picasso, Origen Producciones Cinematográficas, NBC Universal Global Networks.

Doane, Mary Ann (2003). 'The Close-Up: Scale and Detail in the Cinema', *Differences*, 14(3): 89–111.

Donovan, Barna William (2008). *The Asian Influence on Hollywood Action Films*, McFarland & Company Inc.

Douglas, Bronwen (2003). 'Seaborne Ethnography and the Natural History of Man', *Journal of Pacific History*, 38(1): 3–27.

Dubrovsky, Victor (ed.) (2001). *Innokenty Smoktunovsky. Zhizn' i roli* [Innokenty Smoktunovsky. Life and Roles], Moscow: Iskusstvo.

Dumaual, Mario (1983). 'What Now, Young Stars?', *Parade*, 5(12), 19 August: 8–9.

Dunn, Elizabeth (2006). 'Controversial and Classic Up for Auction', *Sydney Morning Herald*, August 25, www.smh.com.au/news/arts/aussie-art-for-sale/2006/08/24/1156012675800.html (accessed 8 May 2013)

Durgnat, Raymond (1967). *Films and Feelings*, London: Faber & Faber.

Durovičová, Nataša and Kathleen E. Newman (2010), *World Cinemas, Transnational Perspectives*, New York: Routledge. e-book.

Dwyer, Rachel (2000). *All You Want is Money, All You Need is Love: Sex and Romance in modern India*. London: Cassell.

———— (2002). *Yash Chopra*. In 'World Directors' series. London: British Film Institute/Berkeley: University of California Press/New Delhi: Roli Books.

———— (2004). '*Yeh shaadi nahin ho sakti!* (This Wedding Cannot Happen!)', in G.W. Jones and Kamalini Ramdas (eds), *(Un)tying the Knot: Ideal and Reality in Asian Marriage*. (Asian Trends, 2) Singapore: Asia Research Institute, National University of Singapore: 59–90.

———— (2005). *100 Bollywood Films*, London: British Film Institute.

———— (2006a). *Filming the Gods: Religion and Indian Cinema*, London, New York and Delhi: Routledge.

———— (2006b). 'Kiss and Tell: Expressing Love in Hindi Movies' in Francesca Orsini (ed.), *Love in South Asian Traditions*, Cambridge: Cambridge University Press: 289–302.

———— (2006c). *Filming the Gods: Religion and Indian Cinema*, London, New York and Delhi: Routledge.

———— (2013). 'Happy Ever After: Hindi Films and the Happy Ending', in Nikolai Ssorin-Chaikov (ed.), *The Topography of Happiness from the American Dream to Postsocialism/ Топография счастья от Американской мечты к пост-социализму*. No further details.

———— (2014). *Bollywood's India: The Imagined Worlds of Contemporary Hindi Cinema*, London: Reaktion Books.

———— and Divia Patel (2002). *Cinema India: The Visual Culture of the Hindi Film*, London: Reaktion/New Brunswick: Rutgers University Press/Delhi: Oxford University Press.

Dyer, Richard (1979). *Stars*, London: British Film Institute.

———— (1986). *Heavenly Bodies: Film Stars and Society*, London: British Film Institute.

———— (1987). *Heavenly Bodies: Film Stars and Society*, London: British Film Institute.

———— (1997). *White*, London and New York: Routledge.

———— with a supplementary chapter and bibliography by Paul McDonald (1998). *Stars*, 2nd edn, London: British Film Institute.

———— (2003). *Heavenly Bodies: Film Stars and Society*, London: Routledge.

———— (2004). *Heavenly Bodies: Film Stars and Society*, 2nd edn, London, New York: Routledge.

The Economist (2006). 'Obituary: Shin Sang-Ok' (27 April), www.economist.com/node/6849979 (accessed 3 May 2013)

Ekman, Paul and Richard J. Davidson (1994). *The Nature of Emotion: Fundamental Questions*. New York: Oxford University Press.

Eleftheriotis, Dimitris (2001). *Popular Cinemas of Europe, Studies of Texts, Contexts and Frameworks*, New York-London: Continnum.

Elliott, Paul (2011). *Hitchcock and the Cinema of Sensations: Embodied Film Theory and Cinematic Reception*, London: I.B.Tauris.

Ellis, John (1992). *Visible Fictions: Cinema, Television, Video*, 1st edn London: Routledge.

Elsaesser, Thomas (1985). 'Tales of Sound and Fury: Observations on the Family Melodrama', reprinted in Bill Nichols *Movies and Methods, Vol II*. Berkeley: University of California Press: 165–89.

El-Shawan, Salwa (1980). 'The Socio-Political Context of al-Musika al-'Arabiyyah in Cairo, Egypt: Policies, Patronage, Institutions and Musical Change', *Asian Music*, 12: 1, Symposium on Art Musics in Muslim Nations: 86–128.

Epstein, Jean (1993). 'Magnification', in Richard Abel (ed.), *French Film Theory and Criticism: A History/Anthology, Vol. 1, 1907–1939*, Princeton: Princeton University Press: 235–41.

Erdbrink, Thomas (2008). 'Iranian Actress Heads Into a Storm', *The Washington Post*, 12 October 2008, www.washingtonpost.com/wp-dyn/content/article/2008/10/11/AR2008101101662.html?hpid=moreheadlines (accessed 19 April 2013)

Evans, Peter W. (1999). 'Culture and Cinema: 1977–1996', in David T. Gies (ed.), *The Cambridge Companion to Modern Spanish Culture*, Cambridge: Cambridge University Press: 267–77.

Fahmy, Ziad (2011). *Ordinary Egyptians: Creating the Modern Nation through Popular Culture*, Stanford: Stanford University Press.

Fanon, Frantz (1967). *Black Skin, White Masks*, trans. C.L. Markmann, New York: Grove Press: 109–40.

Faraci, Devin (2011). 'PULGASARI: Kim Jong Il's Kaiju Film', *Badass Digest* (19 December), badassdigest.com/2011/12/19/pulgasari-kim-jong-ils-kaiju-film/ (accessed 3 May 2013)

Feagin, Susan, L. (1983). 'The Pleasures of Tragedy', *American Philosophical Quarterly* 20(1): 95–104.

Fisher, Philip (2002). *The Vehement Passions*, Princeton: Princeton University Press.

Flores, Patrick D. (2000a). *Makulay Na Daigdig: Nora Aunor and the Aesthetics of Sufferance*, unpublished PhD dissertation, University of the Philippines, Diliman, Quezon City.

———(2000b).'The Dissemination of Nora Aunor', in Rolando B. Tolentino (ed.), *Geopolitics of the Visible: Essays on Philippine Film Cultures*, Quezon City: Ateneo de Manila University Press: 77–95.

Foley, David (2003). 'Indigenous Epistemology and Indigenous Standpoint Theory', *Social Alternatives*, 22(1): 44–52.

Fomin, Valery (ed.) (1998). *Kinematograf ottepeli. Dokumenty i svidetel'stva* [The Cinema of the Thaw. Documents and Testimony]. (Introduction and annotations by Fomin, V.), Moscow: Materik.

Foucault, Michel (1980). *Power/Knowledge: Selected Interviews and Other Writings, 1972–1977*, ed. Colin Gordon, Brighton: Harvester Press.

Frades, Mener G. (1970). 'What Makes Movie Stars Click', *Sunday Times Magazine*, 16 August: 20.

Freire-Medeiros, Bianca (2002). 'Hollywood Musicals and the Invention of Rio de Janeiro, 1933–1953', *Cinema Journal*, 41(4): 52–66.

Gelley, Ora (2012). *Stardom and the Aesthetics of Neorealism: Ingrid Bergman in Rossellini's Italy*, NY and London: Routledge.

Genevieve Official, genevieveofficial.com (accessed 25 November 2013)

Gershanov, *Efim Mikhaïlovich* (1979a). *The Great Soviet Encyclopaedia*, 3rd edn (1970–1979), encyclopedia2.thefreedictionary.com/Lenin+Prizes (accessed 3 May 2013).

———— (1979b). www.rusactors.ru/s/smoktunovsky/index2.shtml (in Russian) (accessed 7 May 2013).

Gibbons, Sacha (1999). 'Writing Through Trauma: Ruby Langford's My Bundjalung People', *Journal of Australian Studies*, 23(63): 64–70.

Gies, David T. (ed.) (1999). *The Cambridge Companion to Modern Spanish Culture*, Cambridge: Cambridge University Press.

———— (2005). *The Cambridge History of Spanish Literature*, Cambridge: Cambridge University Press.

Ginibi, Ruby (1994). *My Bundjalung People*, St Lucia: University of Queensland Press.

Giron, Eric S. (1965). 'Tagalog Lurches On', *Mirror*, 7 August: 15.

Gledhill, Christine (ed.) (1987). *Home is Where the Heart Is: Studies in Melodrama and the Woman's Film*. London: BFI Books.

———— (ed.) (1991). *Stardom: Industry of Desire*. Routledge: London.

Goldberg, Ilan L., Michael Haral and Rafael Malach (2006). 'When the Brain Loses Itself: Prefrontal Inactivation during Sensorimotor Processing', *Neuron*, 50 (April): 329–39.

Gomez-Rivera, Guillermo (1965). 'Spanish and Filipino Culture', *Mirror*, 14 August: 18–19.

Gopalan, Lalitha (2002). *Cinema of Interruptions: Action Genres in Contemporary Indian Cinema*, London: British Film Institute.

Gorenfeld, John (2003). 'The Producer from Hell', *Guardian*, 4 April, www.guardian.co.uk/film/2003/apr/04/artsfeatures1 (accessed 3 May 2014)

Gould, Stephen Jay (1981). *The Mismeasure of Man*, New York: W.W. Norton.

Gourevitch, Philip (2003). 'The Madness of Kim Jong Il', *Observer*, 2 November, www.guardian.co.uk/theobserver/2003/nov/02/features.magazine37 (accessed 3 May 2013)

Government of Spain, *Boletín Oficial de Estado*, 8 March 1963, *Normas de censura cinematográfica*, www.boe.es/boe/dias/1963/03/08/pdfs/A03929-03930.pdf (accessed 24 June 2013)

Graham-Brown, Sarah (1988). *Images of Women: The Portrayal of Women in Photography of the Middle East, 1860–1950*, London: Quartet Books.

Grodal, Torben (1997). *Moving pictures: A New Theory of Film Genres, Feelings and Cognition*, New York: Oxford University Press.

Guerrero, Amadis Ma. (1971). 'A Study in Speculation: Nora and the Golden Budhha', *Weekly Graphic*, 37(52) (2 June): 10–11.

Hadjikyriacou, Achilleas (2012). 'Cacoyannis' Stella: Representation and Reception of Patriarchal Anomaly', in Lydia Papadimitriou and Yannis Tzioumakis (eds), *Greek Cinema: Texts, Histories, Identities*, Bristol and Chicago: Intellect: 185–202.

Haghigi, Ali Reza (2002). 'Politics and Cinema in Post-revolutionary Iran: An Uneasy Relationship', in Richard Tapper (ed.), *The New Iranian Cinema: Politics, Representation and Identity*, London: I.B.Tauris.

Haneke, Michael (2000). '71 Fragments: Notes to the, in Willy Reimer (ed.), *After Postmodernism: Austrian Literature and Film in Transition*, Riverside: Ariadne Press.

——— (2012). *Haneke by Haneke*, entretiens avec Michel Cieutat et Philippe Rouyer, Paris: Stock.

——— (2013) OSCARS Q&A: Michael Haneke, www.deadline.com/2013/02/oscars-qa-michael-haneke/ (accessed 17 January 2014).

Hasan, Ilhami (1986). *Muhammad Tal'at Harb: Ra'id Sina'at al-Sinima al-Misriyya*, Cairo: al-Hay'a al-Misriyya al-'Amma lil-Kitab.

Haynes, Jonathan (2007). 'Video Boom: Nigeria and Ghana', *Postcolonial Text*, 3(2): 1–10.

——— and Onookome Okome (1998). 'Evolving Popular Media: Nigerian Video Films', *Research in African Literatures* 29(3): 106–28.

High, Peter B. (2003). *The Imperial Screen: Japanese Film Culture in the Fifteen Years' War, 1931–1945*, Madison: University of Wisconsin Press.

Hill, Lewis K. (*c.*1948–49). 'Daughter of the Regiment', *Los Angeles Times*, Constance McCormick Collection at the Cinematic Arts Library, Los Angeles: University of Southern California.

Hines, Jessica (2007). *Looking for the Big B: Bollywood, Bachchan and Me*, London: Bloomsbury.

Hirano, Kyoko (1992). *Mr Smith Goes to Tokyo: Japanese Cinema Under the American Occupation, 1945–1952*, Washington and London: Smithsonian Institution Press.

Historical Chronicles with Nikolai Svanidze. 1963. Smoktunovsky/Istoricheskiye khroniki s Nikolayem Svanidze (1963). Smoktunovsky (2008). Directed by Roman Maslo, narrated by Nikolai Svanidze, Kanal Rossia, VGTKR.

Hjort, Mette and Sue Laver (eds) (1997). *Emotion and the Arts*, Oxford: Clarendon Press.

Hollinger, Karen (2006). *Actress: Hollywood Acting and the Female Star*, New York: Routledge.

Honey, John (1989). *Does Accent Matter? The Pygmalion Factor*, London and Boston: Faber & Faber.

Hooper, John (2006). *The New Spaniards* (London: Penguin).

Hudson, Norman (1996). 'From "Nation to Race": The Origin of Racial Classification in Eighteenth-Century Thought', *Eighteenth-Century Studies*, 29(3): 247–64.

Hunt, Leon (2003). *Kung Fu Cult Masters: From Bruce Lee to Crouching Tiger*, London: Wallflower Press.

Idols about Idols. Irina Miroshnichenko talks about Innokenty Smoktunovsky/Kumiry o kumirakh. Irina Miroshnichenko ob Innokentii Smoktunovskom (2008). Directed by Igor Nesterov, Melofilm.

Information Nigeria, www.informationng.com (accessed 25 November 2013)

Internet Movie Database (IMDb) (n.d.) 'Antonio Banderas', www.imdb.com/name/nm0000104/ (accessed 21 January 2013)

——— (n.d.) 'Viggo Mortensen', www.imdb.com/name/nm0001557/ (accessed 21 January 2013)

Iredia, www.iredia.8m.com (accessed 25 November 2013)

Isaac, Benjamin (2004). *The Invention of Racism in Classical Antiquity*, Princeton, NJ: Princeton University Press.

Iseke-Barnes, Judy (2003). 'Living and Writing Indigenous Spiritual Resistance', *Journal of Intercultural Studies*, 24(3): 219–46.

Islands / Ostrova. Innokenty Smoktunovsky (2010). Vitaly Troyanovsky, TV Channel Kul'tura.

Issari, Mohammad Ali (1989). *Cinema in Iran, 1900–1979*, Metuchen, NJ and London: Scarecrow Press.

Jacobson, Matthew Frye (1998). *Whiteness of a Different Colour: European Immigrants and the Alchemy of Race*, Cambridge, MA and London: Harvard University Press.

Janke, Terri (2009). *Writing up Indigenous Research: Authorship, Copyright and Indigenous Knowledge Systems*, Sydney: Terri Janke.

Jedlowski, Alessandro (2013). 'From Nollywood to Nollyworld: Processes of Transnationalization in the Nigerian Video Film Industry', in Matthias Krings and Onookome Okome (eds), *Global Nollywood: The Transnational Dimensions of an African Video Film Industry*, Bloomington: Indiana University Press: 25–45.

Jezewski, M.A. and P. Sotnik (2001). *The Rehabilitation Service Provider as Culture Broker: Providing Culturally Competent Services to Foreign Born Persons*, Buffalo, NY: Center for International Rehabilitation Research Information and Exchange.

Jim Iyke Foundation, www.jimiykefoundation.com (accessed 25 November 2013).

Johnson, Vivien, Ron Radford, Clifford Possum Tjapaltjarri and Tracey Lock-Weir (2003). *Clifford Possum Tjapaltjarri*, Adelaide: Art Gallery of South Australia.

Kabir, Nasreen Munni (1999). *Talking Films Conversations on Hindi Cinema with Javed Akhtar. Nasreen Munni Kabir*, Delhi: Oxford University Press.

Kalaw, Lorna M. (1971). 'Getting to Know Nora – and Liking Her', *Asia-Philippines Leader*, 1(3) 23 April: 27–29, 34.

Kamins, Bernie (c.1947). '*The Miracle of the Bells*: Suggestions for Editorials' [booklet], Laşky Productions, RKO Radio Pictures, November. Performing Arts Special Collections. Los Angeles: UCLA.

Karalis, Vrasidas (2012). *A History of Greek Cinema*, London: Continuum/Bloomsbury.

Karim, Muhammad (2006). *Mudhakkarat Muhammad Karim: Fi Tarikh al-Sinima al-Misriyya*, Cairo: Academy of Arts.

Keal, Paul (1995). 'Just Backward Children: International Law and the Conquest of Non-European Peoples', *Australian Journal of International Affairs*, 49(2): 191–206.

Keen, Suzanne (2007). *Empathy and the Novel*, New York: Oxford University Press.

Kemp, Rick (2012). *Embodied Acting, What Neuroscience Tells us about Performance*, London and New York: Routledge.

Kim, Jong-il (1973). *On the Art of Cinema*, Pyongyang: Foreign Languages Publishing House.

——— (1987). *The Cinema and Directing*, Pyongyang: Foreign Languages Publishing House.

Kim, Suk-young (2008). "Guests" of the Dear Leader: Shin Sang-ok, Choi Eun-hee, and North Korea's Cultural Crisis', *Towards Sustainable Economic amd Security Relations in East Asia: US and ROK Policy Options*, KEI Joint US Korea Academic Studies: 196–208.

——— (2010). *Illusive Utopia. Theater, Film, and Everyday Performance in North Korea*, Ann Arbor: University of Michigan Press.

Kinder, Marsha (ed.) (1997). *Refiguring Spain: Cinema/Media/Representation*, Durham, NC and London: Duke University Press.

King, Barry (2010). 'Stardom, Celebrity, and the Money Form', *The Velvet Light Trap*, 65 (Spring): 7–19.

Knef, Hildegard (1983). *Romy Schneider – Betrachtung eines Lebens*, Hamburg: Knaus.

Kngwarreye, Emily and Margo Neale (2008). *Utopia: The Genius of Emily Kame Kngwarreye*, Canberra: National Museum of Australia Press.

Konisberg, Ira (2007). 'Film Studies and the New Science', *Projections*, 1(1): 1–24.

Koppes, Clayton R. and Gregory D. Black (1993). 'Wartime Films as Instruments of Propaganda', in Steven Mintz and Randy Roberts, *Hollywood's America: United States History through its Films*, St James, NY: Brandywine Press: 157–68.

Krenn, Günter (2010). *Romy Schneider. Die Biographie*, Berlin: Aufbau.

Krings, Matthias and Onookome Okome (eds) (2013). *Global Nollywood: The Transnational Dimensions of an African Video Film Industry*, Bloomington: Indiana University Press.

Kuhn, Annette (2002). *An Everyday Magic: Cinema and Cultural Memory*, London: I.B.Tauris.

Kyodo (2012). 'Abduction Issue was "Settled"': Pyongyang', *Japan Times*, 18 September.

Lacaba, Jose F. (1970). 'Pilipino Forever, or, the Decline and Foreseeable Fall of English in the Philippines', *Philippines Free Press*, 63(35) (29 August): 6–7.

——— (1983a). 'Movies, Critics, and the Bakya Crowd', in Rafael Guerrero (ed.), *Readings in Philippine Cinema*, Manila: Experimental Cinema of the Philippines: 175–81.

——— (1983b). 'Notes on Bakya', in Rafael Guerrero (ed.), *Readings in Philippine Cinema*, Manila: Experimental Cinema of the Philippines: 117–23.

Lacan, Jacques (2006). *Écrits*, trans. Bruce Fink, New York and London: W.W. Norton & Company.

Lagrange, Frédéric (2009). 'Women in the Singing Business, Women in Songs', *History Compass*, 7(1): 226–50.

Lahiji, Shahla (2002). 'Chaste Dolls and Unchaste Dolls: Women in Iranian Cinema since 1979', in Richard Tapper (ed.), *The New Iranian Cinema: Politics, Representation and Identity*, London: I.B.Tauris.

Langer, Freddy (2008). *Frauen, die wir liebten. Filmdiven und ihre heimlichen Verehrer*, München: Elisabeth Sandmann.

Langford, Michelle (2010). 'Practical Melodrama: From Recognition to Action in Tahmineh Milani's Fereshteh Trilogy', *Screen*, 51(4): 341–64.

Langton, Marcia (2003). 'Aboriginal Art and Film: The Politics of Representation', in M. Grossman (ed.), *Blacklines: Contemporary Critical Writing by Indigenous Australians*, Melbourne: Melbourne University Press: 109–24.

Laura, Ernesto G. and Maurizio Porro (1996). *Alida Valli*, Rome: Gremese Editore.

Lepastier, Joachim (2012). 'Haneke père sévère', *Cahiers du Cinéma*, 683 (November): 10–12.

Lest We Forget/Innokenty Smoktunovsky. Chtoby pomnili (2002). Written and narrated by Leonid Filatov, directed by Olga Medynskaya, REN-TV.

Levinson, Jerrold (1982). 'Music and Negative Emotions', *Pacific Philosophical Quarterly* (63): 327–46.

Lieber, Perry (n.d.). 'Valli' [manuscript], RKO studio biography, Los Angeles: Margaret Herrick Library.

Ligiéro, Zeca (2006). *Carmen Miranda: uma performance afro-brasileira*, Rio de Janeiro: Publit.

Lim, Song Hwee (2012). 'Speaking in Tongues: Ang Lee, Accented Cinema, Hollywood' in Lúcia Nagib, Chris Perriam and Rajinder Dudrah (eds) (2012), *Theorizing World Cinema*, New York: I.B.Tauris: 129–44.

Lipsitz, George (2006). *The Possessive Investment in Whiteness: How White People Profit from Identity Politics*, Philadelphia: Temple University Press.

Literature and Theatre. Articles of Different Years/Literatura i teatr, Stati'yi raznykh let, Moscow: Iskusstvo, 558–77, tlf.narod.ru/school/berkovsk_lit_theat_1969.htm#s558 (accessed 5 March 2012)

Llamzon, Teodoro A. (1968). 'On Tagalog as Dominant Language', *Philippine Studies* (October): 729–79.

Lo, Kwai-Cheung (1996). 'Muscles and Subjectivity: A Short History of the Masculine Body in Hong Kong Popular Culture', *Camera Obscura*, 39: 105–25.

Lohman, Lauren (2010) *Umm Kulthum: Artistic Agency and the Shaping of an Arab Legend, 1967–2007*, Middletown, CT: Wesleyan University Press.

Lutz, Catherine (1988). *Unnatural Emotions: Everyday Sentiments on a Micronesian Atoll*, Chicago: University of Chicago Press.

Lydon, Jane (2005). *Eye Contact: Photographing Indigenous Australians*, Durham, NC: Duke University Press.

Lynch, Owen (ed.) (1990). *Divine Passions: The Social Construction of Emotion in India*. Delhi: Oxford University Press.

MacNamara, Paul (*c*.1947a). 'Open Letter to Artists Waiting for Boats' [letter], Los Angeles: Margaret Herrick Library.

———— (*c*.1947b). 'Valli' [manuscript], RKO studio biography, Los Angeles: Margaret Herrick Library.

Maddox, Ben (1948). 'Valli the Unvanquished', *Screenland*, 37 (April): 58–9, Constance McCormick Collection at the Cinematic Arts Library. Los Angeles: University of Southern California.

Manners, Dorothy (*c*.1948–49). 'Snappy Shots: Valli', *Los Angeles Examiner* Constance McCormick Collection at the Cinematic Arts Library. Los Angeles: University of Southern California.

Marawili, David, AM. (2011). *Arts Backbone*, Association of Northern, Kimberley and Arnhem Aboriginal Artists, 11: 1.

Marei, Farida (ed.), (1998). *Malafat al-Sinima; Turath al-Nuqqad al- Sinimaiyyun fi Misr: Kitabat al-Sayyid Hasan Jum'a, Vol. 3 (Cinema Files 10: The Legacy of Film Critics in Egypt. The Writings of El-Sayyed Hassan Gomaa, Vol. 3, 1935–1936)*, Cairo: al-Markaz al-Qawmi lil-Sinima.

Marks, Laura U. (2000). *The Skin of the Film. Intercultural Cinema, Embodiment and the Senses*, Durham, NC and London: Duke University Press.

Markson, Elizabeth W. (2003). 'The Female Ageing Body through Film', in Christopher A. Faircloth (ed.), *Ageing Bodies: Images and Everyday Experiences*, Walnut Creek, CA: Alta Mira Press: 77–102.

Martín, Jesús (2006). 'The Filming of Alatriste', *Viggo Works*, www.viggo-works.com/index.php?page=744 (accessed 24 June 2013)

Martin, Karen and Booran Mirraboopa (2003). 'Ways of Knowing, Being and Doing: A Theoretical Framework and Methods for Indigenous and Indigenist Research', *Journal of Australian Studies*, 27(76): 203–14.

Maslo, Roman (2008). *Istoricheskiye khroniki s Nikolayem Svanidze (1963). Smoktunovsky* (Historical chronicles with Nikolai Svanidze. 1963. Smoktunovsky) narrated by Nikolai Svanidze. Kanal Rossia, VGTKR.

Matilac, Rosalie, Justino Dormiendo and Nicanor G. Tiongson (1994). 'Audiences', in *CCP Encyclopedia of Philippine Art*, Manila: Cultural Center of the Philippines: 99–100.

Matussek, Matthias and Lars-Olav Beier (2007). 'Die Königin der Schmerzen', *Der Spiegel*, 21: 153–167, www.spiegel.de/spiegel/print/d-51644744.html (accessed 18 December 2013)

Mayer, Geoffrey and Keith Beattie (2007). *The Cinema of Australia and New Zealand*, London: Wallflower Press.

Maynard, John (2007). 'Circles in the Sand: An Indigenous Framework of Historical Practice', *Australian Journal of Indigenous Education*, 36: 117–20.

Maynard, Ricky (2008). 'Returning to Places that Name Us', *Portrait of a Distant Land*, Hobart: Bett Gallery Hobart.

Mayne, Judith (1993). *Cinema and Spectatorship*, London: Routledge.

Mazumdar, Ranjani (2000). 'From Subjectification to Schizophrenia: The "Angry Man" and the "Psychotic" Hero of Bombay Cinema', in Ravi Vasudevan (ed.), *Making Meaning in Indian Cinema*, Delhi: Oxford University Press: 238–66.

McCall, John (2007). 'The Pan-Africanism we Have: Nollywood's Invention of Africa', *Film International*, 28, 5(4): 92–7.

McCann, Ben (2011), 'Acting, Performance and the Bressonian Impulse in Haneke's Films', in Ben McCann and David Sorfa (eds), *The Cinema of Michael Haneke*, London and New York: Wallflower Press: 24–37.

―――― and Sorfa, David (eds) (2011). *The Cinema of Michael Haneke*, London and New York: Wallflower Press.

McDermott, Kerry (2012). 'The Glamorous Iranian Actresses Facing a Travel Ban...for Flouting Islamic Dress Codes at Western Awards Ceremonies', *Mail Online*,

18 July, www.dailymail.co.uk/news/article-2175428/Travel-ban-imposed-Iranian-actresses-flout-Islamic-dress-codes-western-awards-ceremonies.html (accessed 15 April 2013)

McDonald, Paul (2000). *The Star System, Hollywood's Production of Popular Identities*, London: Wallflower.

—— (2013). *Hollywood Stardom*, Malden, MA: Wiley-Blackwell.

McGrath, Pamela and David Brooks (2010). 'Their Darkest Hour: The Films and Photographs of William Grayden and the History of the "Warburton Range Controversy" of 1957' *Aboriginal History*, 34: 115–40.

McGuirk, Rod (2002). 'The Double Life of David Gulpilil' *The Age* 14 April, www.theage.com.au/articles/2002/04/12/1018333416820.html (accessed 8 May 2013)

Meeuf, Russel and Raphael Raphael (2013). *Transnational Stardom, International Celebrity in Film and Popular Culture*, New York: Palgrave MacMillan. E-book.

Mercado, Monina A. (1970). 'This Nora Thing', *Weekly Graphic*, 37(6) 15 July: 56.

Metcalf, Cynthia Gray-Ware (2008). 'From Morality Play to Celebrity: Women, Gender, and Performing Modernity in Egypt: *c.*1850–1939', unpublished PhD dissertation: University of Virginia.

Meyrowitz, Joshua (1986). *No Sense of Place: The Impact of Electronic Media on Social Behaviour*, New York: Oxford University Press.

The MKhAT People. Not of This World. Smoktunovsky/MKhATchiki. Ne ot mira sego. Smoktunovsky (2012). Anatoly Smelyanskiy. GTRK Kultura.

Miller, Chris (dir.) (2011), *Puss in Boots*, Dream Works, 2011.

Miller, Llewellyn (*c.*1948–49). 'New Queen?', *Modern Screen*, 33(81), Constance McCormick Collection at the Cinematic Arts Library. Los Angeles: University of Southern California.

Mishra, Vijay (2002). *Bollywood Cinema: Temples of Desires*, London: Routledge.

Mohamed, Khalid (2002). *To Be or Not To Be: Amitabh Bachchan*, Mumbai: Saraswati Creations.

Montserrat, Joëlle (1983). *Simone Signoret*, Paris: PAC.

Moreton-Robinson, Aileen (2000). *Talkin' Up to the White Woman: Indigenous Women and Feminism*, St Lucia: University of Queensland Press.

—— (2004). (ed.) *Whitening Race: Essays in Social and Cultural Criticism*, Canberra: Aboriginal Studies Press.

Morin, Edgar (2005). *The Stars*, Minneapolis: University of Minnesota Press. [Originally published as (1972), *Les Stars*, Paris: Éditions du Seuil.]

Mottahedeh, Negar (2008). *Displaced Allegories: Postrevolutionary Iranian Cinema*, Durham, NC and London: Duke University Press.

Mulvey, Laura (1977/8). 'Notes on Sirk and Melodrama', *Movie*, (Winter): 53–6.

—— (2004). 'Passing Time: Reflections on Cinema from a New Technological Age', *Screen*, 45(2): 142–55.

—— (2012). *Citizen Kane*, 2nd edn, London: BFI Palgrave Macmillan.

Munro, Keith (2008). *Portrait of a Distant Land*, Sydney: Museum of Contemporary Art, Sydney.

Muscionico, Daniele (2008). 'Die Jägerin als Beute', *Die Weltwoche* 29.

Muthu, Sankar (2012). *Empire and Modern Political Thought*, Cambridge: Cambridge University Press.

Naficy, Hamid (2000). 'Veiled Voice and Vision in Iranian Cinema: The Evolution of Rakhshan Banietemad's Films', *Social Research*, 67(2): 564–6.

—— (2001). *An Accented Cinema: Exilic and Diasporic Filmmaking*, Princeton, NJ and Oxford: Princeton University Press.

—— (2011a). *A Social History of Iranian Cinema Volume 1: The Artisanal Era 1897–1941*, Durham, NC and London: Duke University Press.

—— (2011b). *A Social History of Iranian Cinema, Volume 2: The Industrializing Years, 1941–1878*, Durham, NC and London: Duke University Press.

—— (2012a). *A Social History of Iranian Cinema, Volume 3: The Islamicate Period, 1978–1984*, Durham, NC and London: Duke University Press.

—— (2012b). *A Social History of Iranian Cinema, Volume 4: The Globalizing Era 1984–2010*, Durham, NC and London: Duke University Press.

Nagib, Lúcia (2011). *World Cinema and the Ethics of Realism*, New York and London: Continuum.

Nagib, Lúcia and Chris Perriam (2012). *Theorizing World Cinema*, London and New York: I.B.Tauris.

Naija Mayor, www.naijamayor.com (accessed 25 November 2013)

Nairaland, www.nairaland.com (accessed 25 November 2013)

Nance, Haxton (2004). *Gulpilil Tells his Story at the Adelaide Festival; The Gulpilil Show*, Australian Broadcasting Corporation (ABC): 10 March.

Nandy, Ashis (2000). 'Invitation to an Antique Death: The Journey of Pramathesh Barua as the Origin of the Terribly Effeminate, Maudlin, Self-destructive Heroes of Indian Cinema', in Rachel Dwyer and Christopher Pinney (eds), *Pleasure and the Nation: The History, Politics and Consumption of Public Culture in India*, Delhi: Oxford University Press: 139–60.

Narayan, Badri (2001). *Documenting Dissent: Contesting Fables, Contested Memories and Dalit Political Discourse*, Shimla: Institute of Advanced Study.

Neale, Steve (1986). 'Melodrama and Tears', *Screen*, 27(6): 6–22.

Negra, Diane (2001). *Off-White Hollywood: American Culture and Ethnic Female Stardom*, London and New York: Routledge.

Neil, Alex (1996). 'Empathy and (Film) Fiction', in David Bordwell and Noël Carroll (eds), *Post-Theory: Reconstructing Film Studies*, Wisconsin: University of Wisconsin Press: 175–94.

Ngai, Sianne (2005). *Ugly Feelings*, Cambridge, MA: Harvard University Press.

Nigeria Films, nigeriafilms.com (accessed 25 November 2013)

Nikitina, Aleksandra (2010). *Russkiy Gamlet*: Chelovek, kotoryy daval slishkom mnogo voli svoyemu umu' [A Russian *Hamlet*: A Man who Gave his Mind too Much Freedom], *Literatura*, 8 (695), 16–30, lit.1september.ru/view_article.php?ID=201000816 (accessed 5 March 2013)

Oatley, Keith and Jennifer M. Jenkins (1996). *Understanding Emotions*, Oxford: Blackwell.

O'Brien, Karen (2008). 'Academic Language, Power and the Impact of Western Knowledge Production on Indigenous Student Learning', *Australian Journal of Indigenous Education*, 37: 56–60.

――――(2011). 'With My Eyes, My Heart and with My Brain I Am Thinking': Testimony, Treaty and Decolonising Indigenous History from Images', *Australia and New Zealand Law and History Society*, e-journal www.anzlhsejournal.auckland.ac.nz/papers/papers-2011.html

O'Brien, Kerry (2003). *The 7.30 Report*, ABC TV, Canberra, 10 March, www.abc.net.au/7.30/content/2004/s1063295.htm (accessed 8 May 2013)

Okome, Onookome (2007). 'Nollywood: Spectatorship, Audience and the Sites of Consumption', *Postcolonial Text*, 3(2): 1–21.

Parale, Apolinar B. (1969). 'The Pilipino Revolution', *Philippines Free Press*, 62 (11 January): 2: 14–16.

Pareja, Lena S. (1994a). 'Nora Aunor', in *CCP Encyclopedia of Philippine Art*, Manila: Cultural Center of the Philippines: 205.

―――― 'Sharon Cuneta', in *CCP Encyclopedia of Philippine Art*, Manila: Cultural Center of the Philippines: 225.

Pellizzari, Lorenzo and Claudio M. Valentinetti (1995). *Il Romanzo di Alida Valli: Storie, Film ed Altre Apparizioni della Signora del Cinema Italiano*, Milan: Garzanti.

Pennington, Michael (1996). *Hamlet: A User's Guide*, London: Nick Hearn Books.

Perkins, Hetti and Hannah Fink (eds) (2007). *One Sun one Moon: Aboriginal Art in Australia* Sydney: Art Gallery of New South Wales, Sydney.

Perriam, Chris (2003). *Stars and Masculinities in Spanish Cinema*, Oxford: Oxford University Press.

Peterson, Nicolas (2009). 'The Cultural Context of Art from the Desert', in Claudette Chubb and Nancy Sever (eds), *Indigenous Art at the Australian National University*, South Yarra, Vic: Macmillan: 127–53.

Pham, Minh-Ha T. (2004) 'The Asian Invasion (of Multiculturalism) in Hollywood', *Journal of Popular Film and Television* 32(3): 121–31.

Phillips, and Vincendeau (2006). 'Film Trade, Global Culture and Transnational Cinema: An Introduction', in Alastair Phillips and Ginette Vincendeau (eds), *Journeys of Desire: European Actors in Hollywood*, London: British Film Institute: 3–18.

Photoplay (1948). 'Valli of Enchantment', 33:4:59, 99, Constance McCormick Collection at the Cinematic Arts Library, Los Angeles: University of Southern California.

Pinto, Jerry (2005). *Helen: The Life and Times of an H-bomb*, New Delhi: Penguin.

Portes, Alejandro (1998). 'Social Capital: Its Origins and Applications in Modern Sociology', *Annual Review of Sociology*, 24: 1–24.

Prasad, M. Madhava (1998). *Ideology of the Hindi Film: A Historical Construction*, Delhi: Oxford University Press.

Pyatigorskaya, Galina (1990). 'Lestnitsa v nebo, ili Zvezdy pri socializme' [Stairway to Heaven or How to Become a Star under Socialism], *Teatr* 12: 162–71.

Rafael, Vicente L. (1995). 'Taglish, or the Phantom Power of the Lingua Franca', *Public Culture*, 8: 101–26.

_____ (2000). *White Love and Other Events in Filipino History*, Quezon City: Ateneo de Manila University Press.

Rapadas, Erlinda (1985). 'Mapanatili Kaya Ni Sharon Ang Pagiging Box Office Queen?', *Liwayway*, 22 April: 8, 28.

Recollections in the Garden/Vospominaniya v sadu (1993). Directed by Vera Tokareva, Master film, Russian State Committee for Cinematography, TV Channel Rossia.

Reichart, Manuela (2009). 'Ein Kameragesicht', *Film-Konzepte*, 13(1): 10–25.

Reid, Craig D. (1994), 'An Evening with Jackie Chan', *Bright Lights*, 13: 18–25.

Renov, Michael (1988). *Hollywood's Wartime Women: Representation and Ideology*, Ann Arbor, MD and London: UMI Research Press.

Richie, Donald (1987). *Different People: Pictures of Some Japanese*, Tokyo and New York: Kodansha International.

Rigney, Irabinna Lester (1999). 'Internationalisation of an Indigenous Anti-Colonial Cultural Critique of Research Methodologies: A Guide to Indigenist Research Methodology and its Principles', *Wicazo Sa Review*, 14(2): 109–21.

Riley, Michael (2006). *Sights Unseen*, National Gallery of Australia, nga.gov.au/ Exhibition/Riley/ (accessed 8 May 2013)

Riphagen, Marianne and Eric Venbrux (2008). 'Ten Canoes', *Visual Anthropology*, 21(3): 266–9.

Roberts, Shari (1993). 'The Lady in the Tutti-Frutti Hat: Carmen Miranda, a Spectacle of Ethnicity', *Cinema Journal*, 32(3): 3–23.

Robinson, Jennifer (2005). *Deeper than Reason: Emotion and its Role in Literature, Music and Art*, New York: Oxford University Press.

Roustom, Kareem Joseph (2006). *A Study Of Six Improvisations on the 'Ud by Rıyad al-Sunbati*, MA dissertation, Tufts University.

Royer, Michelle (2012). 'Encounters with the "Third Age": Benguigui's *Inch'Allah Dimanche* and Beauvoir's *Old Age*', in Jean-Pierre Boulé and Ursula Tidd (eds), *Existentialism and Contemporary Cinema: A Beauvoirian Perspective*, Oxford: Berghahn: 123–34.

Russell, Catherine (2008). *The Cinema of Naruse Mikio: Women and Japanese Modernity*, Durham, NC and London: Duke University Press.

Russell, Peter (2005). *Recognizing Aboriginal Title: The Mabo Case and Indigenous Resistance to English-settler Colonialism*, Toronto: University of Toronto Press.

Ryan, Judith (2011). *Living Water: Contemporary Art of the Far Western Desert*, National Gallery of Victoria.

Ryazanov, Eldar (1986). *Nepodvedyonnyye itogi* [Sum in Total], Moskva: Iskusstvo.

Sadr, Hamid Reza (2006). *Iranian Cinema: A Political History*, London: I.B.Tauris.

Said, Edward (1978). *Orientalism: Western Conceptions of the Orient* London: Penguin.

Saitō, Tadao (1986). 'Hara Setsuko ron', in Satō Tadao (ed.), *Eien no Madonna: Hara Setsuko no subete*, Tokyo: Shuppan Kyodo Publishers: 125–39.

Salzberg, Ana (2012). '"The Spirit Never Really Ages": Materiality and Transcendence in Three Rita Hayworth Films', in Aagje Swinnen and John A. Stotesbury (eds), *Ageing,*

Performance and Stardom, Doing Age on the Stage of Consumerist Culture, Zurich, Berlin: Lit Verlag: 77–93.

Sanderson, John D. (2010), 'The Other You. Translating the Hispanic for the Spanish Screen', in Verena Berger and Miya Komori (eds) (2010), *Polyglot Cinema: Migration and Transcultural Narration in France, Italy, Portugal and Spain*, Vienna and Berlin: Lit Verlag: 49–74.

Sato, Barbara (2003). *The New Japanese Woman: Modernity, Media, and Women in Interwar Japan*, Durham, NC and London: Duke University Press.

Satō, Tadao (1986). 'Joyū Hara Setsuko no kiseki', in Satō Tadao (ed.), *Eien no Madonna: Hara Setsuko no subete*, Tokyo: Shuppan Kyodo Publishers: 140–5.

———— (2006). *Nihon eigashi Vol. 2*, Tokyo: Iwanami shoten.

Scheuer, Philip K. (1947). 'Actress on Trial Herself as She Plays Court Scene', *Los Angeles Times*, 9 February, Constance McCormick Collection at the Cinematic Arts Library. Los Angeles: University of Southern California.

Schönherr, Johannes (2012). *North Korean Cinema: A History*, Jefferson, NC: McFarland & Co. Inc.

Schwartz, Larry (2005). '35 Years On, *Walkabout* Still a Feather in His Cap', *The Age*, 20 August.

Schwarzer, Alice (1998). *Romy Schneider. Mythos und Leben*, Cologne: Kiepenheuer und Witsch.

Scobie, Claire (2004). 'Gulpilil's Travels', *Sun Herald Magazine*, 24 April.

———— (2006). 'Tribal Voice', *Sun Herald Magazine*, 4 June.

Selznick Publicity Department (*c*.1947). 'The Paradine Case' [manuscript], production notes, Los Angeles: Margaret Herrick Library.

Senfft, Heinrich (1992). 'Die Hatz war unerträglich', *Zeit/Magazin*, 29 May.

Sexton, Jared (2003). 'The Consequences of Race Mixture: Racialised Barriers and the Politics of Desire', *Social Identities*, 9(2): 241–75.

Seydel, Renate (ed.) (2010). *Ich, Romy. Tagebuch eines Lebens* (special edition), Munich: Herbig.

Shafik, Viola (2007). *Popular Egyptian Cinema: Gender, Class, and Nation*, Cairo: American University in Cairo Press.

Sharma, Ashwani (1993). 'Blood Sweat and Tears: Amitabh Bachchan, Urban Demi-god', in P. Kirkham and J. Thumim (eds), *You Tarzan: Masculinity, Movies and Men*, London: Lawrence and Wishart: 167–80.

Shaw, Tony, Denise Youngblood, (2010). *Cinematic Cold War. The American and Soviet Struggle for Hearts and Minds*, Lawrence, KA: University Press of Kansas.

Shin Sang-ok (2007). *Naneun Yeonghwa Yeotta* [I was a Film], Seoul: Random House Korea.

———— and Choi Eun-hee (2001). *Uriui Talchureun Kkeunnaji Anatta* [Our Escape Has Not Ended Yet], Seoul: Wolgan Joseonsa.

Shingler, Martin (2012). *Star Studies: A Critical Guide*, London: Palgrave Macmillan.

Shohat, Ella and Robert Stam (1994). *Unthinking Eurocentrism*, London and New York: Routledge. e-book.

Sibayan, Bonifacio (1966). 'Some Problems of Bilingual Education in the Philippines', *Philippine Journal of Education*, 45(1) (July): 18–20, 70–1.

Silverman, Kaja (1992). *Male Subjectivity in the Margins*, New York and London: Routledge.

Simap Project (2012), www.simap-project.org/download-alatriste-movie-2006-dvd-mp4-divx-dvdrip.html (accessed 24 June 2013)

Singhal, Rahul (ed.). (2004). *Mega Star of Bollywood: Amitabh Bachchan*, Delhi: Pentagon Paperbacks.

Smith, Claire and Martin Wobst (eds) (2005). *Indigenous Archaeologies: Decolonising Theory and Practice, Vol. 47*, London: Routledge.

Smith, Linda Tuhiwai (1999). *Decolonizing Methodologies: Research and Indigenous Peoples*, London: Zed Books.

Smith, Murray (1995). *Engaging Characters: Fiction, Emotion and the Cinema*, Oxford: Clarendon Press.

Smoktunovsky, Innokenty (1979). *Vremya dobrykh nadezhd* [The Time of Good Hopes], Moscow: Iskusstvo.

———(1998). *Byt'*! [To Be], Moscow: Algorythm, www.erlib.com/ Иннокентий_Смоктуновский/Быть (accessed 5 March 2013)

Sobchack, Vivian (1992). *The Address of the Eye: A Phenomenology of Film Experience*, Princeton, NJ: Princeton University Press.

———(2004). *Carnal Thoughts: Embodiment and Moving Image Culture*, Berkeley and Los Angeles: University of California Press.

Söderberg, Hans-Jürgen (1966). *Romy – Porträt eines Gesichts*, Munich: Rob Hower-Film, Film- und Fernsehproduktion.

Solomon, Robert C. (2004). *In Defense of Sentimentality*. New York: Oxford University Press.

Solov'yova, Inna and Vera Shitova (1966). *Innokenty Smoktunovsky. Aktyory sovetskogo kino* [Innokenty Smoktunovsky. Actors of the Soviet Cinema], Moscow: Iskusstvo, 222–37.

Somaaya, Bhawana (1999). *Amitabh Bachchan: The Legend*, Delhi: Macmillan.

Somerville, Margaret and Tony Perkins (2010). *Singing the Coast*, Canberra: Aboriginal Studies Press.

Spark, Ceridwen (2001). 'Gender and Radiance', *Hecate*, 27(2): 38.

Srinivas, S.V. (1996). 'Devotion and Defiance in Fan Activity', *Journal of Arts and Ideas*, 29: 66–83.

———(2003). 'Hong Kong Action Film in the Indian B Circuit', *Inter-Asia Cultural Studies*, 4(1): 40–62.

———(2005). 'Kung Fu Hustle: A Note on the Local', *Inter-Asia Cultural Studies*, 6(2): 289–95.

Stacey, Jackie (1993). *Star Gazing: Hollywood Cinema and Female Spectatorship*, London: Routledge.

Staiger, Janet (2000). *Perverse Spectators: The Practices of Film Reception*, New York: New York University Press.

Stites, Richard (1992). *Russian Popular Culture: Entertainment and Society Since 1900*, Cambridge: Cambridge University Press.

Stone, Rob (2002). *Spanish Cinema*, Harlow: Pearson Education.

Sundquist, Christian (2009). 'On Race Theory and Norms', *Albany Law Review*, 72(4): 953.

Svobodin, Aleksandr (1977/2010). *Innokenty Smoktunovsky, Fenomen* Smoktunovskogo [The Smoktunovsky Phenomenon], Moscow: Bureau of Propaganda of the Soviet Art, www.e-reading-lib.org/bookreader.php/1001707/Svobodin_-_Fenomen_Cmoktunovskogo.html (accessed 5 March 2013)

Swinnen, Aage and John A. Stotesburg (eds) (2012). *Ageing, Performance and Stardom, Doing Age on the Stage of Consumerist Culture*, Zurich, Berlin: LIT.

Tadiar, Neferti Xina M. (2004). *Fantasy-Production: Sexual Economies and Other Philippine Consequences for the New World Order*, Quezon City: Ateneo de Manila University Press.

Taubman, Howard (1948). 'Fact vs. Fiction in the Discovery of a Star', *New York Times*, 11 January, Los Angeles: Margaret Herrick Library.

Taylor, Richard (1993). 'Red Stars, Positive Heroes and Personality Cult', in Richard Taylor and Derek Spring (eds), *Stalinism and Soviet Cinema*, London and New York: Routledge: 69–89.

——— and Derek Spring (eds) (1993). *Stalinism and Soviet*, Cinema, London and New York: Routledge.

Tessé, Jean-Philippe (2012). '*Amour* de Michael Haneke Mal mal mal', *Cahiers du Cinéma*, 683 (November): 6–8.

Tetsuo, Nishida (1988). *Kyokoo-no Eizoo* [Fictional Image], Tokyo: Hihyoo-Sha.

Thomas, Rosie (1985). 'Indian Cinema: Pleasures and Popularity: An Introduction', *Screen*, 26(3–4): 61–131.

——— (1995). 'Melodrama and the Negotiation of Morality in Mainstream Hindi Film', in C. Breckenridge (ed.), *Consuming Modernity: Public Culture in a South Asian World*, Minneapolis and London: University of Minnesota Press: 157–82.

Thompson, Roger M. (2003). *Filipino English and Taglish*, Amsterdam and Philadelphia: John Benjamins Publishing Co.

Thornton, Warwick (2009). 'Shot from the Heart', *Deadly Vibe*, 147: 5.

Those with Whom I/Te, s kotorymi ya . . . (2011). Written and narrated by Sergey Solov'yov, directed by Valery Kharchenko, Channel Kultura.

Tignor, Robert L. (1977). 'Bank Misr and Foreign Capitalism', *International Journal of Middle East Studies*, 8(2): 161–81.

Tiongson, Nicanor G. (1979). 'Si Kristo, Ronnie Poe, at Iba Pang "Idolo": Apat Na Pagpapahalaga Sa Dula at Pelikulang Pilipino', *Sagisag*, September, 4(9): 11–18, 38–9.

——— (1992). 'The Filipino Film Industry', *East-West Film Journal*, 6(2): 23–61.

——— (2000). 'The Imitation and Indigenization of Hollywood', *Pelikula*, 2(1) (March–August): 22–30.

Torre, Nestor U. (1983). 'What Now, Sharon C.?', *Parade*, 5(9) (29 July): 4.

Tremlett, Giles (2006). *Ghosts of Spain*, London: Faber & Faber.

Triana-Toribio, Núria (2000). 'A Punk called Pedro: *La movida* in the Films of Pedro Almodóvar', in Barry Jordan and Rikki Mogan-Tamosunas (eds), *Contemporary Spanish Cultural Studies*, London: Edward Arnold: 264–82.

———— (2003). *Spanish National Cinema*, London: Routledge.

Trintignant, Jean-Louis (2012). 'Je fais semblant de vivre', bibliobs.nouvelobs.com/documents/20120504.OBS4707/jean-louis-trintignant-je-fais-semblant-de-vivre.html (accessed 17 January 2014)

Troyanovsky, Vitaly (ed.) (1996). *Kinematograf ottepeli* [The Cinema of the Thaw], Vol. 1, Introduction and annotations by V. Troyanovsky, Moscow: Materik.

Uchenna, James (2010). 'The Richest Sisters in Nollywood', September, www.nigeriafilms.com/news/9008/15/the-richest-sisters-in-nollywood.html (accessed 25 November 2013)

Vasudevan, Ravi (1989). 'The Melodramatic Mode and Commercial Hindi Cinema', *Screen*, 30(3): 29–50.

———— (1998). 'Sexuality and the Film Apparatus: Continuity, Non-continuity, Discontinuity in Bombay Cinema', in Mary E. John and Janaki Nair (eds), *A Question of Silence? The Sexual Economies of Modern India*, New Delhi: Kali for Women: 192–215.

Velarde, Emilie G. (1980). 'The Constant Star', *Celebrity*, 3 (15 October): 8–10.

Villanueva, Danny (1970). '69: The Year of the Bomba', *Weekly Nation*, 5(20) (5 January): 37–8.

Villasana, Gil (1986). 'Sharon Cuneta: Isang Sulyap Sa Taong Tinigib Ng Tamis, Tinigmak Ng Pait', *Liwayway*, 6 January: 7, 17.

———— (2000). *Stars and Stardom in French Cinema*, London: Continuum.

Vincendeau, Ginette (2005). *La Haine (Mathieu Kassovitz, 1995)*, London and New York: I.B.Tauris.

Volkan, Vamik (1997). *Blood Lines: from Ethnic Pride to Ethnic Terrorism*, NY: Farrar, Strauss and Giroux.

———— (2006). *Killing in the Name of Identity: A Study of Bloody Conflicts*, Charlotteville, VA: Pitchstone Publishing.

Warakurna paintings, Tjukurrpa Purtingkatja (History Paintings Part 2), www.outstation.com.au/exhibitions/tjukurrpa-purtingkatja-history-paintings-part-2/ (accessed 8 May, 2013)

Wheeler, Robyn (2000). *The Complexion of Race: Categories of Difference in Eighteenth-Century British Culture*, Philadelphia: University of Pennsylvania Press.

Willis, Andrew (ed.) (2004). *Film Stars: Hollywood and Beyond*, Manchester and New York: Manchester University Press.

Wilson, A.S.G. (2006). 'Gulpilil "Sad" for Destitute', *Canberra Times*, A.C.T.

Wilson, Shawn (2008). *Research is Ceremony: Indigenous Research Methods*, Manitoba Halifax and Winnipeg: Fernwood Publishing.

Wollheim, Richard (1999). *On the Emotions*, London: Yale University Press.

Woodward, Kathleen (2006). 'Performing Age, Performing Gender', *NWSA*, 18(1): 162–89.

Yang, Xiaowen (1991), 'Li Lianjie yan zhong de Huang Feihong' (Wong Fei-hung in the Eyes of Jet Li'), *City Entertainment*, 323: 23–6.

Yegoshina, Olga (2004). *Aktyorskiye tetrad Innokentiya Smoktunovskogo* [Innokenty Smoktunovsky's Actor's Notes], Moscow: OGI.

Yomota, Inuhiko (2000). *Nihon eigashi 100-nen*, Tokyo: Shūeisha.

——— (2011). *Ri Kōran to Hara Setsuko*, Tokyo: Iwanamishoten.

Youngblood, Denise J. (1992). *Movies for the Masses. Popular Cinema and Soviet Society in the 1920s*, Cambridge: Cambridge University Press.

Yu, Sabrina Qiong (2012). *Jet Li: Chinese Masculinity and Transnational Film Stardom*, Edinburgh University Press.

Zapanta, P.A. (1970). 'The Girl Who Made Good', *Sunday Times Magazine*, 27 September: 42–5.

Zeydabadi-Nejad, Saeed (2010). *The Politics of Iranian Cinema: Film and Society in the Islamic Republic*, London and New York: Routledge.

Zimnik, Nina (2005). 'Romy Schneider, La Passante du Sans-Souci'. Discourses of Vergangenheitsbewältigung, Feminism, and Myth', in Amina M. Brueggemann and Peter Schulman (eds), *Rhine Crossings. France and Germany in Love and War*, New York: State University of New York Press: 251–71.

Zipes, Jack (2011). *The Enchanted Screen: The Unknown History of Fairy-Tale Films*, New York: Routledge.

Zubrycki, Tom and Darlene Johnson (2002). *Gulpilil: One Red Blood*, Australian Broadcasting Corporation, Australian Film Finance Corporation & Jotz Productions, Ronin Films (distributor), Civic Square, A.C.T.

Index

Reference to images are in *italic*; reference to notes are indicated by n.

TAURIS WORLD CINEMA SERIES

Series Editor: Lúcia Nagib, Professor of Films, University of Reading
Advisory Board: Laura Mulvey (UK), Robert Stam (USA), Ismail Xavier (Brazil)

The *Tauris World Cinema* Series aims to reveal and celebrate the richness and complexity of film art across the globe, exploring a wide variety of cinemas set within their own cultures and as they interconnect in a global context.

The books in the series will represent innovative scholarship, in tune with the multicultural character of contemporary audiences. They will also draw upon an international authorship, comprising academics, film writers and journalists.

Published and forthcoming in the World Cinema series:

Basque Cinema: A Cultural and Political History
By Rob Stone and Maria Pilar Rodriguez

Brazil on Screen: Cinema Novo, New Cinema, Utopia
By Lúcia Nagib

The Cinema of Sri Lanka: South Asian Film in Texts and Contexts
By Ian Conrich and Vilasnee Tampoe-Hautin

Contemporary New Zealand Cinema
Edited by Ian Conrich and Stuart Murray

Cosmopolitan Cinema: Imagining the Cross-cultural in East Asian Film
By Felicia Chan

Documentary Cinema: Contemporary Non-fiction Film and Video Worldwide
By Keith Beattie

East Asian Cinemas: Exploring Transnational Connections on Film
Edited by Leon Hunt and Leung Wing-Fai

East Asian Film Noir: Transnational Encounters and Intercultural Dialogue
Edited by Chi-Yun Shin and Mark Gallagher

Film Genres and African Cinema: Postcolonial Encounters
By Rachael Langford

Greek Cinema from Cacoyannis to the Present: A History
By Vrasidas Karalis

Impure Cinema: Intermedial and Intercultural Approaches to Film
Edited by Lúcia Nagib and Anne Jerslev

Lebanese Cinema: Imagining the Civil War and Beyond
By Lina Khatib

New Argentine Cinema
By Jens Andermann

New Directions in German Cinema
Edited by Paul Cooke and Chris Homewood

Queries, ideas and submissions to:
Series Editor, Professor Lúcia Nagib – l.nagib@reading.ac.uk
Cinema Editor at I.B.Tauris, Anna Coatman – acoatman@ibtauris.com